CREATIVE ILLUSTRATION

ALSO BY ANDREW LOOMIS

FIGURE DRAWING FOR ALL IT'S WORTH
DRAWING THE HEAD AND HANDS
SUCCESSFUL DRAWING
FUN WITH A PENCIL

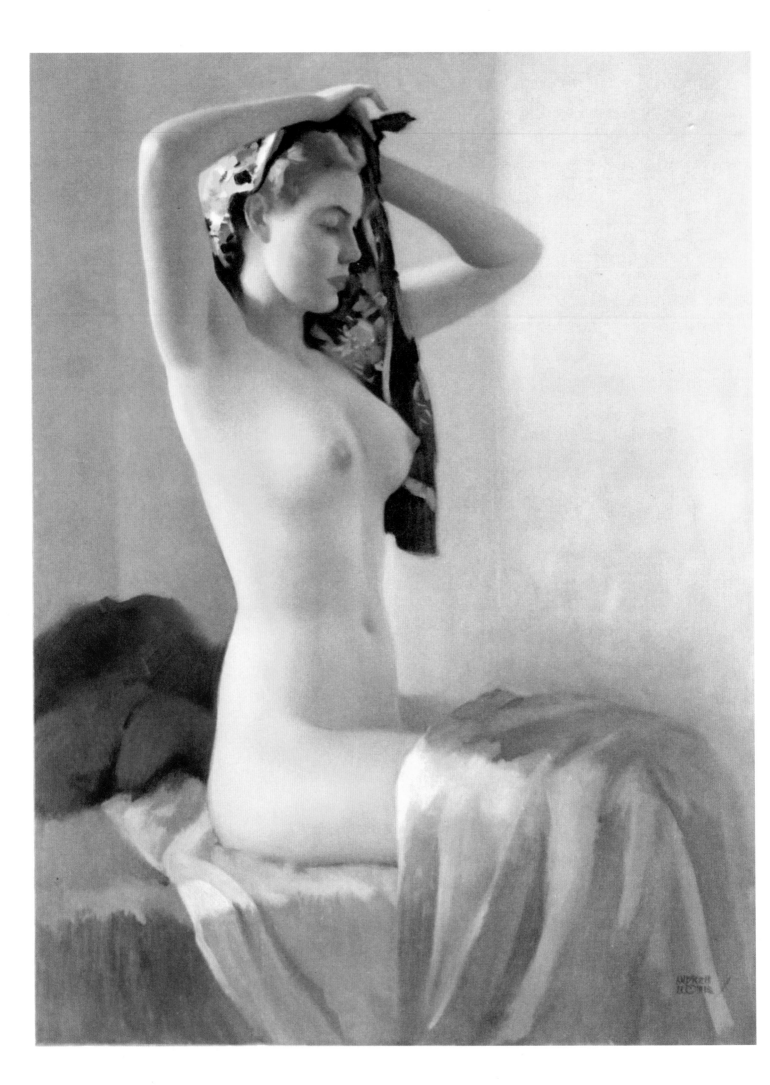

CREATIVE ILLUSTRATION

Andrew Loomis

Ex Libris:
M. De Savigny

TITAN BOOKS

Creative Illustration
ISBN: 9781845769284

Published by
Titan Books
A division of Titan Publishing Group Ltd.
144 Southwark St.
London
SE1 0UP

This edition: October 2012
5 7 9 10 8 6

To receive advance information, news, competitions, and exclusive offers online,
please sign up for the Titan newsletter on our website: *www.titanbooks.com*

Did you enjoy this book? We love to hear from our readers.
Please e-mail us at: *readerfeedback@titanemail.com* or write to
Reader Feedback at the above address.

A CIP catalogue record for this title is available from the British Library.

Printed and bound in China.

To the furtherance

of our craft of illustrating

as a profession for young Americans,

this volume

is respectfully dedicated

ACKNOWLEDGMENT

May I express here my appreciation of and gratitude for the valuable help given me in the preparation of this volume by my beloved wife, Ethel O. Loomis.

CONTENTS, INCLUDING ILLUSTRATIONS

(The illustration pages are indicated by italics)

9

CONTENTS, INCLUDING ILLUSTRATIONS

CONTENTS, INCLUDING ILLUSTRATIONS

11

CONTENTS, INCLUDING ILLUSTRATIONS

CONTENTS, INCLUDING ILLUSTRATIONS

CREATIVE ILLUSTRATION

OPENING CHAT

Dear Reader:

With the wonderful response given my earlier efforts, I believe that through this volume I shall be greeting many of you as old friends. The acceptance of my last book, *Figure Drawing for All It's Worth*, has encouraged me to continue, for there is still much worth-while knowledge in the field of illustration, beyond the actual drawing of figures, that can be set forth. It is one thing to draw the figure well, but quite another to set that figure into a convincing environment, to make it tell a story, and to give it personality and dramatic interest. In short, the figure means little as a good drawing only. It must accomplish something—sell a product, or give realism and character to a story; its personality must so impress the beholder that he is moved to a definite response emotionally.

My purpose is to present what, in my experience, have proved to be the fundamentals of illustration. To the best of my belief, such fundamentals have not been organized and set forth before. So I have attempted to assemble this much-needed information, trusting that my own efforts in the active fields of illustration qualify me to do so. I shall try to make clear the fundamentals that apply to the whole pictorial effort rather than to specific draftsmanship of the figure or other units. I shall assume that you can already draw with considerable ability and have some background of experience or training. In this sense the book will not be built around the early effort of the beginner, nor is it for those interested only in drawing as a hobby. It will be for those having a bona fide desire for a career in art and the determination to give it all the concentration and effort such a career calls for. Success in art is by no means easy, or a matter of puttering at it in odd moments. There is no "gift" or talent so great that it can dispense with the need for fundamental knowledge, much diligent practice, and hard effort. I do not contend that anyone can draw or paint. I do contend that anyone who *can* draw or paint can do it better with more knowledge to work with.

Let us assume, then, that you have ability you wish to put into practical channels. You want to know how to set about it. You want to paint pictures for magazine stories and advertising, for billboards, window displays, calendars and covers. You want every possible chance for success.

Let us not be under any illusions. At the start I must admit that there is no exact formula that can assure success. But there are unquestionably forms of procedure that can contribute a great deal toward it. Such a formula might be possible if the character, technical appreciation, and emotional capacity of the individual were not so much a part of the ultimate results. For that reason, art cannot possibly be reduced to exact formulas devoid of personality. Devoid of personality, creative art would have little reason for existence. In fact, the individual expression is its greatest value, the thing that forever lifts it above picture-making achieved by mechanical means. I shall not presume to quarrel with the camera. But I contend that even with all its mechanical perfection, the real value of photography is in the individual perception of the cameraman and not in technical excellence alone. If art were only perfection of precise detail, the camera would dispense with the need for artists. But until we have a lens endowed with emotion and individual perception, or having the power of discriminating between the significant and the irrelevant, the artist will always dominate the situation. The camera must accept the good with the bad, take it or leave it—must reproduce the complete unemotional and literal appearance of whatever is placed before it.

May I impress upon every reader that illustration is life as you perceive and interpret it. That

is your heritage as an artist and is the quality which will be most sought for in your work. Try never to lose it or subordinate it to the personality of another. As far as you and your work are concerned, life is line, tone, color, and design—plus your feelings about it. These are some of the tools with which we all work and which I shall try to enable you to use. You will work with these tools as you see fit, but my hope is that from this book you may gain added knowledge of how to use them.

Throughout my own early career I felt an urgent need for just this kind of help. The need is still evident, and I have taken the problem upon myself. My ability as an author can be set aside as of little importance. We have the common ground of knowing that the things I shall attempt to talk about are of tremendous importance to both of us, to our mutual success—since I intend to remain as active as possible in the field. I wish you to succeed as much as I wish to succeed myself, for the sake of our craft, which is more important than we are.

If illustration is expression, it becomes a transposition of thought. So it is thought transposed to an illusion of reality. Suppose I speak of a man with a face as hard as flint. A mental image is conjured up in your imagination. However, the image is not yet sharp and clear. This quality of hardness, a subconscious interpretation you feel, must be combined with realism. The result will not be a copy of a photo nor of a living model. *It is a transposition of your individual conception to a face.* You work with your tools of line, tone, and color to produce that quality. Devoid of feeling, you could hardly paint that head.

Drawing for mere duplication has little point to it. You may do it better with your camera. Drawing as a means of expression is the justification of art over photography. Art directors have told me that they use photography only because of the mediocrity of available artists. The demand for good work far exceeds the supply. Therefore commercial art has had to lap over into photography as the next best bet. Rarely does an art director prefer a photo to a well-executed painting. The difficulty lies in getting the painting or drawing that is good enough.

If we are to carry our craft forward, increasing the volume of good art to anything like the proportionate use of photography or meeting the indisputable demand, it will not be through the imitation of photography, nor even through greater technical ability. It will come through the greater scope of the imagination on the part of artists. It will come also through greater technical freedom leaning away from the merely photographic, and through greater individuality. To try to compete with the camera on its own ground is futile. We cannot match its precision of detail. For straight values and local color (which we will hear more of, later) there is little we can add. But for real pictorial worth, the gates are wide open.

You may be certain that the greatest pictorial value lies in all the things the camera cannot do. Let us turn our attention to design, looseness and freedom of technical rendering, character, drama, inventiveness of layout, the "lost and found" of edges, subordination of the inconsequential, and accentuation of the important. Let us incorporate the emotional qualities so sadly lacking in photographic illustration. Let our product be as different from the photo as our individual handwriting is from printed type. If we make the drawing, the values, and the color sound and convincing, from there on we need not compete. From that point on there is nothing to stop us, and from that point on the public actually prefers art to photography. The drawing, values, and color are only the stock-in-trade, the jumping-off place. That much is expected and taken for granted. What we do beyond these will determine how far we go in illustration.

Drawing as drawing alone is not too difficult. Drawing, for the most part, is setting down contour in correct proportion and spacing. Spaces can be measured, and there are simple ways and means of measuring them. Any old line around a contour may be correctly spaced. You can square

off copy, measure by eye, or project it, and get that kind of drawing. But real drawing is an interpretation, selection, and statement of a contour with the greatest possible meaning. Sometimes drawing is not the actual contour at all, but the one that will express the grace, character, and charm of the subject. Until the artist begins to think in line, think of expressing in this way the things he wants to say, he has not elevated himself much beyond his pantograph, projector, or other mechanical devices. How can he hope to be creative if he depends entirely upon them? Resorting to their use in place of drawing for self-expression is a confession of lack of faith in his ability. He must realize that his own interpretation, even if not quite so literally accurate, is his only chance to be original, to excel a thousand others who also can use mechanical devices. Even a poor drawing exhibiting inventiveness and some originality is better than a hundred tracings or projections.

If I am going to give you information of value, it must come from actual practice and from contact with the actual field. Naturally I am limited to my own viewpoint. But, since the fundamentals that go into my own work are for the most part the same as those used by others, we cannot be too far from a common goal. So, I use examples of my work here, not as something to be imitated, but rather to demonstrate the basic elements that I believe must go into all successful illustration. By showing you the means of expression rather than the expression itself, I leave you free to express yourselves individually.

My approach will strip itself as far as possible from the theory of imitation as a means of teaching. For this reason the approach must vary considerably from the usual art text formula. We shall have no examples of Old Masters, for, frankly, what methods and procedures they used are virtually unknown. You can see great pictures everywhere; you probably have your files full of them. Unless I could tell you how an Old Master arrived at his great painting, I could add nothing of value. I cannot presume to give you even an analysis of his work, for your analysis might be better than mine. Method and procedure are the only sound basis of teaching, for without them creative ability has no chance. I dare not incorporate even the work of contemporary illustrators, since each would be infinitely more qualified to speak for himself. I shall leave out all past performances of my own with the rest, for we are not as interested in what I have done as in what you are going to do, working with the same tools. There is but one course open for me if I am to stay on solid ground, that of sharing my experience with you for whatever value it has. You will thus have the chance to select what is of use to you, and to discard that with which you do not agree.

The art of illustration must logically begin with line. There is so much more to line than is conceived by the layman that we must start out with a broader understanding of it. Whether consciously or not, line enters every phase of pictorial effort, and plays a most important part. Line is the first approach to design, as well as the delineation of contour, and ignorance of its true function can be a great impediment to success. So our book will start with line.

Tone comes next. Tone is the basis of the rendering of form in its solid aspect. Tone is also the basis of a three-dimensional effect of form in space. A truthful representation of life cannot be made without a clear understanding of tone. Line and tone are interdependent, and this relationship must be understood.

To line and tone is added color. Again the relationship becomes inseparable, for true color depends almost entirely upon good tonal or value relationship. We may draw an illustration in line only, and it stands complete pictorially. But the minute we go beyond line as contour only, we start to deal with light and shadow, or tone. We are therefore plunged immediately into the complex laws of nature, since only by light and shadow, or tonality, is form apparent to us. The step from tone to color is not nearly so great, since the two are closely related.

19

Granted that we can comprehend the basic fundamentals of line, tone, and color, there is still more to encompass. All three must be united to a pictorial purpose. There are arrangement and presentation, even more important than the subject matter. There is organization of area and tonal mass or pattern in order to create good pictures. To these ends we shall work.

Beyond the technical rendering comes the dramatic interpretation. In the final analysis the illustrator is holding a mirror to life, and expressing his feelings about it. He may paint a pot of flowers beautifully, but it can by no stretch of the imagination be called an illustration. Illustration must encompass emotion, the life we live, the things we do, and how we feel. So we shall devote a part of the book to the "telling of the story."

If we are to illustrate, we must create ideas. Illustration delves into psychology for basic appeals, to create ideas that must reach into the personality of the reader, compelling definite responses. We need to understand the development of ideas as the basis of advertising, too, so that our work may find a market in that field, and be suited to its special needs. Therefore a part of the book will be given over to this subject.

Finally, we must separate the various fields into a variety of approaches, each tuned to its particular purpose. In each field there is an individual basic approach which the successful artist must know. To do an outdoor poster is one thing, and a magazine ad another. All these points I hope to make clear.

There is the matter of experiment and study, which can contribute so little or so much to your ultimate success. This can assure freshness and progress in your work as can nothing else; it is the thing that lifts you out of the rut of daily routine, and places you head and shoulders above your associates. It is the biggest secret of success.

I have searched out to the best of my ability the workable truths. I have organized these into what I shall call the "Form Principle." Within this is the whole basis of approach to the material of this book. These truths have existed long before me, and will continue ever after. I have simply tried to gather them together. They are the things which are present in all good art, and should be a part of all that you do. They spring from the laws of nature, which I believe is the only sound basis for a book of this kind. So let us get on with our work.

THE FORM PRINCIPLE
AS A BASIS OF APPROACH

No MATTER what subject the artist uses or what medium he works in, there is but one solid basis of approach to a realistic interpretation of life— to the representation of the natural appearance of existing forms. I cannot lay claim to being the first to perceive the truths which underlie this approach. You will find them exemplified in all good art. They existed long before me, and will continue as long as there is light. I shall attempt only to *organize* these truths so as to make them workable for you in study and practice, in everything you do. To the organization of these basic truths I have given a name: the Form Principle. This principle is the basis for everything which will be discussed in this book; and it is my hope that you will adopt it and use it for the rest of your lives. Let us start out by defining the Form Principle:

The Form Principle is the rendering of form as to its aspect at any given moment with regard to its lighting, its structure and texture, together with its true relationship to its environment.

Now let us see what this means. Any pictorial effect that will present a convincing illusion of existing form must do so first by the rendering of light on that form. Without light, as far as we are concerned, form ceases to exist. The first truth of the Form Principle that we are concerned with is:

It must be determined at once what kind of light we are working with, for its nature and quality and the direction from which it comes will affect the entire appearance of the form.

If it is impossible to render form without light, then it follows that the nature of the form becomes visible because of light. A brilliant light produces well-defined light, halftone, and shadow. A diffused light, such as the light of the sky on a grey day, produces an effect of softness and subtle gradation of light to dark. In the studio the same relative effects are produced by artificial light for definition and by the natural north daylight for the soft gradation.

The direction or position of the light source, then, determines what planes shall be in the light, halftone, or shadow. Texture is more apparent in a direct or bright light than in a diffused light. The planes of the form are also more apparent in brilliant light.

This brings us to the next truth:

The lightest areas of the form will be within those planes lying most nearly at right angles to the direction of the light. The halftone planes will be those obliquely situated to the direction of the light. The shadow planes will be those planes lying in or beyond the direction of light so that the light of the original source cannot reach them. The cast shadows are the results of the light having been intercepted, and the shape of such intercepting form is projected to other planes. In diffused light there is little or no cast shadow. In brilliant light or direct light there is always cast shadow.

So you will see that the kind of light immediately has to do with the approach to your subject and the ultimate effect. Having less definition, the diffused or over-all light will be most difficult. For "snap," take direct light. For softness and simplicity, use sky light. Direct light produces contrast, sky light produces closeness of value.

Direct light produces much more reflected light, and this is most apparent within the shadow. The amount of reflected light reaching the shadow will determine its value. Everything upon which the light falls becomes a secondary source of reflected light and will light shadow planes in

the same manner as the original source, being brightest on the planes at right angles to such reflected light.

Light can operate in only one manner. It hits the top planes squarely and brightly, then slides around the form as far as it can go. However, in the shadow, the source being of less brilliancy, *reflected light can never be as light as the original source. Therefore no area in the shadow can be as light as the areas in the light.*

More art falls apart for this reason than for any other. Both light and shadow areas must be simplified and painted in the fewest possible values. The object is to make all the lighted areas hold together as one group, as opposed to the shadow areas as another group. If the values of the two groups are not thus separated and held apart, the subject is bound to lose solidity and form, no matter how well modeled and how well drawn. Much of the reason for pictures' falling apart is also because simple light and shadow is not given a chance. Such relationship is destroyed by inserting several sources of light. Thus where halftone and shadow should be to give the true character of the form, it is lost by other lighting, and the values become a hodgepodge of middle tones, highlights, and accents. There cannot be a white in the shadow area. There can hardly be a pure black in the light area. A safe approach is to make all the areas in the light a little lighter than you think you see them, and all the areas in the shadow a little darker. You will probably come out with a better thing than the other way round.

All forms within your picture should appear to be lighted by the same source and be lighted consistently with one another.

This does not mean that light cannot travel in different directions, such as the light around a lamp, the light of two windows, reflected lights, etc. But the light must be a *true* effect of light, such as sunlight, sky light, moonlight, twilight, artificial light, etc., in its real effect and relationship. There is only one way to get this right. Do it by studying from life the true aspect, or take a photo which will give it to you. It cannot be faked.

Faked lighting breaks down every other good quality.

All things represented within a given light bear a relationship of tone and value to one another.

If this relationship is not maintained, then the form cannot be true. Everything has its "local" value, that is, its surface tone appears to be somewhere in the scale from black to white. Bright light can raise the value, and dim light can lower it. But the light raises or lowers all other surrounding values correspondingly, so that the value of the subject holds a constant relationship to other values. It will remain, in any light, so much lighter or darker than its neighbors. For instance, a man's shirt may be so much lighter than his suit. In any light this relationship holds good. Therefore, whether in deep shadow or bright light, we cannot change the value difference between the two. The object is to raise both or lower both but to keep the approximate difference. The relationship of things to one another will be the same always, either in light or in shadow.

A single source of light is best for our purpose and produces the best effect pictorially. This also gives us reflected light. We can use a reflector (usually a white board) to reflect the original light with beautiful effect. This, when working on the shadow side.

Relationship of values is more correct in natural light than in any other.

Sunlight and daylight are the perfect lights for true rendering of form. You simply cannot beat them with all the trick lighting possible.

Overmodeling comes from incorrect values.

If, to make the form go round, we exaggerate the values, we use up the rather limited range between black and white, so we do not have left the proper and lower values for the shadow. The picture becomes dull and lifeless, since we have used values that do not belong to the light and could not be in relationship. The opposite is true when we put lights into the shadows that could not be, destroying the big relationship between the whole light and the whole shadow.

THE FORM PRINCIPLE

The big form makes the subject carry and appear solid, not the incidental surface forms.

Many of the small and intricate forms must be subordinated to keep the big form solid. Folds, for instance, can ruin the effect of underlying form and break it up. Draw only the folds that express form and the natural drape of the material, not every fold just because it is there on the model or in the copy.

The best pictures run to a few simple values.

This will be taken up later on.

The design makes the picture, not the subject or material.

Almost any subject can be used with charm through the help of design and arrangement. Presentation is more vital than subject matter.

The same form may be presented with great variety by a careful arrangement of lighting. Just any light will not do. It must be the best of several experiments.

A landscape beautiful in early morning or evening light may be dull and uninteresting at noonday. A charming head may be ugly in bad lighting. The best plan is always to choose the lighting that tends to big simple form, not form too broken up in light and shadow.

Light and shadow in itself produces design.

The plainest of subjects can be made artistic by weaving patterns of light and shadow through it.

Value relationships between objects produce design.

For example, a dark object placed against a light one, and both against a grey field, would be design. Units may be placed against close values or contrasting values, thereby getting subordination in the first instance and accentuation in the second. The planning or composition of the subject is really dealing with the relationships of the values of certain units as combined with or opposed to others. This results in "pattern," and can be further combined with lighting.

All pictures are fundamentally either arrange-ments of lights, intervening tones, and darks, or else linear arrangements.

You cannot avoid making your subject either a tonal statement or a linear statement. You can combine both, but you cannot get away from one of these. If you do not understand tonal relationship you cannot secure a feeling of "existence."

Line is contour; tone is form, space, and the third dimension.

Get this clearly in your mind.

Contour cannot be continuously defined all around all units and a sense of space be achieved.

Contour becomes lost and found and interlaced or woven into other areas in nature. If the edge is kept hard all around, it cannot avoid sticking to the picture plane, losing the feeling of space, or one edge in back of another. Edges will be taken up in more detail later.

The fundamentals are the same in all mediums.

Each medium has an inherent quality of its own. Once you master the Form Principle, only the peculiarities of the medium remain to be mastered. You will simply have to find out how to express a sharp edge, a soft edge, light, halftone and shadow, in the medium, which is a purely technical matter. But you will render form in essentially the same way in all mediums.

The darkest part of the shadow appears nearest the light, between the halftone of the light and the reflected light within the shadow.

This is called the "ridge" or "hump" by the illustrator, and is most important. It keeps the shadow luminous and the form round.

The Form Principle is the co-ordination of all factors dealing with line, tone, and color.

This book is laid out on the Form Principle, since it enters into everything you will ever do, or see, in the field of illustration. We shall attempt to clarify its various applications as we go along. I suggest that you come back to these fundamental truths often, for they are the answer to most of your problems.

So we start with line!

23

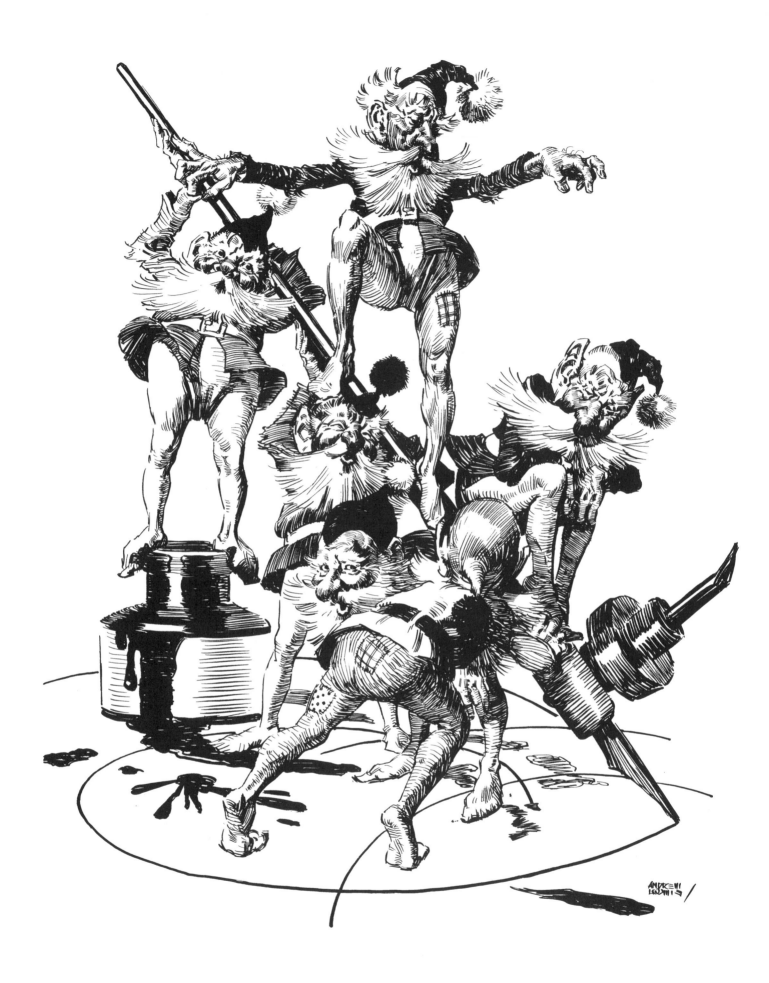

THERE ARE SEVEN PRIMARY FUNCTIONS OF LINE

1. To convey its own intrinsic beauty.
2. To divide or limit an area or space.
3. To delineate a thought or symbol.
4. To define form by edge or contour.
5. To catch and direct the eye over a given course.
6. To produce a grey or tonal gradation.
7. To create design or arrangement.

EVEN if it may seem a bit obvious, let us start the book with the very beginning of artistic expression, that of line. There is truly much more to line in the mind of the artist than in that of the layman. To the latter, line is but a mark of a pencil or a mere scratch of a pen. To the true artist, line can reach great heights, require exhaustive skill, and convey unlimited beauty. Line in its various functions has contributed as much to human progress as fire or steam. All line should have function and purpose. I want you to think of it in that light. Everything from this day forward that you do artistically will bear a relationship to line, either good or bad. You can either make line an asset to your work, or you can let its importance slide by you. But if you choose to ignore the functions of line, your work will make a bad statement of your ability. Line is bound to enter your work for better or worse. You cannot escape it.

Let us see what can be done about it.

25

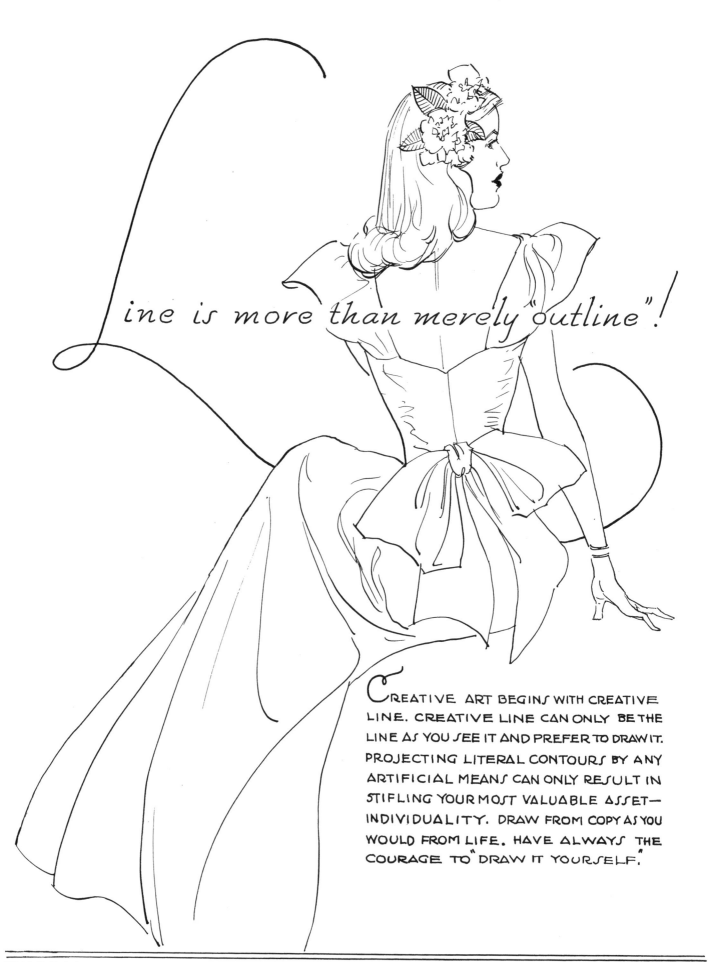

Line is more than merely "outline"!

Creative art begins with creative line. Creative line can only be the line as you see it and prefer to draw it. Projecting literal contours by any artificial means can only result in stifling your most valuable asset— individuality. Draw from copy as you would from life. Have always the courage to "draw it yourself."

This book has been designed to carry forward the fundamentals set forth in "Figure drawing for all it's worth." It must be assumed you have an understanding

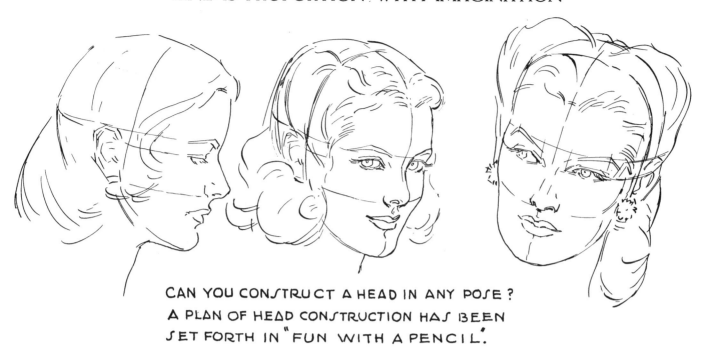

CAN YOU CONSTRUCT A HEAD IN ANY POSE?
A PLAN OF HEAD CONSTRUCTION HAS BEEN
SET FORTH IN "FUN WITH A PENCIL".

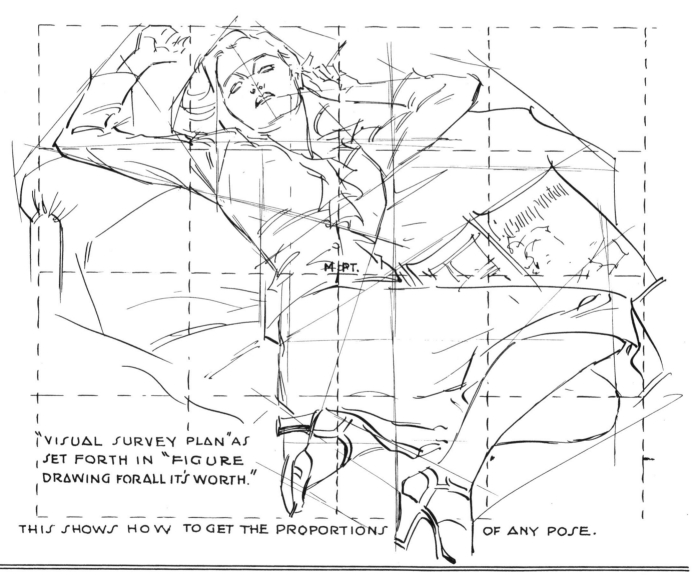

"VISUAL SURVEY PLAN" AS
SET FORTH IN "FIGURE
DRAWING FOR ALL IT'S WORTH."

THIS SHOWS HOW TO GET THE PROPORTIONS OF ANY POSE.

OF THE PROPORTION AND CONSTRUCTION OF THE HUMAN FIGURE. IT IS MY PURPOSE NOW TO HELP
YOU DEVELOP THE FIGURE PICTORIALLY TO PRACTICAL GOALS AND TO A LIVELIHOOD. WORK!

LINE PRODUCES FORMAL DESIGN

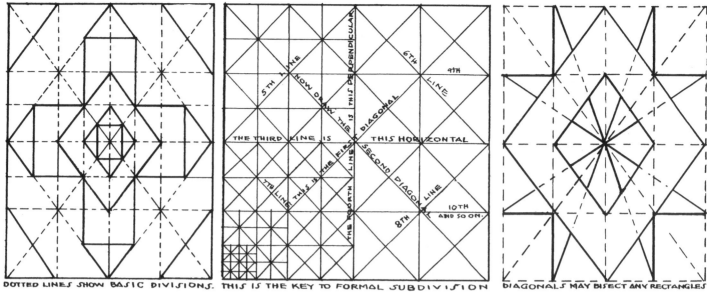

DOTTED LINES SHOW BASIC DIVISIONS. THIS IS THE KEY TO FORMAL SUBDIVISION DIAGONALS MAY BISECT ANY RECTANGLES

SUBDIVISION BY DIAGONALS, VERTICALS AND HORIZONTALS PRODUCES UNLIMITED DESIGN. TRY IT.

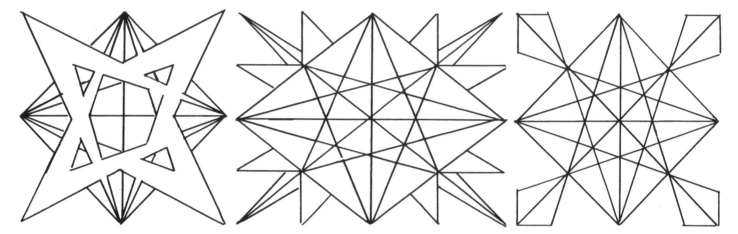

CHOOSE ANY POINTS, BEING CAREFUL TO REPEAT THE DIAGONAL BETWEEN ALL SIMILAR POINTS.

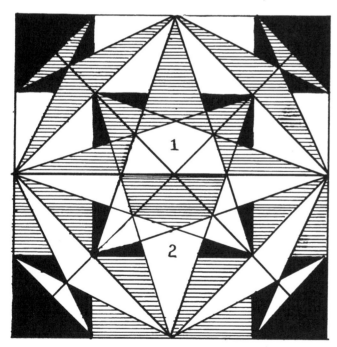

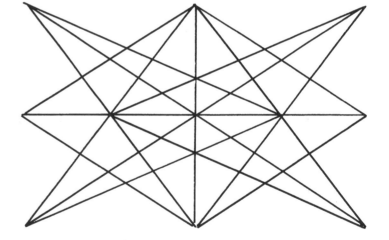

IF A DRAWING IS BASED UPON UNDERLYING LINEAR DESIGN, IT WILL PARTAKE OF ITS UNITY

THIS PAGE IS TO IMPRESS UPON YOU THE BASIC RELATIONSHIP OF LINE TO DESIGN. DIVIDING SPACE EQUALLY PRODUCES "FORMAL" DESIGN. THEREFORE "INFORMAL" DESIGN IS BY UNEQUAL DIVISION. COMPOSITION IS ONE OR THE OTHER.

LINE PRODUCES INFORMAL DESIGN

ARCS INTERLACED

COMBINING HORIZONTALS AND
PERPENDICULARS WITH CURVES.

OBLIQUE LINES INTERLACED.

OVERLAPPING OVALS

OVERLAPPING CIRCLES

OVERLAPPING SQUARES

OVERLAPPING TRIANGLES

OVERLAPPING RADII

OVERLAPPING WAVY PARALLELS

OVERLAPPING ANGLES

OVERLAPPING SPIRALS

OVERLAPPING RECTANGLES

HORIZONTALS AND PERPENDICULARS

29

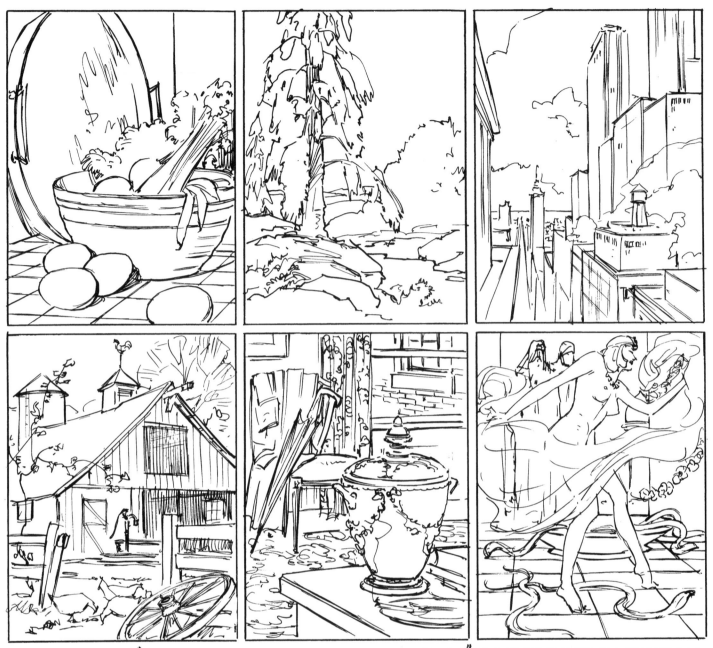

THE PRINCIPLE OF "OVERLAPPING AREAS, FORMS, AND CONTOURS" IS THE BASIS OF ALL PICTORIAL CREATION. SINCE LINE IS OUR FIRST MEANS OF DEFINING THESE, THEN LINEAR ARRANGEMENT BECOMES OUR FIRST CONSIDERATION. THERE ARE MANY WAYS TO GO ABOUT IT. SO LET US START.

Nature is one vast panorama of contours and spaces. Everything is form, set into space. If we were to cut a rectangular opening in a piece of cardboard and look through it, nature would present us with a picture. Within the four limits of the opening, the space would become divided by spaces and contours. To that spacing and arrangement of contours we will give everlasting attention, for it is the basis of all pictorial approach. The novice snaps his camera carelessly at nature. The artist seeks to arrange it. From the artist's approach, almost anything is picture material, *since it is design and arrangement that makes pictures, regardless of subject.* Cut a cardboard so as to make a "picture finder." An opening of three by four inches is large enough. Look through it. Jot down, in miniature compositions, the linear arrangements you find. Your sense of arrangement is the first real indication of your creativeness. Walk about the house or grounds with a small sketch pad. Don't go any farther until you have done a dozen or two small roughs.

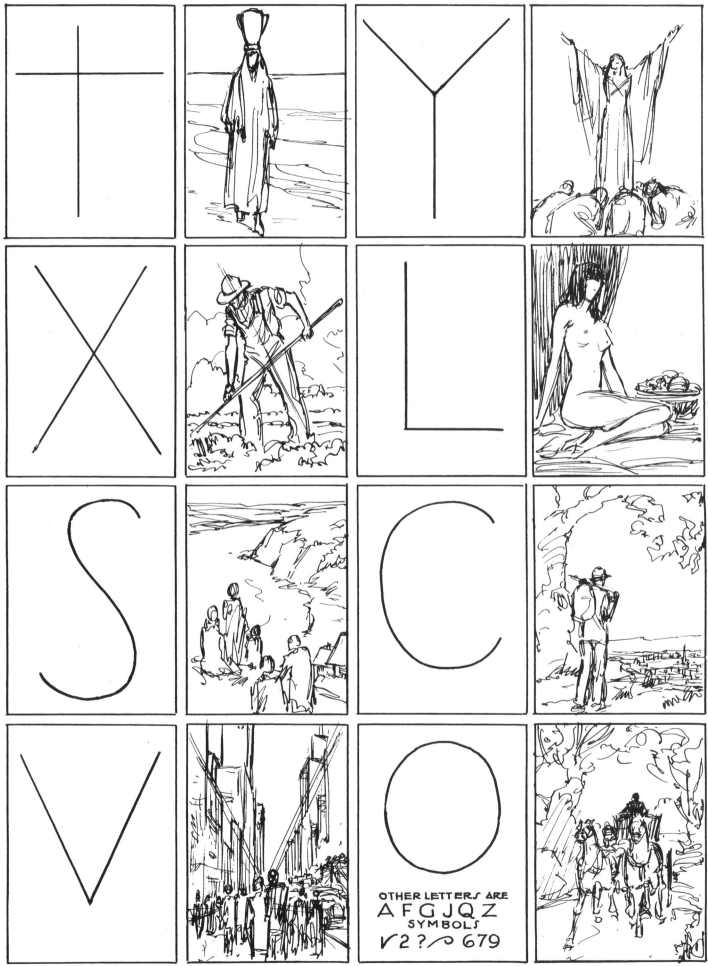

OTHER LETTERS ARE
A F G J Q Z
SYMBOLS
√ 2 ? ∽ 679

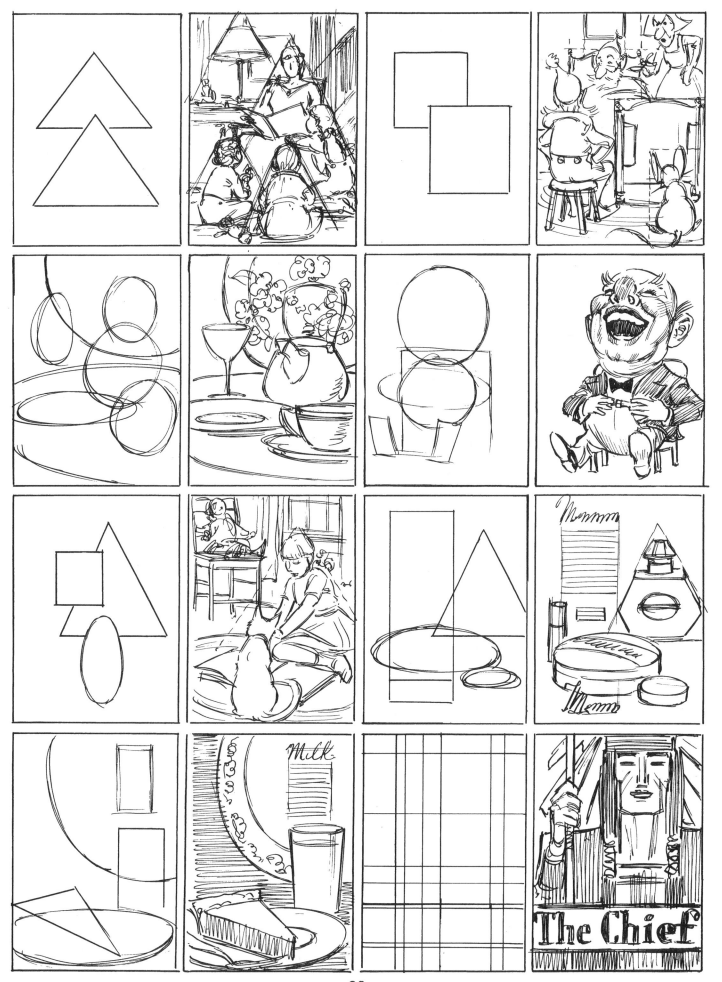

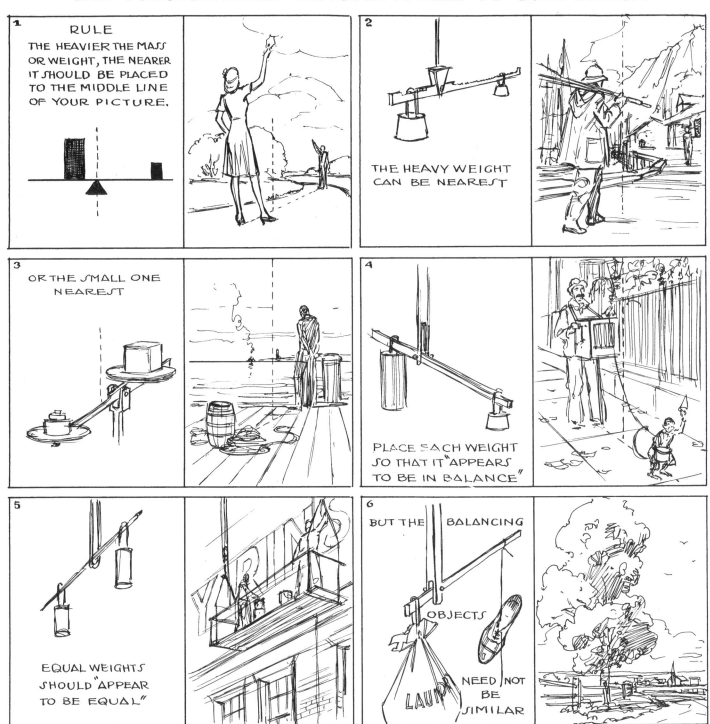

1

RULE
THE HEAVIER THE MASS OR WEIGHT, THE NEARER IT SHOULD BE PLACED TO THE MIDDLE LINE OF YOUR PICTURE.

2

THE HEAVY WEIGHT CAN BE NEAREST

3

OR THE SMALL ONE NEAREST

4

PLACE EACH WEIGHT SO THAT IT "APPEARS TO BE IN BALANCE"

5

EQUAL WEIGHTS SHOULD "APPEAR TO BE EQUAL"

6

BUT THE BALANCING OBJECTS NEED NOT BE SIMILAR

LAUNDRY

To be pleasing, the material within a picture needs balance, or should seem to be pleasantly reposing within the picture limits. Balance is obviously "off" when we feel that the limits would seem better if moved over, or more space added or cut away. This is the best guide we have, for there are no infallible rules of composition. About the only rule is that we give the greatest variety of spaces possible, no two duplicating one another in size or shape (except in strictly formal arrangements, where all things are balanced equally on each side). If two forms are equal, let one overlap the other so as to change the contour. Variety is the spice of composition. We make a small weight balance a heavier one by placing it farther away from the middle of the subject, or the fulcrum, which is the middle point of balance. Balance in composition is a sense of equilibrium between the masses of light and dark, or of the area and bulk of one thing balancing another. The heavier the mass, the nearer the middle—the smaller the mass, the nearer the edge—is a good axiom.

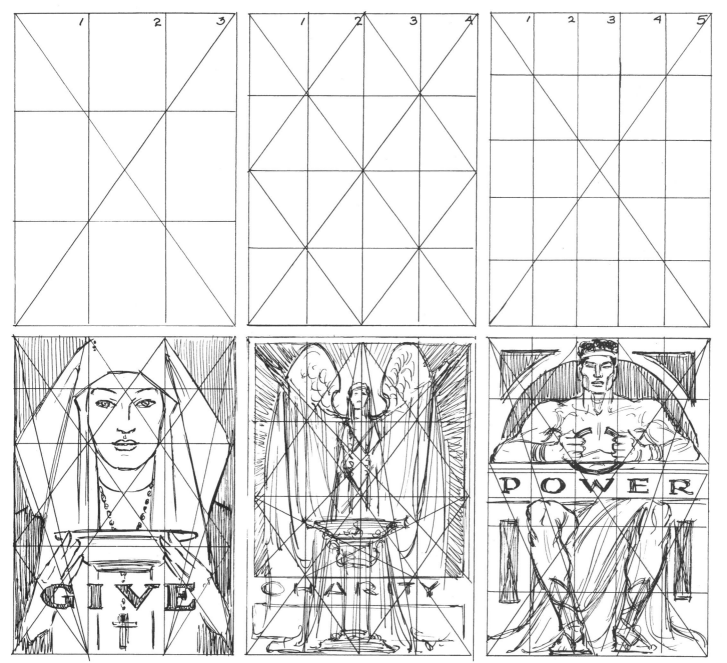

FORMAL DIVISION APPLIES BEST TO SUBJECTS OF A DIGNIFIED OR RELIGIOUS NATURE

There are times when we wish to achieve great dignity of arrangement. Since the Creator's basic design for animate form is the duplication of one side by the other, such as the two sides of the human body, arrangement based on the same plan takes on the same sort of dignity. It does not mean that each side must duplicate exactly, but there should be a feeling of complete equalization of the units or masses, the line and spaces, of one side with the other. Church murals invariably follow this plan. It may be used to great advantage in symbolical subjects, appeals for charity, heroic subjects, or to suggest peace and serenity. Formal balance was almost the only approach in earlier times, and great compositions have been built with it. It is largely the formality of design which lends such magnificence to the work of Michelangelo, Rubens, and Raphael.

Formal subdivision may also be used informally if one is adept enough. I have introduced on the next page another method, quite apart from either formal division of space or dynamic symmetry. I have never found either as satisfactory as this new approach, and I hope it will prove of great benefit to others.

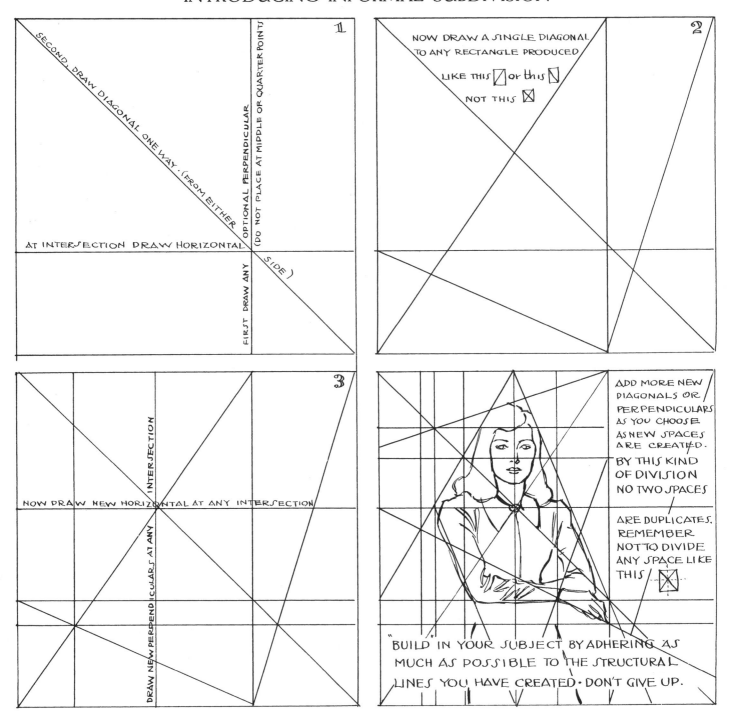

This is a plan of subdivision of my own. It offers greater freedom to the artist. Study it. It will help you to divide space unequally and interestingly. Start by dividing the whole space unequally with a single (optional) line. It is best to avoid placing the line at a point which would be one-half, one-third, or one-fourth of the whole space. Then draw one diagonal of the *whole* space from diagonally opposite corners. At the intersection of the diagonal and your first line, draw a horizontal line across the space. Now draw diagonals in any of the resulting rectangles, but only one to a space. Two diagonals crossing like an X would divide the rectangle equally, which we do not want. Now you may draw horizontals or perpendiculars at any intersection, thus making more rectangles to divide by diagonals again. In this manner you will never break up the same shape twice in the same way. It offers a great deal of suggestion for the placement of figures, spacing, and contours, with no two spaces being exactly equal or duplicated, except the two halves on each side of the single diagonal. If you have a subject in mind you will begin to see it develop.

A DEMONSTRATION OF INFORMAL SUBDIVISION

I HAD ONLY AN IDEA IN MIND OF SHOWING A LOT OF LITTLE
GNOMES PLAYING WITH A PEN. SO FAR I HAD NO IDEA OF HOW
I WOULD ARRANGE THEM. I DIVIDED MY SPACE AS SHOWN.
THE ABSTRACT SHAPES THUS SUGGESTED THE COMPOSITION.

FROM THE FIGURES
"ROUGHED" INTO THE
SKETCH, I DEVELOPED
THEM FURTHER.

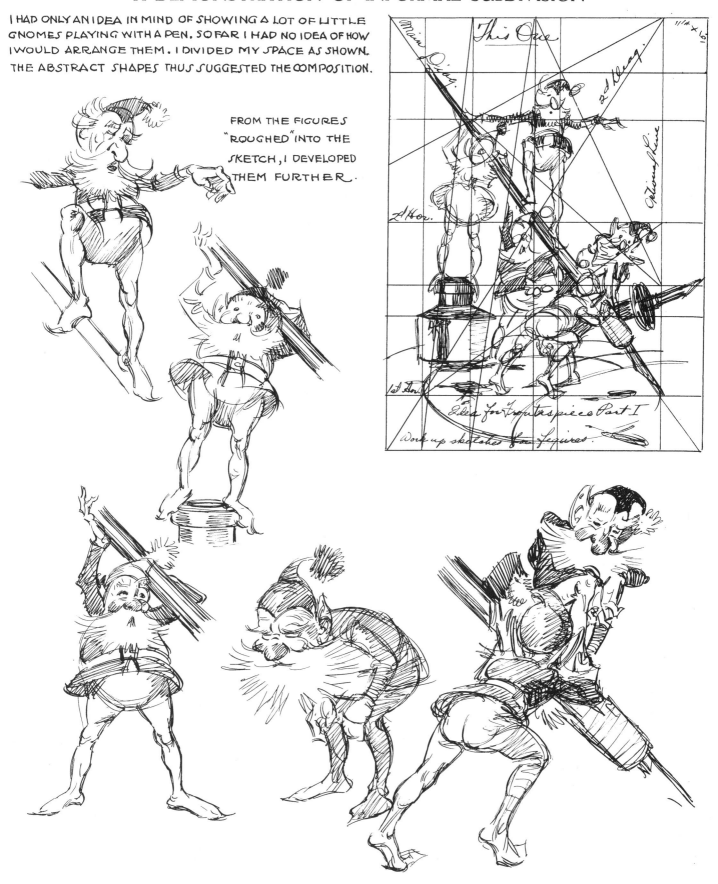

FROM THIS PRELIMINARY WORK, THE FINISHED FRONTISPIECE TO PART ONE WAS CREATED.

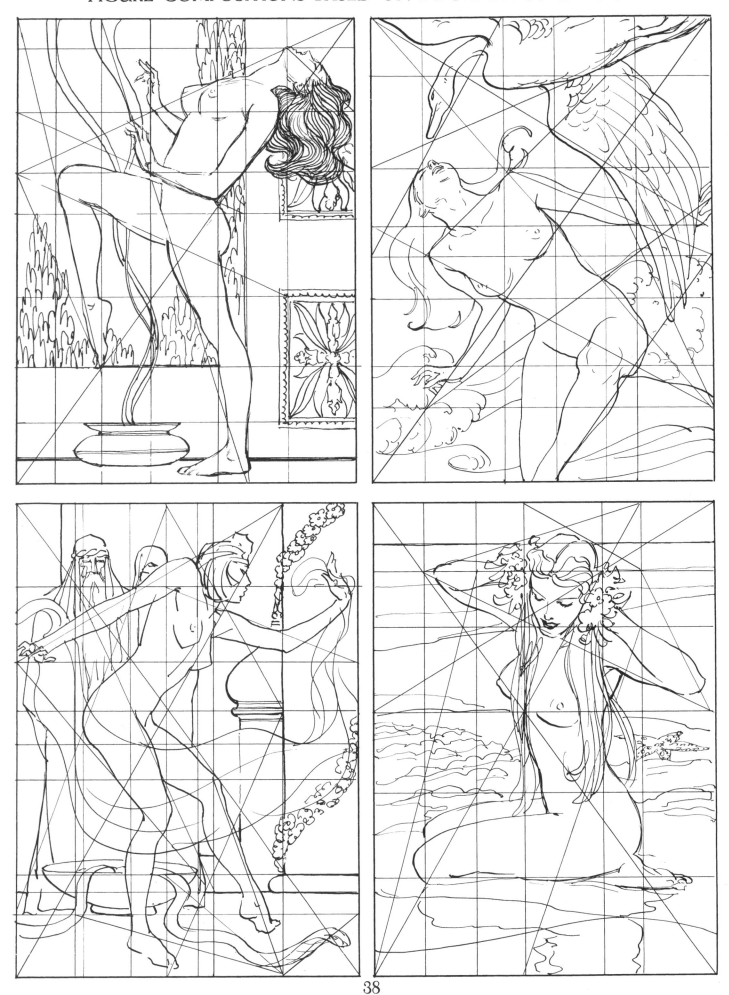

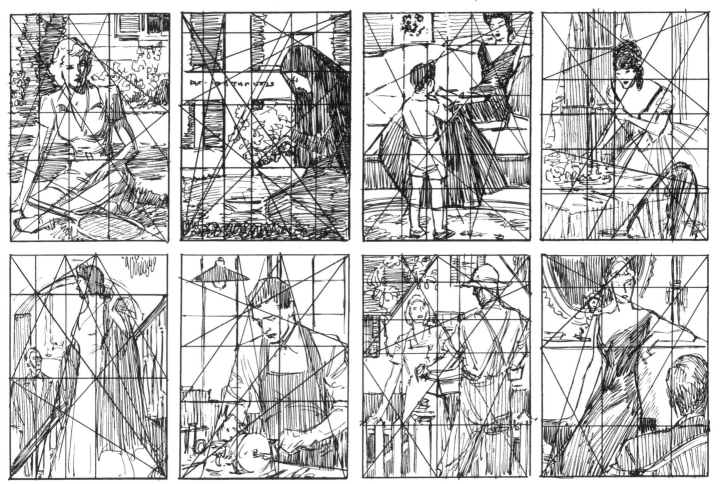

MAKE THUMBNAILS. THE DIVISIONS HERE SUGGESTED THE SUBJECTS AND ARRANGEMENTS.

Since, when a space is divided in the manner shown in these pages, selection plays a great part, and invention the rest, it cannot avoid being creative. That is its strongest recommendation, in comparison with forms of subdivision that start you out with a "set" or formal arrangement to begin with. You start inventing with your first line when you use informal subdivision. It helps to get you over the emptiness of blank paper before you, without an idea in your head. That, I assure you, is the feeling most of us experience, and you probably already know what I mean. If you have a subject in mind, it will develop with one or two tries. If you have no subject in mind, pretty soon the lines will start suggesting something, as these did in the little drawings above. In starting out I had no intimation of what the subjects would be. This method is invaluable in working up ideas, layouts, small compositions. As the ideas develop they can be carried out with models, clippings, and so forth. When the original subdividing lines are erased, it is amazing how well the composition balances or "hangs together." I urge you not to pass this up without a tryout. It has often saved the day for me, and I admit that even in my own work I am often so "stymied" for a good arrangement that I turn to it in great relief. While all of the compositions of the book are not so based, many of them are, and in my estimation the better ones. Any one of the arrangements on this or the preceding pages would be intriguing to do as a painting, and I only wish I had the space. Most artists develop an eye for composition eventually, but this device will get you well on the way. Draw the dividing lines lightly so they can be easily erased.

PERSPECTIVE GUIDE LINES HELP YOU TO COMPOSITION

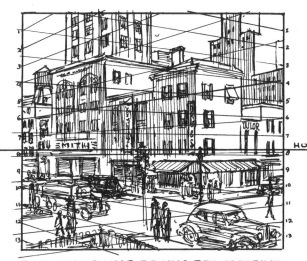

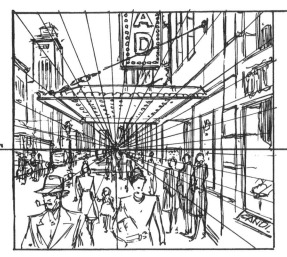

TWO VANISHING POINTS PERSPECTIVE

A FAST WAY TO COMPOSITION. MARK
OFF EVEN SPACES DOWN EACH SIDE.
RUN LINES OUT TO VANISHING POINTS.
THRU PICTURE. YOU CAN NOW USE YOUR
EYE, FILLING SPACE AS DESIRED.

ONE VANISHING POINT PERSPECTIVE

TAKE A POINT ON THE HORIZON, DRAW
RADIATING LINES IN ALL DIRECTIONS
FROM IT. YOU CAN NOW BUILD ON THOSE
LINES BY CHOICE. OF COURSE YOU NEED
TO KNOW PERSPECTIVE TO DO IT.

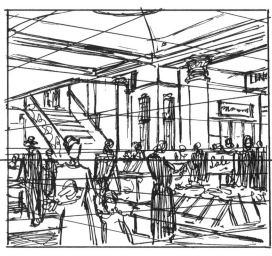

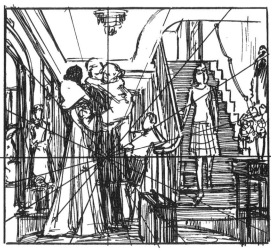

THE SAME APPLIES TO INTERIORS.

ALSO ONE POINT FOR INTERIORS.

THE PERSPECTIVE LINES ARE MERELY GUIDE LINES TO HELP THE EYE.

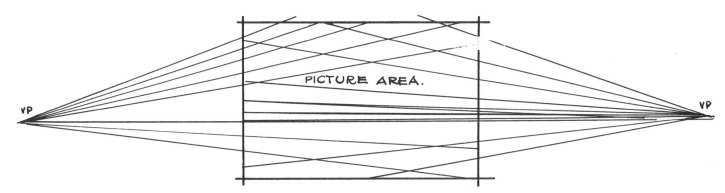

PLAN YOUR PICTURE IN MINIATURE THIS WAY. YOU CAN LATER SQUARE IT OFF
FOR ENLARGEMENT. I USE THIS PLAN A LOT TO GET RIGHT INTO A GIVEN SUBJECT.
THIS IS A MOST PRACTICAL PROCEDURE. NOW IF YOU DO NOT UNDERSTAND
PERSPECTIVE, YOU'D BETTER STUDY IT. YOU CANNOT GET ANYWHERE WITHOUT IT.

EVERYTHING YOU DRAW IS RELATED TO AN EYE LEVEL

It is impossible to draw correctly and intelligently without the consideration of a viewpoint and an eye level. The viewpoint is what is known as the station point in perspective. However, that is really the spot on the ground plane where you are standing. Artistically, the viewpoint is the center of the field of vision and is not to be confused with the vanishing points. If we look straight out at eye level, the viewpoint will be exactly opposite a point located in the middle of the horizon. The horizon is the eye level. Think of a great fan-shaped sheet of glass starting at a point just back of our two eyes and spreading out at our eye level and reaching as far as we could see. This entire sheet of glass would be the picture horizon. No picture can have more than one horizon. It follows that all receding lines parallel to the ground plane that recede from points above the horizon must slant downward pictorially and end in the horizon. Then all lines below the horizon, also parallel to the ground plane, must slant upward to the horizon. Our viewpoint, then, determines the horizon.

Since a picture may not, and seldom does, represent the whole field of vision, the horizon may cross the picture plane, or be above the picture or below it. Suppose you have a large photo of a group of buildings. Without changing the horizon or perspective lines, you might crop out any small section of the photo for your picture. But no matter what part you take, the relationship to the original eye level (or viewpoint of the camera) is apparent. You or the camera look down on everything below the picture horizon or up at anything above it. All things will show only their top surface when below the eye level or picture horizon. We can look into things only when the eye is above them. Round lines like a belt around a waistline must curve up when below the horizon, and down when above. But how many times we see this truth disregarded! How often do we see necks, shoulders, paying no attention to an eye level, roofs slanting down or up when the reverse should be the case! It must be stated here that too large a percentage of artists go into the field of illustration and commercial art woefully lacking in a knowledge of simple perspective. It becomes apparent when the artist has obviously worked from two clippings or photos, each having a different eye level. You may be certain two clips will seldom be in agreement with each other in this respect.

Perspective must be understood by the artist. It applies to every bit of copy he uses. He can start with one thing, for instance a photo of a piano. That will establish the horizon of his picture. Then everything else, including figures, must be drawn to the same eye level. He must redraw the perspective so that the vanishing points will fall in the same horizon set by the piano. Or, selecting a figure, he may adjust the perspective of the piano to fit the figure. The best way to do this is to make small sketches so that wide vanishing points may be used. Use a large tissue pad. Then square off the small sketch and enlarge to the size you want.

To learn perspective means only a small investment at the bookstore, and only a few evenings set aside to learn it once and for all. Why an artist will jeopardize his whole output and a lifetime of effort by a lack of such knowledge is beyond me. For some reason, the man who does not know perspective imagines it is much more difficult than it really is. It is just one of those things, like the study of anatomy, which an artist may keep putting off eternally and suffer for lack of, every day. Perspective is a part of *every form under every condition and cannot be avoided*. It affects your very next job and every one thereafter. If you are working from a single photo the camera may do it for you. But if you change or add one single unit to your photographic copy, you will not be able to do it correctly unless you understand this principle of eye level and viewpoint. If you do not understand perspective, by all means drop everything else and get it at once. You will never draw until you do. (There are so many good texts on perspective that it would be superfluous to give further space to it here. Your bookstore can help you.)

EYE LEVEL, CAMERA LEVEL, AND HORIZON MEAN THE SAME

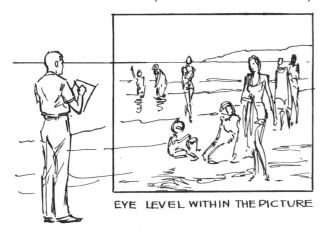

EYE LEVEL WITHIN THE PICTURE

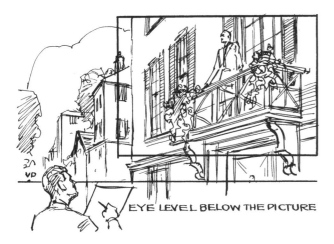

EYE LEVEL BELOW THE PICTURE

EYE LEVEL ABOVE THE PICTURE

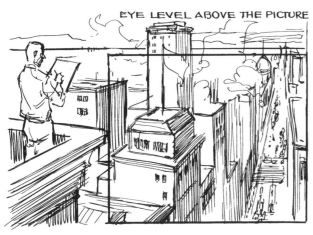

EYE LEVEL ABOVE THE PICTURE

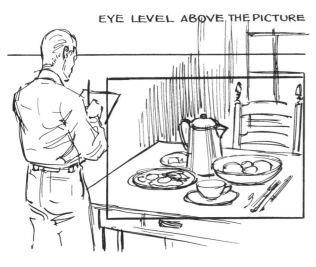

Perspective is the first and foremost means of depicting space on a flat picture plane and the natural or normal aspect of things. If modern art chooses to ignore it, modern art chooses to suffer the negative response thereby evoked. But in illustration we cannot ignore it and make our work appeal with any conviction of reality.

You can easily check any copy to find the horizon. Simply carry any receding straight lines back until they meet in a point. These lines, of course, should be parallel to the ground plane, like two floor boards, two ceiling lines, two parallel sides of a table, or the top and bottom lines of a door or windows. The point at which such lines meet will fall in the horizon. Draw a horizontal line straight across through such a point and that is it. When you have your horizon, note where it cuts across the figure. Then it must so cut across all other figures, at the waist, breast, head, or wherever it comes. All added units *must have their vanishing points in the same horizon.* Suppose you have a clipping of an interior. By finding the horizon you can estimate the height of the camera. By adjusting the figure you may wish to draw within that same interior with this camera level, you can make the figure seem to fit in perspective. Cameras are usually at breast level, so see that the horizon cuts through the figures properly. This is about the only way there is to insert figures properly, so that they will all seem to be standing on the same floor.

Another advantage: if you know beforehand about how high the horizon appears above the floor in the intended copy, you can then adjust your camera to that height when taking pictures of the models whom you intend to use in the picture. You cannot shoot at just any level and make it fit your copy.

When redrawing copy to fit a new eye level, first find something of known measurement in the copy. For instance, a chair seat is about eighteen inches off the floor. Draw a perpendicular at the corner of the chair and measure it off in feet. Then you can take any point in the ground plane. The

FIND EYE LEVEL OF COPY AND MAKE FIGURES COINCIDE

perpendicular acts as a measuring line for uprights. Draw a line from the bottom of the measuring line, through the chosen point on the ground plane to the horizon. Then carry the line back to the measuring line at whatever height desired. Erect a perpendicular at the chosen point, and the similar height is now carried back to the place you want it. This is exactly the same principle as placing figures on the same ground plane.

The accompanying sketches will serve to illustrate the various placements of the eye level or horizon (which is the same thing) and the relationship of one unit to another. To make it a little clearer I have drawn the artist outside his picture, representing you and your viewpoint. I have then squared off the picture material. These will show why the horizon may be at any height in a picture, and also that it is determined by the height and point from which viewed.

I have taken a piano and some figures showing how they must be related. I have also tried to demonstrate the variety of effect to be got out of any subject by using different eye levels. This opens up a world of opportunity for creativeness. A subject rather ordinary at ordinary eye level may become quite startling when viewed from above or from down low. . . . A high eye level is good when you want to break down into text space. A ground-level viewpoint is good when you want a horizontal base line.

Understanding perspective in the figure, you can transpose figure copy to various eye levels, thus permitting you to use copy which you otherwise could not. So long as you have drawn your figure differently and in your own way, no one can object. This is not always easy. It is really better to pay a model, pose her as you wish, and work the thing out on your own, if you can afford it. Money spent on models is the best investment you could make as a creative artist. Your picture then is indisputably your own.

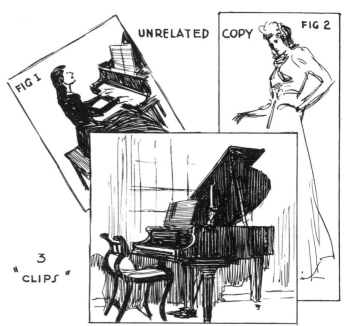

SINCE NONE OF THESE HAVE THE SAME EYE LEVEL ONE MUST BE SELECTED AND THE OTHERS ADJUSTED TO IT · FIRST LET US TAKE THE PIANO AS SHOWN.

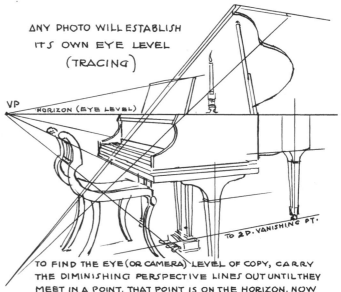

TO FIND THE EYE (OR CAMERA) LEVEL OF COPY, CARRY THE DIMINISHING PERSPECTIVE LINES OUT UNTIL THEY MEET IN A POINT. THAT POINT IS ON THE HORIZON. NOW DRAW THE HORIZONTAL LINE ACROSS THE COPY.

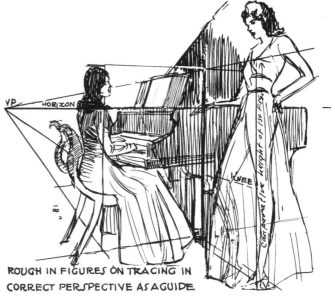

ROUGH IN FIGURES ON TRACING IN CORRECT PERSPECTIVE AS A GUIDE

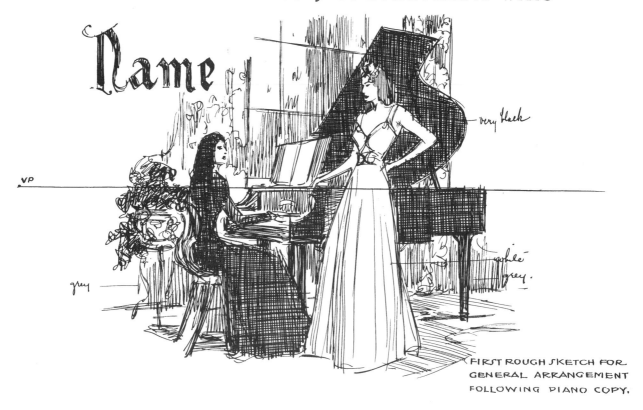

FIRST ROUGH SKETCH FOR
GENERAL ARRANGEMENT
FOLLOWING PIANO COPY.

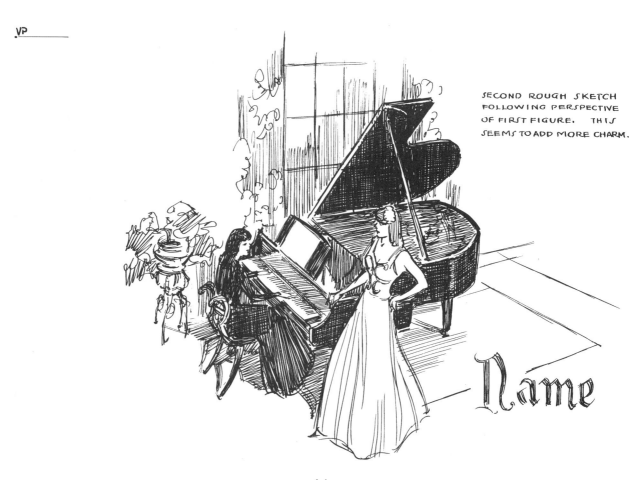

SECOND ROUGH SKETCH
FOLLOWING PERSPECTIVE
OF FIRST FIGURE. THIS
SEEMS TO ADD MORE CHARM.

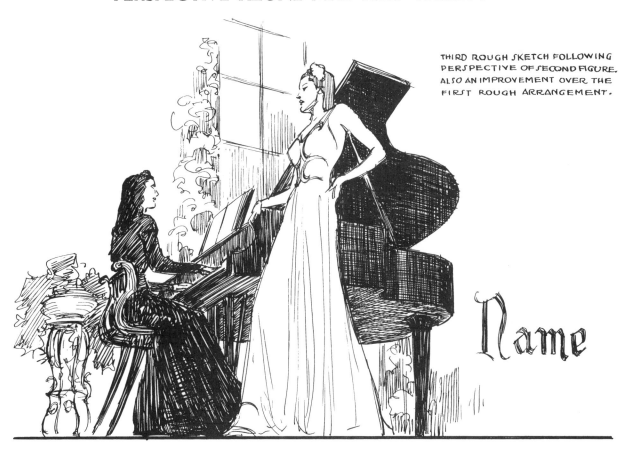

THIRD ROUGH SKETCH FOLLOWING PERSPECTIVE OF SECOND FIGURE. ALSO AN IMPROVEMENT OVER THE FIRST ROUGH ARRANGEMENT.

Name

.VP

IT IS AN EXCELLENT IDEA TO TRY OUT ANY SUBJECT FROM DIFFERENT EYE OR CAMERA LEVELS. YOU CAN OFTEN MAKE SOMETHING STARTLING OUT OF SOMETHING ORDINARY. IF YOU DON'T KNOW PERSPECTIVE, DON'T PUT IT OFF.

It will always be the problem of the artist to take his subject and approach it as differently as possible. There is no doubt that if thought is given in this direction, something unusual can result. John Jones sees almost everybody at about his own eye level. Raise the figures and lower John Jones, and you have him looking up to your characters. There is a certain grandeur and dignity thus given them, something of what we feel when looking up to an orator, a minister in the pulpit, or an actress on the stage. That is good psychology to remember, and it may be used to good advantage.

Opposed to this is the sense of superiority afforded the reader when made to feel that he is looking down on our characters. How much more beautiful a ballroom filled with figures looks from the balcony than from floor level! How we like to climb the hill or mountain and look down on the landscape! The greatest thrill of flying is that sense of height. You can lift your observer psy-chologically by this means. Too often ordinary pictures are ordinary because no thought has been given to an eye level.

To illustrate a child's story, tremendous significance can be given the illustrations by drawing the pictures at the child's eye level. To the little child everything is so high up, so big. Dad towers over him like some great giant. No wonder he must somehow put over his own importance.

Using different eye levels breaks up your picture areas in very different patterns. It is wise to try out small suggestions in this way. This is one method of testing your inventiveness, and when you get something unusual it pays good dividends. In story illustration as well as magazine-advertising illustration, something rather drastic has to be done to get attention, or "impact," as illustrators love to call it. Here is one way to go after it. Get a stepladder and try it out. Or lie on the floor and sketch.

45

USING LINE TO PRODUCE A FOCAL POINT IN SUBJECT

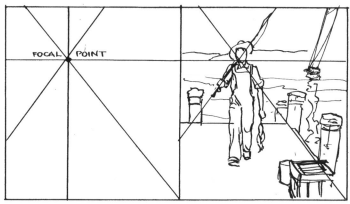

ANY COMMON JUNCTION OF LINES PRODUCES A FOCAL POINT. ANY LINES POINTING TO A VANISHING POINT OR JUNCTION MAKE A FOCAL POINT. A HEAD MAY WELL BE PLACED AT SUCH A POINT.

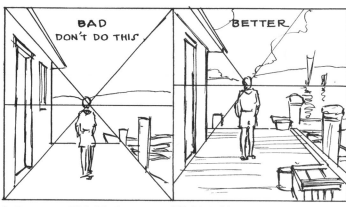

BUT NEVER PLACE A FOCAL POINT EXACTLY IN THE CENTER OF YOUR PICTURE AREA. IT IS ALSO WELL TO AVOID USING DIAGONALS THAT BISECT THE CORNERS AS MAIN LINES.

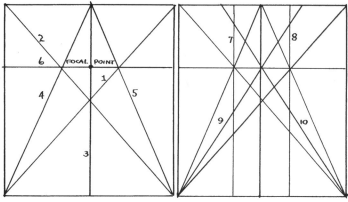

IN FORMAL DESIGN PLACE THE FOCAL POINT ABOVE OR BELOW THE MIDDLE. HERE IS A GOOD LAYOUT.

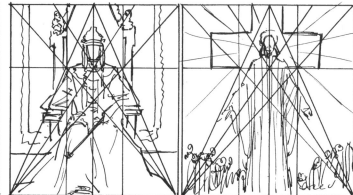

THIS BASIC ARRANGEMENT CAN BE USED FOR MANY DESIGNS. BUILD YOUR SUBJECT AS YOU WISH.

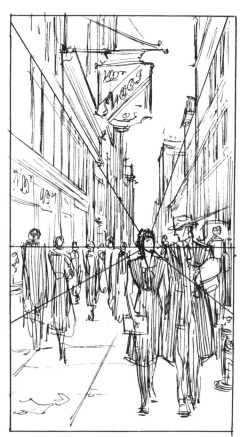

THE VANISHING POINT IS THE "POSITION OF HONOR", PICTORIALLY. IT SHOULD GO TO MAIN CHARACTER.

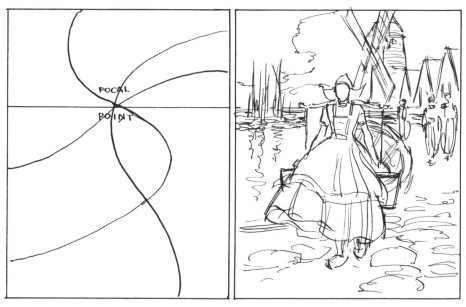

SPIRALS MAY ALSO BE USED TO FOCUS ATTENTION. TAKE IT AS A RULE THAT LINES SHOULD LEAD TO AND CROSS AT THE MAIN POINT OF INTEREST.

YOU WILL OFTEN WONDER HOW TO FOCUS ATTENTION AND INTEREST UPON A CERTAIN HEAD, FIGURE OR SPOT. STUDY THIS PAGE CAREFULLY. EVERY GOOD PICTURE SHOULD HAVE A MAIN FOCAL POINT AND ALL LINES SHOULD DRAW THE EYE TOWARD THAT SPOT. THE OLD SAYING "ALL ROADS LEAD TO ROME" IS FUNDAMENTAL IN GOOD COMPOSITION. YOUR "ROADS" ARE LINES.

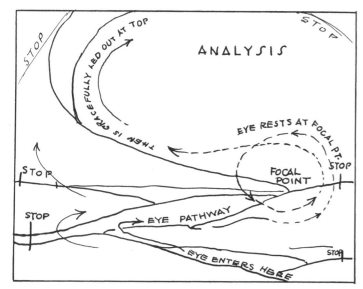

THERE SHOULD BE A PLANNED EASY AND NATURAL PATH FOR THE EYE TO TRAVEL IN EVERY GOOD PICTURE

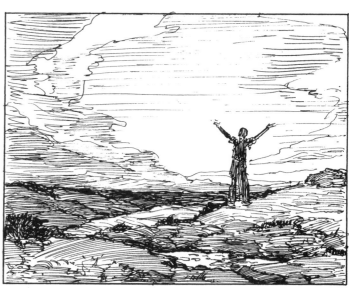

LINES LEADING OUT OF THE SUBJECT SHOULD BE STOPPED BY SOME DEVICE OR ANOTHER LINE LEADING THE EYE BACK

THE EYE SHOULD ENTER AT THE BOTTOM AND EMERGE AT THE TOP—NEVER AT THE SIDES. SINCE CORNERS

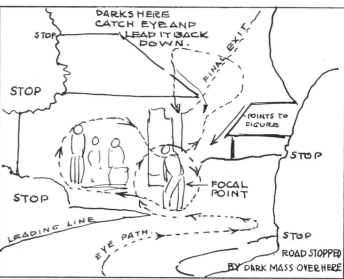

ARE "EYE TRAPS" BECAUSE OF THEIR JUNCTIONS, TRY TO LEAD THE EYE AWAY FROM OR AROUND THEM.

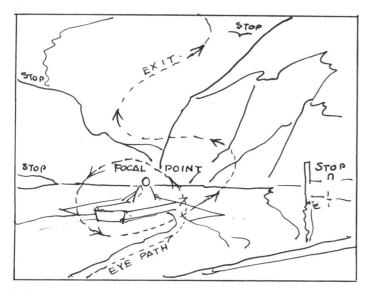

YOU CAN MAKE THE EYE FOLLOW A GIVEN COURSE ALMOST AS YOU WISH BY SKILLFUL USE OF LINE · LEAD THE EYE IN, ENTERTAIN

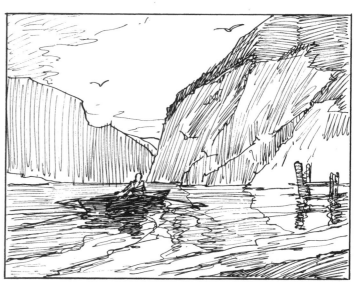

IT WITH A SPOT OF INTEREST AND THEN ALLOW IT TO PASS OUT. IT SHOULD BE A PLEASING PATH AND NOT OBSTRUCTED OR GIVEN TWO WAYS TO GO.

ATTENTION DEVICES

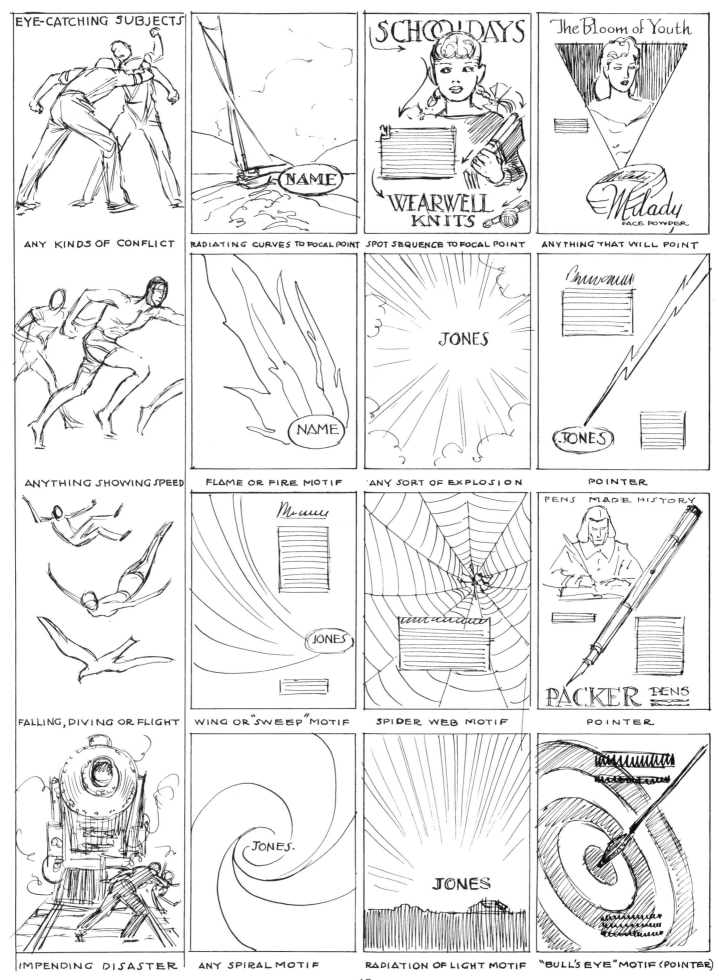

EYE-CATCHING SUBJECTS

ANY KINDS OF CONFLICT

RADIATING CURVES TO FOCAL POINT

SPOT SEQUENCE TO FOCAL POINT

ANYTHING THAT WILL POINT

SCHOOLDAYS

WEARWELL KNITS

The Bloom of Youth

M'Lady FACE POWDER

ANYTHING SHOWING SPEED

FLAME OR FIRE MOTIF

ANY SORT OF EXPLOSION

POINTER

FALLING, DIVING OR FLIGHT

WING OR "SWEEP" MOTIF

SPIDER WEB MOTIF

POINTER

PENS MADE HISTORY

PACKER PENS

IMPENDING DISASTER

ANY SPIRAL MOTIF

RADIATION OF LIGHT MOTIF

"BULL'S EYE" MOTIF (POINTER)

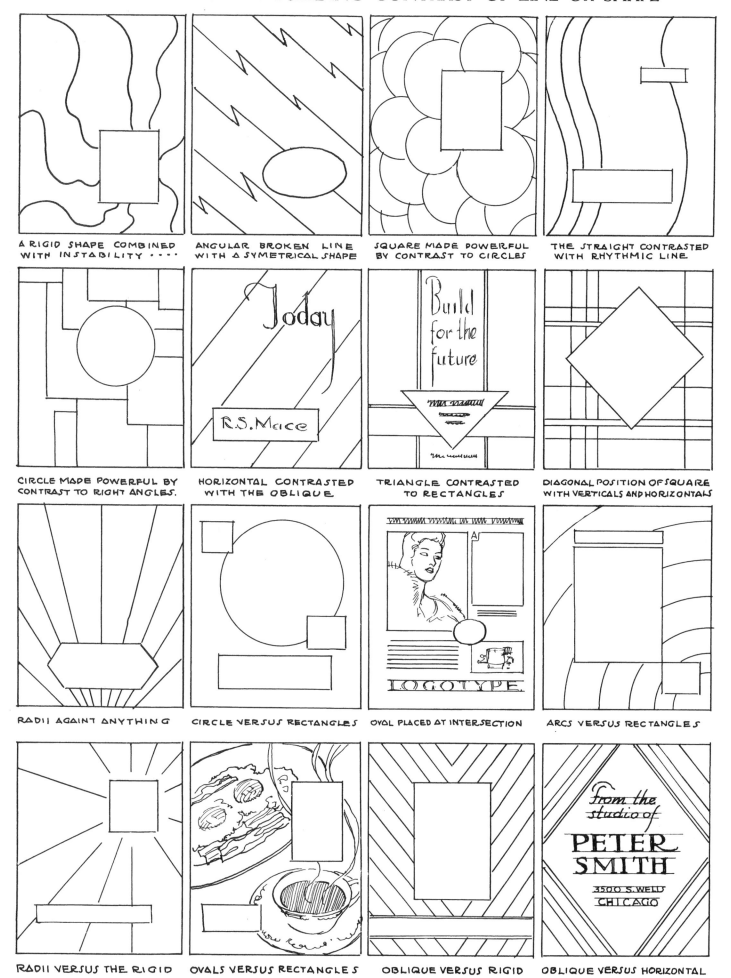

A RIGID SHAPE COMBINED WITH INSTABILITY · · · ·

ANGULAR BROKEN LINE WITH A SYMETRICAL SHAPE

SQUARE MADE POWERFUL BY CONTRAST TO CIRCLES

THE STRAIGHT CONTRASTED WITH RHYTHMIC LINE

CIRCLE MADE POWERFUL BY CONTRAST TO RIGHT ANGLES.

HORIZONTAL CONTRASTED WITH THE OBLIQUE

TRIANGLE CONTRASTED TO RECTANGLES

DIAGONAL POSITION OF SQUARE WITH VERTICALS AND HORIZONTALS

RADII AGAINST ANYTHING

CIRCLE VERSUS RECTANGLES

OVAL PLACED AT INTERSECTION

ARCS VERSUS RECTANGLES

RADII VERSUS THE RIGID

OVALS VERSUS RECTANGLES

OBLIQUE VERSUS RIGID

OBLIQUE VERSUS HORIZONTAL

Today

R.S.Mace

Build for the future

from the studio of PETER SMITH 3500 S.WELL CHICAGO

LOGOTYPE

THE RELATIONSHIP OF LINE TO EMOTIONAL RESPONSE

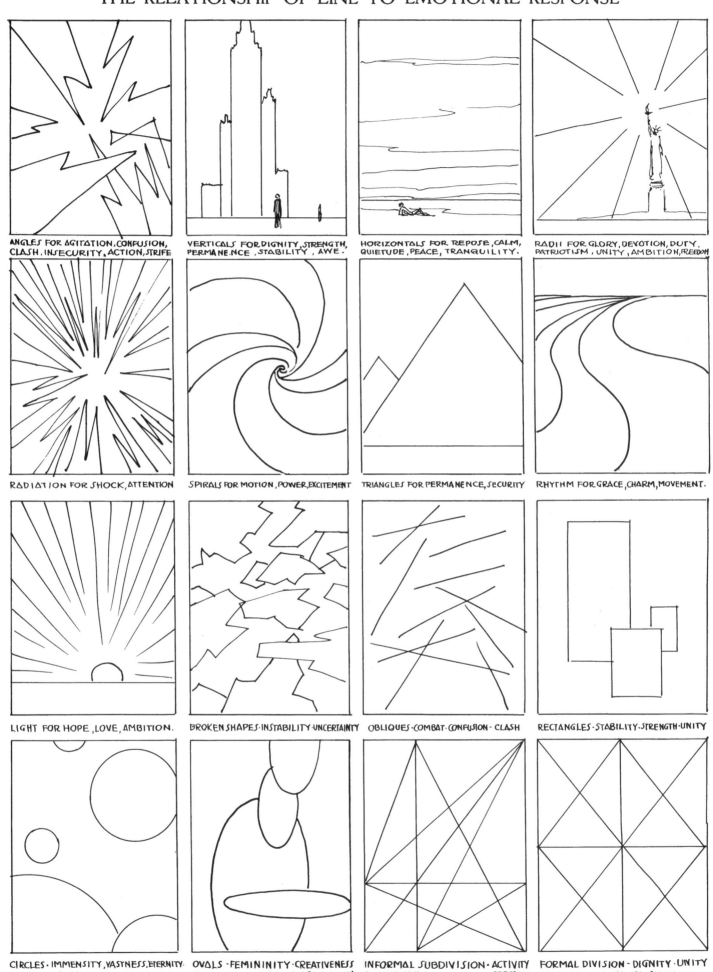

ANGLES FOR AGITATION, CONFUSION, CLASH, INSECURITY, ACTION, STRIFE

VERTICALS FOR DIGNITY, STRENGTH, PERMANE.NCE, STABILITY, AWE.

HORIZONTALS FOR REPOSE, CALM, QUIETUDE, PEACE, TRANQUILITY.

RADII FOR GLORY, DEVOTION, DUTY, PATRIOTISM, UNITY, AMBITION, FREEDOM

RADIATION FOR SHOCK, ATTENTION

SPIRALS FOR MOTION, POWER, EXCITEMENT

TRIANGLES FOR PERMANENCE, SECURITY

RHYTHM FOR GRACE, CHARM, MOVEMENT.

LIGHT FOR HOPE, LOVE, AMBITION.

BROKEN SHAPES·INSTABILITY·UNCERTAINTY

OBLIQUES·COMBAT·CONFUSION·CLASH

RECTANGLES·STABILITY·STRENGTH·UNITY

CIRCLES·IMMENSITY, VASTNESS, ETERNITY. MOTION·EQUALITY·DELIVERANCE.

OVALS·FEMININITY·CREATIVENESS SENSUOSITY·GRACE·PERPETUATION

INFORMAL SUBDIVISION·ACTIVITY EXCITEMENT·ELASTICITY·PROGRESS

FORMAL DIVISION·DIGNITY·UNITY BALANCE·FORMALITY·STRENGTH.

50

BAD COMPOSITION BRINGS NEGATIVE RESPONSE

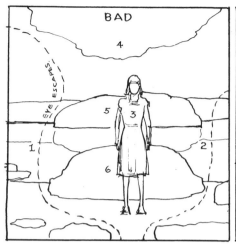

1·2· DON'T GIVE THE EYE TWO PATHWAYS. 3·4·5·6· TOO CENTERED· STRAIGHT FRONT POSE-BAD. 5·6· TOO ALIKE AND EQUAL.

NOW THE EYE IS LED TO THE FIGURE "STOPS" PUT IN ON LINES WHICH WOULD CARRY EYE OUT. POSE MORE IN KEEPING WITH SUBJECT.

WE MAY HAVE A BETTER COMPOSITION BY HAVING THE LITTLE GIRL CLOSER TO DOMINATE THE LANDSCAPE.

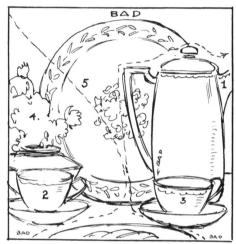 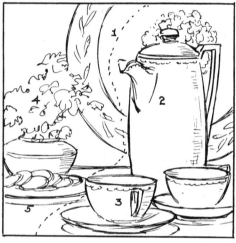

1. DON'T POINT THINGS OUT OF PICTURE. 2·3· TOO EQUAL IN IMPORTANCE. 4. FLOWERS POINTING WRONG WAY. 5· TWO EYEPATHS.

1. ONE EYEPATH NOW. 2 POINTING INWARD 3. CUPS GROUPED 4. FLOWERS CORRECTED 5· YOU NOW KNOW THEY ARE COOKIES. BETTER?

YOU CAN TEST ANY COMPOSITION BY TRACING THE "SPACES BETWEEN THINGS" AND "FILL-IN". SEE IF THEY MAKE A GOOD DESIGN.

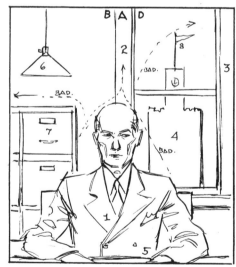 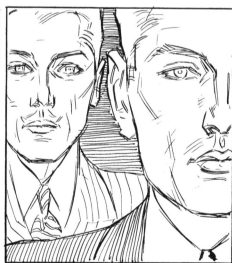

1. FIGURE TOO LOW AND TOO CENTERED. 2. NEVER SPLIT A HEAD WITH ANY LINE COMING INTO IT. 3. DON'T USE THE EDGE OF THE PICTURE TO COINCIDE WITH A LINE IN THE PICTURE. (WINDOW FRAME) 4·6·7·8· TOO CENTERED. FLAG BAD. 5 HANDS CUT OFF. DESK LINE TOO LOW AND TOO NEAR BOTTOM EDGE. MAN'S GAZE BAD.

HERE WE HAVE MUCH THAT IS MISSING IN THE OTHER PICTURE. NOTHING COMPETES WITH HEAD. NOTHING IS CENTERED. THE BALANCE OF THE SUBJECT IS PLEASING, ACCESSORIES HAVE MORE CHARM. "BALDY" COULD JUST AS WELL HAVE BEEN PLACED AGAINST A MORE PLEASING BACKGROUND. TRY TO PLAN EVERYTHING YOU DO.

SOMETIMES A DESIGN MAY BE BUILT OF HEADS ALONE AND WITHOUT HAVING THE HEADS COMPLETE. THE PICTURE MAY BE MUCH MORE ARRESTING THAN IF TWO ENTIRE HEADS WERE SHOWN, ESPECIALLY IF THE TWO HEADS WERE ABOUT EQUAL IN SIZE OR AREA AND EVENLY SPACED.

VARIOUS TYPES OF VIGNETTES

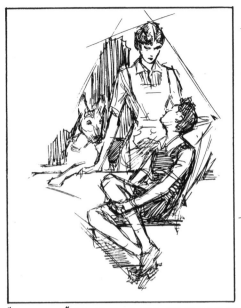

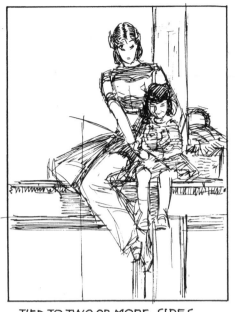

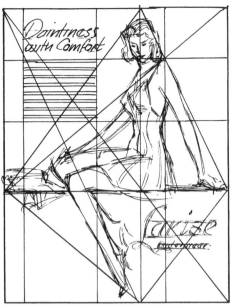

"FLOATING" OR FREE OF THE SPACE LIMITS.　　TIED TO TWO OR MORE SIDES.　　YOU CAN USE INFORMAL SUBDIVISION.

OPEN SPACE TIED TOGETHER BY CONNECTED VIGNETTE.　　"SPOTS" TIED TO MAIN VIGNETTE

MAKING THE WHITE SPACE PART OF THE PICTURE. VERY USEFUL.　　"BORDER" VIGNETTE.

A VIGNETTE IS A DESIGN PURE AND SIMPLE

"SILHOUETTE" VIGNETTE
(DARK MASS AGAINST LIGHT)

"RELIEF" VIGNETTE
(LIGHT MASS AGAINST DARK)

"SKETCHY" VIGNETTE
ANY SIMPLE MASSES VS. EACH OTHER

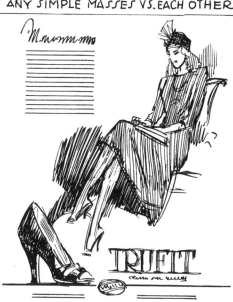

COMBINATION VIGNETTE WITH A SOLID PICTURE AS DOMINANT.

VIGNETTE TIED TO PRODUCT.

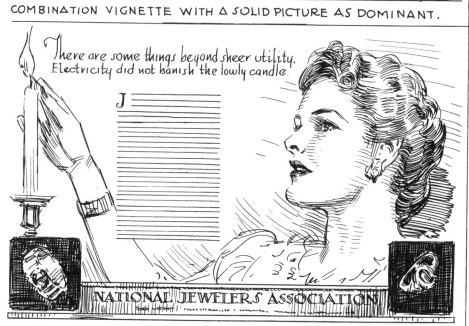

COMBINATION VIGNETTE DOMINATING OVER SQUARE UNITS.

VIGNETTE TIED TO COPY SPACE

DESIGNED BY INFORMAL SUBDIVISION · BLACKS ADDED WITH BRUSH · SAME PEN WAS USED THROUGHOUT.
NOTE ATTENTION BROUGHT TO MAIN FIGURE BY WHITES AND USE OF "X" IN THE POSE · BLACKS HELP·

PEN DRAWING IS BUILT ON A PRINCIPLE

"AH, GIVE ME NATURE, DANCING BUTTERFLIES AND FRESH MINT IN THE AIR."

THE WORKING PRINCIPLE OF PEN DRAWING IS THE DEVELOPMENT OF TONE BY A MIXTURE OF THE LIGHT OF THE WHITE PAPER WITH THE DARK OF LINE. IT IS LIKE A WIRE SCREEN IN A WINDOW. THE HEAVIER THE WIRE AND THE CLOSER THE MESH, THE MORE IT DARKENS THE LIGHT. SO, SET ABOUT TO PRODUCE A GIVEN VALUE BY THE AMOUNT OF WHITE THAT COMES THROUGH. YOU CAN MAKE A "SCALE" OF PEN VALUES TO WHICH YOU CAN ALWAYS REFER. THEN YOU KNOW ABOUT HOW LIGHT OR HEAVY TO MAKE YOUR LINES, ALSO HOW CLOSE TOGETHER THEY SHOULD BE FOR THE TONE OR VALUE YOU WANT. FOLLOW THE FORM, EITHER LENGTHWISE OR ACROSS IT, WITH YOUR STROKES. TRY TO KEEP "OPEN" OR WHITE SPACE AS A PART OF THE DESIGN. DRAW MOSTLY THE SHADOWS. "TONE ALL OVER" IS VERY DIFFICULT. PLAN STROKES CAREFULLY BUT INK THEM IN DIRECTLY AND FREELY.

56

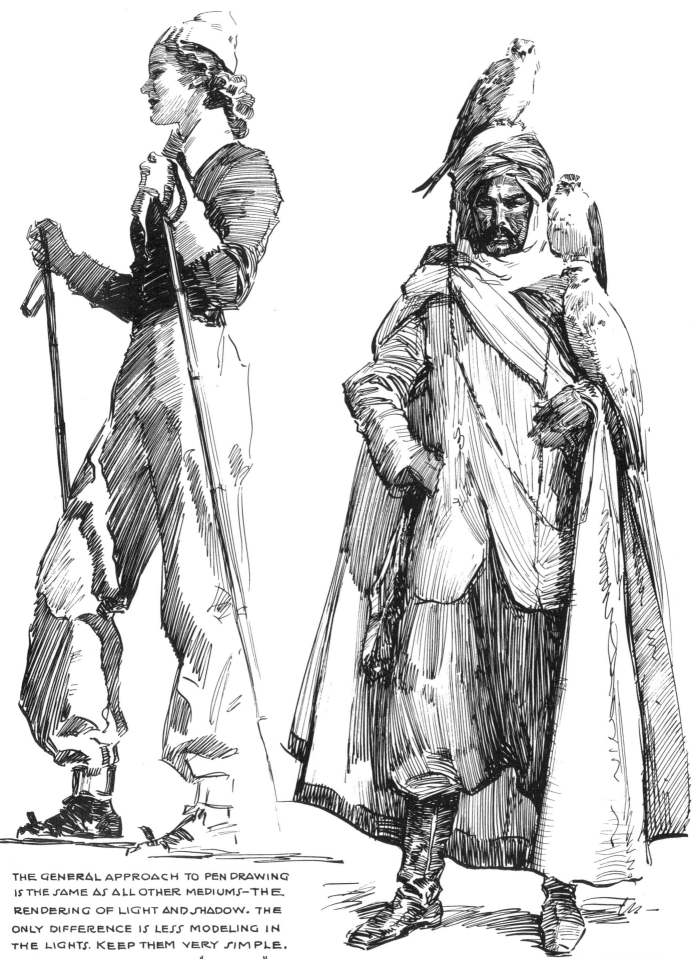

THE GENERAL APPROACH TO PEN DRAWING
IS THE SAME AS ALL OTHER MEDIUMS—THE
RENDERING OF LIGHT AND SHADOW. THE
ONLY DIFFERENCE IS LESS MODELING IN
THE LIGHTS. KEEP THEM VERY SIMPLE.
DON'T WORRY SO MUCH OVER "STROKES" AS OVER THE STATEMENT OF GOOD WHITES, GREYS, AND BLACK

PEN-AND-INK PROCEDURE

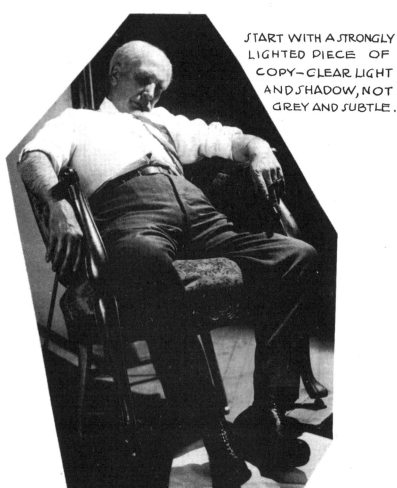

START WITH A STRONGLY LIGHTED PIECE OF COPY—CLEAR LIGHT AND SHADOW, NOT GREY AND SUBTLE.

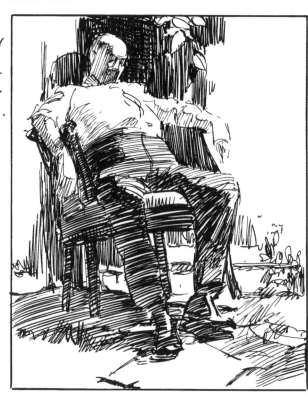

MAKE A PRELIMINARY ROUGH, SETTING DOWN THE STATEMENT OF MASS ARRANGEMENT IN THE SIMPLEST POSSIBLE TERMS. DO NOT WORRY YET ABOUT TECHNIQUE. CONCERN YOURSELF WITH DESIGN OF BLACKS, GREYS, WHITES. THIS WILL PRODUCE A GUIDE TO VALUES TO BE PUT IN THE FINAL WORK AND THE "PATTERN" EFFECT OF THE WHOLE

GOOD PREPARATION IS MORE THAN HALF THE BATTLE.

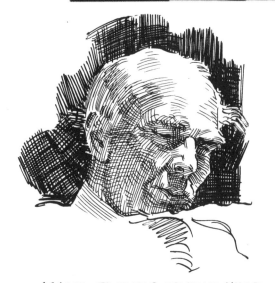

MAKE STUDIES OF THE HEAD OR OTHER IMPORTANT PARTS, IN ORDER TO PLAN YOUR STROKES. (THIS SAVES MUCH GRIEF!)

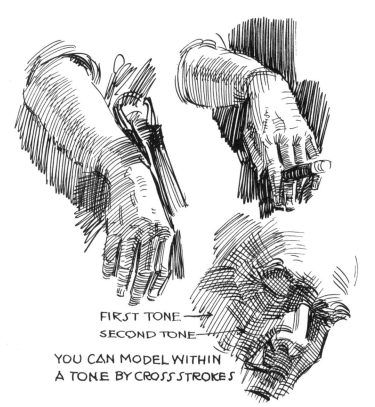

FIRST TONE →
SECOND TONE →

YOU CAN MODEL WITHIN A TONE BY CROSS STROKES

WHEN YOU KNOW WHAT THE VALUES ARE GOING TO BE, IT IS EASIER TO PUT THEM DOWN NEXT TIME.

58

SUNDAY AFTERNOON

COMBINATION PEN LINE AND BRUSH ON WHITE SMOOTH STRATHMORE BRISTOL. MANY GOOD EFFECTS ARE POSSIBLE BY THIS COMBINATION. THE DESIGN WAS WORKED OUT BY USING INFORMAL SUBDIVISION.

MORNING

BRUSH DRAWING ON STRATHMORE BRISTOL BOARD. COMPOSITION BASED ON CIRCULAR ARRANGEMENT WITH A "RADIANT LIGHT" BEHIND HEAD. THIS NEVER FAILS TO "PULL" THE EYE INTO YOUR SUBJECT - DRAW RADII FIRST.

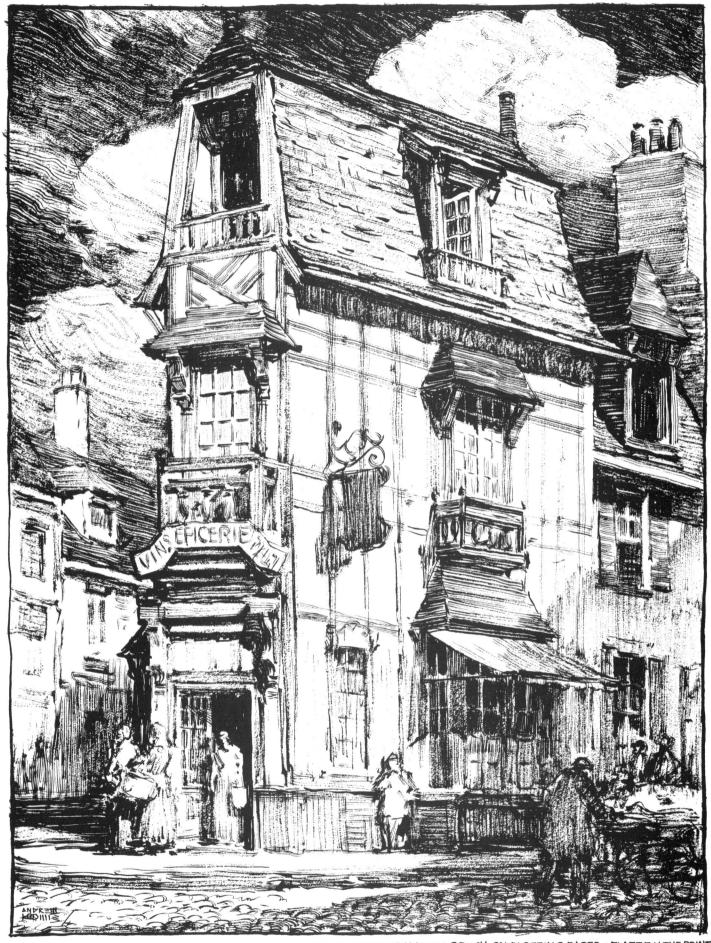

USE A WATER COLOR BRUSH, NOT TOO LARGE · BLOT MOST OF THE INK FROM BRUSH ON BLOTTING PAPER · FLATTEN THE POINT OF THE BRUSH SO THAT SEVERAL LINES CAN BE DRAWN AT ONCE IN A STROKE · WORK FOR MASSES OF LIGHT, GREY AND DARK.

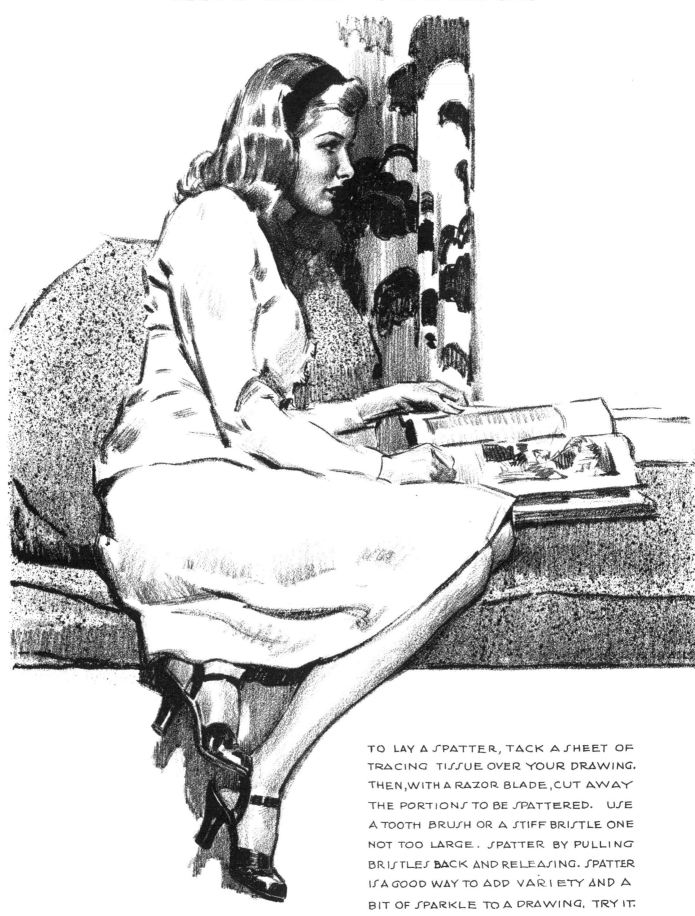

TO LAY A SPATTER, TACK A SHEET OF
TRACING TISSUE OVER YOUR DRAWING.
THEN, WITH A RAZOR BLADE, CUT AWAY
THE PORTIONS TO BE SPATTERED. USE
A TOOTH BRUSH OR A STIFF BRISTLE ONE
NOT TOO LARGE. SPATTER BY PULLING
BRISTLES BACK AND RELEASING. SPATTER
IS A GOOD WAY TO ADD VARIETY AND A
BIT OF SPARKLE TO A DRAWING. TRY IT.

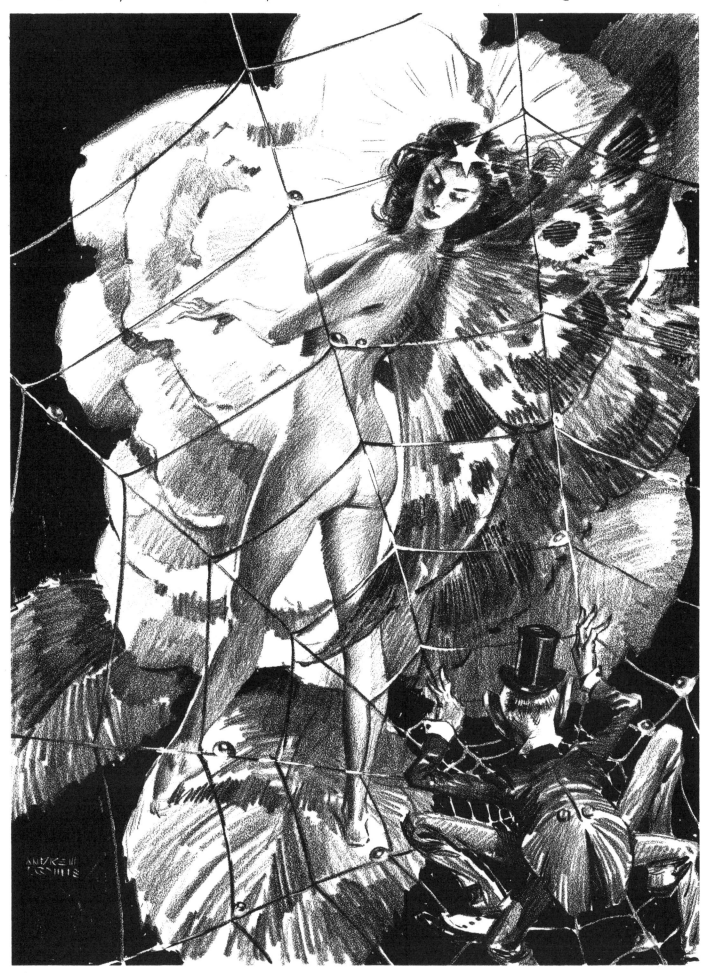

THERE ARE NEW POSSIBILITIES IN THIS COMBINATION

DRAWN WITH PRISMACOLOR BLACK 935 PENCIL ON BAINBRIDGE COQUILLE BOARD NO. 2 .
BLACKS ARE PAINTED IN WITH HIGGINS BLACK DRAWING INK. THIS COMBINATION MAKES
A FULL RANGE OF VALUES FROM SOLID BLACK TO WHITE. IT PERMITS LINE REPRODUCTION
BUT GIVES A HALFTONE EFFECT. FINE FOR STUNNING EFFECTS WITH CHEAP PRINTING ON PULP
PAPERS. IT IS WORTH EXPERIMENTING WITH. PAPER IS TOO SOFT FOR A PEN. USE A BRUSH.

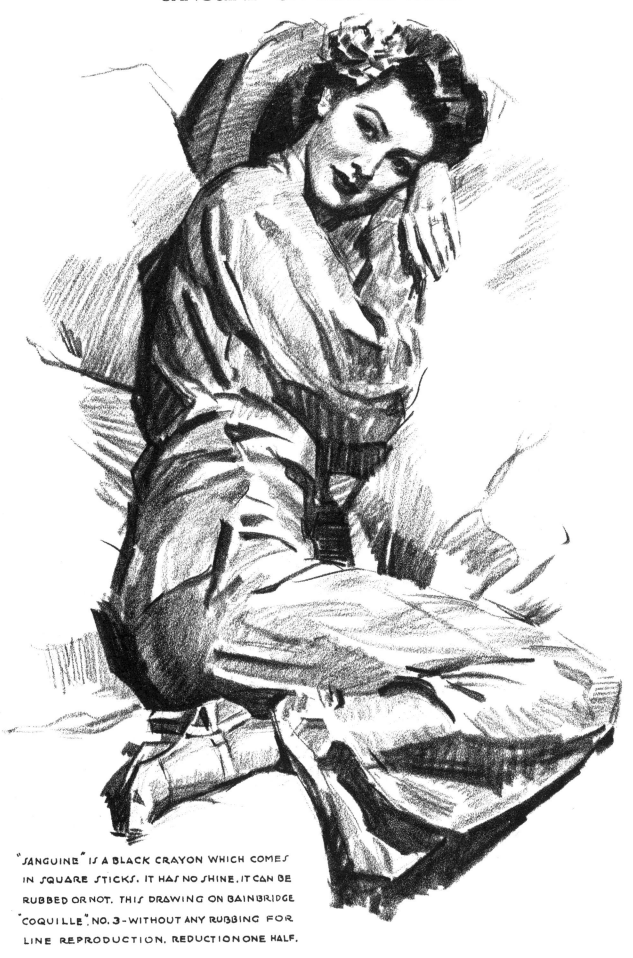

"SANGUINE" IS A BLACK CRAYON WHICH COMES IN SQUARE STICKS. IT HAS NO SHINE. IT CAN BE RUBBED OR NOT. THIS DRAWING ON BAINBRIDGE "COQUILLE", NO. 3 - WITHOUT ANY RUBBING FOR LINE REPRODUCTION. REDUCTION ONE HALF.

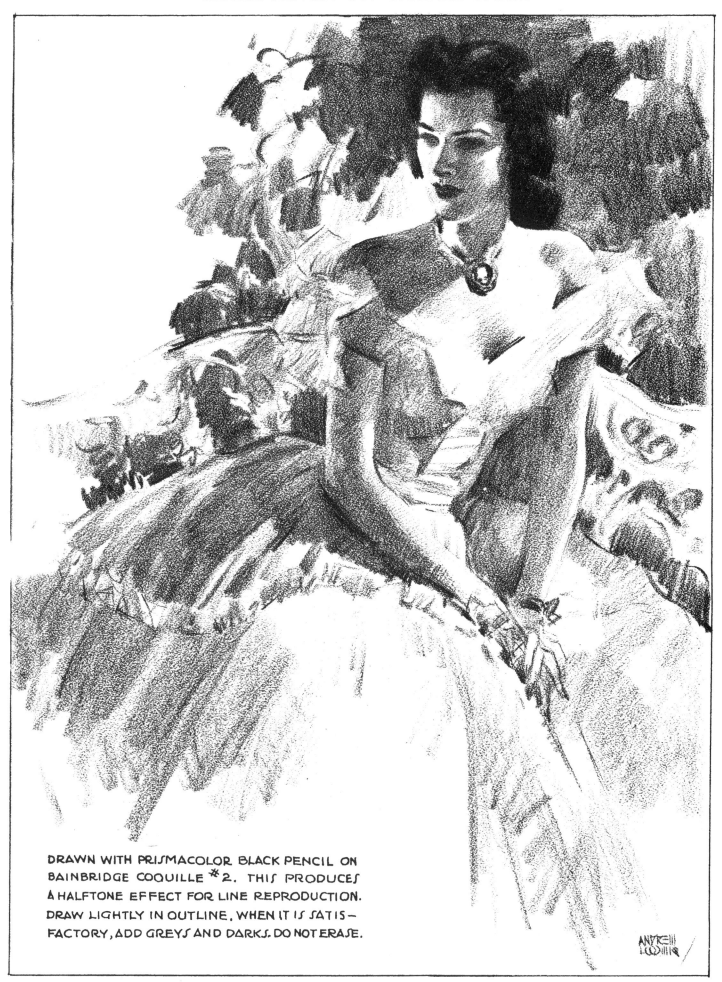

DRAWN WITH PRISMACOLOR BLACK PENCIL ON
BAINBRIDGE COQUILLE #2. THIS PRODUCES
A HALFTONE EFFECT FOR LINE REPRODUCTION.
DRAW LIGHTLY IN OUTLINE. WHEN IT IS SATIS-
FACTORY, ADD GREYS AND DARKS. DO NOT ERASE.

DRAWING PROCEDURE

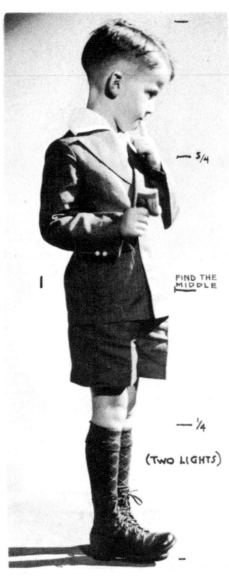

— 3/4

FIND THE MIDDLE

— 1/4

(TWO LIGHTS)

I

GET GOOD COPY, BUT—
DON'T SLAVISHLY COPY IT!

THERE ARE MANY WAYS TO DRAW.
DRAW YOUR WAY, BUT MAKE IT
A LOGICAL PROCEDURE. DON'T
TRY TO DO EVERYTHING AT THE
SAME TIME. ALL DRAWING IS
PROPORTION. IT IS EITHER JUST
LINE OR THE RENDERING ~ OF
LIGHT ON FORM. EVERY AREA
HAS IT'S OWN PROPERTY OF BEING
EITHER IN LIGHT, HALFTONE OR
SHADOW. YOU MUST DECIDE WHICH.

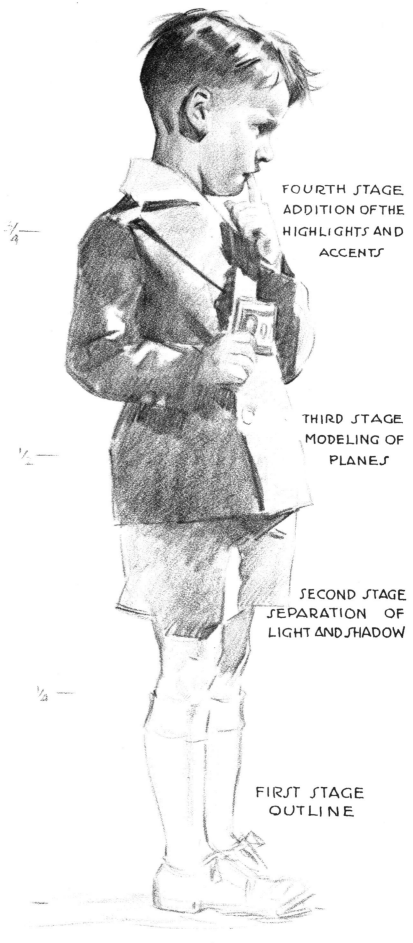

FOURTH STAGE
ADDITION OF THE
HIGHLIGHTS AND
ACCENTS

THIRD STAGE
MODELING OF
PLANES

SECOND STAGE
SEPARATION OF
LIGHT AND SHADOW

FIRST STAGE
OUTLINE

MATERIALS- COQUILLE #3 - PRISMACOLOR BLACK

70

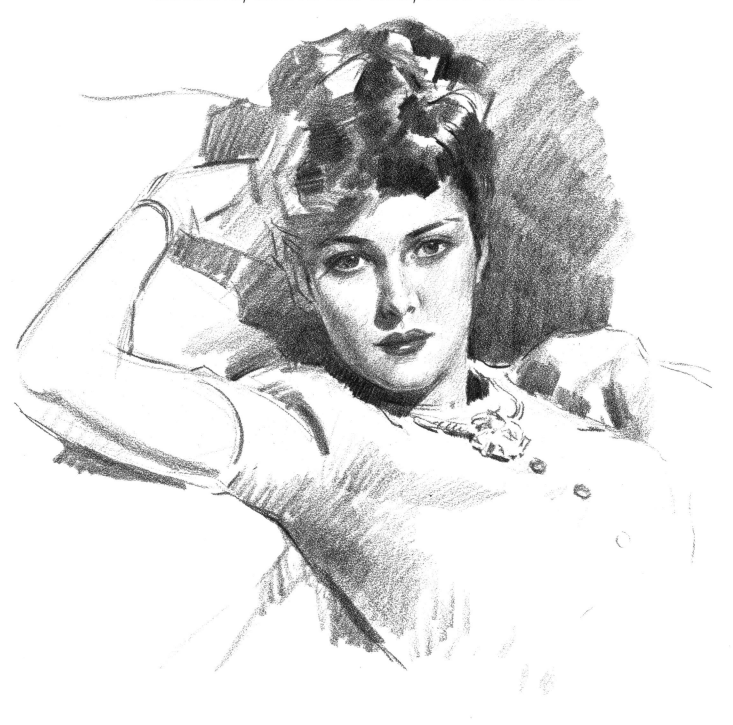

I HAVE LEFT THIS DRAWING INCOMPLETE
SO IT WILL SHOW THE PROCEDURE. GET RID
OF "DRAWING CRUTCHES" AND MAKE YOURSELF
DO IT ALL. THE ONLY WAY ONE CAN DRAW IS TO
DRAW CONTINUALLY. WHEN YOU DO IT, YOU GAIN
MOMENTUM· IF YOU CHEAT AT IT— YOU LOSE.

71

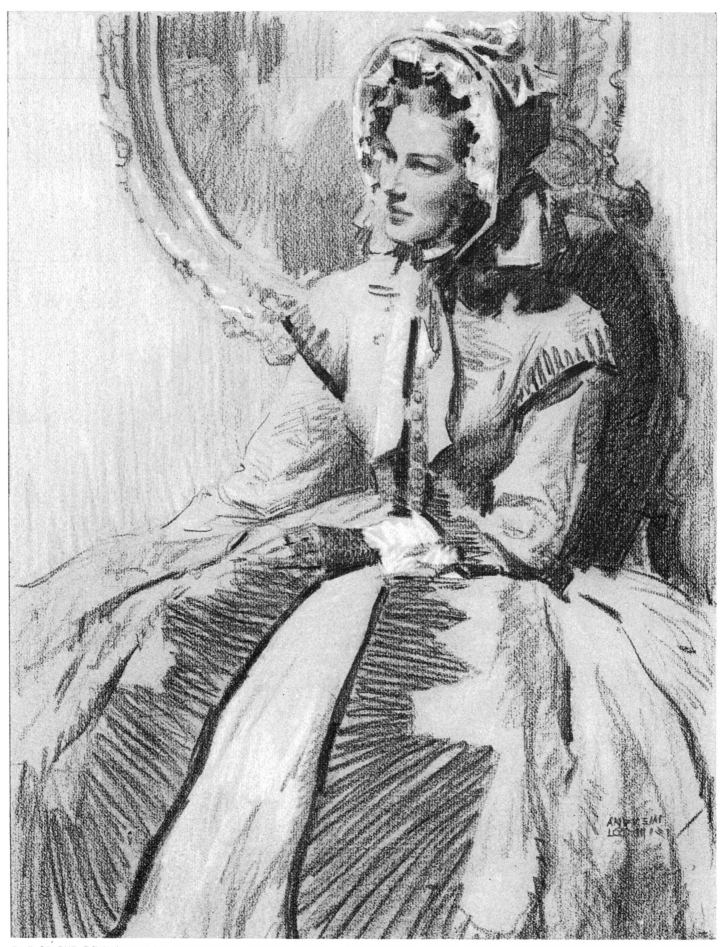

ONE OF THE BEST WAYS TO MAKE PRELIMINARY STUDIES. USE THE TONE OF THE PAPER FOR THE LIGHTS. THE PENCIL IS FOR THE HALFTONES AND DARKS. WHITES ARE USED ONLY FOR HIGHLIGHTS OR WHITE AREAS. CHARCOAL AND CHALK ARE EQUALLY GOOD.

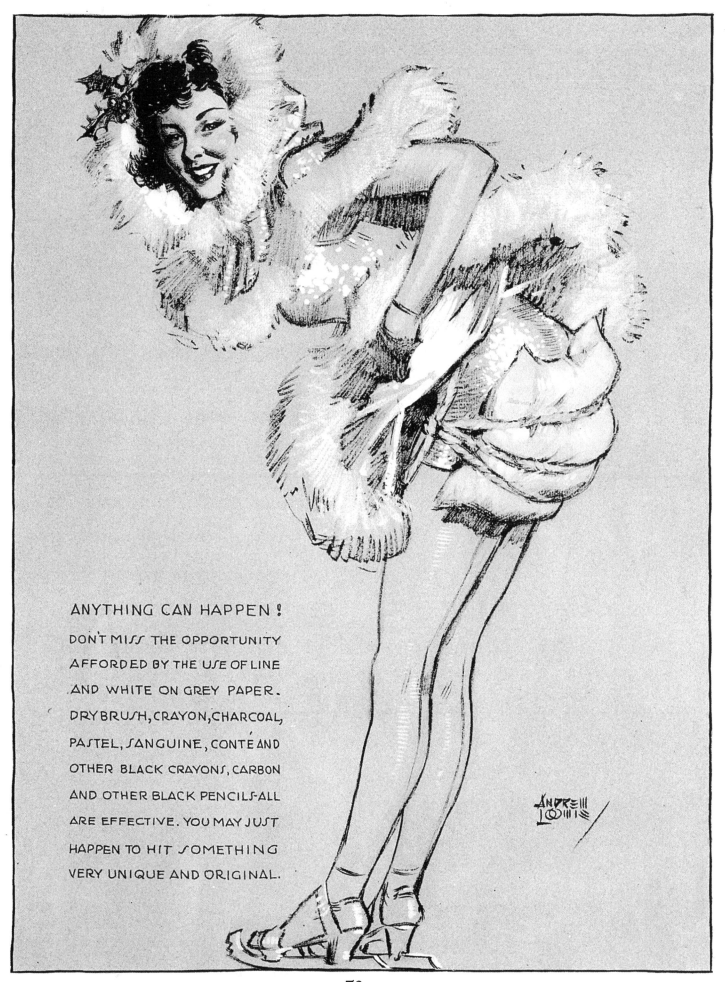

ANYTHING CAN HAPPEN !

DON'T MISS THE OPPORTUNITY

AFFORDED BY THE USE OF LINE

AND WHITE ON GREY PAPER.

DRY BRUSH, CRAYON, CHARCOAL,

PASTEL, SANGUINE, CONTÉ AND

OTHER BLACK CRAYONS, CARBON

AND OTHER BLACK PENCILS-ALL

ARE EFFECTIVE. YOU MAY JUST

HAPPEN TO HIT SOMETHING

VERY UNIQUE AND ORIGINAL.

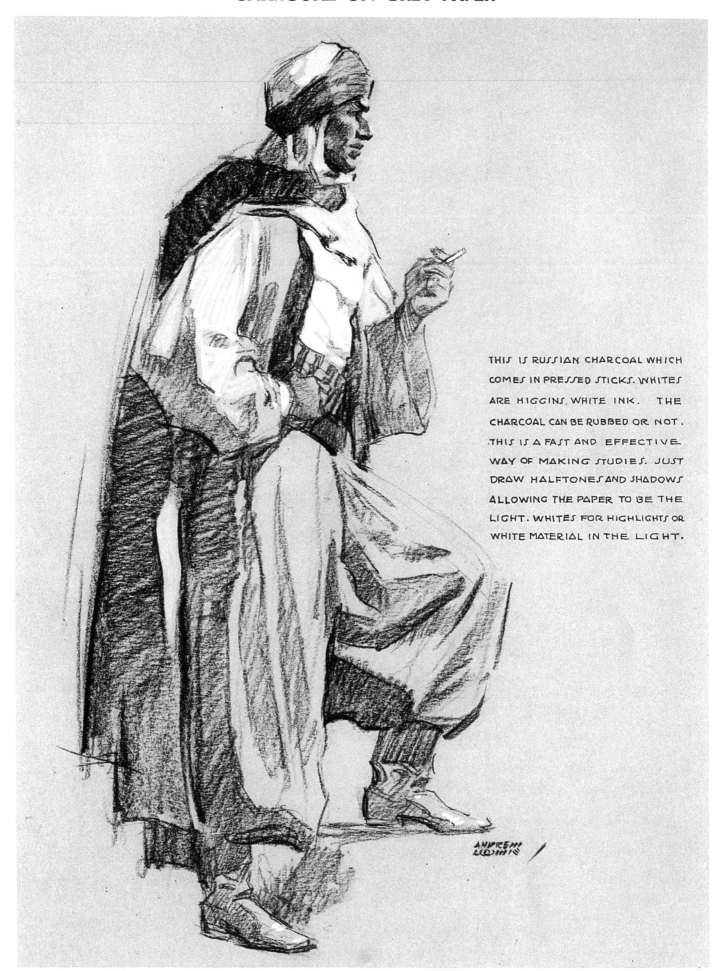

THIS IS RUSSIAN CHARCOAL WHICH
COMES IN PRESSED STICKS. WHITES
ARE HIGGINS, WHITE INK. THE
CHARCOAL CAN BE RUBBED OR NOT.
THIS IS A FAST AND EFFECTIVE
WAY OF MAKING STUDIES. JUST
DRAW HALFTONES AND SHADOWS
ALLOWING THE PAPER TO BE THE
LIGHT. WHITES FOR HIGHLIGHTS OR
WHITE MATERIAL IN THE LIGHT.

"SCRATCH BOARD"

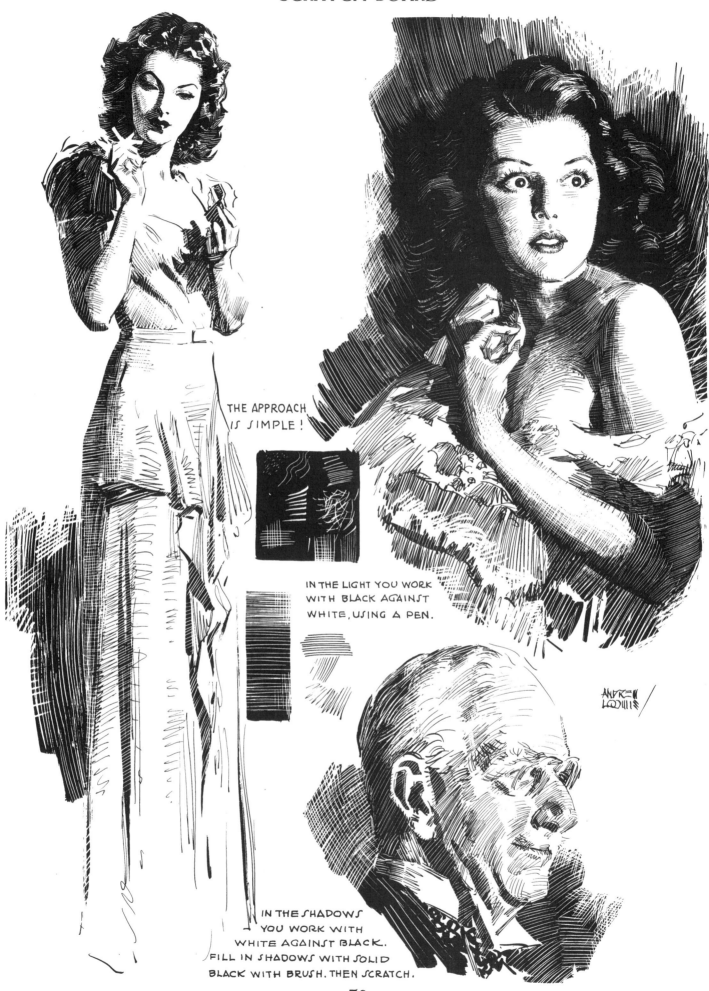

THE APPROACH IS SIMPLE!

IN THE LIGHT YOU WORK WITH BLACK AGAINST WHITE, USING A PEN.

IN THE SHADOWS YOU WORK WITH WHITE AGAINST BLACK. FILL IN SHADOWS WITH SOLID BLACK WITH BRUSH. THEN SCRATCH.

ANDREW LOOMIS

"SCRATCH BOARD"

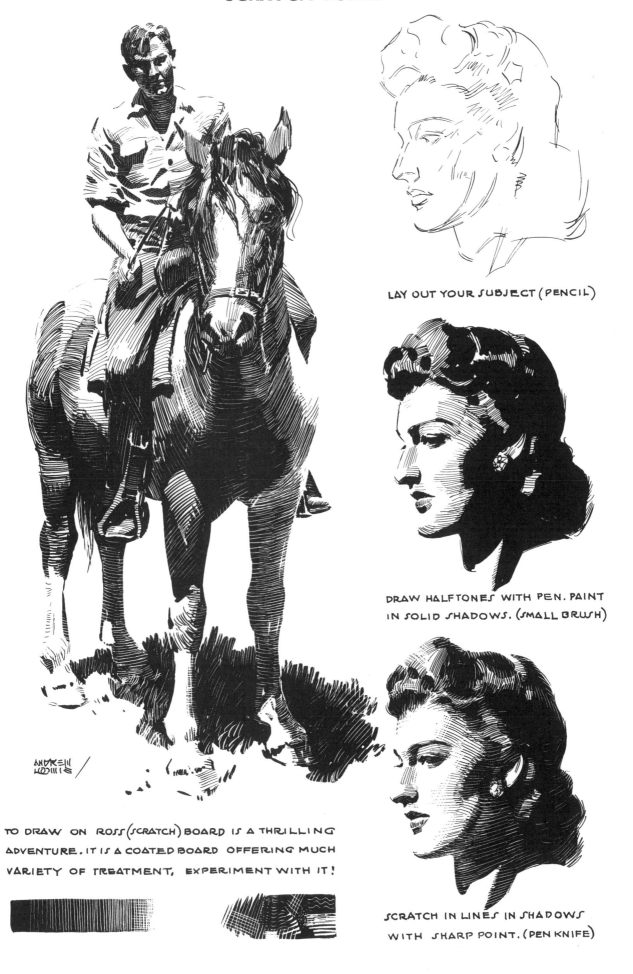

LAY OUT YOUR SUBJECT (PENCIL)

DRAW HALFTONES WITH PEN. PAINT
IN SOLID SHADOWS. (SMALL BRUSH)

SCRATCH IN LINES IN SHADOWS
WITH SHARP POINT. (PEN KNIFE)

TO DRAW ON ROSS (SCRATCH) BOARD IS A THRILLING
ADVENTURE. IT IS A COATED BOARD OFFERING MUCH
VARIETY OF TREATMENT, EXPERIMENT WITH IT!

CRAFTINT

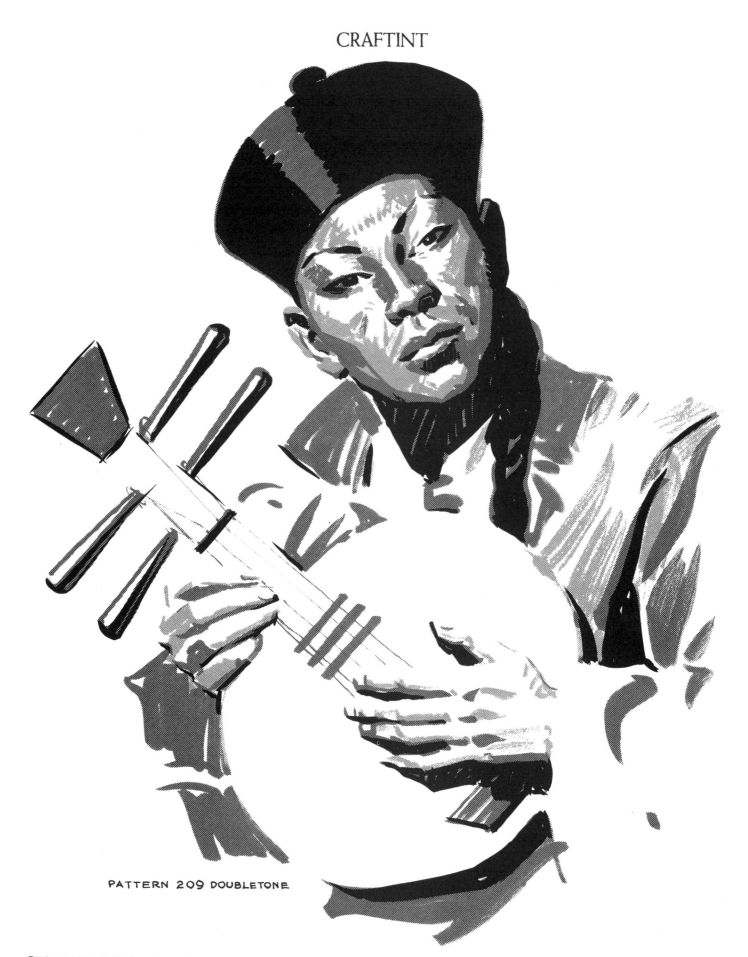

PATTERN 209 DOUBLETONE

CRAFTINT IS SOMETHING YOU SHOULD GET ACQUAINTED WITH. THE SCREENS TAKE THE PLACE OF BEN DAYS. YOU MAKE THEM RIGHT ON YOUR ORIGINAL DRAWING BY SIMPLY PAINTING IN DEVELOPERS WHICH WILL RENDER THE SCREENS VISIBLE. THE BOARDS COME IN A VARIETY OF FINE AND COARSE PATTERNS WITH EITHER A SINGLETONE OR DOUBLETONE EFFECT. BLACKS ARE ADDED WITH HIGGINS INK. TRY THIS.

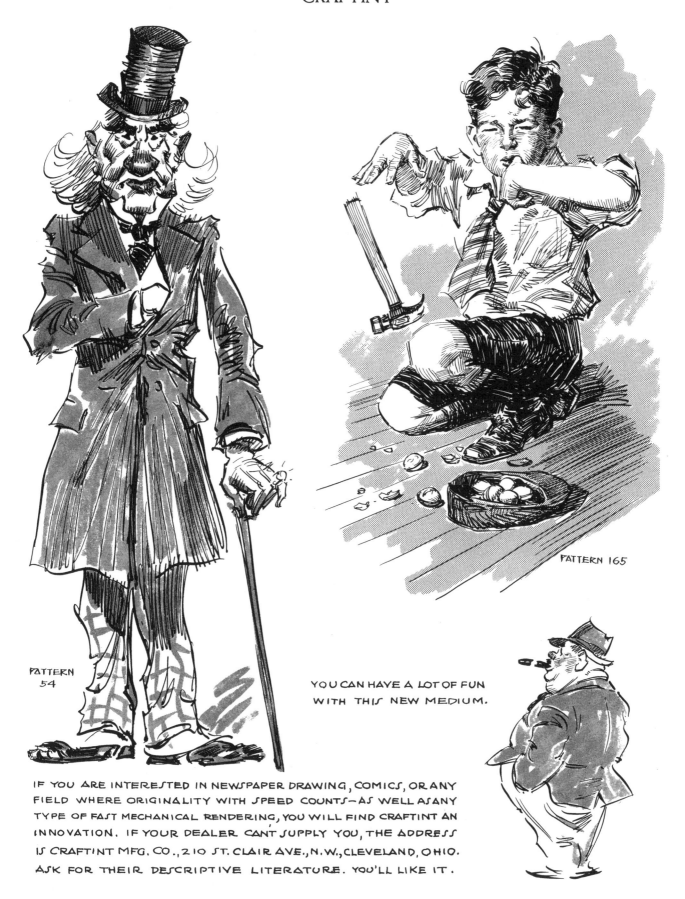

PATTERN
54

PATTERN 165

YOU CAN HAVE A LOT OF FUN
WITH THIS NEW MEDIUM.

IF YOU ARE INTERESTED IN NEWSPAPER DRAWING, COMICS, OR ANY
FIELD WHERE ORIGINALITY WITH SPEED COUNTS—AS WELL AS ANY
TYPE OF FAST MECHANICAL RENDERING, YOU WILL FIND CRAFTINT AN
INNOVATION. IF YOUR DEALER CAN'T SUPPLY YOU, THE ADDRESS
IS CRAFTINT MFG. CO., 210 ST. CLAIR AVE., N.W., CLEVELAND, OHIO.
ASK FOR THEIR DESCRIPTIVE LITERATURE. YOU'LL LIKE IT.

Tone

THERE ARE **4** ESSENTIAL PROPERTIES OF TONE

1. Intensity of light in relation to shadow.

2. Relationship of value to all adjacent tones.

3. Identification of the nature and quality of light.

4. Incorporation of the influence of reflected light.

Tone is the degree of value between white and black—the lightness or darkness of a value in relationship to other values. Tone is the visual appearance "of the moment" as affected by light and reflected light on a surface, or by lack of light, producing darkness. Everything has its own or "local value," which can be brightened or darkened by light or the lack of it. The painter is interested only in the effect of light or darkness on the local value, and not in the local value itself. So when we speak of tone we mean: how light or dark is it in relation to other things? How light is the face in light as compared with the face in shadow and with the background, coat,

and so forth? Thus dark skin in bright light might appear very light, or light skin very dark if in shadow or silhouetted against bright light. We speak of a dress as light pink, middle grey, or dark blue. We are speaking then of local value or color and not of tone. In tone value the same dress might be any one of the three values according to the conditions of the moment or "influence" of light, shadow, or reflected light. When drawing or painting, we therefore look for the effect, regardless of what it is known to us to be "locally." Almost the only time the local value and the tone value are the same is in a neutral diffused daylight.

BASIC INTENSITIES OF LIGHT VERSUS SHADOW

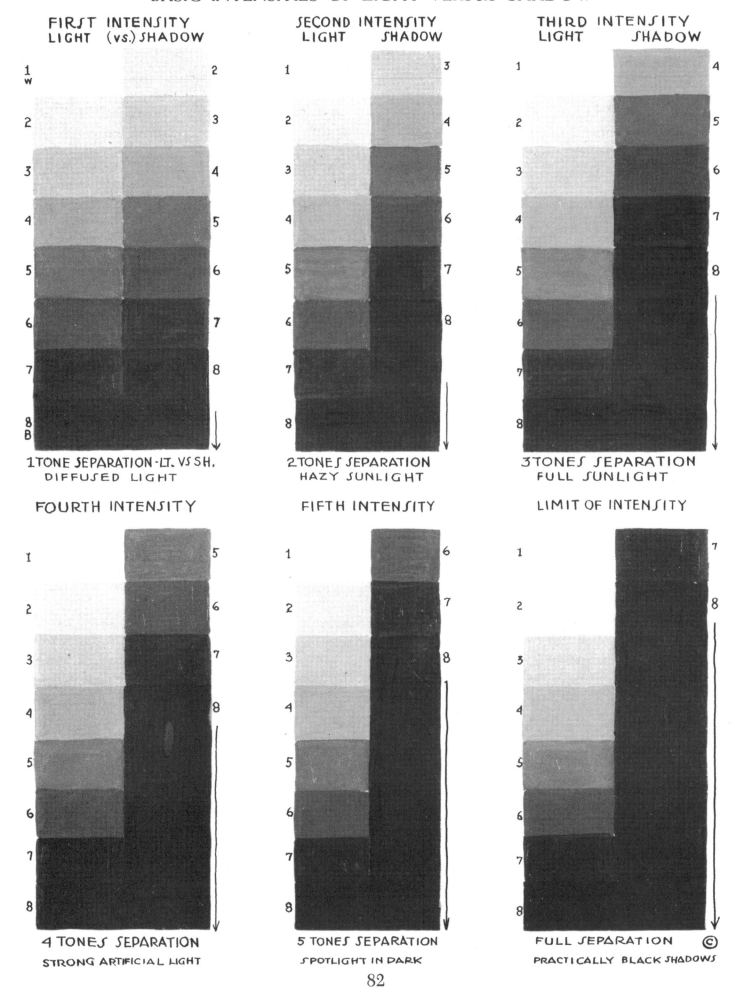

FIRST INTENSITY
LIGHT (vs.) SHADOW

1 TONE SEPARATION - LT. VS SH.
DIFFUSED LIGHT

SECOND INTENSITY
LIGHT SHADOW

2 TONES SEPARATION
HAZY SUNLIGHT

THIRD INTENSITY
LIGHT SHADOW

3 TONES SEPARATION
FULL SUNLIGHT

FOURTH INTENSITY

4 TONES SEPARATION
STRONG ARTIFICIAL LIGHT

FIFTH INTENSITY

5 TONES SEPARATION
SPOTLIGHT IN DARK

LIMIT OF INTENSITY

FULL SEPARATION
PRACTICALLY BLACK SHADOWS

THE FOUR PROPERTIES OF TONE EXPLAINED

We know that so-called "white" skin is not really white. However, it may appear white in a photo. We know it is not black, though shadow can be very black on flesh in photographs. The camera then is, theoretically, recording tone, the "influence of the moment." It is true that film and paper do not always record tone truthfully or as the eye sees it, but it is tone nevertheless.

We can take photos or draw and paint pictures of the same subject in many different sets of values according to lighting conditions.

So this brings us to the first property of tone.

1. *Intensity of light in relation to shadow.*

All light and shadow bears relationship. The brighter the light the darker the shadow appears, by contrast. The lower the light the more nearly the shadow approaches the value appearing in the light. In a diffused light, the lights and shadows become diffused also. In a dim hazy light the lights and shadows are very close in value. So we find that the relationship of light to shadow depends entirely upon the intensity of light.

On the preceding page are set up basic intensities. Now it is true that whatever degree of difference there is between the light and shadow will affect all the lights and shadows consistently throughout the subject. If the shadow, for example, is only one tone darker than the light, then every shadow, barring reflected light, would be one tone darker than the tone in the light, all through the subject. If the light is stronger, there may be two tones of difference. Then, whatever tone we paint in the light, we must paint the shadow two tones darker. The basic difference goes on to about six intensities, for that is about all the values we have between black and white. Any more would hardly show separation in the average reproduction. On the next page you will find a subject worked out in four of the six intensities. On a black night a figure in a searchlight would appear to have black or nearly black shadows throughout. But in a diffused light on a cloudy day the same figure would have shadows so close in value as to be hardly discernible. These, then,

are the extremes of the intensities. So there is no such thing as a fixed relationship of light to shadow. Local value has little to do with it, and all belongs to the Form Principle, the "aspect of the moment, in relationship to its environment."

2. *Relationship of value to all adjacent tones.*

In any given light, all things are so much lighter or darker than what they appear against, or what surrounds them. Thus the "patterns" or areas within a picture bear a relationship to one another. If one area, for example, is two tones darker than another, it has a two-tone-darker relationship. It is this relationship that must be held. We can then place them anywhere in the scale so long as we keep them two tones apart. Thus we can key all the values high or low and still maintain the relationship. It is like *mi* to *sol* in the musical scale, which can be played high up or low down on the whole keyboard. Another illustration might be the making of a light or darker print of a photo, all the values going up or down together but maintaining the tonal relationship to one another. That is what we mean by "key" in a picture. If such a relationship of one tone to another is not held, then the subject falls apart, loses all brilliancy and relationship, and becomes what is known as "muddy" in value. This is the reason for dullness.

3. *Identification of the quality of light.*

By the kind and relationship of values the picture takes on the kind and quality of light. If the values are right the subject appears to be in sunlight, daylight, or night light as the case may be. You may be certain that the quality of light you get into the subject goes a long way in making the picture beautiful and having a "quality of existence." One part of a picture with wrong values may suggest a strong light—another part, a diffused light. This sets up an inconsistency with nature and makes a hodgepodge of your picture. All lighting must be consistent throughout, which means all values must fall within one of the intensities described and also be consistent, for only with true values can we paint light.

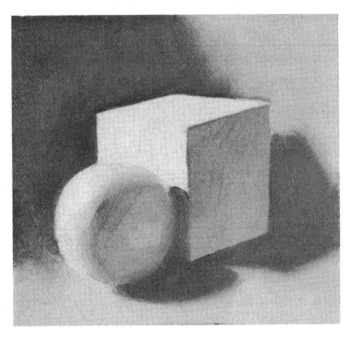

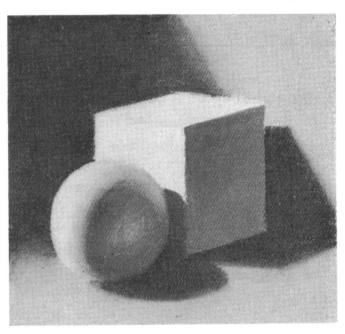

2ᴰ INTENSITY = SHADOWS SET 2 TONES DARKER THAN WHATEVER VALUE USED IN THE LIGHT.

3ᴿᴰ INTENSITY – NOW ALL SHADOWS ARE SET THREE TONES DARKER THAN VALUE IN LIGHT.

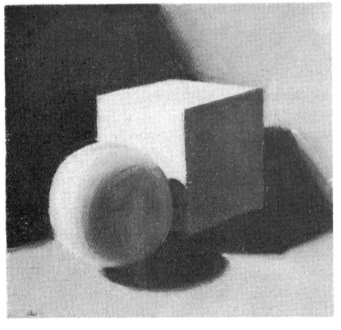

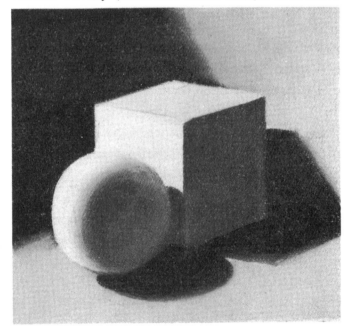

4ᵀᴴ INTENSITY = SHADOWS 4 TONES DARKER. 5ᵀᴴ INTENSITY = SHADOWS 5 TONES DARKER.

NOTE THAT LIGHT APPEARS STRONGER AS SHADOWS ARE DARKENED, THOUGH ACTUALLY THE SAME.

MIX A SCALE OF EIGHT VALUES FROM WHITE TO BLACK. FOR ANY EFFECT OF LIGHT, WE CAN ONLY

WORK DOWN FROM WHITE TO DARK. THEREFORE WE CAN ONLY ATTAIN BRILLIANCY BY CONTRAST.

FOR HIGH-KEYED AND DELICATE LIGHT, USE A CLOSE RELATIONSHIP OF LIGHT TO SHADOW.

FOR BRILLIANCY AND FORCE, USE A FOUR OR FIVE TONE SEPARATION. REMEMBER

ALL THE LIGHTS AND SHADOWS MUST HAVE A CONSISTENT TONAL SEPARATION EXCEPT

WHEN A SHADOW IS OBVIOUSLY LIGHTENED BY REASON OF REFLECTED LIGHT.

THE MEANING OF KEY AND VALUE MANIPULATION

ALL THE VALUES IN BOTH LIGHT AND SHADOW ARE RAISED OR LOWERED TO CHANGE THE KEY

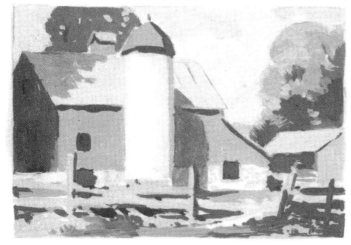

WHEN MAIN VALUES ARE AT THE TOP OF THE SCALE IT MAY BE CALLED "WORKING IN A HIGH KEY."

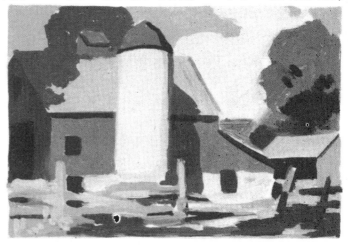

THE SAME RELATIONSHIPS MAY ALL BE DROPPED A TONE OR TWO · THIS IS CALLED "A MIDDLE KEY."

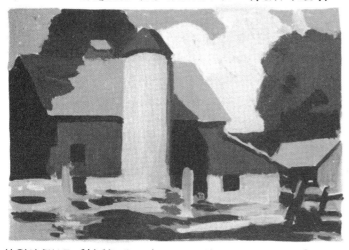

NOW THE SAME RELATIONSHIPS DROPPED TO THE BOTTOM OF THE SCALE ARE "LOW KEY".

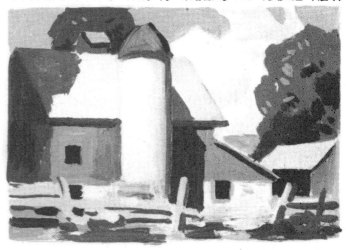

HERE WE HAVE INTENTIONAL FORCING OF RANGE TO INCLUDE THE FULL SCALE.

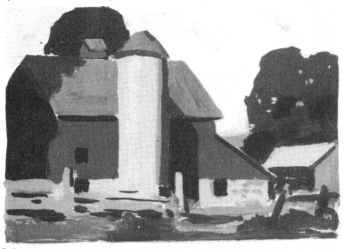

FORCING OF THE DARK AGAINST LIGHT.

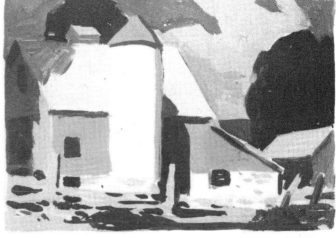

FORCING OF THE LIGHT AGAINST DARK

DEMONSTRATING THE EXTENDED VARIETY OF TREATMENT OF VALUES AT YOUR DISPOSAL WHEN WORKING WITH A CORRECT UNDERSTANDING OF "KEY" AND "INTENSITY". NO TWO OF THE SIX TREATMENTS ARE ALIKE. THIS IS A REAL REASON FOR MAKING SMALL

SKETCHES OR "THUMBNAILS" BEFORE GOING AHEAD WITH FINAL WORK · NOTE THE DRAMATIC EFFECT OF THE LAST TWO · YOU NEVER KNOW WHAT POSSIBILITIES LIE IN YOUR SUBJECT UNTIL YOU REALLY EXPERIMENT, IN OTHER WORDS IT'S PLAIN THINKING ! ! !

THE FOUR PROPERTIES OF TONE EXPLAINED

4. *Incorporation of the influence of reflected light.*

Now when we speak of a basic intensity of light, we must take into consideration the fact that shadows, besides having an intensity relationship to light which puts them so many tones below, are also subject to other influence. Everything upon which the light shines gives off some of that light in reflected light. So shadows cannot be made to fit any rule entirely. If light is shining on a white background, naturally some of that light will reflect into the shadows of objects near by. So the shadow of the same object in the same light might be lighter or darker because of reflected light, or according to what the influence is from its environment. Nearly all shadows contain some reflected light in any daytime or natural light. In artificial light the shadows may appear quite dark (and photograph as black) unless we supply either some reflected light or a so-called "fill-in" light. But the fill-in light should be soft and of less intensity, for we are really substituting for the normal effects nature would give us. Sunlight itself needs no fill-in light to be right and beautiful, though all kinds of reflectors are used in outdoor motion-picture setups. If the fill-in light principle is not understood, the result looks faked and, rather than adding realism and charm, it may actually detract.

Reflected light, then, is a "plus factor" to the basic intensity, and must be so understood. Reflected light is really luminosity within the shadow. However, the edge of the shadow nearest the light will usually keep the intensity relationship. By taking the reflected light away, the shadow drops to the basic intensity relationship. So watch for this. You might look at it this way: "This shadow would have the tonal difference of all the other shadows, were it not for the particular reflected light raising it." So some shadows may catch more reflected light than others within the same picture. The truth is that if you do not include the reflected light where it would normally appear, your form loses solidity and becomes "dead" in the shadow. It appears too heavy, with no light and air. Reflected light has a way of making things appear to be round—to exist with a three-dimensional aspect.

A certain amount of manipulation of values is possible when we know what we are doing. Our purpose is not always to catch the effect as it is, but rather the most dramatic effect possible. Light changes fast when we are sketching. During one sitting we may have many varying effects. How often the sun starts out bright and the sketch is under way. We try to state the effect. Then the sun goes under and stays under. The only thing to do is to set the sketch aside, for if we continue it it will not have the same aspect, nor will it be true to the fundamental approach to values. Start a new one, smaller if the time is short, and wait for another sunny day for the other. The sun moves too, and the shadows change. So keep the sketch small and simple and work fast if you really want to get an effect. A barn might be painted a dozen ways, by manipulation alone. It is really better to make several small sketches or notes of the effects. Then make a careful drawing of the material. Armed with these effects, you can go back and paint your subject at leisure.

It is permissible to do anything you wish in paint. Nobody stops you. One can only like or dislike what you do. If you base your pictures on big basic truths and understanding you will do good ones. If you sit and putter with effects, allowing yourself to guess rather than going out to find the truths you want, you will do bad ones.

We must understand that nature has a much wider scale from her brightest light to darkest dark than from our white to black. So we must either seek subjects within our value range or adjust them as best we can. The camera in black-and-white photography has the same limitation of value, so photography at least tells us about how far we can go in the way of value range in black and white.

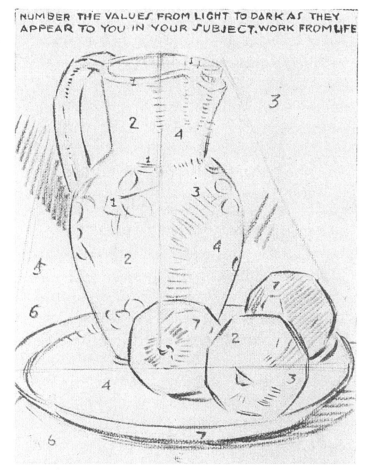

NUMBER THE VALUES FROM LIGHT TO DARK AS THEY APPEAR TO YOU IN YOUR SUBJECT. WORK FROM LIFE

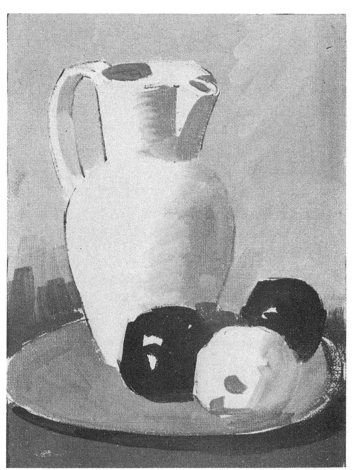

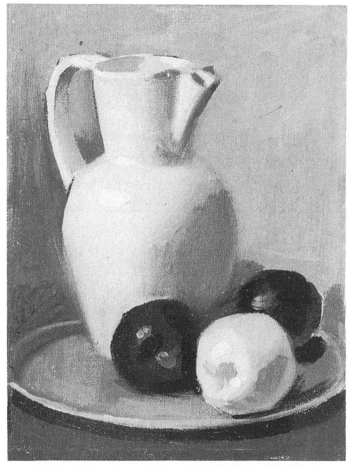

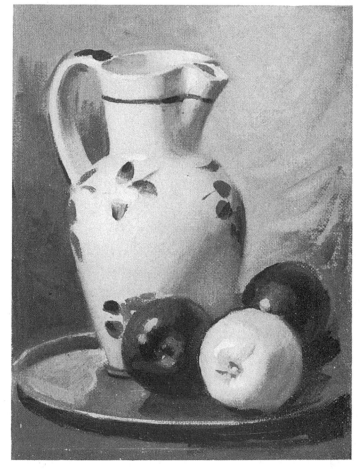

By this time it must be evident that we can render nothing pictorially without making some sort of a linear statement. Now we can also state that nothing can be rendered in the effect of light and shadow without tone. Line becomes tone eventually when close enough together, and one merges with the other. Tone still has contour, which is related to line, or area, also related to line. There is linear feeling in tonal arrangement. Such area, bounded by contours, being of different values becomes "pattern." Pattern is an arrangement, then, of line and tone. In the early part of the book we based composition on line, and now we can begin the other way round, basing it on tone. Tone really represents the volume and mass of form, and the space between solid things. Therefore it represents the visible appearance of our environment as revealed to us by light. It substantiates the surface or character of what we see within contours or edges. This is something line cannot do unless line is made a medium of tone. We may call it "shading," meaning just turning the form, or we may call it "modeling," in its true tonal aspect and relationship with other things around it. Too many young artists only "shade" their drawings and paintings, without getting any real solidity or conviction. Every bit of so-called shading must fall correctly into the value scale from black to white, or "miss the boat" entirely. Shadows all rendered in the same value can give little more than a so-called embossed effect, something bulging out a little from the picture plane, but with none of the appearance of life.

So all things have a value between black and white. All things have a value according to light and shadow. All things separate from one another within our field of vision because of values. So we can begin with these value shapes, stated as flatly and simply as possible, and practically devoid of modeling or surface detail.

Having such simple areas of related values, we can later build up the particular character of the surface or form. This simple statement is our value pattern, which will build up the big masses of the subject, and the flat or general statement of the picture. We have only about eight separate values to work with in all. We shall need at least a tone or two to round the form, in whatever value the flat tone appears. Allowing two tones for each pattern gives us four patterns. Therefore we shall build pictures with a white pattern, a light grey, a dark grey, and a black pattern. That is about all we really need; in fact, that is all there is. Each pattern can be varied one tone without getting into and mixed up with another pattern.

On the following page we find that by juggling these four values we get four basic tonal approaches. In each case one is chosen for the general or background tone and the three remaining are placed against it. Each plan will have equal visibility and vitality. Any picture or poster based in this way will have "punch" as far as values and pattern are concerned.

It is best to have one of the four values dominate the others in actual area or space. Thus we can use white as a background, and play our greys and darks against it with perhaps some white also as a part of pictorial matter. Or we can have a light grey as the dominant tone, with dark grey, black, and white playing strongly against it. Either the dark grey or black as the background is very telling and powerful as a basic tonal arrangement. Many subjects may be tried out in several ways, and many subjects fall naturally into one or another of the four plans.

I present this plan of tonal arrangements because it seems characteristic of beginners or early professional work to be disorganized as to pattern and values, resulting in a hodgepodge of neutral tones, or tones so scattered and broken up as not to have the much-needed impact.

It will be seen at a glance what a powerful and organized effect tonal arrangement can have if based on one of the above four plans. Such use of tone is by no means compulsory, since we may have predetermined a subject as being close in value and within a narrow range. But when full vitality and strength of value is required or desired, plus carrying power and contrast, then the

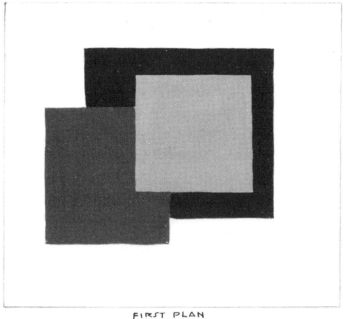

FIRST PLAN

SECOND PLAN

THIRD PLAN

FOURTH PLAN

1. GREYS AND BLACK ON WHITE.

2. BLACK, WHITE, DK. GREY ON LT. GREY.

3. BLACK, WHITE, LT. GREY ON DK. GREY.

4. GREYS AND WHITE ON BLACK.

use of a basic tonal plan is your best answer.

The whole theory of pictorial design is organization of line and tone, and (later) color. The values will be more telling if organized into simple groups that will hold up in mass one against the other. Scattered and confused small patches has the opposite effect, of breaking down the carrying effect of tone. Military camouflage makes use of this principle.

There are really few subjects which when thought about will not lend themselves to such simple arrangement. You can be almost sure that

if one does not, then you are hardly on your way to a good picture. There is an "all busy," or mosaic, type of picture, which might be likened to an Oriental rug in design. Or there might easily be, in an otherwise simple design, one "busy" pattern, broken into bits of pattern, stripes, or patches. This is often desirable and effective. More pictures are bad because no attempt at tone organization has been made than for any other reason. It is to get rid of the weak, washed-out effects, or the dull, heavy, and muddy use of values, that this approach is offered.

HOW TO LOOK FOR THE "MEAT" IN YOUR SUBJECT

It can be taken as a sound rule that the simpler the presentation of a subject, the better it will be pictorially. A simple presentation technically resolves itself into a few simple organized areas of a few values. To prove my point, suppose we enter a room with papers, clothing, or other material representing contrast, strewn or scattered about. We have the immediate reaction of wanting either to clean up the place or to escape from it. We speak of a place as being "littered" with trash. What really happens is that it is littered with contrasts or confusion of tone and the effect is unpleasant. Pictures can just as easily be littered and just as unpleasant. So if the first glance can find no reason for a bewildering array of tones, the eye will pass up your picture for a more organized one. This was the main secret of the great Howard Pyle: his simplicity and organization of tone. We shall speak more of him later. This is the secret of good advertising material or any subjects seeking to command attention.

Let us comprehend that it is more pleasing to look at the extreme contrast of black and white if supported by easy natural sequences of grey. The eye will automatically seek the darks and lights placed within the greys. For the eye sees contrast instinctively. Therefore the spot of interest should be afforded contrast with its environment. Note how in the second, third, and fourth plans the eye goes at once to the white area. In the first plan it seems to go to the black. Black and white used together against areas of grey will always command immediate attention.

It really does not matter much which plan is used so long as the areas of the four values do not become too equalized or the whole thing too broken up. Subjects which must be taken in quickly, such as posters or displays, should be in the simplest possible tonal arrangement. Subjects that have more time to be looked at can be a little more intricate, if need be.

Every subject can first be analyzed for the so-called tonal "meat" in it. By that we mean: what are the tonal possibilities here? If the subject has something of broad expanse of tone, such as snow,

sky, a broad stretch of water, dark night, wall space, or a floor, we can seize immediately upon that expanse as our dominant tone. Such expanses set up a mental image of tone. We can then instinctively turn to the basic plan most closely allied to the image. That leaves us mainly the planning or arrangement of the rest of the subject in some sort of design against the over-all tone, or larger areas.

To give you some examples, let me suggest the following:

> Dark figures in a snow scene: the first plan.
> A man with a lantern: the fourth plan.
> A light boat in the open sea: the second or third plan.
> Figures on a sunny beach: the first or second plan.

Beyond the well-defined four approaches we have a few variations. We may take two values for the interest and play them against the other two, instead of three against one. Or we may take one or two values and spot or interlace them through wider areas. I have given you a series of small pictorial arrangements just to get you started. The basic tonal arrangements are so numerous as to be almost inexhaustible, once you understand the method. I have transposed some of the first pencil roughs to larger black-and-white oils, then selected one of these for a full-page sketch. But it goes on and on. Why? Because nature and life fall so naturally into organized tone as almost to pick out the plan for you. And nature is inexhaustible for suggesting arrangement and inventiveness. That is why I shall keep urging you to go to the real source for yourself. See if you can't stay off the other man's back; *you* have eyes and inventiveness too. Take a finder and a pad and pencil almost everywhere and keep busy. You will see tonal plans all around you, and the whole approach suddenly becomes clear. I can assure you there is no better one. Every good artist uses it.

The tonal plan offers many opportunities for variety in the same subject. Often the material

can be changed about in great variety. Suppose we have a head and shoulders of a girl to draw. We can in a small rough get the effect of how the picture might be built with middle tone, greys and black, against a very light background. In that case we would naturally give her dark hair. We would probably light it from the back, throwing her face into halftone or shadow. We could dress her in dark grey to complete the four general values. Suppose we choose a black field. Then we might make her a blonde, using the light to the front or three-quarter front. The light and shadow would produce the greys we want against the dark.

Sometimes the areas of pattern can be switched about. The figure might be a light one or dark one; we can try it out as light against dark or the reverse. A sky might be bright or dark, or trees, buildings, and other material might be tried both ways. What we are after primarily is striking design if possible, and it is so much more important than the subject or material itself. Being a pictorial inventor is just as interesting, perhaps even more so, than the actual rendering of the subject when we have decided on something. Strangely enough, if you have really conceived your own design and subject you will find yourself doubly interested in carrying it out. Having conceived it, it becomes relatively simple to work it out with lights and a model. But starting out with no conception, or depending upon "snapping up" something as you go along, is mighty poor procedure and has two strikes against it at the outset. Without the tonal plan you will find yourself falling into the bad habit of making most of your pictures alike, even lighting your figures the same way, depending on the merits of the model's face or figure to get you by. It can get very boresome to readers. Design is the best bet. Design is rarely a complete accident. It has to be balanced, simplified or stripped to essentials, and usually tried in several ways to arrive at the best one. Almost

everything in the way of form can be tied together or interlaced with other space or form to produce good, even unusual, design, regardless of its complete or identifying contour. By identifying contour I mean a shape which might identify itself as a flat silhouette. A hog in silhouette might not be the most beautiful design as a separate and complete thing. But a hog contour can be most beautiful as a line related to other lines, a shape intermingling with other shapes you will design. Sunlight and shadow can play across a hog with intriguing beauty, as well as value or color. A couple of hogs could be the subject of a masterpiece. The point is, it is not the hog at all, it is the inventiveness and charm with which you portray it.

So many of us attach so much to the material and subject, so little to the design and arrangement of it. We accept so easily without planning. We are so eager to find the prettiest model (or dress, or shoes) and then paste her onto some sort of flatness and try to call it a picture. I cannot censor you for it, for it is typical. But I can point out that the one hope of producing better work is through the conception, not the material. One artist told me he thought his work had never really clicked because he had never run across quite the prettiest girl that he thought he might be able to draw. So I recommended my best model, with no better luck for him. I had not the heart to tell him the real reason, for who can be too sure that his own work is not often wanting in design and conception? It is not easy, and it demands the utmost of your time. Design is always there to experiment with, to allow you to express yourself in your own way. It is the thing that makes you or breaks you, when everything else is said and done.

I cannot urge you half enough to give thought and planning to the merest sketch, the smallest job. At least be certain you know no other or better way. If you have not tried any other way, how can you be sure? A page of thumbnails takes much less time than you waste with a bad start.

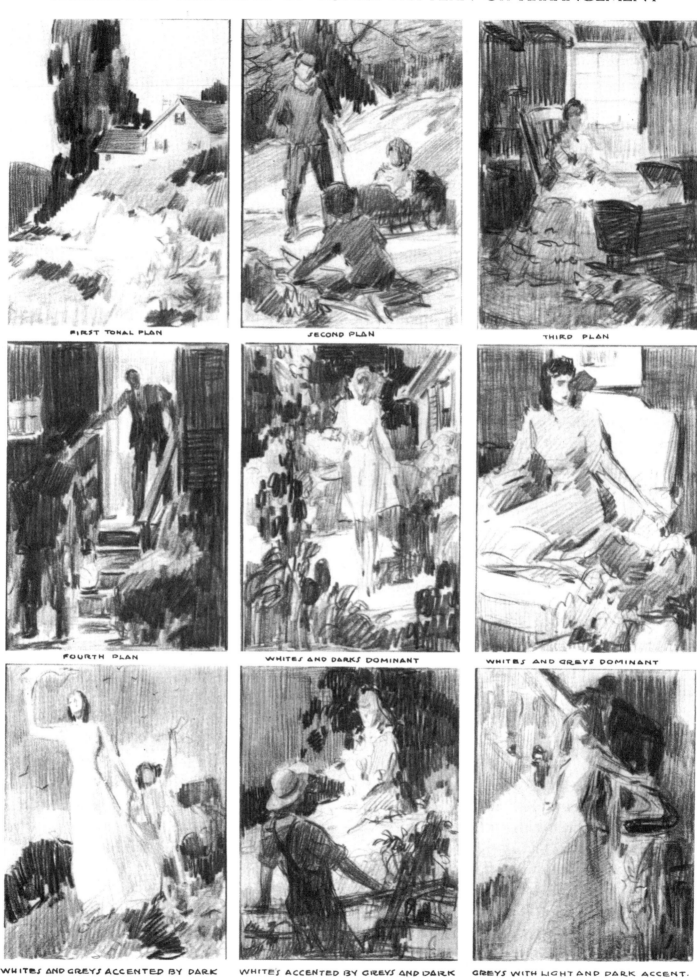

FIRST TONAL PLAN

SECOND PLAN

THIRD PLAN

FOURTH PLAN

WHITES AND DARKS DOMINANT

WHITES AND GREYS DOMINANT

WHITES AND GREYS ACCENTED BY DARK

WHITES ACCENTED BY GREYS AND DARK

GREYS WITH LIGHT AND DARK ACCENT.

THIS SUBJECT FALLS NATURALLY INTO THE FIRST TONAL PLAN.

THIS ONE IN EITHER THE SECOND OR THIRD TONAL PLAN.

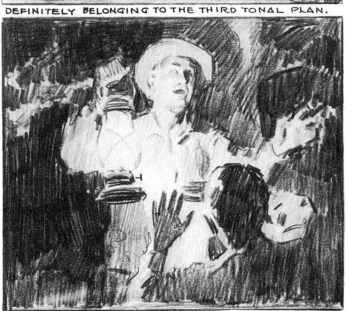

DEFINITELY BELONGING TO THE THIRD TONAL PLAN.

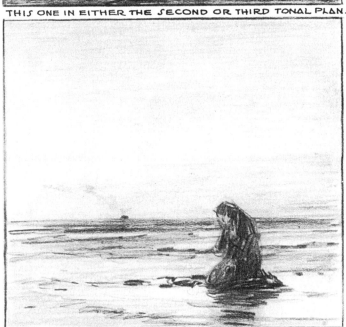

THIS WOULD BE THE FIRST OR SECOND.

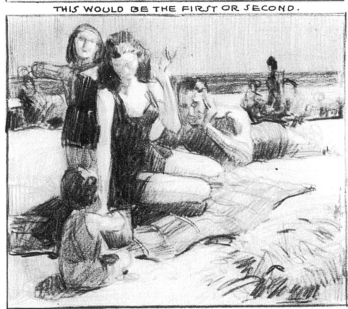

THIS CALLS FOR THE FOURTH PLAN

SECOND PLAN. THUS ANALYZE YOUR SUBJECT IN MINIATURE.

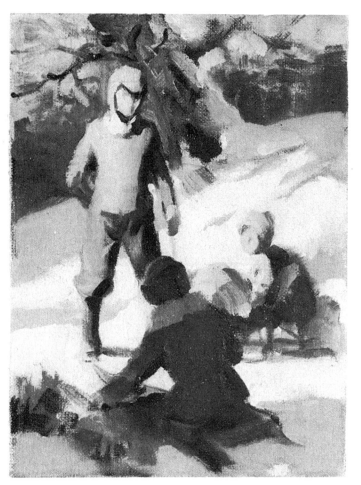

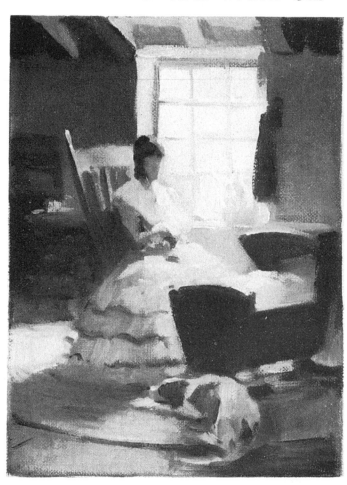

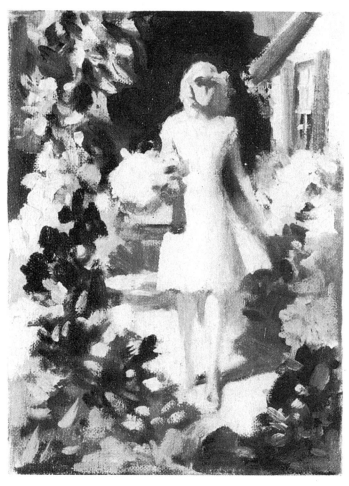

94

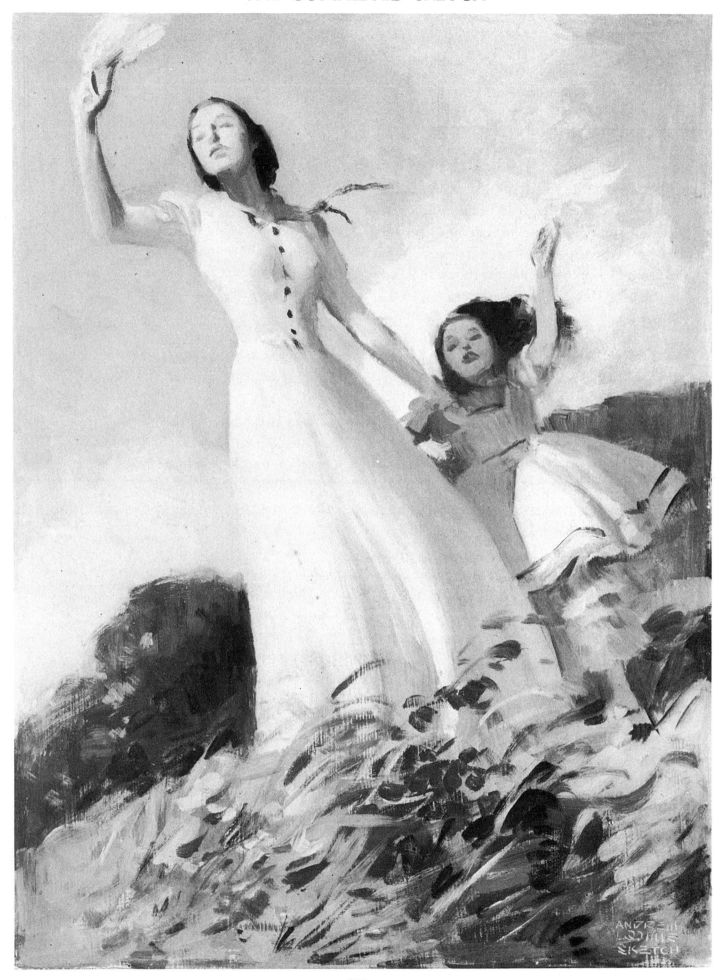

SUPPOSE WE TAKE A SUBJECT AND WORK IT OUT

Old Mother Hubbard
Went to the cupboard
To get her poor dog a bone,
When she got there
The cupboard was bare,
And so will ours be, unless we
 do something about it.

The subject, the simplest nursery rhyme. The picture, no easy matter. Now, what is your conception? Yours and mine are going to be very different. Who was Old Mother Hubbard? What did she look like? How was she dressed? Where did she live? How? What was the interior? What kind of a dog? What is the drama or action? How can we tell the story?

The first thing I'm going to do is go sit in the corner and think for a little while. I see a little old lady with a full skirt, a white kerchief and bonnet, hobbling about with a cane. She could be ragged and unkempt or neat and clean. I choose the latter. The dog is a big dog, a sort of old spotted hound. In the kitchen I see an old hand water-pump in the sink. I see crisscross window panes in the window over the sink, and the open cupboard alongside. I see her telling the dog there is none and the old hound seeming to understand, even forgive. Yes, there is a lot in the subject. Now, how do *you* see it?

Let us think of it in relation to a tone plan. It is obviously an interior, and that would probably be grey. At least I see it as grey. So that eliminates both the white and black as the dominant tones, throwing us into the second or third tonal plan. Grey is melancholy like the subject, which helps. Now, already, here is black and white against grey, a sound approach. If we dressed her in grey, then the interior could be dark, or dark shadows might be introduced. To get a white pattern we can have the window, her bonnet and apron, a partly white dog. Maybe something white as an accessory—a pitcher, a bowl. The black pattern or spots will be taken care of by the old lady's dress, the shadows, or in whatever way we find.

The first temptation would be to run and buy a Mother Goose book. Why? Because we want to see what somebody else did. We lack any confidence in ourselves and hope to get some ideas. That's one way. That is the worst way, the least original way, and the one thing not to do. Old Mother Hubbard is just as much yours as mine or anyone else's. Who knows when, how, or where she lived, and who cares? Mother Hubbard is just so much design, so much character, and so much story. If we have to be too authentic, we will delve into history, spend a lot of time, resulting in little more than we already have to work with. Maybe we could come out with an authentic dress. But we are not making a picture to sell or stress a dress. Let us make it to suit us best. Its only real value is in what we do with it.

Let us conceive our subject, then look about us to find a face which spells Old Mother Hubbard as she fits our conception. I have worked out four arrangements. These were without model or copy, for just now I'm not interested in anything but the design and story. Of the four, I like the last one. It would not be very difficult now to get a model, and the costume, even the dog, and go ahead. It would be interesting to go on and paint the picture. But the important part is done, and I am not really as concerned here with showing you a finished job as in showing you how I would have approached this commission, were it a commission. I can just imagine what fun Norman Rockwell would have with this, and what a beautiful thing he would end up with to show us. And I'm sure he would do every inch of it on his own. That is what made him great. Start out by giving yourself the same chance.

Get out your pad and pencil and begin. Take Jack Spratt instead of Old Mother Hubbard, or any one of a hundred others. But take one, and try it, for perhaps the first time, and make up your mind now that you will do it that way from here on.

TECHNIQUE IN TONAL MEDIUMS

TECHNIQUE is a very controversial subject at best. There are perhaps as many viewpoints regarding technique as there are individuals applying it. It is not my purpose here to "favor" one technical approach over another, or to attempt to steer you away from an individual application of mediums, for therein lies your own personalized style. If you do not allow yourself to be too much influenced by some single idol, you will develop your own technique in spite of yourself: it is bound to be a part of your personal characteristics just as is your handwriting. My intent here is to stress the general method, and the reasoning back of it, rather than to say how it shall be applied. When I speak of technique here I am thinking of *qualities* that should be incorporated into good technique; those qualities being the sound rendering of form in true values, the consideration of edges and accents from an artistic point of view, the design and balance, contrast, subordination and accentuation. If you can achieve these, it will not matter how you do it.

I wish also to point out certain characteristics of the mediums themselves, and the inherent qualities of each which are not always obtainable in another. It is hardly necessary to go into the formulas for materials, paint-mixing, and so forth, since this has been expertly covered by other writers. The permanence of your materials I do not consider especially important at this point, since the problems presented here may be looked upon as practice and exercise or experiment on your part.

Most of the elements of good technique lie in individual interpretation of the qualities of the mediums. You may use a stick of crayon in any way you wish, but the values, the proportions, the contours and edges, are more or less limited to good and bad drawing. Drawing can be really bad for only one reason: that it fails to carry conviction to the beholder.

After all, every drawing is a statement, either convincing or not. If we do not convince we cannot expect interest or response. In the long run, there is no real substitute for truth and nothing quite so lasting. For that reason I feel quite certain that realism in the sense of a "quality of existence" will outlast any other form of art. We cannot convince the beholder that what appears to him as distortion of truth is right and proper. But tell him the truth as he knows it and glorify it, and he meets you more than halfway.

There is only one way to assure consistently good work. That is consistently thorough preparation. The preliminary visualization or conception is, I believe, done better without models and copy. It leaves you freer to express yourself. But having formulated, even crudely, your idea and expression, then by all means take every step to avoid faking or guessing in its final execution. While there may be pride in doing without model and copy, there is no point in it. If the best artists invariably prepare the best possible working material in the way of working from life, aided by camera shots and studies, how can the man who fakes and works blindly, hope to compete?

The first matter for your consideration is the development of a thorough approach. Call it routine if you will; I'd rather think of it as good habit. Start with the tissue pad, but before you haul out too many clippings, see if you cannot visualize the thing from a standpoint of mass and design. Perhaps you do not yet know the details or nature of the accessories. But make little suggestions of figures going through the action and somehow spotted into interesting masses of white, grey, and black. You can think of something later on to make up the masses. It may turn out to be a piece of dark or light furniture, a mass of foliage, or what not. But work for your own design.

The procedure of copying and finishing a figure and then trying to fill the spaces left around it

with some sort of background usually results in either bad arrangement or none at all. It is very unsatisfactory. Think of an environment, if any is to be shown, and then find ways to place your figures into it. Think of light and shadow pervading that place and falling upon the units within the space.

It is better, actually, to think of the setting before you think of the figure, or of the design or shapes that the figure will eventually be a part of. Suppose we draw, from a clip, a bathing beauty standing in the dead center of white space and filling it almost from top to bottom. Then suppose we start thinking of background. What is there left to do but fill up the two empty sides with beach, water, and sky? Naturally as a design it's going to be a dud. We gave design no chance. Now suppose we make some patterns of dark (eventually rocks), some greys (eventually shadows, water, or sky), and some whites (eventually clouds). We soon find the spot for the bathing girl. The grey might be a wave breaking, the foam a white pattern, with the girl in a light or a dark suit to fall into the design. She might be sitting, lying down; a pattern might turn into a cape blowing, a white spot might be a gull. She might be half in light and half in shadow. A thousand and one things can happen to make it interesting. This is what I mean by "approach." Give your inventiveness half a chance and you will create. Or you can easily stifle it by jumping unthinkingly to the final effort, trusting to luck. If you just find copy and reproduce it literally, or even just sit down and copy a photograph you have taken yourself, how can you possibly go the next man one better? All you can do is possibly to make a little better copy, and it ends right there. You haven't given your client much to choose from. Maybe next time the other man will copy better than you, and you will be out.

The creativeness is in the planning, pure and simple; the rest is good carpenter work. Consider that always in your approach.

The next consideration is the rough sketch. Even if the client does not ask for one, your final work will be better if you will form the habit of roughing the idea out first for yourself. After your thumbnails have been planned, after you have your clips, photos, or studies, make some sort of a tentative statement of the whole thing as you want to work it out. This gives you every chance to improve from the start; it shows up the difficulties, if there are to be any; and changes will not have to be made on the finished product, perhaps after hours or days of work. Maybe the figure should be moved over, or raised or dropped. Maybe the girl should have a dress of a different value. Perhaps the pose might be better. You never know these things until they have been stated. You don't make good pictures by changing your mind in the middle of the procedure. No medium looks as good worked over as it does when planned and put down fresh, to stay that way. It takes a long time to learn this, and some of us never will. It is comparable to the advantages of a well-planned speech over an impromptu one. Settle all the arguments with your picture before you stretch the final canvas or before you spoil that nice big sheet of expensive water-color board. It pays!

If there is time it is better to make a first study of a figure, then work from the study rather than from the original copy, or from the figure into the final. I realize this is not always possible. But it pays out in directness, freshness, and looseness. It is hard to make it free and spontaneous the first time. We all struggle to get the drawing, values, form, and design all down at once, and it is quite impossible to do it every time. It makes more work, but it makes your best work. So the best habit is the thumbnail, the rough, the studies, then the final. It is a combination others will find hard to beat. If you can make the study in the same medium, so much the better, for you will have worked out the problems in advance.

As I have indicated, your particular technical approach, your mannerisms, your style, must be your own; something which cannot be determined or even guided by anyone else. But we can discuss some of the means at your disposal, something of the attitudes toward your work that

99

must be incorporated into your style, whatever it is. The first consideration is that of detail.

THE PROBLEM OF HOW MUCH DETAIL

This is something that you will decide, in the end, for yourself. It is almost certain that you will have to begin with the ability to give completeness or "finish" to your work when expected of you. And by nature you may prefer a closely accurate and finished type of work. There is nothing wrong in working that way, and there will always be a place for such a method. However, since photography does the same thing so well, I myself prefer art that gets as far away from the photographic as possible—granting at the same time that this is *not* always possible. I shall endeavor to give you throughout this book examples carried out in each direction, since it is true that more clients prefer finish than looseness and freedom. As you already know, I believe the future in art lies in individuality of conception, and to me, greater individuality is expressed by a big broad interpretation than by being too accurate and literal. But the early work of any artist known for breadth and looseness usually shows that he had to master detail before he could subordinate and eliminate it.

It must be admitted that the step from detail, once mastered, to looseness and suggestion, is extremely difficult. It is really much harder to paint loosely than tightly, for doing it either way must carry conviction and truth, if not literal truth. Tightness begins with being so concerned with surface that we lose plane and mass, and so conscious of contour and edge that we do not soften or lose it. A round form can be so smoothed in gradation of tone that it loses all character. One may see the turning of the form in a series of several tones. The better artist models that form in but two or three planes. The fewer the planes the broader the work, for breadth of execution is really breadth of vision. One may see an edge sharp and defined. Well and good, but he need not dig out edges that he can't see and sharpen and define those also. Definition will never be the basis of art, but rather selection, accentuation, subordination. Making all things through your picture equally important is like playing all the notes of a composition with monotonous and equal intensity, without accent or modulation. A picture rendered in this way never seems to elicit that "Ah-h-h!" It can so easily lack vitality and spirit.

Detail can be shown in things close up, but to make things recede, form must resolve itself more into plane and mass as it goes back. That is what happens in our vision. We do not see eyelashes at ten or twelve feet, nor tiny face wrinkles. We do not see the slight variance of small surface forms. We see just light, halftone, and shadow. If far enough back, we see just light and shadow.

Much of the error of too much detail is committed thoughtlessly. The artist takes a close-up of a model, and then places that detail too far back in his picture. Again, it must be realized that the camera lens is much sharper than the eye, and sharper to a greater depth of focus. This will not be believed until you make the following simple experiment. Hold up one finger at arm's length in front of you. Look at the fingernail. How clearly can you see detail in back of it, while seeing the nail? Everything behind it becomes diffused or is seen in a double image. Now concentrate on the distance behind it, and you will see two fingers. Closing one eye, you see as the camera does. The two eyes cannot focus on two distances at the same time. You may think the whole field of vision is sharp. To prove it is not, ask a person to hold his hand a few inches to the right or left of his face. Now concentrate on the center of his chin. While looking at the chin, how clearly can you see his hand? When you are looking at his hand how clear are the features in his face? The truth is that that marvelous instrument the eye is constantly making focal adjustments, and so quickly that the whole field of vision appears sharp. But since it is possible for the eyes to *concentrate* on only one distance at a time, if a picture contains a point of focal interest, with material outside of that area slightly subordinated and slightly more

diffused near the frame, then the whole effect is really more true than complete detail all over. I do not mean that there should be a circle of sharpness surrounded by fuzziness, but that as you go away from the focal point more detail can be subordinated and more softness permitted with a powerfully realistic effect. It concentrates attention upon, and enhances, the detail where you want it. You will find this in Rembrandt, Velasquez, Titian, Gainsborough, Romney, Sargent, Eakins, Alexander, and a host of others. You need not take my word for it. Degas was a master of concentration and subordination of detail, plus great consideration for design and arrangement. The young illustrator can profit by study of his work. Pyle's work was complete enough, but seldom finicky.

If detail all over the picture is shown as it would appear close up, then everything is brought forward to the front plane of the picture, or to the actual surface of the paper or canvas. This is much like a telescope or opera glasses in bringing a scene forward. Technically, then, your picture becomes a sheet of detail: all things lying right on it, without a feeling of space between the various distances as we go back. Unless the detail of the background is subordinated to the foreground, all will seem to be sticking together in a single plane, regardless of perspective and diminishing size. The answer is that surface detail should become submerged in tone as it goes back. For example, the weave of a sweater is apparent only for a few feet. After that, the sweater becomes simple tone. How important are the weave, the tiny folds, or any of the small details, anyway? The big forms are what we are concerned with. To add detail that we could not see is as false as to define contours we cannot see. The fact that the camera can see it more sharply than we can does not make it one bit better as a picture. We are painting to produce an illusion of life as we see it, not some duplication of mechanical sight. So the farther back, the less modeling, the simpler the tone, the less the planes (meaning less halftone), the less reflection in shadows, the flatter statement of simple light and shadow. The distance can become almost poster in effect. Try it, and amaze yourself with the three-dimensional quality it gives. This is especially true in outdoor subjects.

There is a clock about ten or twelve feet from where I sit. I know that grey spot at the top of the dial is an X and two I's. But the clock really appears to have spots of grey around the dial. If I were to paint this setting and put the numerals clearly on the clock I would sacrifice any feeling of the distance between, and the clock would sit right up on the front plane, like a watch in my hand. Yet in most of our present-day illustration this is done over and over, and by good men. They are putting down what they know to be there, but not as they truly see it. It is thoughtless and erroneous, and easily so proved, once pointed out. The artist must make an heroic attempt to disentangle detail and tone in his own mind and vision. He must realize that his vision is a thousand times more beautiful than the camera's if he will but trust it. If he is to obtain that greater beauty, he must combat the too-great detail registered by his camera rather than abide by it slavishly. It will be better if he learns to trust the camera less and believe more in his own inventiveness and feeling, trying to see with reason and imagination. Only in this way can his work soar to heights unattainable mechanically.

Perhaps an artist has not yet reasoned that there is any goal beyond detail and finish. Then let him look at the landscape on a misty day and see the real beauty of subordination. Let him study outdoors in twilight against a flaming sky, the mystery of moonlight compared to midday. Let him drape a figure in gauze, look at the reflections in water, look beyond falling snow, or even scrape off his sharp picture with a palette knife, finding infinitely more beauty than he had before. There is a door open to all of us, if we will but pass through.

THE TREATMENT OF EDGES

Perhaps the most important element in obtaining freedom and looseness is found in the treatment of edges. There is a "lost and found" of edges as they truly appear in space. But the eye must educate itself to see it. You may not belive this quality exists in nature, for it is hardly apparent until you seek it. There may be obvious softness of edge, as, for instance, the hairline around the face, or the fuzzy edge of a fur cape, but softness does occur even on hard edges—edges which really are a line or a hard surface, like the four sides of a square polished table, or edges which are hard to the sense of touch. Unthinkingly we may put them into our work as something hard all around. That is putting down what we know is there but not seeing it. Look at the real table top and you will find the edges are different all the way round. The four edges will pass by some tones that seem to merge with them. In other places they will stand out sharply in relief. The top may have reflections of light which, running to the edge, will be sharp, and dark reflections which may make the edge undefined. So edges are a part of the Form Principle, since they are relative to the surrounding tones and influenced by their environment. The same edge may be sharp or soft according to the conditions of the moment.

Look about you where you are sitting right now. The first edges you are conscious of are the ones where there is considerable contrast of value —light against dark or the reverse. Then you will find there are some that are not quite as insistent. In painting you could start softening these somewhat. They are to be quieted down, because they really are that way when compared to the strong ones. Next, you will find there are edges which are enveloped by and merged into shadow. You have to look hard to see them. Finally, I hope there will be some you actually cannot see but will only know are there. These are the edges to be lost entirely in painting. It is by studied treatment of the edges that we get the illusion of space.

If we look only for sharpness and delineation, that is all we are going to see. How many of us ever really look for softness, for merging tones, for tones being lost into and enveloped by shadow? Yet these are the qualities that we revere in the work of the really great artists. If we see only the sharpness in life, we may see only the sharpness in great pictures. When we find there is also softness, we find they also have it. We find there is a balance of sharpness and softness all the way through, neither all hard or all woolly. Our pictures really differ in quality from the great ones not so much in medium and dexterity as in vision. We have not developed that vision to as great an extent, and mostly because we have failed to make equal contact with the truth of nature itself. We do not develop vision if we do not use it. Your camera and your projector are never going to develop your vision. They will hang like a weight upon it without your even realizing that this is so. Because the quality of "lost and found" in edges has so much to do with vision and the inner feeling of the artist, it cannot be reduced to formula. But I believe I can guide you to some of the instances where you are apt to find it if you will but look with your own eyes. Let us define several kinds of soft edges.

1. For the first, let us take the softness produced by "halation" of light. Halation is the spreading of light from a particular source over the surrounding tone, like the blur around a candle flame. That halation does exist is proved by the blur produced in a photograph around a light source such as a bright window or lamp. A softness like this is obtained by softening the tone *outside* the contour, as, for example, beyond the inside edge of the light of the window. If you want a light to appear brilliant, let a little of that light travel across or into the surrounding tones. The edge itself may be held fairly definite, but there is a raising of the values touching the edge.

In painting we also have what is known as a "passage" from one tone to another. An edge may appear hard and insistent against its neighbor. We want accentuation somewhere else, and

would like to subordinate this edge. This often happens with the shoulders and arms of a portrait. To soften or subordinate such edges we may bring the two tones closer in value at their meeting, letting one tone fade into the larger adjacent tone gradually. The edge may still be held, not smeared together. In effect it is like extending the value of one tone for a little way into the other. For example, a light background would be darkened a little when approaching a dark edge or lightened somewhat when approaching a light edge. This puts less attention on it, but still holds the edge, without making a garment, for example, look like fuzzy wool.

2. The next kind of soft edge is much more obvious. That is where the material itself is soft and becomes a mixture of itself with what is behind it. For example, the edge of a man's beard, a wisp of hair, the fine twigs of a tree, lace and transparent materials, mist, clouds, spray, and so forth.

3. The next kind of edge is soft because of fusion values, when the edge becomes the same value as that value which it appears against. If they are quite close anyway, it is safe to lose them a little more. You can use the sharpness elsewhere, where it does more good. This is really where light appears against light, grey against grey, and dark against dark.

4. Where the turn of the form presents a gradation of tone approaching the value behind it. Example: light on hair turning to meet the light.

The above four are natural or actual causes of lost edges. Now let us consider deliberate instances where it enhances the pictorial qualities to soften an edge.

5. In cases where two sharp edges occur and cross, one behind the other, theoretically soften the one in back as it meets the front one. Example: when a line of a hill crosses behind a head, soften the line of the hill especially where it meets the head. It need not be miles back of the head; soften even the line of the back of a chair as it meets the head, or the contour of any form passing behind another contour. It keeps them from sticking together.

6. There can be softness and diffusion incorporated for purely artistic presentation, to get rid of harshness and overinsistence. A tree in the distance naturally would be painted with more softness than one in the foreground, to get it back where it belongs and to create the illusion of space. The sense of space is actually more important than the tree. Painting both trees sharp would bring both into the front focus and up to the picture plane, which is false.

Do not interpret this as meaning you must paint everything in the front as hard and sharp and everything in the back as fuzzy and out of focus. There should be a certain consistency of vision about the whole thing, not as though the beholder were nearsighted. The changes should be gradual and subtle, not too obvious. There can be softness in the close edges too, mingled with the crispness, and some sharpness in the edges farther back. The picture should have feeling of the subtle "interlacing" of masses so the different areas do not separate themselves too distinctly as would the countries on a map. Following any edge around should give it "lost and found" quality, with more of the subordination in things at a distance than those close up. All sharp is bad. All fuzzy is bad. The beauty lies in playing one against the other. Study some fine art from this standpoint and it will open your eyes. But mainly try to see it in life for yourself. It is there, but so subtly that it must be stressed. Nature already has space, but we have only a one-plane surface to work upon and must do something almost drastic to get rid of things seemingly pasted on and sticking there. Too much illustration is just that.

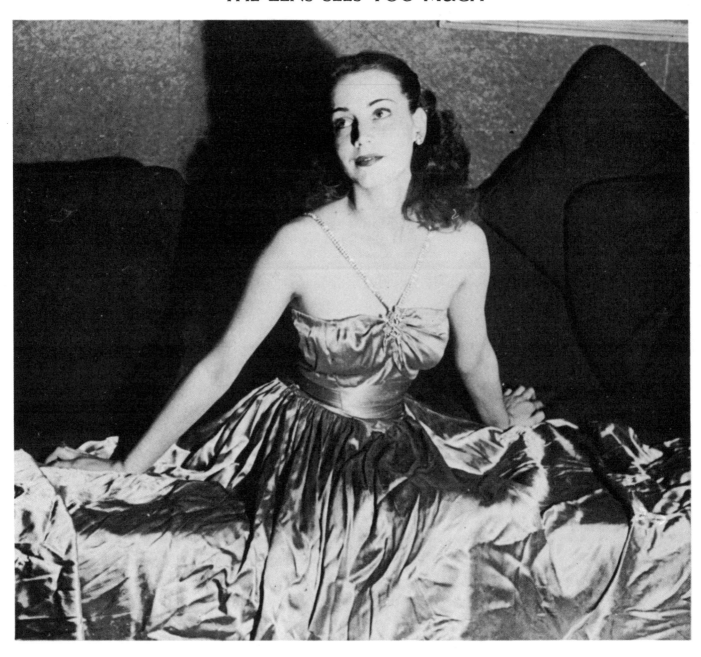

I present here a photo which I shall endeavor to paint from in as finished a manner as possible. I shall try to hold the values and the very smooth modeling of the form. Frankly, this will be of the so-called "slick" type of painting, which nevertheless holds a place in our craft. The painting will appeal to a great majority of clients who really like the slickness. But even here we can beat the mechanical and exact image presented by the lens. We can at least subordinate the overabundance of detail, especially in the dress, and some-what simplify and glorify the rest. This comes as near to "photographic" painting as I would ever want to go. I have included it to show that even the finished and exact need not be harsh and hard. The softnesses save it, I hope. Please notice that I have sought no edges that are not there, and have subordinated many that are in the copy. Study both closely, area for area. I do not suggest that you paint this way; it is but one way. You will paint your own way, as you prefer to paint.

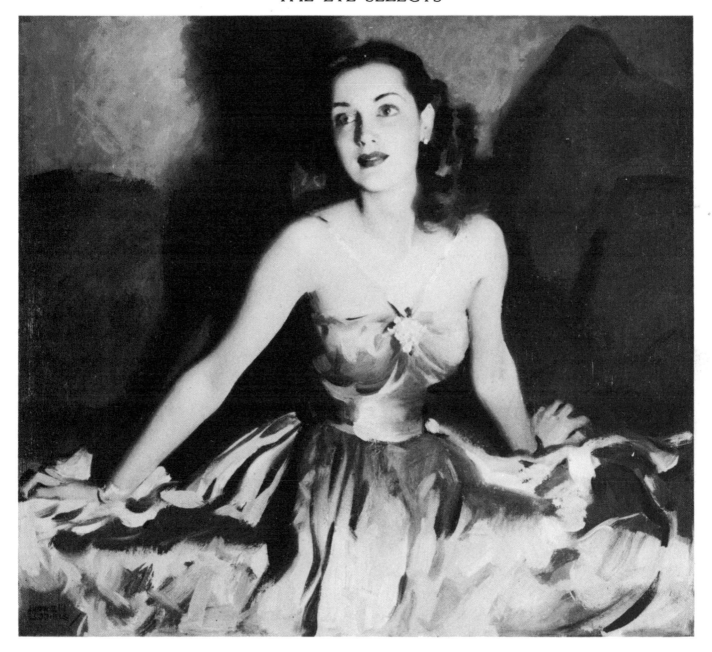

People will often unknowingly praise an artist by telling him, "That looks just like a photo, how wonderful!" These are sad words to the conscientious craftsman. Yet as an illustrator we must face the fact that a large percentage of people are detail-conscious, that detail pleases them. We can give them detail when we have to, even if it hurts a little. But at least we can choose what detail we are going to give, subordinating what we do not like. Every photo is full of unpleasant detail, and every photo has the possibilities of something charming. So we must study hard to decide what shall be and what shall not. If the values and planes go in well, if the softness and sharpness are taken care of, such irrelevant detail will not be missed. We can beat the camera, because the camera cannot choose nor subordinate, thank Heaven.

Note the number of soft edges, without producing a fuzzy or woolly effect. It will be interesting to note that you will find softness opposed to sharpness all through, not all one nor the other. This for the young artist who sees everything hard and brittle.

105

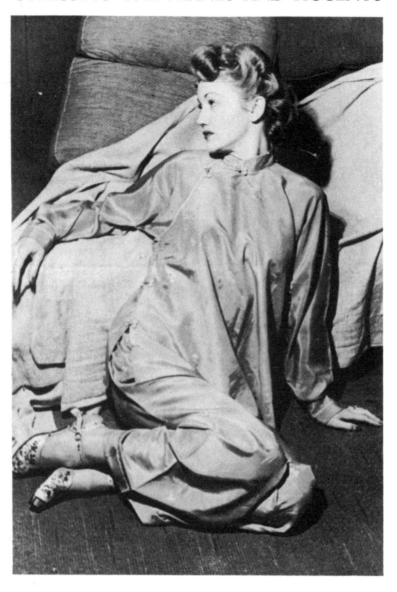

Here I give you my photographic copy. Incidentally, it takes courage to lay yourself open thus. But if I am going to teach it is only fair to let you see what I am working from. In this photo I deem the background meaningless, irrelevant, and superfluous. So why not eliminate the whole thing and give only enough to keep the figure from being pasted on a white page? At least there should be some feeling of the figure's being in space. The interesting thing to me here is the form, and secondly the character. There is so much intricate form in the garment itself, it is quite enough for the eye to take in.

Again we beat the camera because we can elim-inate competing interest, concentrating where we will. I have stressed the crispness of the planes and accents, losing only the edges that actually appear to be lost in the copy. We have attained, I believe, sharpness without harshness. The form is complete without being "petted" and "boned" out. In each area you will find a simple area of light against simple halftone and merging into almost flat and simple shadow. I have tried to use a minimum of strokes to get the biggest possible statement of the plane. There will always be a demand for this concentrated and clean-cut type of approach. It lends itself admirably to all types of illustration.

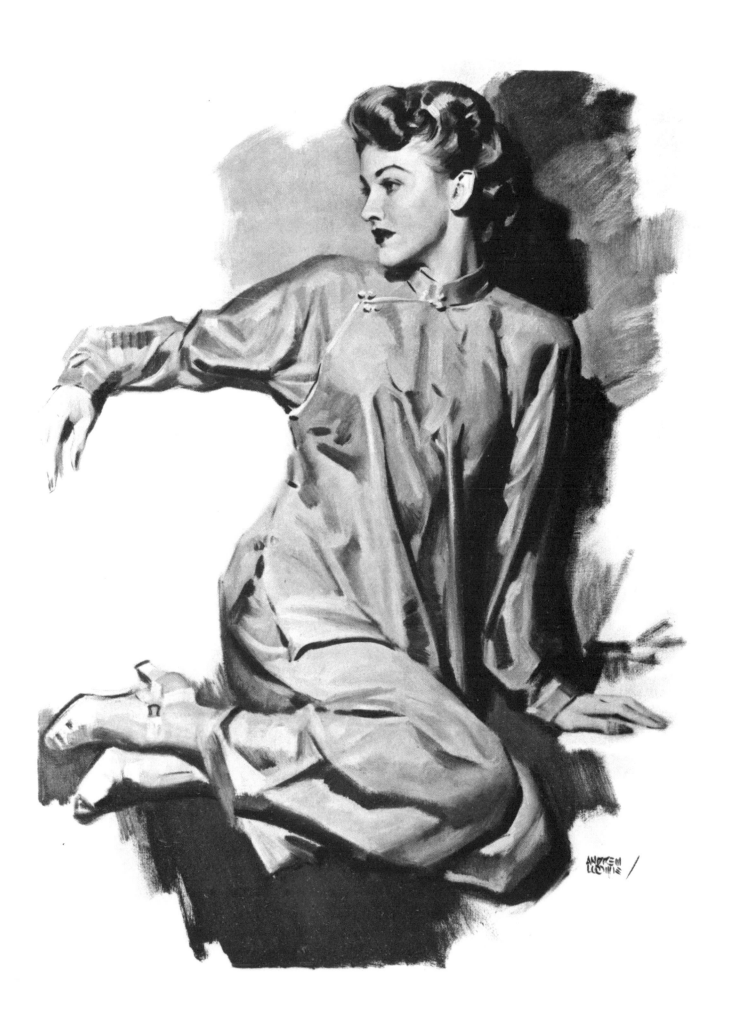

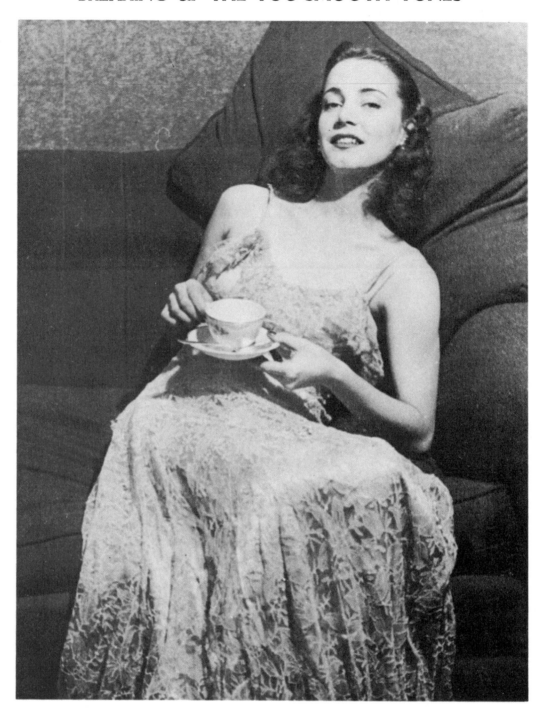

Here is another photo selected as copy. One of the main things that identify a photo as a photo is the ultra-smoothness of the tones. In working from this copy, I have broken up some of the tones, also some of the edges. The intricate detail of the dress has been subordinated. The couch has been made relatively of less importance than the figure, therefore with less definition. The big planes of the figure are stressed. I have tried to avoid as much as possible the flatness of the tones. While there are times when flatness is desirable, often areas painted too flat and smooth will appear "tinny" and monotonous. Some change of tone within a tone, to break it up slightly, seems to add vitality where there is none. If possible, an area should always look painted, not pasted; this is one of the ways to do it. Note the accents placed here and there of dark against light, to add punch. The lights have been forced somewhat to obtain extra brilliancy. The background has been lightened in spots to avoid the monotony of tone in the photo.

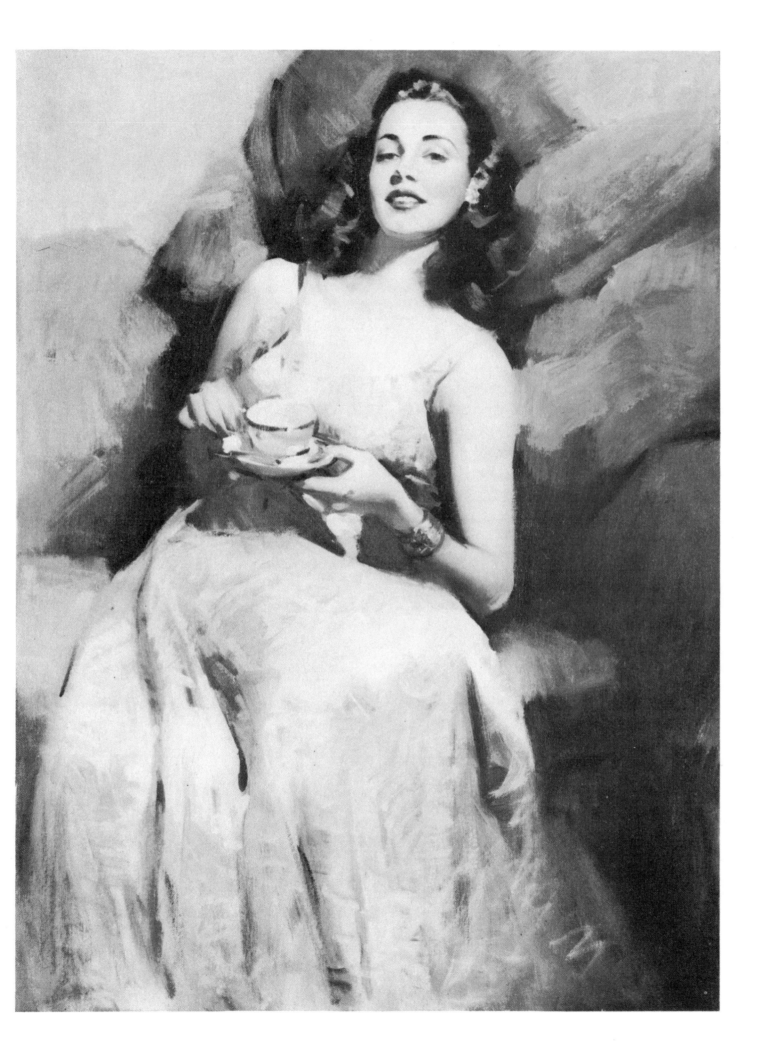

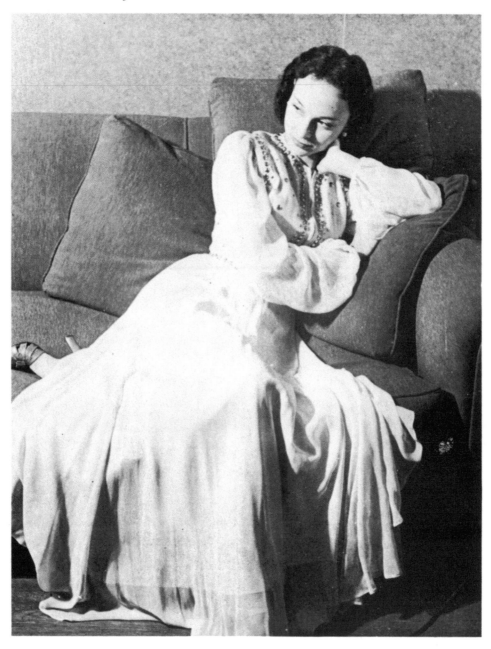

Here we have a photo, rather ordinary in design and lacking the contrast and brilliancy necessary for good reproduction. To follow it too closely would produce a dull picture. So a livelier pattern is introduced into the background, and the curves of the couch seem to give it more variety. The contrasts are stressed by adding a darker pillow against the white dress, and the intensity of light to shadow is somewhat increased. At the same time some of the edges are softened or modulated. The softnesses introduced do much to relieve the photographic look. The lighter tone of the couch keeps the dress from being quite so isolated as a separate unit and seems to interlace it with the other tonal areas. I believe the detail is sufficient to satisfy almost any client liking a "finished" look in the art he buys. It can look much more finished than it really is, so long as the values are in order and pleasing. In this case we could not have eliminated a background, for the dress would have no contrast to speak of with a white background. So we had to invent one to suit.

110

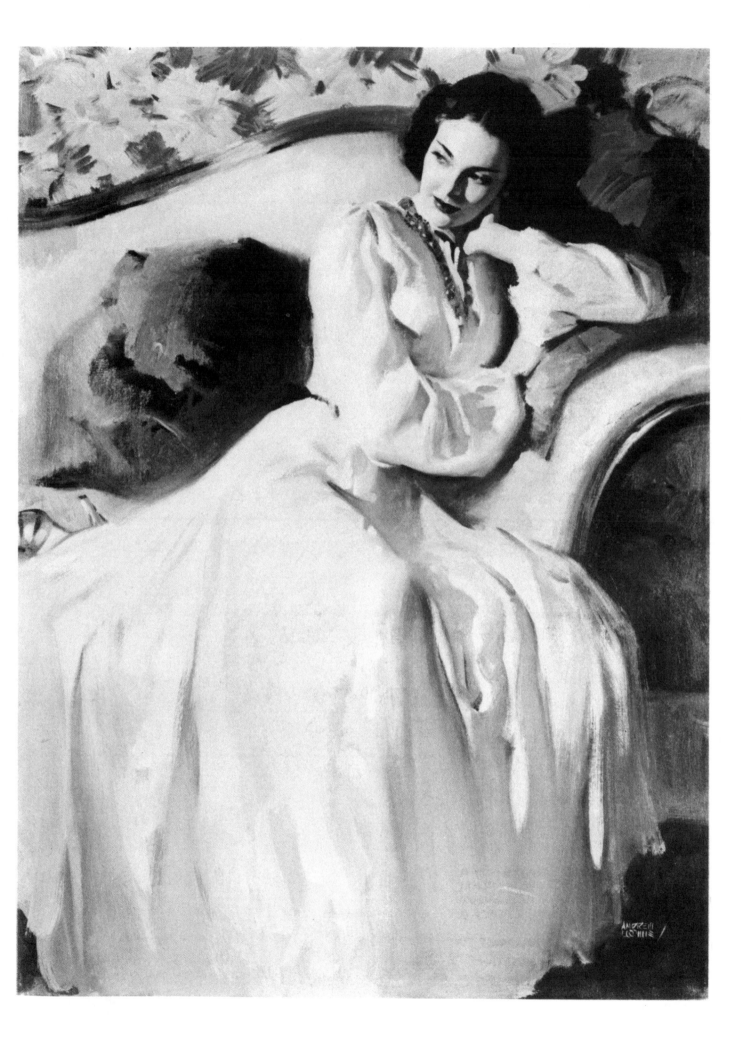

THE "BIG TONE" APPROACH

I chose to call this approach the "big tone" approach, for that is exactly what it is. It could just as well be named the "pattern approach." We shall aim to set down the big tonal patterns of our subject as simply as possible. Pattern, after all, is big-tone effect, one area opposed to another in value and all working together to produce some sort of a design. There is really design, either good or bad, whenever we put areas of variable tones together. It dawns on us as painters that the effect of the arrangement of such tones is really more important pictorially than the subject or the things we are painting.

Here is another reason for the not-too-literal interpretation of nature's complex forms and surfaces, but rather the seeking of design through the material nature presents to us. You can instantly see how this involves taste, selection, and inventiveness. Such an approach, then, is creative and not a passive acceptance of fact. You are adding the intelligence of vision so sadly lacking in your camera.

Sometimes the simple postery statement is better than the more finished thing, for it is conceived and executed in truth—truth in the larger sense rather than a minute inspection of truth. One big truth is more understandable than a lot of little ones (with, perhaps through ignorance or incomprehension, some of the more important ones left out). So close do some of the abstract artists come to it, yet just missing the elements that might make them so much greater, an alliance with creation itself. It does not seem possible that anything that works out as well as the great natural laws, which have stood for a few billion years and control the very universe, could be quite as wrong as these artists contend. Could it not be a lack of insight or perception? At least I urge you young artists, before you go too far into the abstract and incomprehensible, to think hard before you discard the wealth of material nature has lavished upon you. You cannot live without light—and neither can your art.

On the opposite page we have taken a simple figure subject. I believe my demonstration will be perfectly understandable to you. I attempt to show the power of simple light, halftone, and shadow, as allied to the Form Principle. You can be a good painter going no farther than this, by getting these tones and simple forms right in drawing, values, in relationship with one another according to the light, and in relationship with the surrounding elements.

It is really so simple that the general lack of understanding of it is amazing. Most of the difficulty, I think, arises from the fact that copy is so seldom made, or models posed, in simple light and shadow. Naturally if you break up these original simple tones, which are the best you could possibly have, with a half-dozen other lights, you have no form left, nor any opportunity to state it. You find yourself trying to duplicate a myriad of meaningless tones to no good purpose. You can break up form as easily with lights as you can break up a town meeting with cross-purposes. Nobody gets anywhere and the result is nil.

Ahead of anything else, choose simple lighting to start with, if you are ever to paint. You can light your subject from back or front, and reflect it back if you wish, but use *one basic light* whenever possible for the best interpretation of form.

Nature takes care of that, outdoors. We mess things up when we take over inside.

112

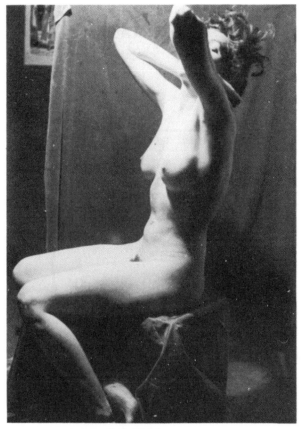

COPY

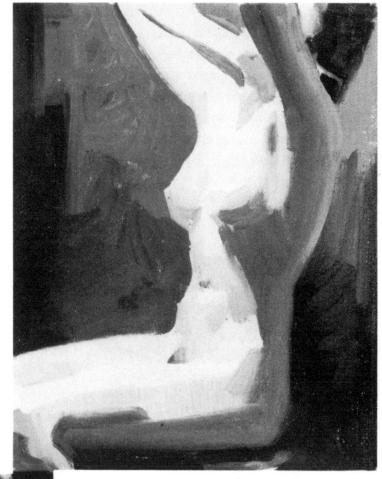

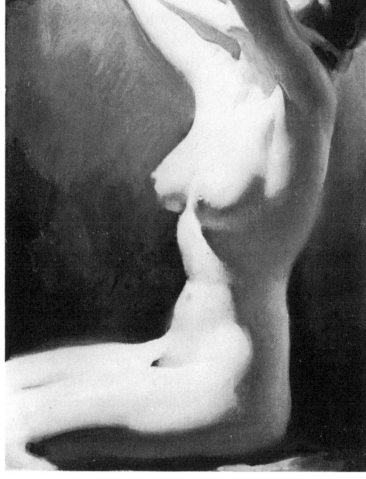

1. ANALYZE YOUR SUBJECT FOR BIG FLAT TONES OF LIGHT, HALFTONE AND SHADOW.

2. USE TONES APPROXIMATING A MIDDLE VALUE OF EACH AREA, OR ALLOWING FOR A SLIGHT RAISING OR LOWERING OF THE VALUE, BUT HOLDING THE BIG MASS RELATIONSHIP OF LIGHT AND SHADOW AGAINST ITS SURROUNDING ENVIRONMENT. (SEE FORM PRINCIPLE)

3 NOW PULL THE FLAT POSTERY TONES TOGETHER, STUDYING THE EDGES OF THE SHADOW CAREFULLY. THE OBJECT IS TO KEEP AS MUCH OF THE SIMPLE STATE-MENT AS POSSIBLE.

4. ADD ACCENTS OF LIGHT (HIGHLIGHTS) AND DARK (ACCENTUATION). STUDY THE EDGES FOR "LOST AND FOUND" QUALITIES. THIS ONE OF THE BEST WAYS TO PAINT.

113

THE DIRECT APPROACH

This procedure varies from the "big tone" approach only in manner. The difference lies in not covering the canvas to start with, but taking the light, halftone, shadow, with whatever goes around it, and painting as you go along. Its ultimate difference is that it may emerge with a somewhat more spontaneous and freer effect, a certain looseness not always possible by the other method. But value for value, form for form, edge and accent, it is basically the same.

The accompanying example was started at the top and finished at the bottom. The figure was sketched in roughly with a brush. The lights were laid in first, then the halftones, then the shadows, then the reflected lights in the shadows. Accents of light and dark were put in last. This whole procedure was carried right through the head, then the chair, waist, arms, skirt, and legs.

In making fast sketches and studies the procedure is ideal. But by this procedure the whole tonal qualities of the picture may not be as good. I use it when not painting to the four corners, or when making a partial statement or vignetted subject.

It is somewhat more difficult than the big tone approach because it is more difficult to get everything right and consistent, the first time down. The study here is in black-and-white oil, but the direct approach applies to all mediums, especially water color and transparent wash, where directness is charm.

This type of approach is not as suited to overpainting when the first paint is dry or tacky. If you can, finish as you go, and leave clean surface to continue upon. This is about the fastest procedure there is, provided you get it right. You can get it right by having made a preliminary rough or sketch and knowing just what you want. The time used in making the sketch is usually made up in not having to guess and experiment with the final work. Some painters do not draw in the subject at all in line, but draw as well as paint as they go along. This is fine in sketching or preliminaries, but if you start the final that way, you may start out too large and not get the whole thing into the allotted space. Nearly every illustration must fit a certain space or proportion. Often space must be left for text, lettering, titles, panels, and name plates. All must fit within a marginal size. If your subject will not fit, it will have to be either cropped or done over. When you are thinking of balance and design, and work out your final on that basis, it is rather heartbreaking to see it cropped, with the design gone haywire.

In direct painting you are really dealing with patches of tone first, laying them one against another. The edges are more "arrived at" than set down and filled in. Bits of accent, and outline, can be added later. Naturally this all creates a freer and looser effect than flatly filled-in areas. But even so, tightness and looseness is hardly a matter of approach so much as vision, as has been stated. If you see it "tight" you will probably paint it that way, or the opposite.

Do not be discouraged if your early work is tight and a bit "boned out" or "hard." You are really storing up knowledge for a looser style later. Looseness rarely "just happens." It is often the product of many years. When one knows what he is doing, the more he does it the easier it gets. You may be able to paint the same form in four strokes some day that now takes fifty. It is largely a matter of self-education.

Looseness in painting is not always speed. Some of the freest and loosest painters take the longest. Some do it over several times, in addition, to get that effect. It is not always the first painting. Maybe the first try was tighter than yours that you may be worrying over.

I believe the real reason an artist prefers looseness of style as he progresses is that the subject becomes individual, unlike any other. An impression expresses imagination, and also leaves something to the imagination of the beholder. It therefore interests more than the complete factual statement.

If you want to try copying this for experience, go ahead. I would prefer, however, that you get someone to pose, or that you similarly translate into sketchy terms some photographic copy.

114

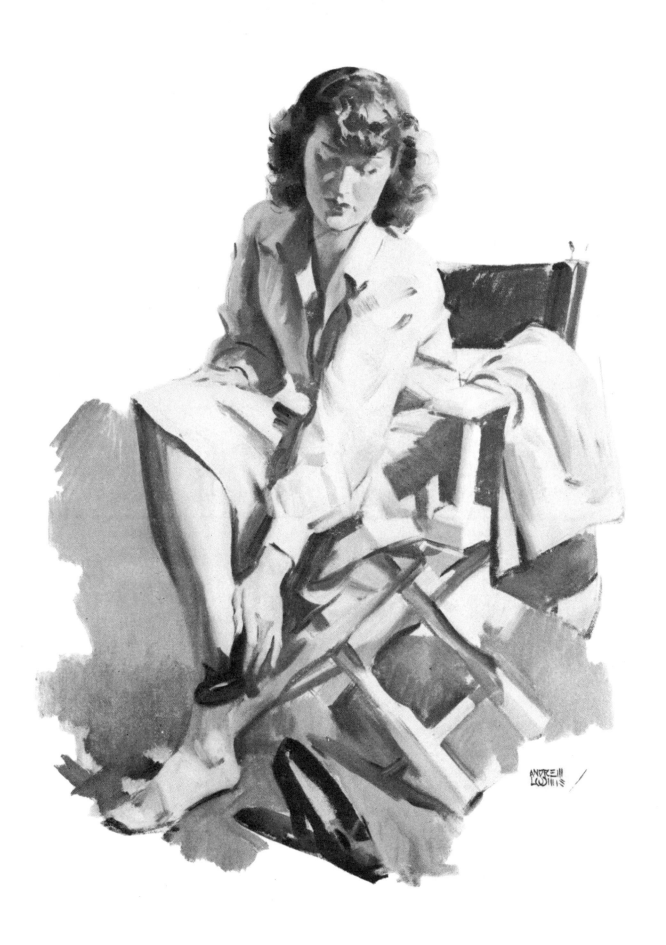

This is a delightful way to paint. It is closely allied with the "big tone" approach. However, instead of painting the large tones in to a sharp edge and softening them later, the large tones are set in and immediately softened. The surface detail is added then to the soft tones in overpainting while the paint is wet. The edges are defined where needed, leaving the general softness as desired. This is one of the best ways to combat hardness or tightness in painting. Tightness comes from small forms, too much precision, and everything filled in to a sharply defined edge everywhere.

I believe this approach will come as a revelation to many young painters who have not tried it or do not know about it. It results in a feeling of much more quality, and at the same time adds a three-dimensional effect to one's work if it has been persistently sticking to the front, or picture, plane. It eliminates much of the "pasted on" effect of the units of your picture. Try to hold as much of the softness as possible. A few dexterous strokes may add all the finish you want. I feel quite certain this must have been the approach of both Sargent and Anders Zorn, whose paintings reflect the kind of quality this approach gives. It applies to solidly painted pictures better than others, but can be effectively used in sketches, vignettes, and almost any type of illustration.

It will be well worth your while to make some experiments along this line. I never believed in confining one's approach to a single method. I love to experiment with everything I can think of, or that may be suggested to me wherever I see it. I like to use a method or medium as much in tune with the subject as I can. Some things seem to call for "brittle" treatment, while others call for "delicate and soft." While you are learning, learn to express yourself widely. There is not so much danger then in "burning out" your approach or making it grow tiresome to your public.

You will note that in the first stage of this head a fairly careful charcoal drawing was made. Then the large tones were laid in over the fixed charcoal. Even in the first statement there is a feeling of the light and form. This is heightened in the next stage by only a few strokes laid over. With the detail of the features and some more light and dark accents, it becomes completed. In order to show you the stages I had to make four separate subjects. With you it would be but one. But by making the four, the last one was painted in a very short time, since I had had the experience of the others. This approach is quite direct, and if possible should be completed while the paint is wet. By adding some poppy oil to your turpentine when painting in oil, you can slow down the drying.

This approach would apply better to opaque water color than to transparent. It is quite a trick to keep it wet long enough to get the softness, but it can be done. Crayon and charcoal are admirable for this approach, or any medium that can be rubbed, then picked out with an eraser.

So many students hope to watch a professional to learn technique. Technique is your own. Method or approach is always a matter of knowledge. There is no reason for any artist who has the good of his craft at heart to keep such things a mystery. Technique cannot be learned by watching, only by doing. If an artist can tell you how it is done, it is so much better than watching him, or even than copying his efforts.

Try out the soft approach if you like it. If you do not like the effects in it, then pass it up. However, it is a very, very good way to beat old man camera, or projector. We can't trace fuzzy images. Maybe you can fuzzy up the hard ones and then bring them back. I don't know. I do it with eyes, hands, and (I hope) thinking.

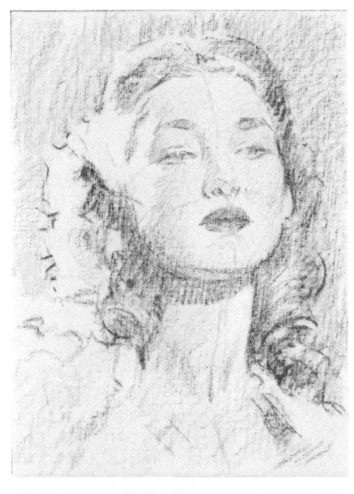

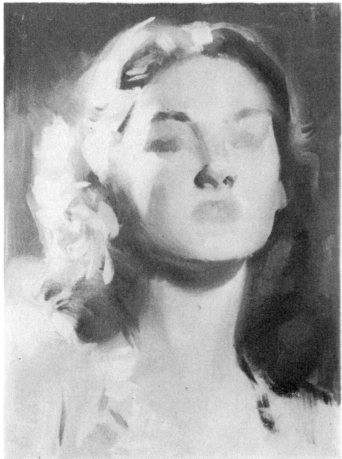
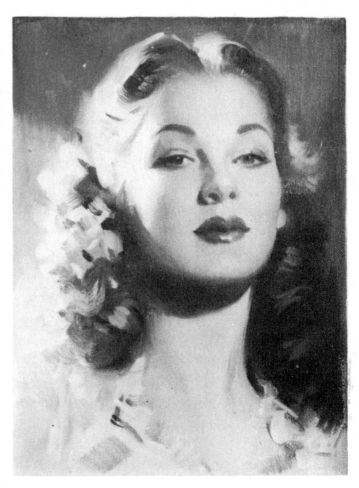

THE BRITTLE APPROACH

When things are in a sharp strong light, or when the subject itself seems to call for a certain crisp or brittle quality, I want you to be able to think in these terms. Usually this sharpness would be in subjects of good contrast, using plenty of good lights and darks.

Here we have a brunette in a black-and-white striped dress. The dress is "perky" and the stripes give it "snap." I just can't see this subject painted in mystery and softness. So we put the black hair against practically a white, carry the crispness into the background and all through the dress. Because the dress is busy in pattern it seems to ask for simplicity elsewhere. So we do not fill up the picture with too much other pattern.

Almost all edges are defined here, though if the dress were a single tone the edge would be too hard. But the stripes break up the area, pulling the eye within the contours rather than making one conscious of them. This was overpainted quite a lot on dry paint, a method which is the opposite of the preceding soft approach, and which adds the very quality of brittleness which we tried to avoid in the other instance.

Most young artists paint rather to the hard than to the soft anyway, so this will not need much explanation. About all you can do with this approach is to paint up to your edges, and stop—which most of you do. But it is not without value and charm when incorporated into the right sort of subject.

Light and shadow really looks brittle out in the bright sunlight, and there is no reason for not painting it so. There are many subjects where crispness is the aim. So experiment. The most crisp effects can be obtained by painting light over a dark but dry undertone. Sometimes an old canvas is perfect for this type of approach. Or you can stain a new canvas with a tone and thin turpentine and let it dry. Opaque water color is excellent for a brittle or crisp effect. One well-known artist works his opaque right over regular beaver board, painting in all the white later with opaque.

Pastel has some of the crisp brittle quality when used over toned papers or boards and not rubbed. It can be done very beautifully and with charming effect. The more rubbing you do with pastel, the more softness, so it is open to either approach. However, pastel being a grainy or chalky medium to start with, most of its charm lies in leaving the pastel pretty much as it goes down without rubbing. It can get so smoothed out that it loses its character entirely and ends up as a more or less unidentifiable medium after reproduction. Any medium should retain some of its own character. It should not look like something else.

Remember, crispness seems to apply mostly to bright light. Remember, too, that crispness and softness combine beautifully together, are better combined than either by itself. So do not decide to go all to the hard, ever, because that is right back where you started. We all start out "the hard way."

Note that this painting is not entirely without softness. It needs the few soft edges to establish crispness by contrast.

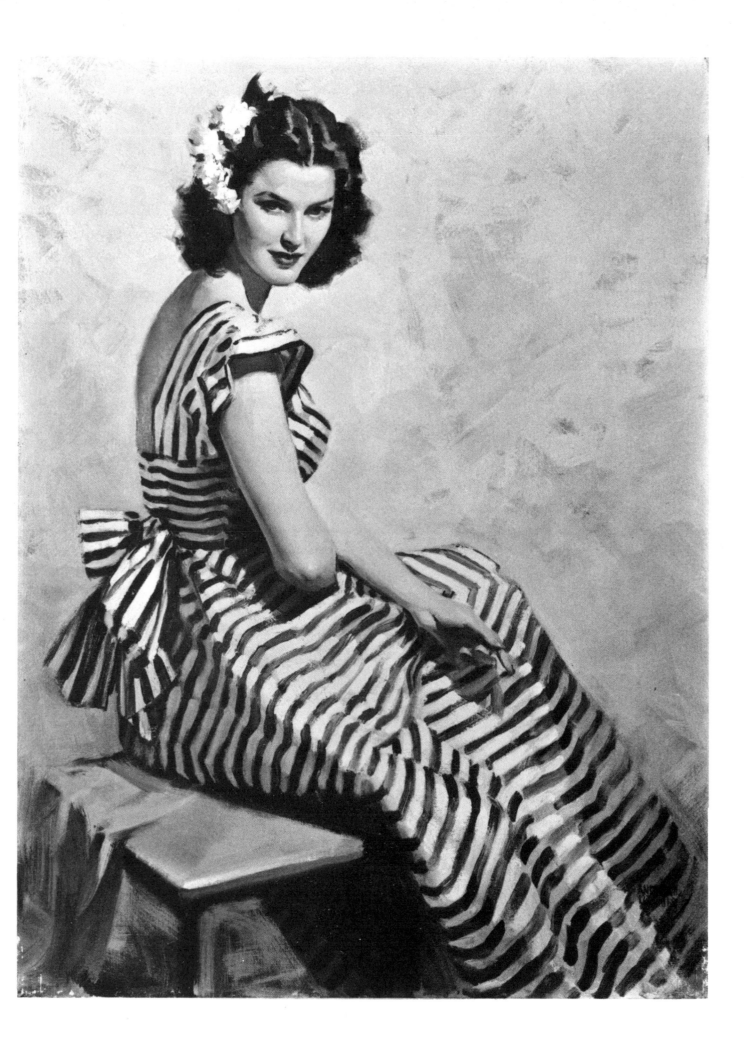

THE "BLOCKY" TREATMENT AND OTHERS

While I believe the method of applying pigment should be left to the individual, there is no harm in calling attention to various treatments which come under the head of general procedure, with a variety of effect. At times the subject itself seems to call for a certain type of handling to be in spirit with the thing. Every artist seems to become afflicted at some period with a tendency to paint things too round and slick to give the vitality to his work that he desires, but is quite unaware of what he can do about it. One of the best ways to give added form and structure to already smooth forms is the "blocky" treatment.

This is achieved mainly by transposing monotonous curving contours and forms to a series of straight lines and by painting straighter and flatter planes. Strangely enough, the form retains its delicacy, but seems possessed of a stronger feeling of bulk and solidity when treated this way. The plane is carried as far as possible in one value and then given over to the next. Care must be exercised not to smooth the planes too much one into the next as you go round. The beginning of the shadow can be held fairly distinctly as a tone with an edge just beyond the halftone. The contours may be accented with bits of straight outline. The values themselves are held to the true values without undue "forcing." If you will study the accompanying plate I believe this text will become clear.

The blocky treatment applies especially well when painting heads, particularly when there is not much bone structure, resulting in extreme smoothness. Baby heads respond beautifully to this approach. It is about the only way of giving extra vitality to a rather slick subject. It applies to drapery, rocks, clouds, or almost any form, and helps to eliminate the photographic look of painting. It is well worth experiment.

There are other treatments. One is the use of small strokes following crosswise to the form, which enhances the structural appearance and solidity. Such treatment adds softness to painting, whereas painting down the form defines it more sharply with a hard edge, since the brush follows the edge of the contour. It could be taken as an axiom that if you want it sharp and defined, paint down along the edge. If you want softness, paint across the form to the edge, or actually beyond the edge.

The big- or wide-stroke painters usually paint up and down the form, as witness Sargent, Zorn, and Sorolla. Without loss of vitality we have examples of the "cross-form painters in small strokes" in Ettore Tito, Childe Hassam, Daniel Garber, Edmund Tarbell, Zuloaga, and many others. This form of painting has the added advantage of using much more color within the same area, and often "broken color," which started with the French Impressionists.

We also have what is known as "scumbling," which is done mostly with the side of the brush instead of the end, with very soft and beautiful results. Very little of the effect of the straight bristles of the brush is left in the paint. Finally, there is palette-knife painting, perhaps the loosest of all, which can be combined with the brush or treated as an entire approach.

I have given a few examples of these treatments here and elsewhere in the book, and I think they will identify themselves to you. I believe all of these are worthy of experimentation, and assure you that there are many good painters of each type. Such techniques can be applied to all tonal mediums. It is interesting to set up a subject and paint it in various ways, or even a photo, and interpret it in many ways. Then the photo works for you, not you for the photo.

120

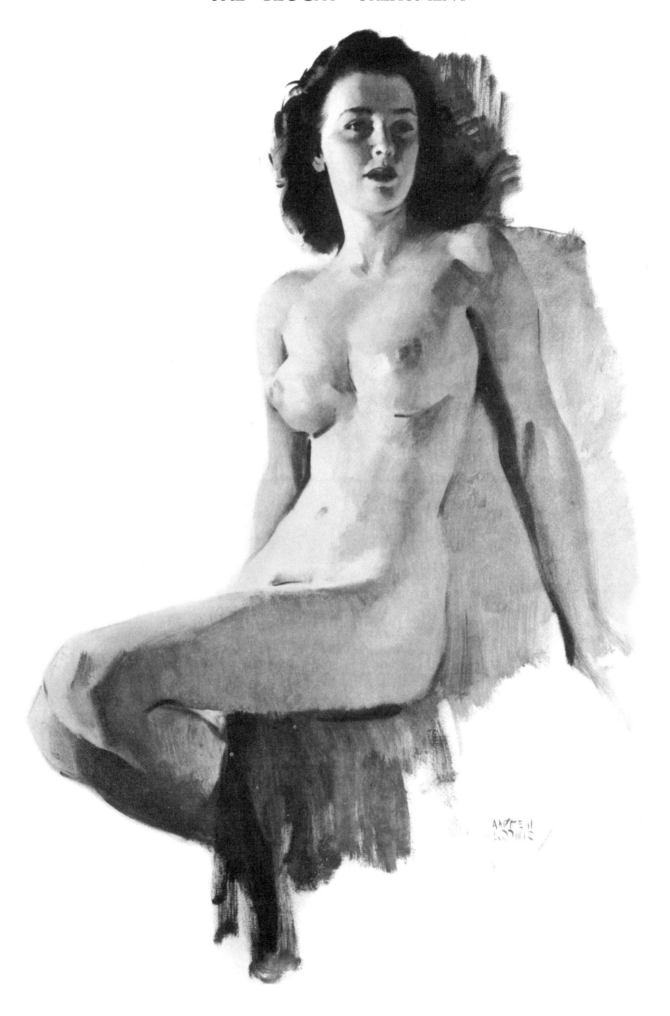

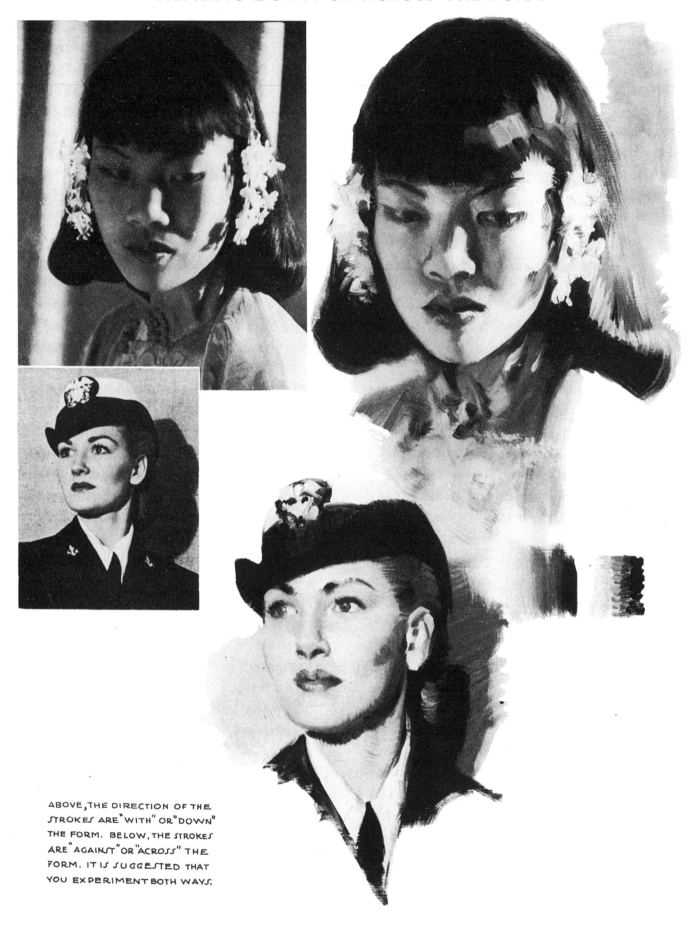

ABOVE, THE DIRECTION OF THE
STROKES ARE "WITH" OR "DOWN"
THE FORM. BELOW, THE STROKES
ARE "AGAINST" OR "ACROSS" THE
FORM. IT IS SUGGESTED THAT
YOU EXPERIMENT BOTH WAYS.

"SCUMBLING"

THE TONAL MEDIUMS

ANY MEDIUM which will produce a scale of values between black and white may be regarded as a tonal medium. Such mediums call for a screen or halftone process to reproduce. When drawing for reproduction on cheap paper or newsprint, good contrast is necessary. For the finer papers more subtle gradation can be achieved by a finer screen. So if you use a grey stock, or any greys within the picture, it will be more expensive to reproduce than the so-called line cuts. The exceptions are the Ben Day or Craftint screen, or a grained surface like the Coquille board, which really produces a series of fine black dots which will reproduce by the line cut process.

There is such a thing as a highlight halftone which omits an overall screen so that the whites come up pure white. But this belongs to the halftone type.

I shall make a series of subjects to identify the medium only. I suggest you try them out. It will not be accomplished in a day. Every medium, though conforming to the basic approach of the Form Principle, will have its peculiar characteristics. What you should really attempt to do in mastering a medium is to be able first to state your planes and values correctly. Then learn to make a sharp or soft edge. Learn to achieve a soft gradation of tone when wanted, or a crisp and blocky or sculptural effect. Learn to place accents of light and dark. That is all there is in any medium, but it is not as easy as it sounds. I think wash and water color are just about the most difficult mediums of all, but two of the most beautiful when handled well. It is odd that most artists start in water color as first choice. It seems to me that crayon, charcoal, carbon pencil, dry brush, and similar mediums, all offer much simpler opportunity to express yourself in tone. Then the step to other types will be much easier. But do what you like in the way of mediums: they are all yours to experiment with, and to help you find yourself.

I do not believe in isolating one medium and working in that alone for the rest of your career. Proficiency in one helps in another. I believe the pencil has helped me to paint, more than anything else. Certainly it is easier to do a good pen drawing when you can state simple light and shadow well in other mediums. Tonal mediums of the drawing type all help mediums considered as painting. But make up your mind that the whole thing is all one, and that with experiment and practice you can say what you are able to say in any medium. That is the way it should be. It will broaden your whole scope of pictorial effort, and not only keep you going longer, but afford you unconfined pleasure in your work.

Such versatility is not nearly as amazing as it might appear, when the fundamental things are applied. It is really quite thrilling to transpose a subject from one medium to another. Very often the preliminary work may be done in one medium, when the artist is working with good fundamentals, then transposed to another, without any conscious effort.

There is no harm in studying the work of other men in various mediums, even copying it (for practice only, of course) if you feel that you can learn something thereby. But anything you do from life is your own, and I really believe it is by far the best plan. You are then developing your own approach from the start, and it may turn out to be something most distinctive and original.

Get some tonal mediums and start doing something on your own with them, the very best you can. Technique has a way of taking care of itself. Your case will be no exception.

CHARCOAL AS A TONAL MEDIUM

DRAWN WITH RUSSIAN CHARCOAL ON STRATHMORE BRISTOL. LAY A LIGHT TONE OVER THE WHOLE AREA, RUBBED WITH RAG. LAY IN MASSES OF GREYS AND DARKS. PICK OUT LIGHTS WITH KNEADED ERASER. CHARCOAL IS BOTH A LINEAR AND TONAL MEDIUM. IT IS MOST EFFECTIVE WHEN SOME LINEAR QUALITIES ARE COMBINED WITH TONE. IF THE DRAWING IS TOO RUBBED IT TAKES ON A PHOTOGRAPHIC LOOK WHICH SHOULD BE AVOIDED. MAKE IT A "TONAL DRAWING".

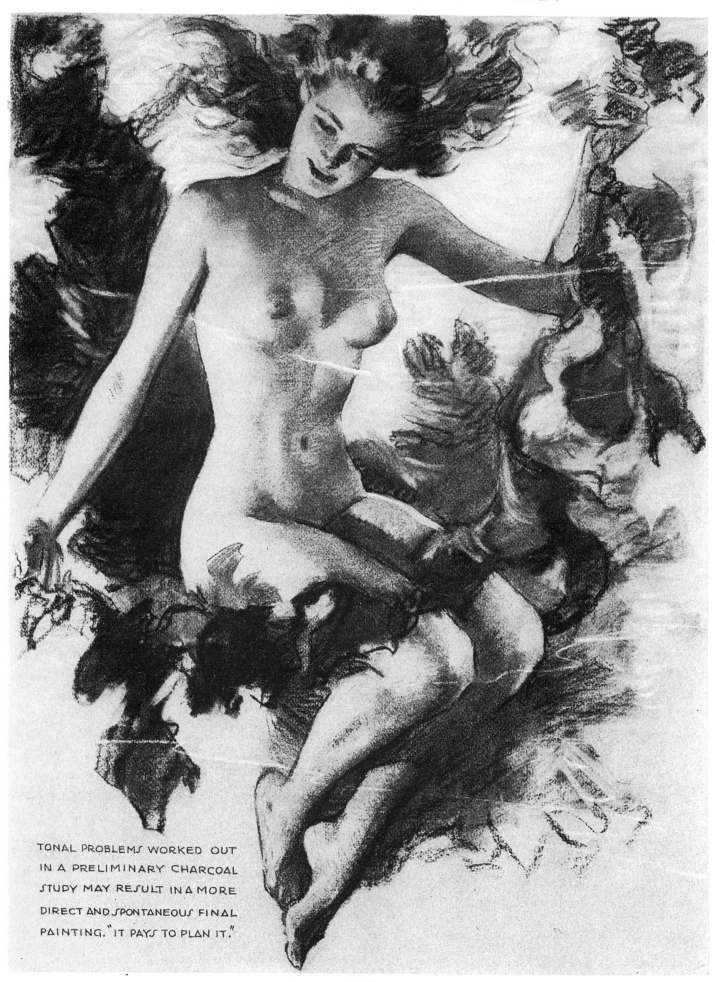

TONAL PROBLEMS WORKED OUT
IN A PRELIMINARY CHARCOAL
STUDY MAY RESULT IN A MORE
DIRECT AND SPONTANEOUS FINAL
PAINTING. "IT PAYS TO PLAN IT."

THIS COMBINATION IS FAST AND EFFECTIVE FOR PLANNING ROUGHS, SKETCHES AND COMPOSITIONS.
BELOW — PENCIL CHARACTERIZATIONS FOR ABOVE SKETCH.

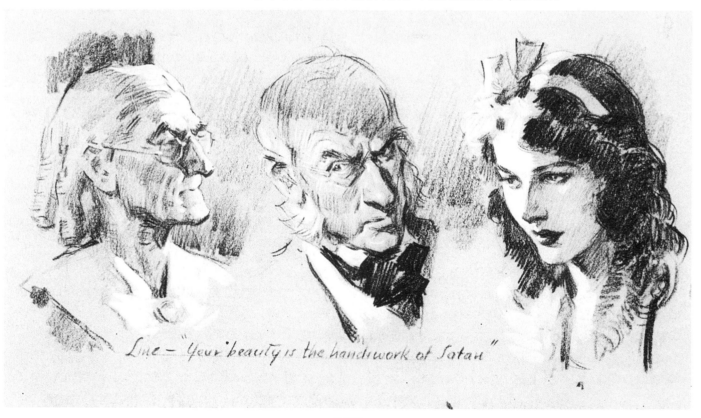

Line — "Your beauty is the handiwork of Satan"

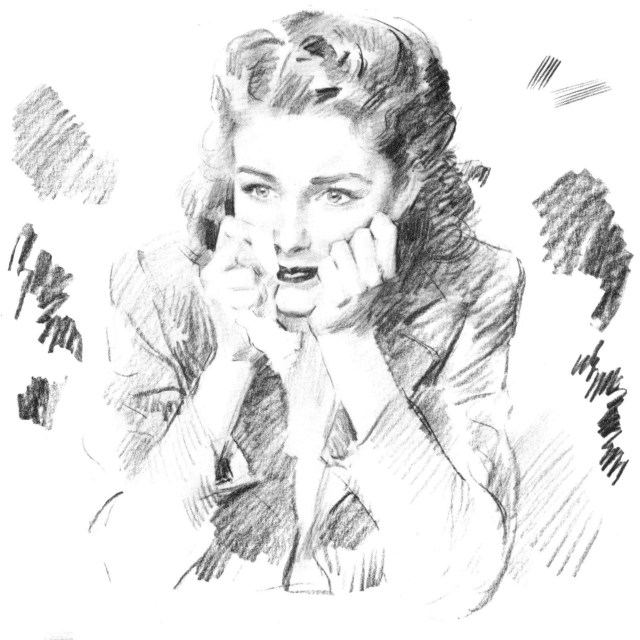

CARBON PENCIL IS A FAST AND DELIGHTFUL MEDIUM FOR THE ILLUSTRATOR. WHEN IT IS RUBBED IT GIVES THE EFFECT OF WASHES. IT CAN BE USED ON SMOOTH OR GRAINY PAPERS WITH A VARIETY OF EFFECTS. THIS DRAWING WAS MADE ON SMOOTH STRATHMORE BRISTOL WITH A DIXON "CHARON" 790 PENCIL. THERE ARE ALSO THE FAMOUS "WOLFF" CARBON PENCILS. CARBON PENCIL GIVES A WIDE RANGE OF VALUES WITH GOOD BLACKS AND NO SHINE, MAKING IT EXCELLENT FOR REPRO— DUCTION. BY ALL MEANS EXPERIMENT WITH THIS MEDIUM. YOU WILL FIND YOUR OWN WAY OF EXPRESSION. BUT KEEP IT FREE AND DIRECT. IT IS NOT AS DIFFICULT TO HANDLE AS WASH.

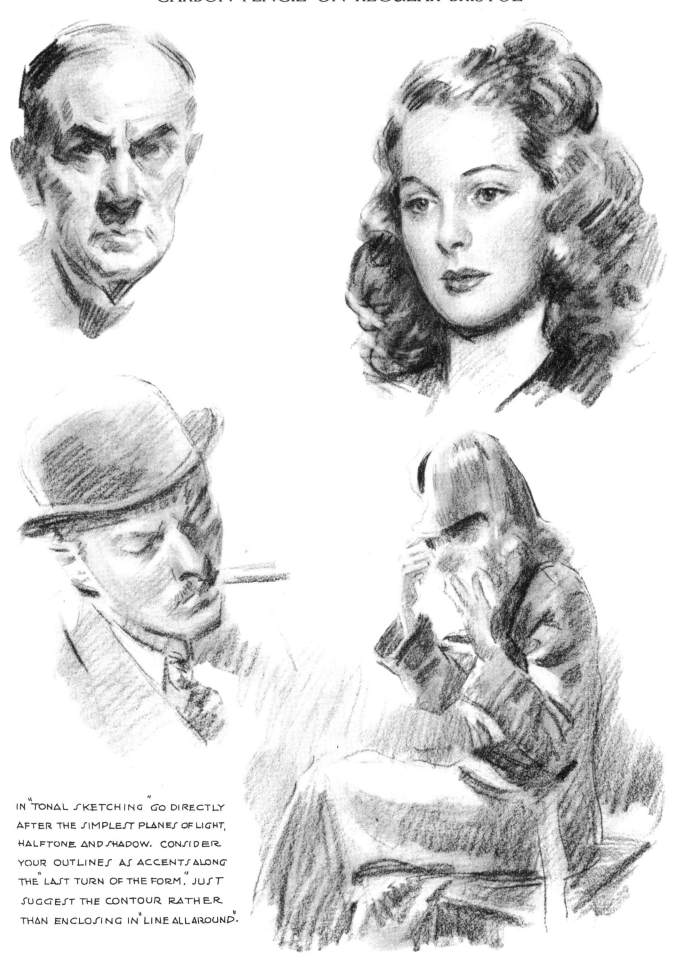

IN "TONAL SKETCHING" GO DIRECTLY
AFTER THE SIMPLEST PLANES OF LIGHT,
HALFTONE AND SHADOW. CONSIDER
YOUR OUTLINES AS ACCENTS ALONG
THE "LAST TURN OF THE FORM." JUST
SUGGEST THE CONTOUR RATHER
THAN ENCLOSING IN "LINE ALL AROUND".

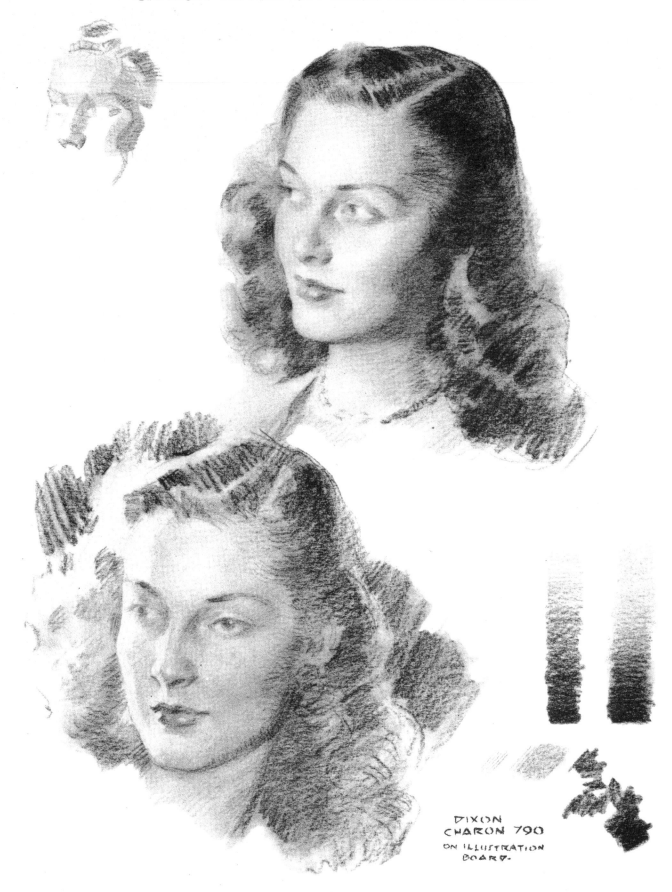

DIXON
CHARON 790
ON ILLUSTRATION
BOARD.

GO AFTER THE FORM, HOLDING BACK ON THE SHARP DETAIL. YOU WILL FIND IT IS BETTER WITHOUT IT.

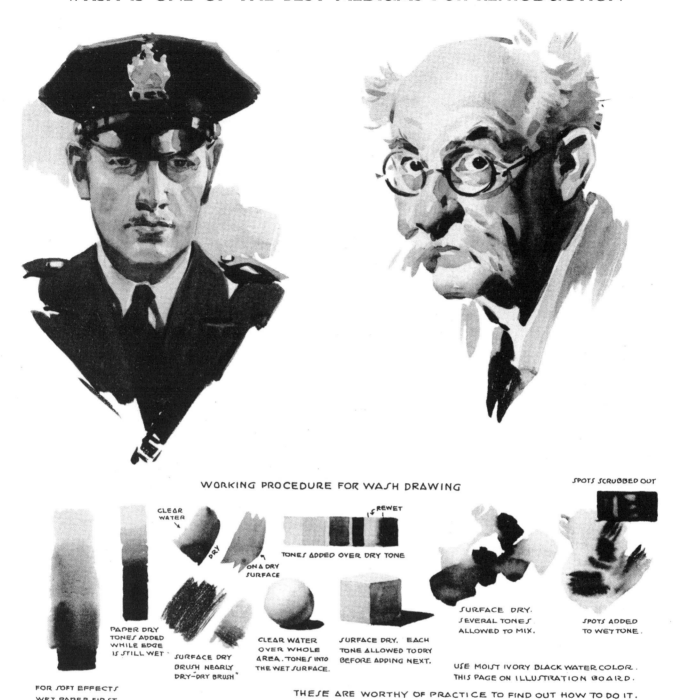

WORKING PROCEDURE FOR WASH DRAWING

SPOTS SCRUBBED OUT

CLEAR WATER

REWET

TONES ADDED OVER DRY TONE

DRY

ON A DRY SURFACE

PAPER DRY TONES ADDED WHILE EDGE IS STILL WET

SURFACE DRY BRUSH NEARLY DRY—"DRY BRUSH"

CLEAR WATER OVER WHOLE AREA. TONES INTO THE WET SURFACE.

SURFACE DRY. EACH TONE ALLOWED TO DRY BEFORE ADDING NEXT.

SURFACE DRY. SEVERAL TONES ALLOWED TO MIX.

SPOTS ADDED TO WET TONE.

FOR SOFT EFFECTS WET PAPER FIRST

USE MOIST IVORY BLACK WATER COLOR. THIS PAGE ON ILLUSTRATION BOARD.

THESE ARE WORTHY OF PRACTICE TO FIND OUT HOW TO DO IT.

WASH DRAWING.

WASH DRAWING IS THE MOST SPONTANEOUS AND DIRECT MEDIUM OF ALL. IT IS THEREFORE THE MOST DIFFICULT—UNTIL YOU DEVELOP A WORKING PLAN FOR THE MEDIUM. IT IS BASED ON THE SAME "FORM PRINCIPLE" OF ALL OTHER MEDIUMS — THE TONE, THE PLANE AND THE EDGE. THE ABOVE WILL SHOW HOW TO PRODUCE EACH OF THE VARIOUS EFFECTS. IF YOU WILL STUDY THESE DRAWINGS YOU WILL FIND THE EFFECTS APPLIED.

STUDY YOUR SUBJECT CAREFULLY. WHERE THE MODELING OR EDGE IS SOFT WORK INTO A WET SURFACE. WHEN SHARP (AS THE CUBE ABOVE) WORK ON A DRY SURFACE. "A STROKE INTO WET IS SOFT, A STROKE INTO DRY IS CRISP." SOME CHANGING CAN BE DONE BY SPONGING OUT OR BY SCRUBBING WITH BRUSH AND CLEAN WATER AND BLOTTING. "A WASH FOR A PLANE" IS GOOD PROCEDURE. DON'T STIPPLE. WASH SHOULD BE AS FREE, BROAD AND DIRECT AS POSSIBLE.

HOWARD PYLE

Fortunately I am able to give you, in his own words, the general theory of approach used by Howard Pyle, as it was given out to his students. It has been copied and handed down from artists of one generation to another. I must frankly admit that it has passed through many hands, so there is nothing to verify its absolute authenticity, but in substance it is as Pyle himself wrote it down. My copy was given to me some twenty years ago—I cannot now recall by whom. Since Pyle has been revered as the "Father of American Illustration," and since he gave this out freely, I believe it is proper that it should be recorded permanently for the sake of the craft. There may be very few, if any, other existing copies by now. There are but few of his students living. Unless they likewise set down his message, it could be lost forever. I feel fortunate in being able thus to pass on his words, and I assure you that you are equally fortunate in having them.

AS TO ELEMENTARY INSTRUCTION
AS TO COLOR AND FORM

Light—All objects of nature are made visible to the sight by the light of the sun shining upon them. The result is that by means of this we see the colors and textures of the various objects of nature.

From this it may be seen that color and texture are the property of light and that they do not enter the property of shadow. For shadow is darkness and in darkness there is neither form nor color.

Hence form and color belong distinctly to light.

Shadow—As the object illuminated by the sun is more or less opaque, so when the light of the sun is obscured by that object, the shadow which results is more or less black and opaque, being illuminated only by the light reflected into it by surrounding objects.

By virtue of shadow all objects of nature assume form or shape, for if there were no shadow all would be a flat glare of light, color and texture. . . . But when the shadow appears, the object takes form and shape.

If the edges of an object are rounded, then the edges of the shadow become softened; if the edges of an object are sharp, then the shadow is correspondingly acute. So, by means of the softness or acuteness of the shadow, the roundness or sharpness of the solid object is made manifest.

Hence, it would follow that the province of shadow is to produce form and shape, and that in itself it possesses no power of conveying an impression of color or texture.

I have tried to state these two facts because they are the foundation of all picture making: for in the corresponding mimic separation of light and dark, the mimic image of Nature is made manifest. So the function of all art instruction should be to teach the pupil to analyze and to separate the lights from the darks, not technically but mentally. That which a pupil most needs in the beginning is not a system of arbitrary rules and methods for imitating the shape of an object; that which he needs to be taught is the habit of analyzing lights and shadows and of representing them accordingly.

HALFTONES

1. Halftones that carry an impression of texture and color should be relegated to the province of light, and should be made brighter than they appear to be.

2. Halftones that carry an impression of form should be relegated to the province of shadow, and should be much darker than they appear to be.

This is the secret of simplicity in art. The equation might be represented thus:

LIGHT	SHADOW
(i.e. texture, quality, color)	(i.e. form and solidity)
Highlight—Tint—	Halftone—Reflection—
1 2	3 2
Halftone	Shadow
3	1

This is, as I said, the foundation of technical art. And, until the pupil is entirely able to separate those two qualities of light and shadow from one another in his perception, he should not be advanced beyond the region of elementary instruction—no matter how clever and "fetching" his work may appear to be. And, during this progress of instruction the pupil should be constantly encouraged with the assurance that what he is doing is not mere drudgery but is the necessary process by means of which—and only by means of which—he may be able to manifest the beautiful thoughts that lie dormant in his imagination.

I may say here, in this connection, that the pupils who come to me are always so confused as to those two qualities of light and shadow, and their habit of exaggerating the halftones has become so confirmed, that it takes oftentimes several years to teach them analysis and simplification, yet without this power of analysis and simplification, it is, as I say, impossible to produce and truly perfect any work of art. For that separation is fundamental to the law of Nature, and until it becomes a habit of thought, no spontaneous work of art can be produced.

It is suggested that you read and reread this many times for your own interpretation. While it becomes perfectly clear in time, I, by experiment, have found that it takes a considerable period to register in one's mind as to actual practice. That this is not unusual is verified by Pyle's own statement that it "takes oftentimes several years" before it is fully comprehended.

Because of the profoundness of this theory, and the inexperience of most students in the application of it, I shall presume to carry the explanation of it somewhat further, with due apologies and with the reservation that such interpretation may be at fault because of lack of comprehension on my own part.

COMMENTS ON HOWARD PYLE'S THEORY OF APPROACH

Howard Pyle is dead, but he left this treasure behind him. It is perhaps the greatest bequest, beyond the wealth in his paintings, that our craft could have had bestowed upon it. It is part of his great mind, which has had such a profound influence upon American illustration. If it may seem to the young artists of today that illustration has taken on different trends, let us understand that the difference does not lie in any change of the fundamental thoughts he has here given us. The things he has observed and set down for us are without question basic truths, and it is true that good pictures can be built in no other way. Time cannot efface those basic truths any more than time can efface the laws of nature, for they are one and the same. If there is any apparent difference between his work and the present trend, the difference lies in changes in concept or presentation rather than in changes of working knowledge. In our day a single head against a white or tonal flat background may be construed as an illustration, but as such it is simply a short cut to effectiveness, with most of the infinite care, the greatness of conception and execution, characteristic of his own effort, virtually absent.

There is not much latitude left for the fullest expression when all the finer qualities of composition, tone, and pattern, light, color, and texture are deleted from illustration. I cannot believe illustration can hold much expansion, progress, or betterment without them. Those illustrators having the ability to express truth in beautiful terms of tone, color, and design will always be the ones sought out, and will stand head and shoulders above the lethargic camera copyist, or the mere imitator of his neighbor's product. Our interest in Howard Pyle is not for his name or personal greatness alone, but also for the great things he stood for. For sheer draftsmanship, keen insight in character portrayal, the sense of the dramatic, interpretation of mood, and the ability to set his figures into an expressive and convincing environment, it must be honestly admitted that there is no one to equal him today. None of these qualities can be dispensed with without detri-

ment to the craft, any more than it would be possible to omit the basic ingredients of, say, a fine piece of metal.

Lack of space, pressure of production time, the need of the startling, the different, of shock-producing effects, have had their influence. The introduction of the candid camera and higher sensitivity of film, allowing the camera so much more latitude, has also had an effect. But our product is no better than his, not even as good. Such changes have not lessened the validity of his principles or their value to the artist. In fact, the good illustrations today are his principles walking around in new clothes.

Howard Pyle's mind was so analytical, so easily capable of grasping truth, that his theory as set down probably appeared completely obvious to him. Yet I find that in most cases it is difficult to grasp the bigness of it in actual practice, even to hope to see with anything like the understanding he speaks of. I admit I have read it perhaps a hundred times, at various periods of personal practice, and each time there seems to be a new glimmering of meaning which comes out of the application I have made of it. Perhaps you will get it faster than I. For those who do not, I offer here my guidance as to what was his full intent and meaning. My interpretation is, of course, subject to argument, and I urge you, if you believe it incorrect, to make your own. Or, you may question whether it needs interpretation at all. But having worked with students, I know the danger in assuming that facts which seem quite obvious to you as an instructor, with a background of experience, will be equally obvious to the student. In fact, he may even believe he understands when his own effort proves he does not. The dawning of a truth comes with its actual application, not the day it is heard. And it enlarges in meaning with self-discovery of its merits in its application.

His treatise begins with the statement that all things are made visible by the light of the sun shining upon them. This is not meant literally, for even a cloudy day is lighted by the sun penetrating the white clouds, but the effect is totally dif-

138

ferent from that produced by full bright sunlight. And since this is a different quality of light, the treatment of light and shadow will be correspondingly characteristic. These statements of his we must analyze. Again, he assumes that we are intelligent enough to reason that any light produces modeling on form, whether it comes from the sun, or a candle, or a modern electric bulb. He is speaking a big truth in very general terms, and we must ascribe to light its various qualities without taking literal exception to his statement.

In the next paragraph he states that color and texture do not enter the property of shadow. Taken too literally, that would mean that all shadows are devoid of color and texture. Then all shadows would be neutral grey or black and perfectly flat. To prove he does not mean it literally, he speaks of reflected light, and admits that light has the property of color and texture. Therefore reflected light can project color and texture into the shadow. What I believe he wants us to understand clearly is that color and texture are most brilliant *within* the light, and those qualities must be reduced or subordinated when entering shadow, since the main function of shadow is not to convey the impression of color or texture, but primarily to define form. My contention, then— which will be taken up later—that color is reduced in intensity in the shadow, is backed up by Howard Pyle's own theory, which should bring conviction to the reader. The local color, in reduced intensity, is obviously within the shadow. A red dress is red in either light or shadow, but admittedly is brighter red in the light. Also, that shadow may be influenced in color by the color of reflected light, as for example the blue of the sky. Howard Pyle does not question this in his own work, and he asks us to make a similar analysis.

Since the visual qualities of color and surface texture are subject to the nature and color qualities of various kinds of light, it follows that both light and shadow are dependent upon light and reflected light, plus their color influence on local color, for the pictorial color we interpret. The yellow or orange light of the late afternoon sun will present a very different color aspect to the same landscape than will midday or a grey day. All things within that light will partake of and add to their local color the color of the light. The soil that would be a neutral grey on a cloudy day may become red-orange in that light. The hills and foliage become golden, and lost in deep violet shadow, that earlier appeared blue-green against blue shadow. I believe Pyle intended that we analyze our subject for these truths and abide by what we find to be true. He would, I am sure, encourage us to show all the purity of color within the light that is consistent with truth, and would want us to keep it in the light where it belongs. I am equally certain that he would have us see shadow as it appears to us, and consistent with the color as we see it. Nothing can so dull our effort as lack of vision coupled with blind adherence to formula. I would say to any student: If you cannot see that which is prescribed in a formula, you either are not ready for it or, as far as you are concerned, formula is worthless. For your vision and interpretation come ahead of anything else in determining your place in art. What you do in the beginning confirms neither the right or wrong of what you stand for. Your subsequent development and perception will determine that. It is well to give careful attention to all instruction and give it a fair trial. And it is well, also, to give your vision every chance, understanding that you do not reach a solution at the outset of any problem. You are not in a position to condemn instruction without trial.

Pyle tells us that halftones belonging to the light should be painted lighter than they appear to be, while those in the shadow should be painted darker. This is perfectly true. Recognizing the limited range of value at our disposal as compared with actual light, we see that it is not possible to set down the full range of lightness to darkness that may appear in nature. For the pictorial effect it is necessary, as far as possible, to hold the whole mass or contrast of light versus shadow, and to keep them in simple mass relationship. Otherwise they may become hopelessly lost in our short

value range. The subject can easily become "washed out" from lack of contrast, or muddy because the light and shadow are too close in value. Pyle is saying that we cannot hope to paint pictures in their true aspect if we disregard this natural truth. Experience convinces us that he is right. If you do not believe this, try it for yourself. The overall relationship of light to shadow is much more true and important than the particular aspect of a value which, if followed accurately, would rob us of the feeling of light.

Suppose we compare an underexposed negative and print with a properly exposed pair. The underexposed set does not bring the values in the light out bright enough in the black-and-white scale, nor the darks low enough; the effect is dull and lifeless. It therefore lacks proper contrast of light to shadow.

There is only one point he makes that I have never been quite able to agree with. This is that shadows are more or less opaque, not being in full light and lighted only by reflected light. My contention is that just the opposite is true. The lights are opaque and the shadows are transparent. My argument is that anything *in* the light stops the light and reflects it back at you. The only time light is transparent is when it can penetrate the material, such as water or other liquid, glass or other transparent material. We cannot see past or beyond the light on opaque objects; our vision

stops at the lighted surface and rests there. The opposite is true of shadows. We do see into shadows. The shadow is actually in front of the plane, having been cast by a turn in the form or by some effect of light. One is a perfect balance for the other, any way you take it. But though they give the illusion of mystery and darkness, indefinition of surface and form lying deep within it, they are still the *only* transparent areas within a subject. How I wish, Howard Pyle, you might speak to us on this point! I cannot believe that, with the great mastery you showed in handling the transparency of shadow in your own work, you intended us to interpret "more or less opaque" as meaning that transparency can be completely omitted. You do *not* say "opaque," so at least you leave the door open—which in itself is characteristic of your greatness.

The opportunity to study Howard Pyle's work is limited, since it is becoming increasingly difficult to find. Most of the original work has been bought up privately, and even his reproductions have been purchased for private files. My readers may not have the privilege of being familiar with it. I do not believe either originals or plates could be secured to be included here, and I therefore have made a page of tonal roughs to give you an idea of the excellence of his tonal arrangements. Perhaps these may suffice. I apologize for copying his work, even roughly.

140

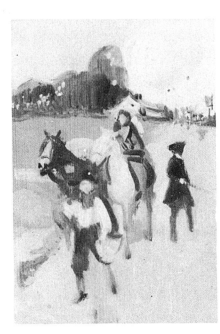

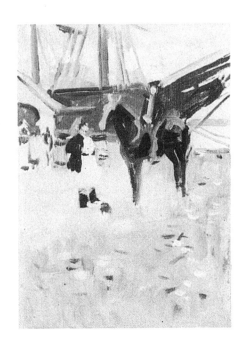

Before leaving the subject of tone and getting into color, there are things of importance to be considered. First is the relationship of tone to color. If you will think of the black-and-white value scale, then try thinking of a color arranged in the same manner from something as light as we can make it down to a value almost as dark as black, you will understand what is meant by "value," or is sometimes referred to as "tone value" in color. Later on I shall attempt to show you exactly how such a scale in every color can be accomplished. For the present, let me say that it will be more than a matter of taking a color and lightening it with white. Color starts in the middle of the value scale, with the strongest intensity, being diluted as it lightens, or mixed with a "toner" to make it relative to a whole scheme. Then to darken it we start again at the middle of the scale, and add black, its complement, or some additional mixture, to lower its value. That is why good color is not so easy as good black and white. If it were true that a pale-blue dress were simply blue and white mixed in the light, with the pure dark blue in the shadow, color would be easy. But we will find that this is not true: the pale-blue dress is also a pale-blue dress in its shadow, the value being lowered by some means which will not destroy the "identity" of the original color—will not make it look as though the dress might have been made up of two shades of blue.

We cannot adhere to the Form Principle until we can render form tones truthfully in color, as we do in black and white. The flesh, for instance, is the same kind of flesh in shadow as it is in light. So we cannot paint it pink flesh where the light falls and orange flesh where it is in shadow. If the shadows are lighted up with a warm light, that is a different matter, for then all the shadows will be so lighted throughout the subject. Shadows can be either warmer or cooler than the light, according to the conditions we are working with. The point I am trying to make is that we cannot possibly put color into a formula of always being so-and-so. Every color subject imposes a set of conditions of light, color, and reflected color which must be adhered to if the result is to be good. Outdoor color is different because of different influences, such as the sky and the sun, both being a source of color and affecting the subject much differently from the way the same subject would appear indoors in a cold light, or artificial light.

Color, then, is not something in a pot or puddle to be lightened with white, as can be done when we are painting in black and white. If we cannot do a study in black and white and do a good thing from the standpoint of values, we certainly cannot do it better in color just because it is color. Lack of understanding of the foregoing is exactly what makes so much tawdry and cheap-looking color work in our magazines. It cannot be blamed upon the engraver; it must be dropped right in the lap of the artists, where the error truly belongs. Most of the bad effect comes about from the "faking" of color when the painter has not the faintest idea as to what the fundamental color truths really are.

The Form Principle is built on values, and it cannot get anywhere without them, even in color. When painting in color from a black-and-white photo, the fundamental values that are in the photo must somehow also be got into the color. I do not mean that the camera is completely accurate as to values, and that because the shadows appear black in the photograph our shadows must be painted black also. On the contrary, we can do something to correct the unrelieved darkness of these shadows, throwing reflected light or "fill-in lights" to bring them out of their inky blackness. When photos are taken outdoors, the values run fairly true and light as they should be—with proper exposure and printing, of course. If you already have a preconceived theory that flesh in the light is so-and-so and that shadows are some other mixture, forget it at once. Flesh can be painted from almost any palette so that the value is right and the color consistent with the surrounding elements.

The best way in the world to learn values as well as color is to work from life. If you are work-

ing in black-and-white paint, from life, you are naturally going to have to take those things before you which are in nature's colors and transpose them to black-and-white values. You will find with concentration and study that you will do it better than will your films and sensitized paper. Always look for the lightest thing in the light and compare it with the darkest thing also in the light, not in the shadow. Then look for the lightest thing in the shadow and compare it with the darkest dark of the shadows. In this manner you think of two groups of values, those in the light as opposed to those in the shadow. They must not so "overlap" as to get mixed up and lost, becoming neither one nor the other. The lights must hold together as a whole group, while the group of shadows should be "stepped down" enough so they also seem to hang together.

Every bit of the form should instantly identify itself as belonging to one group or the other. Consider your halftones always as a part of the light. I mean the planes between the brightest light and the edge of the shadow. If you let those halftones get too dark, you cannot hold the whole light of the picture together as opposed to the whole effect of shadow. The same is true of the shadow. If you let the reflected lights within the shadow get too light, your picture gets mixed up again, and loses unity and brilliance, for the overall effect of shadow must be lower, or darker, than the overall effect of light. Note that I do not say a shadow value cannot be lighter in value than something else might be in light. Flesh, for example, may be lighter in the shadow (not much) than a dark suit would be in the light. But then the dark suit against that flesh in shadow would be practically black. *The relationship of things to one another is the same always, either in light or shadow. That relationship must be maintained under all circumstances.*

To make this clear, let us suppose you put a white square of paper on a board. Next to it you put a grey one two tones darker, and a third two tones darker than the second. Now, you can put the board in any light, or turn it into shadow, but you cannot change the basic relationship of the three squares. That is what is meant by the relationship of things to one another. Now suppose the three squares were three cubes of the same value relationship as the three paper squares. You would then have to take that relationship into light, halftone, and shadow, since you would be dealing with solids. All the sides in light would still be two tones apart, the sides in halftone would keep the same two tones of separation between one another, and the shadows would also still be two tones apart on each cube. Such relationship would be set into one of the light intensities as described previously.

The biggest obstacle to good work is the lack of consistency in these relationships. If you work from life you will gradually see the truth about values. Photos, however, especially those in which a half-dozen sources of light exist, can get woefully mixed up in this respect. In other than a single source of light, our cubes could get to be anything in value and all mixed up for relationship. In the same way, so can heads and clothes and anything else in our pictures.

You may be certain that relationship of values will be more correct in a natural source of light than any other. You may be certain that if you paint the natural relationship of value between things you will have a better picture.

So before leaving black-and-white study (in fact, you will never leave it), try to understand that form is truth of tone and nothing else. Good color is also truth of tone rather than brightness of pigment. There are so many ways to "slick over" faults in color work that often they are not apparent. Set up a still life. Make a small black-and-white study. Then try it in color. You will thus understand what I am talking about better than through any language at my disposal. You may believe you are good in color and also in value relationships, but when you really begin to see these things as they are in Nature, you will find many errors in your work. We all do. Correct values can make a picture have that "quality of existence."

I have tried to cover most of the tonal mediums, and the various effects to be had out of each. However, I am limited in these to my own approach, as you will be to yours. If you will really make the effort to work in as many of them as possible, you will find that what you do in one really does help you in another. You will eventually find yourself doing the same things in any medium—that is, you will put into each all the understanding you have of values, drawing, and other qualities. Your work will take on an individuality all your own, which will be evident in any medium.

There is room for good pen-and-ink men, and I am quite sure that this medium is coming back very strong. There is not half enough good charcoal work, or carbon-pencilwork. There are only a few really good black-and-white-wash illustrators. Black-and-white oil will always be practical and desirable. Perhaps you can work in a combination of mediums to produce a new and unusual effect. Dry brush is one of the coming mediums for newspapers as well as magazines.

One thing I would like to impress continually upon every reader of this book: There is no especial way that illustration is supposed to be done. Occasionally an art director will drag out another man's work and say to you, "Now, this is it." After things are all finished and approved, it is very easy to say, "Do it like that!" But if *you* do one that is liked, someone will be telling the next fellow to do it *your* way. I repeat: There is no better way than the way *you* do it best, and that is bound to be *your* way, with your own taste and ability at work.

In the preparation of samples, do not base your work on pictures by other artists. There is nothing wrong in working from almost any photographic copy for samples as long as these are not to be sold. The magazines are full of material which may be used in this way. But it is better to take your own photos, or use your own model, and work up samples from these. If you look at nature you certainly can call whatever you do your own, and it is by far the best policy.

A few good samples will make a better impression than a lot of mediocre ones. Try not to have two samples very much alike. Two or three various types of heads are enough. They will show what you can do. Babies and children always make good samples. Most art directors have a hard time finding artists who can do them well.

Don't make great big samples, with large packages to open on the art director's time. Carry a portfolio that can be opened easily by untying, not something that will be done up in yards of crackly brown paper, to clutter up his place. That is irritating. If you carry canvases, have them framed lightly and neatly. A single piece of corrugated board tied around them is best.

For subjects, try hard to figure what your prospective client would be most likely to use. School work, unless applicable to his regular needs, will not interest him, especially life drawings. Don't take minute and careful pencil drawings around as samples. Pencil drawings, unless practical for reproduction (meaning good blacks, not too shiny) are bad. However, pencil drawings submitted as layout or compositional work, or even roughs and sketches, are excellent. But use a big fat black-looking pencil if you want to impress him. The work should look as if it were done easily and fast.

If you use a medium that rubs, be sure it is fixed, or put a sheet of tissue over it. Mat your sample drawings and make them as neat and clean as possible. Have your name and address on the back of every sample so that if an art director wishes to hold it, there will be no trouble in finding you, or in returning it. I have seen a man lose out on an order simply because the director forgot who he was and therefore could not look him up. Don't expect him to remember names; he is too busy with everything else.

The best market of all is for good drawings of girls. Character subjects are also good. If you like to work with square or compositional subjects, include some as samples. If you feel you don't do them well, stick to heads, figures, and vignettes. If interested in still life, draw some food, or

something packaged—something that looks as if it were selling a product, not just a vase of flowers, or fruit, or a few books and some eyeglasses.

A good procedure is to select an actual product that is advertised and make your own version of an advertising illustration for it. You can lay out the whole ad as a rough, using the correct name plate or logotype. It looks businesslike to an art director.

Later in the book we are going into the preparation of work for the various fields of illustration. I suggest you finish the book before you get too eager to get into actual work, if you are not already in it.

I have always believed that when you are in one phase of the commercial type of work, you should have a weather eye out for the next. Perhaps you are already employed. Keep making better and better samples, no matter what you are doing. They will come in handy and may boost you along right in your own place, by letting your employers know what you can do beyond your regular job. If you want to be an illustrator, you can be working at it all the time in your spare time, going to school, experimenting with mediums, practicing all you can. If you have good exhibits ready when opportunity knocks, you will go up fast. If you have not taken that extra trouble, you will not be thought of as being ready for anything more than the job you are doing regularly.

Many men stay in mediocre jobs because they have really done little or nothing to get up out of them. Your samples are salesmen. If you have been turned down at a place, show up again in six months with some new samples.

If, in showing your samples around, you find that they cause little favorable reaction at the first several places, better get rid of them and do some new ones. Good work is liked, and bad work disliked, in almost all places. Do not keep showing work that has frankly been considered bad by a few representative art buyers.

Getting in is largely adaptability. Granted you have ability, it is a matter of adjusting that ability to a purpose. That will be true of everything you ever sell. I am sure that most young artists, if they really thought about it, could be much better salesmen than they appear to be. If you wished to sell a man a suit of clothes you would not bring in an ice box. But I have seen aspiring young artists take "a yard of pansies," or subjects equally inappropriate, around to all the important art directors. There is a place for calendars, fashion drawings, posters, dramatic illustrations, pretty girls, foodstuffs and still life, children, or almost anything you want to do. But make it fit. A good sample can be wrong or right according to where it is shown. A bad sample will never be good no matter where shown.

Try not to work too small. Make the sample as impressive as is compatible with convenience in carrying. Tiny heads have little appeal. Make your sample from one and a half to two times the probable size of any final reproduction—larger still in the case of paintings. Present neither broadsides nor postcards. Work on good materials, good bristol or illustration board, never on thin crumply paper, except in the case of layouts and sketches. These are better on a good bond layout paper so that they will not be transparent and show one drawing through another.

Sometimes young artists ask whether names have anything to do with getting a start. Most of the time an artist need not worry about his surname. If you happen to have one that is very difficult to remember, Adolphus Hockenspieler, for example, adopt a simple one that is easier for everybody. Perhaps just a part of it, like "Dolph Hocker." Many artists use a single name, usually the surname, for this reason.

The point to remember is: Do everything within your power to simplify things for the art director when you approach him—your choice of subjects, your work, your attitude, your interview, and even your name if must be. Above all, do not "talk up" your work or your ability. He can decide about that for himself. You do not sell your merits—they sell themselves.

Now let us look at color.

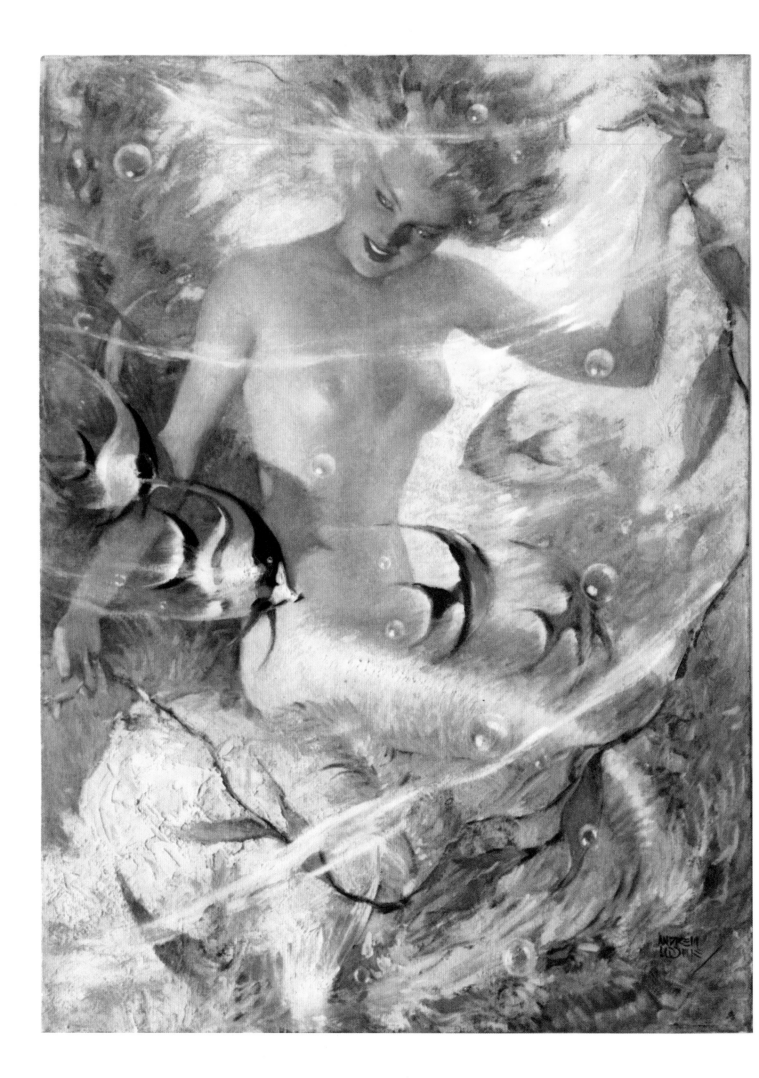

Color

A NEW APPROACH by ANDREW LOOMIS

LET US, FOR ONCE, APPROACH
COLOR AS ALSO BELONGING
TO NATURE'S GREAT PLAN
THAT ALL THINGS SHALL
EXIST IN AND BE A PART OF
ATMOSPHERE AND LIGHT.

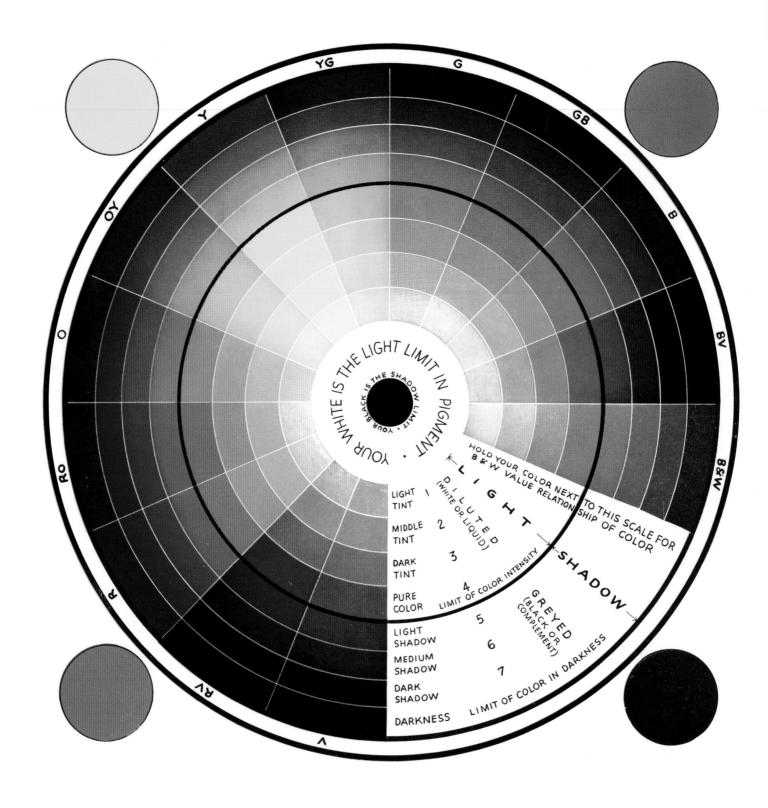

PRESENTING

THE SPECTRUM, AS RELATED TO LIGHT AND SHADOW

BASED ON STANDARD FOUR-COLOR PROCESS PRINTING

This gives you the colors with the values extended from lightest light to darkest shadow in a neutral light and without other influence or color reflection. Consider this as "local color."

COLOR

IN PRESENTING my readers with the problems of color, I believe a new approach is necessary. So far in my own experience I have found that color is usually approached in the sense of something detached, as some sort of special science. The difficulty of such an approach, as far as the student is concerned, lies in transposing the theory to everyday life, the things about him, and applying it in a practical way. We know that all pictorial approach is subject to the basic truths concerning tone, light, and shadow. If color is also subject to the natural laws governing tone, light, and shadow, which it unquestionably is, then the only pictorial approach to color which can be of real value must incorporate these principles. In fact, to approach color without encompassing its relationship not only to light and shadow but also to the effect of atmosphere and reflected color, is to leave us dangling in mid-air, for these things affect every color that we set down pictorially. Color is so subject to natural laws of light and surrounding influence that it cannot be considered separately as a matter of science, temperament, and taste. To do us any good, the study of color must be closely allied to all other fundamentals of art. It is so much a part of tone values and design as to be inseparable from them. Color is thus definitely a part of the Form Principle.

A color may be beautiful to our esthetic sense, but horrible when placed within our picture. Pictorially, a color is beautiful only because of its relationship to other color, and such relationship must be understood. So to pick a color from an average color chart has little practical value, for the odds are that it will be totally unrelated and pictorially false.

Color can be bought in many hues and shades, but without much real value to us at the outset. We must first understand that the basis of all the color we shall ever need lies in the three primaries: red, yellow, and blue. We start with these in their purest possible state. To these we add white to lighten and produce tints, and black or other mixture to darken the pure colors. By the intermixture of red, yellow, and blue, coupled with black and white, it is possible to produce almost every conceivable color that will stay in harmony within our picture. Basically, red, yellow, and blue are used to produce every color we set down, even to the earth colors, burnt sienna, raw sienna, and the ochres. Now let us look at the possibilities of the three primaries, plus black and white. You must understand that in color printing our white only substitutes for white paper, that the thinned-out dot on the white paper of the stronger basic color is the printer's only means of getting light tints by the four-color halftone process. So our tints may not be reproduced with absolute accuracy, since our white may cool the color somewhat more than the white paper mixture with the pure color. In the case of water color, where no white is used, the reproduction will be more exact.

The three primaries, red, yellow, and blue, by mixing in pairs produce the secondary colors of green, violet, and orange. These, with the primaries, give us the six full-strength colors of the spectrum. They are arranged in sequence in a circle. Then by mixing each with its neighbor, we get six more colors, called the tertiary colors. These are red orange, yellow orange, yellow green, blue green, blue violet, and red violet. We now have twelve colors of maximum intensity and brilliance. Adding black and white we have our full color and color value scale.

Beginning with the pure color we can add white to produce a series of tints of the pure color, from full strength to palest tint. Beginning with the pure color we can carry the color down to darkness, by adding black or by mixing with the complement, which we will speak of later.

This is where our approach will differ from the

149

ALL COLOR IS RELATIVE TO SURROUNDING INFLUENCE

FALSE COLOR

THE SHADOW COLOR IN NATURAL LIGHT CANNOT BE A COLOR WHICH CONTAINS NONE OF THE ORIGINAL. HOWEVER ALL SHADOW IS SUBJECT TO THE INFLUENCE OF OTHER COLOR THAT MAY BE REFLECTED INTO IT AND THUS MIXING WITH THE ORIGINAL COLOR.

SO IN THE CUBE AT TOP A BLUE LIGHT REFLECTED INTO THE SHADOW WOULD PRODUCE A GREEN.

TRUE
WITHOUT OTHER COLOR INFLUENCE, THE SHADOW WOULD THEN BE THE SAME COLOR (DARKER) BUT ALSO REDUCED IN INTENSITY BY IT'S COMPLEMENT OR GREY.

usual one. We will set about to carry any color through all the steps from the lightest light to utter darkness. This is something of real necessity to the student, but which often, to my knowledge, has been grossly ignored. So we come to our first axiom. *A color is relative first to the amount of light shining upon it which gives it lightness or darkness.* By way of illustration, we may have a girl in a yellow dress. She may be in a bright light or a low light. She may be in sunlight or shadow. Therefore what we use for the color will have to come out of a scale of light to dark with due consideration of all other color influence. The dress is not just yellow but tones of yellow grading up and down. If she were in the shadow, with the blue light of the sky as the only source of light, we could not possibly paint the dress with only raw yellow. So we have another axiom. *Color is relative to all surrounding color influence.* Suppose we have color in a warm light. The warm colors get more intense, and the colors on the cool side tend to become more neutralized. In a cool light the tendency is reversed. Nature uses her three primaries to produce grey. Yet by the same process a great number of other colors are produced when the proportions are unequal. Mixing these with white, the "soft" greyed colors are produced. In fact, with the addition of black or white to these tonal colors, practically any color or tint imaginable can be reached. The main object in selection of pigment lies in brilliance and ability to mix toward the warm or cool. Since no primary colors can perfectly do this, we use a "warm and cool" of each. If the color itself is warm, such as cadmium red or vermilion, we know it cannot produce a good purple by mixture with blue. Therefore we must, if a brilliant purple is needed, use a cool red like alizarin crimson with a cool blue like ultramarine. Always paint your subject as brilliantly as possible, and let the engraver do the best he can with it. If you give him dead color, he can't make it any better.

All colors as we see them are colors modified by the "conditions of the moment." Warm light gives

COLOR IS STRONGEST IN THE LIGHT

a greater brilliancy to warm color. It subtracts brilliancy from a cold color. Lack of light lowers the tonality, bright light raises it. We call the original color of an object the "local" color. We paint local color only in neutral light.

We must look upon our chart as local or uninfluenced color. The shadow colors are representative of uninfluenced shadows—shadows that do not have any other color reflected into them. In a neutral north light your shadows would come quite close to those represented, provided they were not otherwise affected by other influence. This chart at least will give you a practical basis by which to approach your subject. If you are attempting to paint in color from black-and-white copy, it will help a great deal. But in the back of your mind keep the following truth. *All colors become a source of reflected color when in light and will reflect themselves into lesser light.* To this we add another. *All colors in shadow become recipients of other reflected color and will change accordingly.* This means that you must consider each plane of the shadow area, and whether it would catch the color of something else. This not only makes the units of your picture seem to belong together, it also produces harmony between your color masses. It brings us to another color truth. *Any two colors will be harmonious when one or both contain some of the other.* That is why our spectrum is harmonious all the way around.

Atmosphere has its effect upon color. Colors as they recede tend toward the color of the atmosphere. On a "blue day" they get cooler. On a grey day they become greyer. On a misty day they become tempered and finally lost in the atmosphere. Color on a cloudy day is much different than on a sunny day. But whatever the condition, nature lends some of its atmosphere to all the colors and they thus become related. We will discuss later how you can take one color or influence and mix it through all your colors.

We come to another truth. *The local color should never completely lose its identity in the shadow.* For instance, a yellow cube cannot have

FALSE COLOR

THIS IS NEITHER A PINK NOR A RED CUBE

ONLY A TRANSPARENT MATERIAL COULD HAVE COLOR LIKE THIS, PLASTIC, GLASS, GELATINE, ETC. AS A SOLID SUBSTANCE THE COLOR IS FALSE.

THIS IS A PINK CUBE

COLOR CANNOT BE PURER OR STRONGER IN THE SHADOW UNLESS A SIMILAR COLOR HAS BEEN REFLECTED INTO THAT SHADOW, CAUSING ADDITIONAL BRILLIANCY.

THIS IS A RED CUBE.

THIS AND THE PINK CUBE LEAVE NO DOUBT AS TO THE COLOR OF THE SOLID.

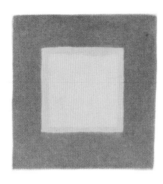

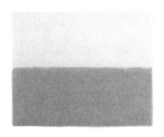
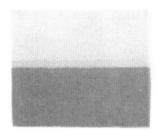

SHOWING HOW BRILLIANCY MAY BE ADDED
BY INTENSIFYING THE COLOR ON THE EDGE
OF THE LIGHT AREA NEXT TO THE SHADOW.

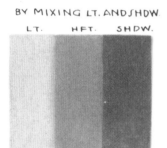
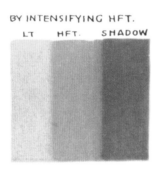

BY MIXING LT. AND SHDW. BY INTENSIFYING HFT.

LT. HFT. SHDW. LT HFT. SHADOW

SHOWING HOW DIFFERENT WHEN THE HALFTONE
IS MADE BRIGHTER COLOR RATHER THAN BY
SIMPLY MIXING THE COLOR IN THE LIGHT
WITH THE COLOR IN THE SHADOW TO MAKE
THE HALFTONE. WE CANNOT "JUST RUB"
THE LIGHT AND SHADOW TOGETHER AND
PRODUCE ANYTHING BUT DULL COLOR.
BUT SOMEHOW MOST OF US STILL DO IT.

PROVING THE SAME COLOR APPEARS TO
BE BRIGHTER AGAINST A "GREYED" COLOR.

a shadow without some yellow in it. On the other hand, a pink cube cannot have a red shadow, since the local color must be consistent in either light or shadow. *No color in shadow can have brighter color intensity than the same color would have in the light.* We cannot change the identity of the local color.

In our chart you also find a black-and-white scale. If in your black-and-white copy the area you intend to paint is of a certain value, then the color should be matched somewhere close to that value, or you will upset the natural sequence of values which the light gave to the units in your copy. The color in that instance may be of your choice but the value is more or less fixed to be in scale with the rest of your picture, and should be so considered. The intensity relationship of light and shadow should be planned as carefully in color subjects as you would in black-and-white renderings. Color can be made to fall into "pattern." A certain value can be repeated with great variety, holding the value but changing the color.

If the color in the shadow cannot exceed in brilliance the local color as seen in the light, then it follows that the purest and most intense colors belong to the light. Note the black line in the chart, dividing the color range into light and shadow. So the axiom, *all colors in their greatest intensity or tints of the pure color should be relegated to the lights and halftones. When reaching the shadow these colors are reduced or greyed, or the color changed by influence of other color reflecting into the shadow.*

It is not necessarily true that the color in the brightest light is always the strongest color. Light, being white, can dilute color, just as can the white on your palette. In order to reach the high value we may be forced to lighten the color. Yet on the next planes, which are the halftone planes, color may be more intense, being still in light. So then, *the halftones may contain the most brilliant and pure color.* Color can greatly lose its local color in highlights, which become the white or color of the light source. Working directly into or against the

light forces us to put our most brilliant color in the shadow; since the lights are so diluted with light, the shadows are our only chance. But even here we are working in reflected light against the dominant light, and much color is apparent, though not as bright as it would be with the light behind us.

Here is one of the best ways in the world to obtain brilliancy of color: *Keep your color most intense on the edges of the lighted areas, where it merges into shadow.* This seems to cast an aura of additional color over the whole lighted area. Just taking a local color of the light and rubbing it into a darker color of the shadow (which most of us do, most of the time) produces no brilliancy. It is apt to be just color in the light, then mud, then reduced color in the shadow. This is one of the least known and least practiced truths.

Now we come to a surprising fact. *Most of the visual color of nature, we find, is not pure color.* Aside from brilliant flowers, and even there to some extent, we find that a color is tempered with other color, is greyed or influenced in some way so that it is not an even flat color throughout. That leaves our purest color for edges, accents, and other manipulation to enhance the softer greyer color of nature. For this reason, *we cannot paint nature from a tube or a pot.* We must relate our color by intermixture, subordinate or intensify where it is most effective. In fact, we cannot simply copy in color. We must, to a large extent, create color through the truths nature gives us. An area of color is much more true and effective if it incorporates some of its next-door neighbors. For instance, rather than a flat blue, some of the blue green and blue violet next door can be associated. Instead of a flat yellow, some yellow orange and yellow green can invade the flat color. This is another bit of painting knowledge that can enliven dull work. Since nature is largely grey, *don't be afraid of nature's greys.* Brightness is relative. A color will be brighter against a greyed color than it will against another bright one. Fine artists say that the greys make the picture, meaning that the greys are the necessary foil for the bright

colors to look bright against. Grey colors are "tonal colors."

I have stated that the pure colors and pure tints are to be a part of the light. That is true, but it does not mean that all color in the light is pure color, since not all local color is pure color. All our tints of the pure colors can be greyed, which increases our range of color to the skies, meaning that there can be thousands of variations. For instance, we have a pure pink. But we may also convert it to a grey pink, a dusty pink, an orange pink, a lavender pink, a brown pink, and so on, and each may be made to run the scale from light to darkness. A dusty pink dress may have to be rendered all the way from bright light to deep shadow and still look like a dusty pink dress all the way through. This can be done only by correct values and a careful adjustment of the color evident in the light, this being carried into the shadow and at the same time being lowered in tone by greys or neutralization.

Since pigment is already limited in brilliancy compared with transparent or projected color, tones that are grey in the light offer the biggest problem. There is only one remedy used by most good painters to keep their canvases from getting unwholesomely grey, and that is, *if the color in the light is grey or greyed, then the color toward which the grey leans may be intensified in the halftones and also in the shadow.* This amounts to making the shadow slightly warmer or cooler than the color in the light. For instance, we may have a grey white tone in the light. The shadow, then, instead of being a mere black-and-white grey, will take on more color than the light, being warmer or cooler. Thus the shadow on white might lean toward the warmer tones of green, yellowish or orange grey, or lean the other way to the blues and lavenders, according to the quality of the light and environment. A warm grey can thus be painted somewhat cooler in the shadow, or a cool grey slightly warmer. This phenomenon seems to exist in nature, possibly due to reflected color which is not always obvious. At any rate, it adds life to painting.

THE LIMITATION OF COLOR IN PIGMENT

Let us understand that, after all, color is the most lenient and unformulated of all the fundamentals. You have greater liberty here for your individual feeling than in other departments of your craft. Good color cannot be achieved without intelligent approach; at the same time, good color, so long as all other things are well, such as drawing and tonal values, may be achieved and still be wholly apart from literal fact. Indeed, if the value is right, it may almost be stated that the color will not look bad. It is values and tonal relationships that spoil more color than anything else. Color is just as certainly correlative of tone as tone is of line; all three are one and a part of one another. *All the visual effects of nature are seen as color or as greys that can be produced by color.* Black and white is man's invention, and simply represents the color's value without the color. Seeing without color is either lack of perception or actually defective vision.

Since light has a greater range of brightness and darkness than pigment, then color also has greater brilliance in life than we can reach in pigment. Therefore we must work within the value limitations of pigment, or between white, color, and black. There is nothing else we can do about it. But the limitations are not as bad as they seem, once we understand what it is all about. *No color can be made brighter than its full strength.* It can only be made lighter or darker, or less intense by mixture. It can be made to vary in hue by adding other colors, warmer or cooler, but nothing yet known can make it brighter than white paint or paper unless by actual additional light thrown upon it. Purity of pigment is not the whole objective of the painter; *tone and harmony come first.* Vitality in painting comes from value relationships, not the untouched rawness of pigment. Contrast between strong colors cannot be the whole aim, for contrast is greatest when the strong is pitted against the weak.

It is natural to assume that the picture containing the largest number of colors will be the brightest picture. Unfortunately, color does not work out that way. The reason is that all colors combine to produce white in light. In pigment they produce grey or brown. So colors tend to neutralize and dull one another unless considered (1) by value, (2) by related harmony, (3) by color contrast. Pictures built on a few basic values, a light, one or two middle values, and a dark, seldom go dead. In the second instance, pictures built on color sequence can hardly go dead. When color is thus related it cannot neutralize itself. In the third instance, the picture remains basically alive by reason of complementary color. A color cannot be dead against its complement. (See Pages 164-166 for fuller discussion of related color and complementary color.)

It is when a painting becomes a hodgepodge of values, colors indiscriminately placed against one another, all vying with one another for attention, that the whole brilliancy is cut down. You may be sure that one primary plus its neighbors, and opposed by its complement, will never go dead. These, supported by greyed colors, with a black and white introduced, will always be brilliant. *It is a safe rule not to have all three primaries in their pure state in any one picture.* Tone one or two of them with some of the other. Grey one by adding a little of its complement (a mixture of the other two). Do something so that you do not have a large mass of each fighting with the others. They do fight, because none of the primaries in their original state have any ingredients in common. We create harmony. *Until we produce a pleasing mixture, the primaries in themselves have no harmony.*

Color may be related by painting into an all-over undertone. In the four examples shown, a yellow, a grey blue, a red orange, and a green undertone were used. This principle applies only to mediums that are wet, so that as we add the overlaying colors some of the undertone becomes mixed into them. This produces an "influence" on all the colors, drawing them into relationship and harmony. It is an excellent plan for making thumbnails and small color sketches, and a quick and beautiful way of producing harmony. Almost any color may be painted into the tone, so long as

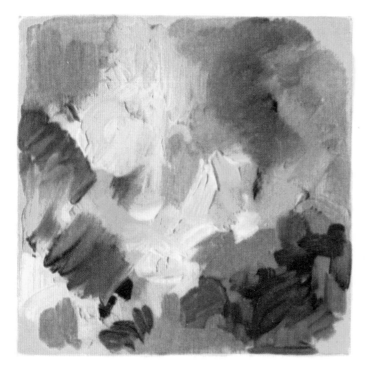

COLOR PAINTED INTO A WET YELLOW UNDERTONE

SHOWING INFLUENCE OF A BLUE-GREY UNDERTONE

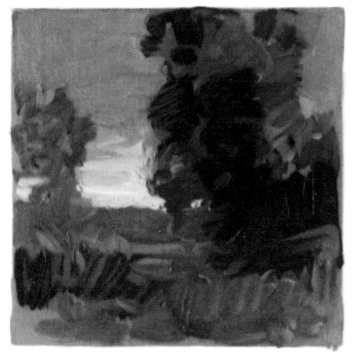

RED ORANGE USED AS AN UNDERTONE

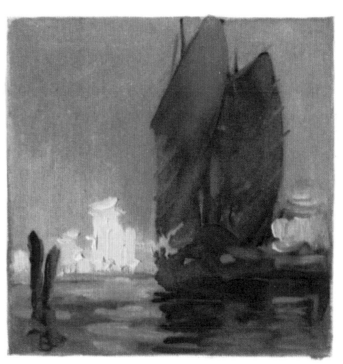

COLOR PAINTED INTO A WET GREEN UNDERTONE

it takes up some of the undertone. Other good effects are obtainable with dry undertone if some of the undertone is allowed to show through.

When we speak of color as "related" we mean that it actually contains some of the pigment of the color or colors it is put with. This is like a blood relationship among humans. Green is like the son of yellow and blue, being a half mixture of each. A blue green is like a child that has taken the pre-dominant characteristics of one parent; yellow green is more like the other. When a group of colors all contain some of one particular color or "influence," then it is like a group of more distant relatives. The spectrum is like a family with three parents. Yellow as the father would have the orange children from the red wife, and the green children from the blue wife. Rather complicated, but so is color.

155

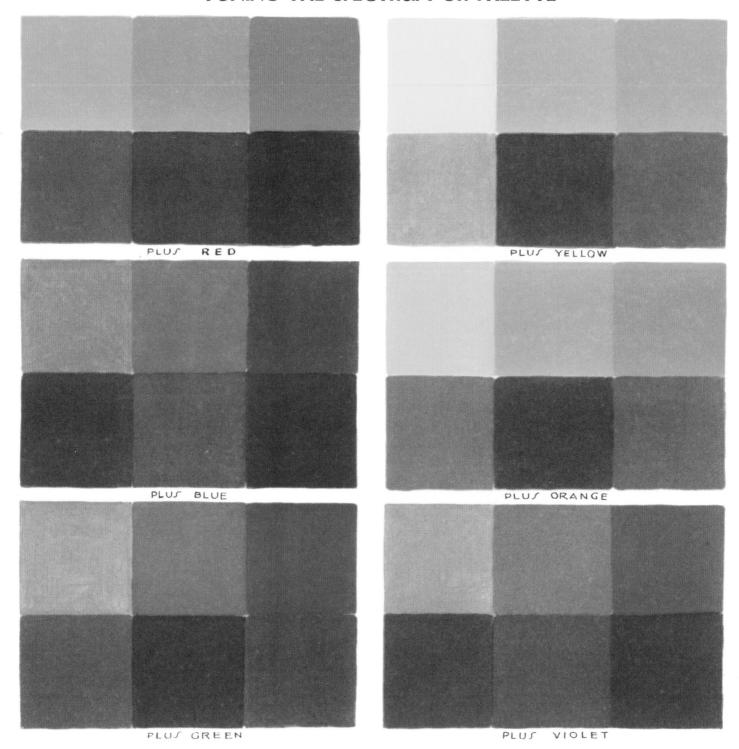

PLUS RED

PLUS YELLOW

PLUS BLUE

PLUS ORANGE

PLUS GREEN

PLUS VIOLET

Here is another way to relate all the colors of your palette. Choose one color of the spectrum. Mix some of it into every other color. You can make a very delicate mixture, or up to about one-third. The more you add, the more you are cutting down the brilliancy of all the colors which normally contain none of the color you are adding. But your color will all retain its "identity," though brought into closer harmony. The above are about the limit of mixture. Note in each group one color stays pure, and so will the colors which contain the toning color. The opposite colors change. I have painted four heads in four schemes to show that it is possible to paint flesh in any influence. Stick to your scheme when you start it. When it's all done, you may add a touch or two of pure color outside the scheme if you are so tempted. But more often you will like it better as it was. Very beautiful color may be arrived at in this manner. My examples are only a hint of its possibilities.

156

RED TONER

ORANGE

BLUE TONER

GREEN

157

COLOR, ITS FUNCTION AND CHARM

Color is very much like a bank account. If you dip into it too much soon you have none. To the layman color seems quite limited, just the six pure colors of the spectrum. He is therefore tempted to get all six into his subject to get what he thinks of as "full color." He thinks in terms of so many pans or tubes of color, using this one for this and that one for that. If he runs out of colors then he goes and buys some more tubes containing something still different, like a tube of magenta, maroon, or brown pink. Color is anything but that. I shall try to point out that color works out in just the opposite manner.

The most colorful and beautiful paintings often come from the restriction of color, rather than the profuse application of it. Let us understand that the color in the spectrum is really white light broken down into its elements. Things have color only because certain surfaces have the power of absorbing some of the elements, and reflecting back the others. Were there no color in light, there could be no color in anything. True enough, we can buy colors; but these are pigments, which have in themselves such power of absorption or reflection. Take away all light and they are colorless and, so far as we are concerned, could all be so much black.

So to produce good color we go to the fundamental laws of color, that each of the primaries is an element of light itself. Since we cannot see color beyond the spectrum with the naked eye, such as infra red, or ultra violet, color is limited to the three elements that we can see. In pigment, since it is not actually light, but matter, the intermixture of red, yellow, and blue cannot produce white, as does light, and so produces sediment. The colors being neutralized by one another, the result is darkness, either in greys, brown, or black. The tendency then of pigmentary color in mixing is to reduce in intensity the three primaries. The secondary mixtures of green violet and orange are not quite as strong and bright as the red, yellow, and blue of the primaries. The third mixture, called the tertiaries, becomes even less intense. Now begin to add one color containing two primaries to anything containing the third primary, and the tendency will be toward even less brilliancy, reaching toward the greys or browns, rather than making the color appear any brighter. So in the primaries we really have all the brilliancy there is in pigment. Assuming that we start with the brightest possible red, yellow, and blue, and go from the intermixture of any two of these around the circle, we lay out the full gamut of so-called pure color, with all the brilliancy at our disposal.

Instead of thinking of color as being limited to the six colors of the spectrum, think of these as the heads of six great families, like six pioneer settlers who are the foundation of the whole population to follow. Some of the strains stay pure, as for example all colors which have the influence of yellow evident, or blue, or any of the six. Others become so interrelated that the color becomes almost nameless as color, and so other names are tacked on for identification, either telling what they are made of or suggesting something they look like. Into this group fall yellow ochre, the umbers, burnt sienna, cobalt, manganese, or cerulean blue, rose madder, crimson lake, alizarin crimson, vermilion, Venetian and Indian red, gamboge, Mars yellow, and others. These are pigments which vary from the original primaries of the spectrum. Then we have such names as taupe, chartreuse, beige, sage, maroon, cerise, lavender, lemon, and others, which are mixtures which can be approximated in the mixtures of the primaries. This great array of names is simply confusing and does not belong in the basic theory of color. Color as far as we as artists are concerned is simply, red, yellow, blue, black, and white. We can start our subject with *any* red, *any* yellow, or *any* blue of our choice, with good and interesting results. However, if we are working for reproduction it is logical that we start with primaries as close as possible to those the printer works with. To procure uniform results these have had to be standardized, and so are known as standard primaries. They are as given in our standard color wheel on page 148, and will act as a guide for you.

COLOR

I do not mean that you cannot use color in any way you wish, or out of any tube with any name on it. I only wish to point out that the engraver can give you only colors that are the result of the intermixture of the colors he must work with. If you cannot mix a color that you are using out of your three primaries, you can be certain he cannot either.

When the color of any picture comes from a basic source of a few primaries, it automatically establishes harmony and a basic relationship of one to another. It can't help it, because all contain the same elements or ingredients, and relationship in color is no different than in a human family. The traits and characteristics of the orignal source are carried into the offspring.

I used the word "few" above because we can use a little more latitude, if need be, than only one red, one yellow, and one blue. While I fully indorse that procedure, because of the fact that there is no actual mixture of the ink except in minute dots lying in close proximity to one another or overlapping one another, the printer's color is not quite as neutralized by mixture as our paints. Therefore we may use two of each primary, a warm and cool of each. This means one leaning each way around the circle. Therefore we may have a yellow leaning toward the orange as a cadmium yellow, and one toward the green as a cadmium lemon. For the blue we can use a cobalt or cerulean or even a little viridian mixed with blue for the warm blue leaning toward the green. The other blue leaning toward the violet would be an ultramarine blue. The warm red would be cadmium red or vermilion and the cool red an alizarin crimson. Now, using the double set of primaries with black and white, almost any color, hue, or tint under the sun can be approximated. These can run into thousands of variations and make it unnecessary for the artist even to worry about anything else. Some of the brilliancy may be lost in reproduction, but it's better to give the engraver brilliancy plus, than brilliancy minus. He may swear at you a little, but he would be madder if you gave him a dull painting and expected him to pep it up. The only way he can pep up your picture is to subtract neutralizing color.

One thing I want to stress is that you cannot make a subject colorful by using all pure color, that is, all primary and secondary color. Color is a plus and minus proposition. We need greyness and softness as a foil for the brilliant areas. Every part of the picture should be a part of a whole conception, with the purest and brightest concentrated where it will do most good. Note in the frontispiece of the book that the bright color has been concentrated about the girl's head, and the other color is softer and more muted by intermixture. To keep forcing all the areas toward the six spectrum colors sets up competition which in the end is vying for attention and results in less brilliancy for any one area. Then there is no way to gain any more color. The color can be set down stronger as color, but often less beautiful. Nature is seldom one flat bright pure color anywhere. In Nature, colors are made up of variety all through, which means warm and cool variations, or colors broken or blended together. The sky is not one blue, the ground not one green or brown or grey. The foliage in the distance is quite different in color than that close by. The charm of color lies in warm and cool variation, in the greyed or muted color along with the pure and brilliant. If you can put three reds together they are more beautiful than one red, and this is possible by letting the red lean to the warm and cool within the same area. It is the same with every color in the universe. Note how the color varies in a flower, and how the color is carried into the foliage and stem. Note the great varieties of greens we have in the same subject outdoors. This does not mean a great array of tubes of color: simply intermixture of what we started with, toward the warm and cool. I have tried to play warm with cool color in the frontispiece of Part Three of this book.

This is difficult to make clear to the student and oftentimes to a client. Brilliance reaches a point of saturation beyond which there is no more. We can say that sugar is at its maximum of sweetness

in its raw state. In the same way, color is at its maximum of brightness in *its* raw state. Too much raw sugar is sickening, it must be balanced with something else. And so is color. We can bear raw bright color only so long. As, with edges, charm lies in the softness contrasted with the sharp, so in color it is the bright contrasted with the softer and greyer colors. The greyed and more subtle color will be associated with good taste, just as it is in other uses, with now and then a splurge of color to relieve the monotony.

COLOR CONTRAST

For those who do not understand the meaning of pigmentary complementary color, let me point out that the primary complement of a color is that color which is farthest removed from it by mixture, or containing none of the original color. Thus the complement of a primary would be a mixture of the other two. They line up as follows:

PRIMARY	COMPLEMENT
Red	Green (yellow plus blue)
Yellow	Violet (red plus blue)
Blue	Orange (red plus yellow)

The secondary complements are those containing a like strain but farthest removed by mixture. They line up:

SECONDARY	COMPLEMENT
Yellow Green	Red Violet (both contain blue)
Blue Green	Red Orange (both contain yellow)
Blue Violet	Yellow Orange (both contain red)

The secondary complements are even more beautiful because they are related, and not quite at the extreme of color contrast.

COLOR HARMONY OR RELATED COLOR

Since we know that we can relate any two colors by mixing some of one with the other, the colors of the spectrum fall into three groups in which each is related to the other because each contains some of the same primary. Thus all colors containing yellow are related by the yellow. The same is true then of each of the other two primaries. In their purest state the related groups are given below. But the colors may be greyed still more, and as long as they contain a common ingredient they will be related. So the groups are as follows:

THE YELLOW GROUP

Yellow (the strain)	The same effect is pro-
Yellow Orange	duced by painting into a
Red Orange	yellow (wet) undertone,
Yellow Green	or by mixing some yel-
Green	low into every other col-
Blue Green	or of your palette.
Plus any greyed color containing some yellow	

This produces a picture in a yellowish key or as if pervaded by a yellow light.

THE RED GROUP

Red (the strain)	Red undertone or red
Red Orange	influence.
Orange	
Yellow Orange	
Red Violet	
Violet	
Blue Violet	
Plus any greyed color containing some red	

THE BLUE GROUP

Blue (the strain)	Blue undertone or blue
Blue Green	influence.
Green	
Yellow Green	
Blue Violet	
Violet	
Red Violet	
Plus any greyed color containing some blue	

The above as applied to painting means a "color key" for a picture. So you can paint in a yellow, red, or blue key with a wide variety of effect. Or for other subjects you can go a step farther and key or influence all your colors with any single color. For example, blue green might be the dominant strain or influence throughout all

THE RED GROUP

THE YELLOW GROUP

THE BLUE GROUP

COLOR PAINTED INTO A GREY UNDERTONE

the color of a moonlight subject, meaning not that all colors are blue green but that they are tempered or influenced by blue green. The effect of such relationship of color is extremely beautiful. So long as the dominant color is or can be mixed from the standard primaries, it is perfectly possible to reproduce it by the standard four-color process.

It follows that to produce harmony and beauty of relationship of color throughout your subject you have the choice of relating them by (1) a common ingredient, (2) mixing into a wet undertone, (3) intermixture of the color of one area into another, (4) painting the subject out of one of the groups, (5) using as a palette for your subject any three colors each of which will contain some of one of the three different primaries. Thus the three primaries may not need to be pure. You can take almost any combination you choose, if one contains yellow, another blue, and the third red, in either pure or adulterated state. This results in what is known as "Triads." Triads are really a means of removing color from its pure raw state. Thus a combination of yellow orange for one, blue green instead of blue for number two, and red violet instead of red, would be a "triad." You can make a triad of secondary or tertiary colors, you can use one primary with two secondary, or practically any combination you choose, so long as they come from mixtures with the three primaries. If you chose three colors all too close together in the spectrum wheel, such as blue, green blue, and blue violet, you would be so limited as to not have any complementary contrast, and though the result might still be beautiful through close relationship, it would appear "all to the blue" and the color range would be very short. It would be a beautiful combination in a fabric, but scarcely enough range for a picture. This will indicate the very great variety of approach there can be to color.

What is meant by color shades is of vast importance and should be clarified here. The shade of a color is the result of the *proportion of its ingredient colors, or a color plus.* For instance, yellow green and blue green are shades of green, the shade varying only because the proportion of yellow to blue is different, since both shades contain the same ingredients. But there are many more shades of green, meaning that red enters the mixture. We may have olive green, grey green, brown greens, sea green—going on almost indefinitely. These are all composed of the same old friends, yellow and blue, with various proportion of red, black, and white. It is obvious that all pigments of a given color do not match—we have a great variety and assortment of them, but they cannot be inserted harmoniously into a subject that did not start with them in the original palette *or the three chosen primaries of the picture.* Get this clear: There are three primaries of the spectrum, but you chose your *own* three primaries for your picture and paint the whole thing with them, and those three primaries are the parents to all your color. They are not to be confused with the spectrum primaries, since they may contain only ingredients of the primaries. They are called primaries only because they are the primary basis to all further mixture. If you will understand this you will never have to worry about relating color.

One thing to remember is that pure color is brightened only by light itself, not white paint; that is why color belongs to the light. Since it loses intensity in proportion to the light taken from it, we must cut down its brilliancy when we are painting it in shadow, or it will be false. If your picture is bad in color by using a three-color basis, it is not the fault of the color, but of values and relationships of the color to light or shadow and to reflected light and color.

We must distinguish "local" color as color uninfluenced. If we throw an orange light on green, or wish to make the green appear in our picture as if it were in an orange light, we must change the local color to what it appears by adding orange. This is where color adheres to the Form Principle, being color in the "aspect of the moment" and influenced by its environment. Should the light be cool, we would naturally add blue to the color.

COLOR SELECTION AND BACKGROUND

The color of your picture should be chosen after careful deliberation as to the nature of your subject. If it must reach out and catch the eye with strong color, especially in competition with other color, then it should begin with the primaries or color in its pure state. Purity and strength stay in the color longest when it contains fewest elements. Therefore, when two colors contain the same elements, like blue, blue green, green, and blue violet, all of which contain blue, they may be mixed without much loss of brilliancy. But when red or orange starts mixing into them they tend to become neutralized, and with enough of the complementary red or orange, finally turn to browns. *All colors when mixed with their complements become brown or grey in proportion to the amount of the complementary added. All equal mixtures of complements end up as the same brown when mixed from the same palette, for we are arriving at an equal mixture of the same yellow, red, and blue.* So, in adding yellow to purple, you make the total mixture red plus blue plus yellow; and you are doing the same thing when you add red to green, for the sum total is then yellow plus blue plus red, which adds up to the same thing and the same color. Therefore all your variety of color lies in *unequal mixtures of the pure or plus black or white; and with such understanding color becomes unlimited, with the possibility of hundreds of variations.*

Here enters the important element of simplicity. We found with tone that a few simple values make the best picture; it turns out that color acts the same way, for color and tone are closely allied. This is the main reason for a simple palette. How simple it can be has been shown us by the great Velasquez, and Zorn, Sargent, and others. Zorn used a vermilion, a blue black, and a yellow ochre for many of his pictures with amazing brilliancy. This means one pure and two greyed colors. The brilliancy lies in the relationship of value and tone as much as in color. We do not paint bright by the number of colors, but by the masses and values.

Consider your subject and its purpose. To catch the eye it will need startling contrast of color, which really means a play of complements. As a general rule posters, covers, and window displays can be built upon the principle of a primary against its complement, or using the secondary complementaries. But again the subject has to do with the choice of color. Some subjects that are bright and happy naturally call for bright color. A picture of an inmate of a concentration camp would hardly be painted with bright snappy color. By understanding the mixture of color we can approach its function. We can make color enter a key, a mood, or reflect the spirit of the task. Knowing relationship, you will not paint a bright yellow moon in pure blue skies. Pure or bright color blaring out falsely in relationship does not increase the effectiveness of an ad, even if those who do not understand color believe it does. A beautiful relationship will always create better response. Beautiful relationships are none the less brilliant; it is simply knowing how to arrive at brilliancy. If your client asks you to follow a sketch that is raw and ugly in relationship, make him a thumbnail of a related scheme where one area partakes of another, with a single area left pure, and let him see it. The difference should convince him.

Besides color itself, every color has a value. Naturally colors close in value will tend to merge, like a red on a green of about the same value. The yellows are in the high values, also tints of the other two, but the purples, reds, browns, and dark blues all hover about the same low values. So, if contrast is needed, first see that there is contrast in value, and then contrast in color will be easily reached. Backgrounds affording contrast to material in front of them must be selected this way. If the contrast of value is there, the color contrast need not be greatly separated. Therefore a line of dark green lettering might be fine on a creamy or tan background. Most wide expanses of color should be toned down with complement or grey, to give other color a chance. "The larger the area, the softer the color" is a good axiom. Avoid primary colors for backgrounds. Keep your bright colors on your units of interest.

WHAT TO DO WHEN YOUR PICTURE IS DEAD IN COLOR

It is important to stress here the fact that color in a miniature sketch may be quite arresting and pleasing because it is small. In fact, the smaller the area, the brighter the color that can be used. But you may find that in the final work, when the sketch has been greatly enlarged, the color begins to get a bit raw. The reason is that the color cones in the retina of the eye are limited. We have only so many of each that register the different color vibrations. The eye when taking in a large area of pure color quickly tires, and to defend the color nerves the opposite color sensation is set up. Stare at a bright red spot for a minute and then look at a white sheet. A bright green spot will develop. If you stare at a blue spot, the image will be yellow or orange. In each case it will be the complementary of the color, or the color which would tone down or neutralize the original color which is tiring those nerves. So the longer we look at a bright color the duller it seems to get. We can learn from this that if we provide rest for the nerves in associating balancing colors within the same picture, all the colors will stay bright longer. We therefore can associate a bright area with greyed or muted color, or else complementary color to obtain and hold brilliancy.

When your picture is dead or unpleasant, the fault is usually too much raw unrelated color, rather than not enough. It does not help to try to pile still brighter or different raw colors into the thing. A battery of primary and secondary colors all vying with one another can completely vitiate the whole color effect. Following are some remedies for bad color.

Try greying all but two colors or mixing a single color into all but one or two of the others, and see what happens. Also look at your subject on the basis of a simpler tone plan, arranging it into a pattern of light, middle tone, and dark. If this cannot be done, your subject may be too broken up in masses, which is just as important to color as to tone. Try reducing your whole color scheme to three or four basic colors from which you will mix all the rest. Take very bright and raw color out of your shadows. Get your brightest colors into the areas in the light. See that all three primaries do not appear in their raw state within the same picture. If they are there, that is most of your trouble. Tone two of them with the third one.

Sometimes introducing a neutral grey, a black or white, or any or all of them into a subject otherwise full of color will snap it up, both from a value standpoint and by providing suitable contrast for the brilliancy elsewhere. This means that you will have to sacrifice color in one place for the sake of more brilliancy elsewhere.

If the subject persistently refuses to come around, it means that the values are somewhere "out," or that something could not be in such value relationship under the existing conditions. It means that the overall relationship of light to shadow is bad somewhere. *Remember, a color cannot be right until the value is right.* Also remember, *color cannot be purer and stronger in the shadow than the same color appears to be in the light.* Pictures cannot hold up if the lights are cool and the shadows warm on one thing, with the reverse of warm lights and cool shadows on another within the same subject, unless by some reason of reflected light and color. You can't have a hot shadow on a face that should be lighted by the blue of the sky, nor cool under planes that should be lighted by the warm reflection of sunlit ground. Think always of the possibility of the color of one area shining into and influencing another.

Overstatement of modeling or of values that are in the light will naturally also lower the value of your color and make it appear muddy. See that the lights are kept simple in relationship to simple shadows, and of consistent intensity throughout. See that reflected lights in the shadows are not overstated or too light in value, destroying the mass effect of the shadow as opposed to the light.

There are a few instances where the picture is at fault because all the color is too grey. The only remedy there is to intensify color at the edges or wherever else possible. But a more common fault is too much color.

THE EMOTIONAL EFFECTS OF COLOR

If you are planning a subject that must be lived with for a long time, use the soft or tonal color unless the picture is quite small. A large and very bright picture, after the newness is gone, tends to get on one's nerves. Pictures for reproduction in advertising and story illustration are for more or less momentary interest and therefore lend themselves to brighter treatment, which is proper. Yet even here a quiet, soft, and restful color scheme may attract attention by deviation from the usual bright color in company with it. Murals and pictures for the walls are usually more pleasing if held in a light high key and greyed in color.

Psychologists tell us that different colors do really affect us emotionally. Some can please while others irritate, we being almost allergic mentally and physically to some. Reds and yellows seem to excite. Greens, blues, and greys, or lavenders and purples, are more soothing and restful. Perhaps the quiet and restful colors of Nature have a lot to do with resting our frayed nerves by a vacation to the country. Combining exciting colors with exciting line (See Part One), and restful colors with restful line, becomes perfect co-ordination of line and color. Nature chooses tonal greyed colors for the permanent things with greys, browns, tans, greens. Her bright color is fleeting. It is reserved for flowers, skies, sunsets, insects, the glory of autumn, fruits, and feathers—things which will not be with us long. Here is a great truth for art.

Let us then think of color as having emotion. Put lively color into a lively subject, a red on the girl on skiis. If it is to be two lovers in the moonlight, let the color run to blues, greens, pinks, and violet. If peace and quiet, let the color run to greys. Imagine Whistler's "Mother" painted in bright red or yellow! Stop and think how color affects you. Think of the dark greens, blue blacks, and greys of a cloudy day at mid-ocean. Think of the fresh greens of spring and the pink of fruit blossoms after a long cold winter. Think of the golden color of ripe wheat, the full glory of the bright sun after a rain. Think of the red glow of

hot metal and the bright yellow of a log fire. Cold is blue and grey and violet like the shadows on white snow. Then think whether color really affects you or not.

Subjects generally cannot be painted all to one side of the spectrum. We need some warmth to balance the cool, and vice versa. While either might predominate, we find that one is enhanced by the other. The play of warm against cool, then, in color is the source of great charm. This does not mean hot against cold or the extremes of complementaries, but something varying the shade of a color as it covers an area or comes next to another area. For example, an otherwise flat yellow might have a play of delicate pinks, greens, pale orange tints, and even blues and lavenders, introduced into it to give it great charm. This does not mean that you put colored spots all over another color. The value of the original tone must be closely matched and the color handled with subtlety. Too much of the complementary color will tend to mute the undercolor. If overdone, the purity of color will go and turn to brown or mud. You can play like colors together with wonderful effects, such as warm greens with cool greens, warm reds with cool reds, and so on. Keep your colors neighborly, or living close to one another in the spectrum, and they will not vitiate one another. That is one reason the color wheel looks so fresh and bright, because the transition from one color to another is gradual.

Speaking of transition, there is what is known as transitional color. That is obtained by placing colors that normally fall between two colors in the wheel at the edges between these two color areas. Suppose we have then an area of red and one of rather bright yellow in the same picture and touching each other. Then the edge of the red would be painted an orange as it touches the yellow. Thus the transition is made from one to the other with great beauty instead of harshness.

Color offers the greatest opportunity for the creative part of you and for the expression of your individual feelings. There is no law to say what you must do. I am suggesting what you *can* do.

169

Outdoor color varies from indoor color mainly in the basic approach. In outdoor sunlight the light is warm, especially toward the end of the day. The blue sky reflecting into the shadows causes them to be generally cooler than the lights. So for outdoors the effect for the most part is warm lights and cool shadows. Now, indoors, by studio skylight, which usually is turned to the north as the most even and constant or unchanging light, just the opposite is true. The room being lighted by the cool blue of the sky, the lights are cool and by contrast the shadows appear warm. There should be no hard and fast rules, however, in either case, since in certain instances white and dazzling sunlight may appear quite cool against shadows reflecting considerable warm light from the ground. Indoors, we may actually get the sun or reflection from other warm sources. So the only thing to do is to follow warm and cool color as you see it and feel it to be.

We can follow the general idea that warm lights and cool shadows give an "outdoor effect," while the opposite gives one of indoors. The main thing is not to paint a girl on the beach in which painting the color appears to be indoors. Nor would we paint her sitting indoors with cold blue shadows for no good reason. If you have an outdoor subject it will help a great deal to make a quick outdoor study for color. There is no better way to sense the difference between the two.

To be a good illustrator, you should get this difference of the qualities of your color into your work when needed. If you know that the subject or incident is outdoors, you can contribute a great deal more conviction and feeling to it if you place it outside by the color you use.

Subjects indicative of night by all means should be placed under artificial light to draw or paint or even photograph. The effect of a close-up artificial light is very different from daylight or sunlight. Night light gives a strong contrast of light to shadow, and this must be carried out in color, in the proper set-up of values. A night subject with airy, light, and transparent shadows is most unconvincing and false. Night subjects indoors lean to the warm keys with almost an all-over effect of warmth. Night subjects outdoors can be warm lights with deep blues and purples in the shadows except where such shadows are receiving warm reflected light. Lamplight and firelight are unquestionably warm.

There are too many instances of illustrators' paying no attention whatever to this phase of color, whereby much is lost, both to them as artists and to the reader in his response. It must be remembered that color has a psychological effect upon the reader whether he is conscious of it or not. He has sensed for himself subconsciously the difference between outdoor and indoor color, perhaps without ever having analyzed it. It is not hard to prove the truth of this difference between indoor and outdoor color. One Sunday afternoon sketching outdoors will convince the artist that outdoor color is nothing like the color he sees in his studio. But if he remains ignorant of this truth, he can go on the rest of his life making the same mistakes and not knowing it.

Sunlight has a crispness, not only of light and shadow, but of color also, in the play of warm and cool. The studio light is soft, with gentle merging of light and shadow, and it pays to get outdoors and find out more about it. Indoor color has to be supplied in the local color of things. Yet outdoors, even the grey things like an old weatherbeaten barn get full of color from the sun, the sky, and reflected warmth, plus the color they have of their own. Rocks indoors would never look like the same rocks outdoors in color unless it were on a cloudy day.

Color can be faked, but it must be understood and worked with intelligently or it can quickly become a mess. So many artists seem to acquire a color formula, this for flesh and this for flesh shadow, and so on. Nothing could be more off the track. Every subject has its own particular color aspect, and the only way to achieve the truth is to go get it from the thing itself. If we have to fake color from black-and-white photography, we can never do it well until we have looked a lot at life and Nature's color.

Before starting the final work in color on any subject, get the habit of setting down the general or postery statement of it in a very small rough. No dimension need be more than three or four inches. Flat tones are better for this than an intricate statement. Try out some schemes which you feel would be related to the subject matter. It is better to lay out three or four of these. In one try a tonal color scheme, or all the colors containing a little of one single color. Try one or two of the color groups, as an experiment. Try reducing all the colors with a little grey or black, saving one or two areas to go in pure. You can try one of strong intensity (See Part Two), or one more light and airy, according to the subject. Too much finish and detail here is lost motion. You are simply thinking of color and general values, and it is not necessary to go into a lot of extra work in the way of form and drawing.

Set up your sketches and step back several feet. Decide which one seems to fit your problem best. If you are undecided between two, take the one which carries best at a distance. When the effect of a small rough is good from a distance, you can be quite certain you have the most important element worked out. The larger one should carry well also if you will hold to your masses and simple statement as much as possible.

If your final subject, when reproduced, is to be set on a white page, or surrounded by white margins, this should also be included in your rough. With a rough for a story illustration, patches of light grey should be placed in approximate location to simulate the effect of blocks of text or script of the story. With a rough for a magazine ad, the general spotting of headings, text, nameplate, and other elements should be suggested. Thus you strive for a whole effect in miniature and simplified statement. This may alleviate much disappointment when the finished thing appears.

Bleed subjects, or those running to the edge of the page with no margins, should be approximated against dark tones, since the space beyond the edge of the magazine page most often appears dark. Roughs for lithograph displays also are sub-

ject to this kind of approach, since they are more often displayed against middle tone or dark than light. The outdoor billboard always has a white margin or "blanking space."

Stating this general effect should not mean more than a few minutes of work per rough. Even if you spend a few hours in planning color, it pays good dividends. If every artist will sell himself to the point of real enthusiasm toward his subject by such planning, it will certainly leave its imprint in his work. Starting anything in the nature of final work with doubt or misgivings, with curiosity as to how another approach might have worked out, or even with the thought that if you don't like an effect it can be subsequently changed, all tends to produce worked-over and uninspired results. Too many of these are very bad for you, and you are really working against yourself as well as your client.

I give you a page of preliminary color roughs, carried a step further than the original roughs, on the page which follows. This would be a second operation, or a further development of a very first conception. My thought was to work out some little figures undersea, and I could have enjoyed doing any one of them for the final. You will note that I did not confine myself literally to the sketch. In fact, I wonder if the little sketch is not almost better than the final? You will find the charcoal study of the figure in Part Two.

There is nothing so discouraging as to have a subject returned to you to be "pepped up" in color, after you have put every bit of brightness you know how into it. Most of the time dull color comes from not having planned it. This is the real advantage of roughs. You know what is going to work out and what is not. You can change your roughs to your heart's content, but be decided when you approach your final. No one can ever be sure of an effect of color until he has set it down and looked at it. Instructions sometimes have a way of sounding wonderful, but looking awful when first tried out. If the plan is not going to work out, find out early and do something about it.

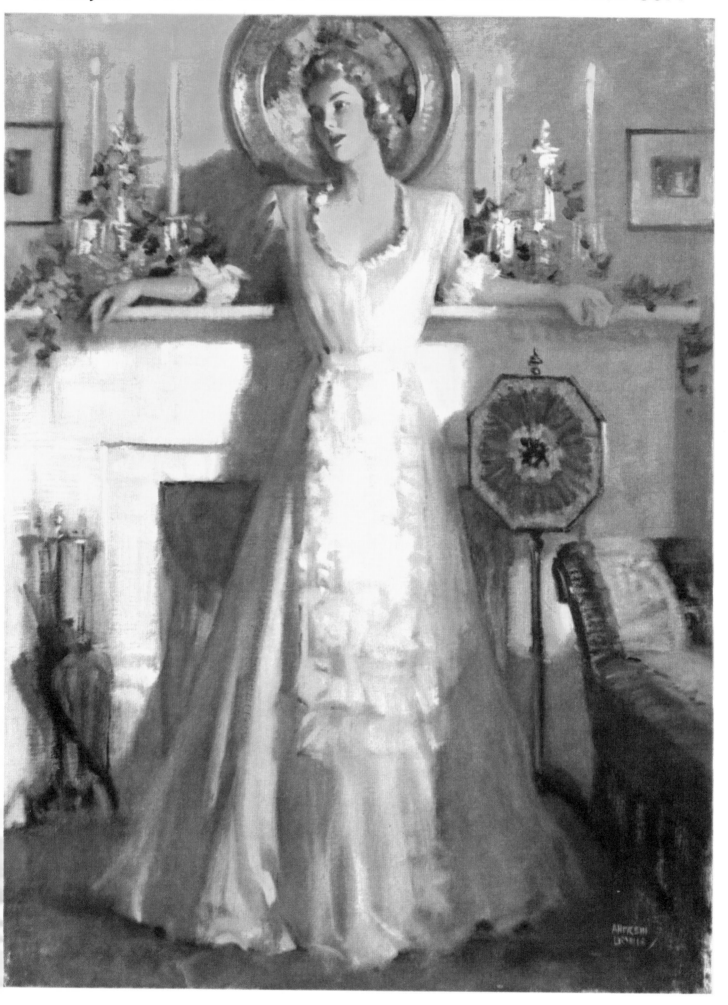

WHAT IS COLOR CHARM, AND HOW CAN WE KNOW IT?

Charm in color springs from several sources. Even ahead of personal taste I should put the working knowledge of color. First and foremost comes color relationship, which I believe has been fairly well worked out here. Now personal taste comes along. Taste in color seems to develop from extreme rawness to the more subtle graduation of color. We start out as children loving bright red, yellow, and blue, the primaries, as it is logical to do, because these colors get attention among the greys of everything else. Then we begin to love the pure tints, or the primaries diluted with white. So a little girl begins to love pale pinks, yellows, blues, for her dresses and hair ribbons, while the boy continues with his full-strength colors. He likes bright red in his sweaters; and blues, green, and blacks. But he also likes the little blond girl in her pastel shades. The second step in the development of color taste begins to include "association," or the fitting color for its purpose. The boy will wear a red sweater but not a red suit; he now wants tweeds, tans or browns or dark blue. The girl begins to like plaids, stripes, and figured material, or something having more than one color.

Certain color characteristics stay on through life in line with individual characteristics. A gay person will like gay colors, a sedate and somber individual will express himself in greyed or neutral color selection. But assuming that we are neither all gay, nor completely sedate, most of us find a logical place for each.

So color charm lies in the appropriate, in relation to its purpose and its environment. I believe that much of what seems inherent bad taste in color is really lack of workable knowledge of the application and association of color.

Color that is bad is usually only "out of place." In simple terms, that means it is dissociated from and unrelated to its surroundings. The same color can be made beautiful through relationship either by changing the surroundings or by making a slight adjustment in the color itself. A color must either be a complement (or close to it) to its background or contain the ingredients that are somewhat present in its surroundings. Anything becomes obnoxious when too completely dissociated from its environment. That is simply the very foundation of good taste.

Suppose a person says. "I like bright red." That by no means indicates bad taste. But suppose he says, "I like pure red with pure yellow with pure blue." That would indicate a completely undeveloped color sense. Any one of the three can be beautiful in a rose garden, *balanced by the color of its environment*. Standing alone, they are raw and completely dissociated. If the brightness of a color is pleasing to us it indicates it is being seen in appropriateness and within a proper color setting. If it seems unpleasant, the trouble lies in the setting, not the color. There is nothing wrong with bright color, we all love it. But we do not paint our houses with the same color we like in flowers, nor would we pick a suit of the same material we like in a necktie. We like a red motor car, but we abhor the same red as blood. We love a red carnation, and hate red flannel underwear.

Learn to trust your instinctive feelings about color. When you do not like a color, do something with it until you do. Grey it, tone it, change it, make a tint of it, change the value. If it is pure and does not seem bright enough, you can't make it any brighter. So grey the colors around it until it takes on relative brightness.

Charm is not always brilliancy. Charm may lie in quiet unobtrusiveness. It may lie in variation, in subtle repetition, and in reserve. Charm in color is like charm in a person. A loud blatant person is hardly charming, yet a charming person may have force and conviction in the right place. I have noticed that persons possessed of seemingly bad taste in other directions invariably have bad taste in color. One who dispels all dignity and convention, who interrupts in conversation, who leads a generally disorganized life, would paint in that kind of color.

174

SHOULD WE ELIMINATE BLACK FROM OUR PALETTE?

I believe that the use of black on the palette depends on the craftsman's ability. There cannot be a rule set up either for or against. When your picture is reproduced, you may be sure that black plays an important part in the final result. Black used intelligently as a toning agent can be most wonderful. But the misuse of it can certainly produce a dull, lifeless effect.

First let us understand that black theoretically represents darkness and loss of brilliancy. It therefore belongs more to shadow than to light. But still there can be greyness in light, and used . there, its purpose is the silencing of overinsistent color, putting it in reserve and relegating it to lesser importance. Many fine painters have used black in this way with great success. There are those who say black does not exist in life and nature. That is true when speaking of black as a color. But lack of color, greyness, and darkness *does* exist in Nature. To say black does not exist is to say that shadow and darkness does not exist. If all color were truly that which comes out of our tubes it would be one thing. But a tube color is seldom right in color, value, or tone. Painting is so much subordination as well as brilliancy.

The greatest danger of black in the hands of the novice is that he makes the value with black and adds a little color. This produces an effect much like transparent color washed over a black-and-white photograph. The result is that all his shadows are black, and the same black for everything. The good use of black never lets the black overpower the color it is toning, or allows the color to lose its identity. There must be some color in the shadow, even though it gets very low in tone. Carrying warm colors deep in shadow is difficult with black, since the mixture of black may produce a certain coldness. In that case, a burnt sienna should be added to the black. However, you will note in our color wheel that the lowest dark seems to fall into place without obvious change of color.

It is not my intention here to take issue with the pure color theorists. I believe that in art we should be free to follow the dictates of our vision and feeling, and if black does the job better in our estimation there is no reason for not using it. If the use of it, after reasonable experiment, seems to work against one, by all means dispose of it, and substitute anything else that will work out.

Black considered as darkness, and not color, is really the opposite of considering our white as light. The color theorists cannot dispense with white and reach the needed values. If they can produce the blacks with color, fine; but nevertheless they are still using black, whether they mix it themselves by neutralizing strong colors with one another, or use it ready mixed. The one advantage of producing the extreme darks with color is that if we can reach the low value it need not be black. Color if dark enough will appear black anyway. I do this whenever possible, but I still may use the tube black as a toning agent to lower the value of a color, for you may thus hang onto the identity of a color longer than you can by mixing it with other color.

The important thing is not how you do it, but whether you can do it. If you can reduce a color without making it another color, throwing a known color into shadow and making it look like that same color in shadow, then any way under the sun you can do it is right.

One thing you cannot do is use the pure strong color as shadow, simply diluting the color with white for the area in light. This will always keep your color false and cheap-looking. Toning color down through eight values is certainly an important part of your equipment and has much to do with your success as a colorist.

Nature's color is most beautiful if we can but see and understand it. You go to her source to express the truth as you see it. So you are a part of color also. Now let us take up other important qualities of good pictures.

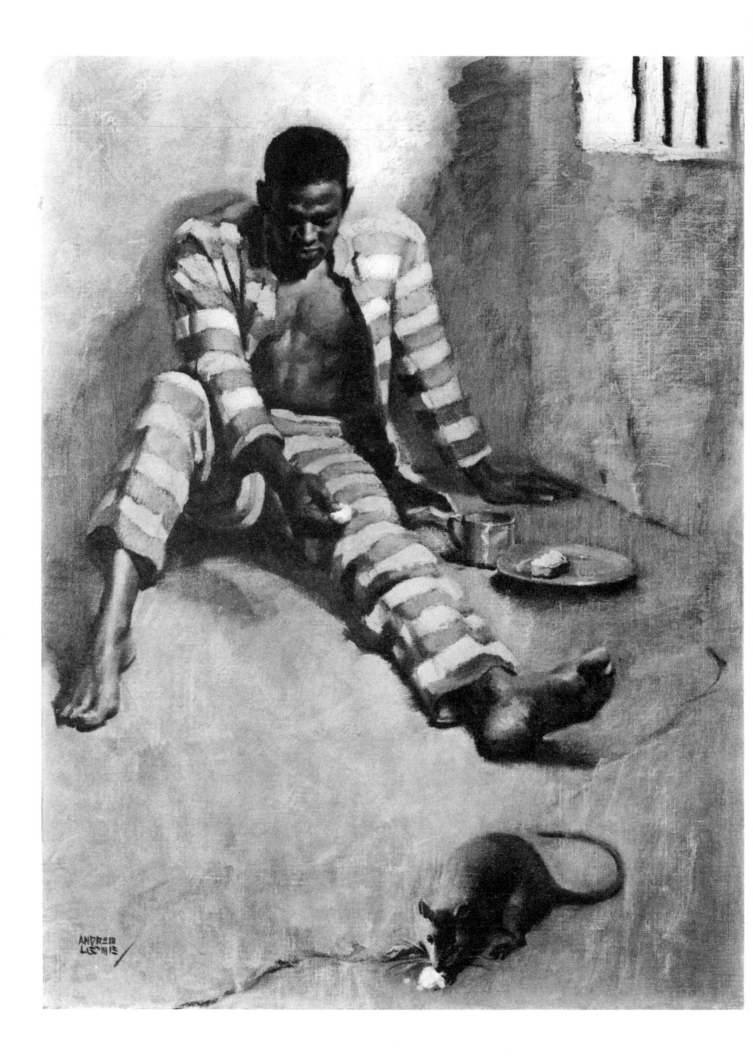

Telling the Story

THERE ARE FIVE ESSENTIALS

1. Visualization
2. Dramatization
3. Characterization
4. Arrangement
5. Embellishment

WHAT IS ILLUSTRATION?

THERE is no better way to approach any task than to have a clear understanding of what is expected of you. Just what is the need and purpose of an illustrator? Let us understand that the primary function of illustration is to make a graphic interpretation of an idea. The idea to be interpreted must be thoroughly visualized. A completely abstract idea can thus be given the semblance of reality. Therefore a picture without an idea or defined purpose can hardly be thought of as an illustration.

The beginning, then, of every illustration is really a mental procedure on the part of somebody—an author, a copywriter, or the artist himself. Some sort of a mental image is present and transmitted to the artist, or else one is conjured up in his own imagination. With his knowledge of form, light, color, and perspective, he is the only one in the group who is able to make that graphic interpretation, though it may be quite clear in the minds of the others. Therefore, the illustrator's true function is to be able to grasp that image, or create one, and bring it to life, carrying through the intent and purpose of the idea. The illustrator subordinates himself to such purpose, yet lends his creative skill to carrying forward that purpose. It is important that every young person entering the field of illustration have the understanding that his job is truly one of co-operation. Most successful illustrators make every possible effort to co-operate, and to make those with whom they are dealing feel that co-operation. This is of great importance to your success as an illustrator.

THE THREE GROUPS OF ILLUSTRATION

Illustration may be divided into three broad groups. You may be called upon to do your part in any one of the groups, and you must be ready.

The first kind of illustration is that which tells the complete story without a title, text, or any written message to help. This type you find on covers, posters using only a trade name, book jackets, displays, or calendars. The client, then, is depending entirely upon you to put over an idea or arouse a desired response. Your work will do the whole job.

The second kind is that which illustrates a title, or which visualizes and carries forward a catchline, a slogan, or some written message used in conjunction with the picture. Its function is to lend force to the message. In this group are most often subjects which carry brief copy for limited reading time, such as posters, car cards, display and magazine advertising. The story and picture function together as a complete unit.

The third kind is that in which the story told by the picture is incomplete, its obvious intention being to arouse curiosity, in short, to intrigue the reader to find the answer in the text. The third type of illustration might be called "come on" or "guess what" pictures. Many advertisements are built on this plan, to insure the reading of the copy. If the story were completely told it might fail in its purpose, and the script or text could easily be passed up. Unfortunately, this happens too often, and when it does, the fault lies in the conception of the picture. It may take three-quarters of a story to get the heroine into the hero's arms, but if the reader is informed of this happy result immediately through the illustration, the whole attempt of the author to maintain suspense is spoiled. Your picture may be beautifully done, but utterly worthless if it gives the story away. An artist must keep this in mind and recognize the need of co-operation. A picture which "tattles" is just as undesirable as a person who does.

In all art, all things work together, and so the essentials of telling the story pictorially all blend

and are dependent upon one another. It is hard to separate them completely, so we shall cover them roughly at first and go into more detail later.

VISUALIZATION

Visualization is building up a concrete image from an abstract one. First we must endeavor to get all the facts, and then embellish those facts with our own imagination. After establishing our subject as belonging to one of the three groups, let us find out the point and purpose of what we are about to do. Let us discern what the mood and flavor of the subject is to be. Is it happy? Is it action, violence—busy, vital? Or is it to be soothing, restful, relaxing, consoling, or somber in its approach? Our subsequent decisions as to interpretation will depend much on what we thus determine the "big idea" to be. Read or get the whole story before you attempt anything. Find out what the characters are like, the setting, general accessories, and the costumes. In fact, you are but setting the stage for the scene, and looking up the characters to play the parts. Can the story be told best by the environment and the characters in it, or is it something that should depend on gestures and facial expression, necessitating "close ups" of the characters with probably only a bit of background? In modern illustration the characters come first and the setting next. You can start getting busy with some tiny little roughs, trying things out as they suggest themselves. You are not hiring models yet, you want to find out what to do with them when you do get them.

DRAMATIZATION

There is usually a dramatic way to tell a story if you will think it out. The first thing we think of is likely to be just about what everybody else would think of. To tell it differently, don't accept the obvious thing immediately. If the story itself is not interesting, perhaps it can be made so by poses or gestures, expressions and suggestion. You might get up in front of a mirror and act the thing out, just as the characters might do. Seldom will a passive interpretation of character with no emotion on your part secure more than a passive response. Every character should be as interesting as possible, and his action planned. Make some little skeleton poses for gesture and try to reason out the action of one character with another, and the position on the floor or a setting as it would be in a good play or movie. The artist must be an actor at heart if he would make his characters act in his pictures.

The eye level chosen will determine much of the dramatic effect. Shall we look up at them, down on them, or straight at them? You can juggle these characters about for space in your picture area, making them fit a good design. Remember that each character should have an individual and different pose of some kind. Don't give two characters approximately the same amount of area in your composition if you can help it. Don't put your characters into the composition in uncomfortably crowded placement, or at the sides with a hole in the middle of the picture. The center area of your picture is the place of honor, pictorially, and should be given to the most important character when possible.

Drama is something you feel, and I cannot tell you how to pose a model. Nor would you want me to. Dramatization is most creative on your part and is a chance to express your originality. Let us realize that truly to observe and appreciate the drama of life as it is enacted we must consciously set ourselves apart as observers. We can be so much a part of it as to miss it entirely. The farmer sees no drama in his routine, but the playwright does. Nellie the shop girl does not know she is a character full of subtle drama, but the author does. Drama is everywhere, and it lies in naturalness and truth more than in fancy.

You are in the position of the motion picture director. Suppose you lay out a little ground plan of the setting where the action is taking place. Suppose it is in a room. Place the furniture, the doorways, windows, and so forth. If you have selected an interior to follow, draw the ground plan of that. Then, to get the "feel" of the action, place your figures in likely spots.

You can turn the ground plan about for a viewpoint. Perhaps you want a bit of the fireplace, or you want to see a face from a certain angle. On the next page I have laid out such a plan. Then you can drop or project the floor plan into a little perspective elevation of furniture, interior, and figures. It is hardly necessary to go into complicated perspective for such little roughs. By squaring off the floor you can locate the units or material.

As the movie director would do, you must decide on what he would call the "camera angle." You can try the angles all around and see what you get. Shift things around at will until an arrangement you like comes to light. It is a good plan when you go to the next movie to watch the pattern compositions constantly changing before you, and the placement of figures, the action and gestures. Motion pictures are in a very high sense the same sort of dramatization you are going after. If you are just sitting there following the story and constantly looking at the faces you may miss the whole good it can do you as an illustrator. You may be sure the director would not let his characters stand stiffly about as if waiting for a cue to recite their lines. The ease and naturalness that the actors display in their roles is half the battle in making good motion pictures. Watch what the other characters are doing as the main character goes along in his part. Characters can be grouped into units of pattern for your composition. Some sort of emphasis may be placed on certain characters by contrast of value, by lines leading through other characters, by color, or by the attention of faces turned toward them. Let them do natural things. A girl might be taking off her gloves or daubing on some lipstick, or perhaps she registers interest in the main character. A man holds a cigarette lighter for the lady, fingers the cocktail glass—anything but stiff-necked poses. The author or copywriter seldom gives you anything to go by for dramatization, mainly the conversation, and a hint of the setting. But this is real fun for you, if you will get interested enough in it. And it all makes "pull" and interest in your pictures.

CHARACTERIZATION

Casting the play is an important part of the director's job, and it must be of yours, too. You try to visualize the characters as vividly as possible. Sometimes you will change the character of your model to suit the character in your story. Try to hunt up suitable models. It is too easy to use the same model two or three times in the same subject by just changing from blonde to brunette, or using a different costume. This is the lazy way, and it is costly in the long run. If you continue to show good characterization it will lend variety to your work. In the end it will keep you going when your competitor is all through. I never believe in trying to make a matron out of an eighteen-year-old girl by painting streaks of grey in her hair. Characterization for the most part is getting workable facts. What does an old lady's bony hand really look like? How does she do her hair? What are the planes in the jowls of an old hard-fisted gambler? You cannot fake these things, and they tell so much when they are right. There can be character in an old shoe, things spread out on a table—in fact, all the accessories may tell a story of the life that is going on in your subject. If the character is tired and worn, the clothes can suggest it. Don't be afraid of creases and wrinkles on anything but a fashion plate. Make them fall naturally into place, stressing the form more than the garment. Watch for "lost and found" edges. Try to interlace the figure with its background wherever possible so that the contour is not completely defined all around. (See The Treatment of Edges.) This relieves "stiffness" of figures in your composition. Do not make all figures equally important.

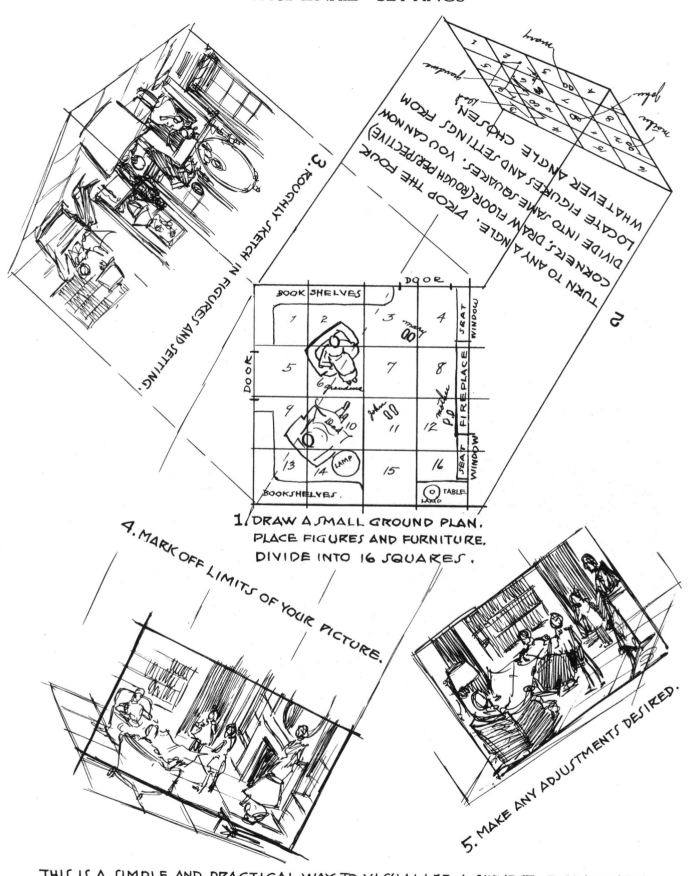

3. ROUGHLY SKETCH IN FIGURES AND SETTING.

2. TURN TO ANY ANGLE. DRAW FLOOR (ROUGH PERSPECTIVE) CORNERS, DIVIDE INTO SAME SQUARES, LOCATE FIGURES AND SETTINGS FROM WHATEVER ANGLE CHOSEN. YOU CAN NOW

1. DRAW A SMALL GROUND PLAN. PLACE FIGURES AND FURNITURE. DIVIDE INTO 16 SQUARES.

4. MARK OFF LIMITS OF YOUR PICTURE.

5. MAKE ANY ADJUSTMENTS DESIRED.

THIS IS A SIMPLE AND PRACTICAL WAY TO VISUALIZE A SUBJECT. IT CAN GET YOU STARTED WITH A SENSE OF REALITY. YOU CAN LAY OUT A SETTING WITH LOGICAL PLACEMENTS AND FIGURE ACTION, AND VIEW IT FROM ANY ANGLE.

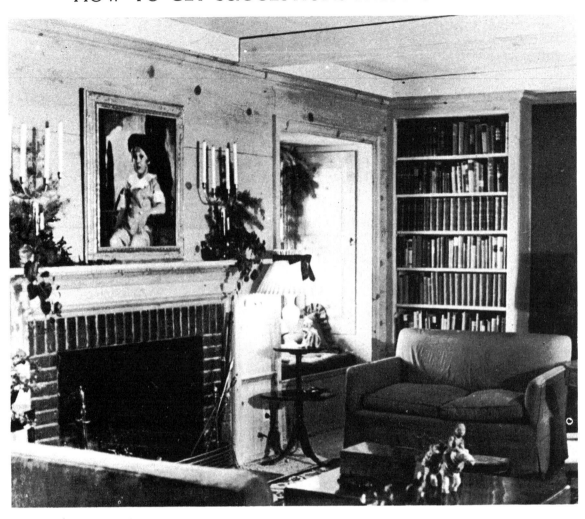

Above is a typical photographic interior as it might be clipped from any one of a number of magazines on the market. You will need a pad of transparent tissue paper. The object here is to help you visualize a situation on the tracing paper. You can move the tracing paper about and, allowing for perspective, thus move the furniture about if you wish. I do not suggest, of course, that you make a complete copy of any copyrighted material, but since the magazine is published to give one information and ideas as to interior decoration, there should be no objection to using it as a source of information and suggestion. The point is that the clipping should not be a "swipe." Draw-

ing interiors with figures is an excellent form of practice in dramatization and in the setting of figures into an environment with respect to perspective and lighting. Establish a lighting on your rough suggestions of the figures by studying the lighting of the photo. You can in turn put such lighting on your model, and set the camera or eye level to be consistent with the eye level apparent there.

If you have difficulty in placing figures by imagination, it is suggested that you study my earlier book *Figure Drawing for All It's Worth*, in which I have tried to give just this type of information.

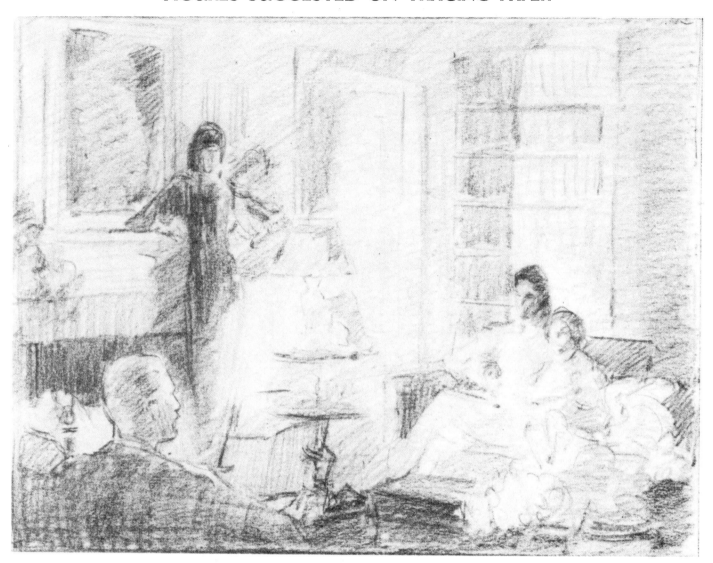

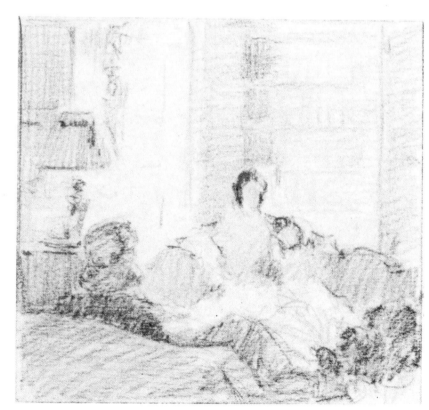

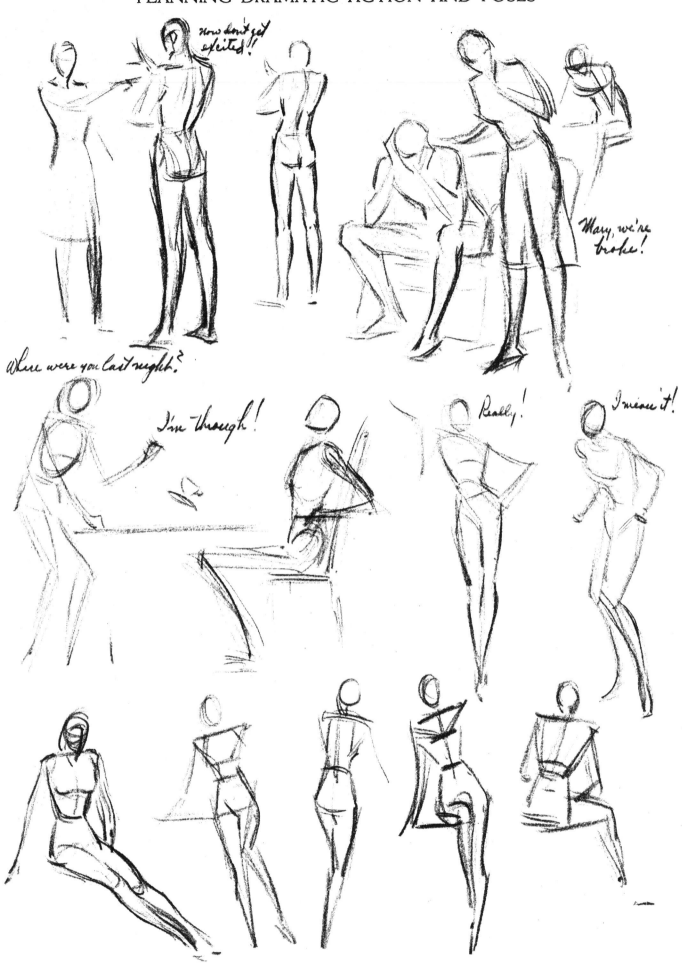

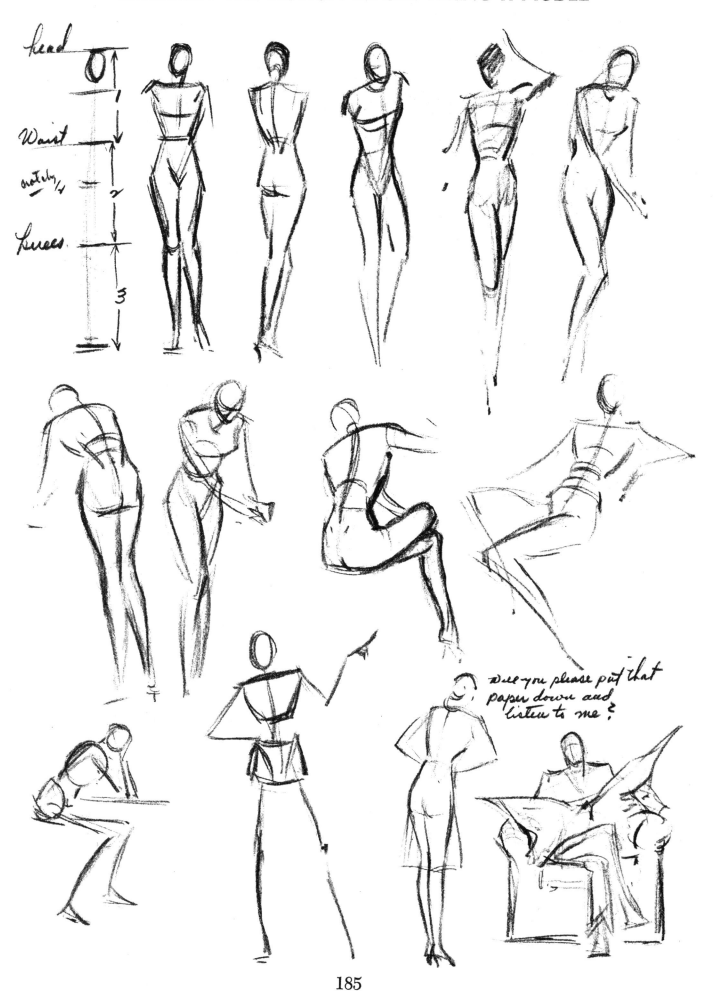

will you please put that paper down and listen to me?

THE ESSENTIAL ARRANGEMENT

The manner in which a picture is conceived will vary with every artist. In advertising commissions the subject often comes to you in layout form, already visualized by an artist in connection with the agency. These men for the most part are exceptionally skilled in the general presentation of an idea. As a general rule, however, they are interested more in placement and mass, and the detail or final interpretation of the idea is left to you. The purpose of the layout or sketch has been to visualize the idea generally for their own client to obtain a "go ahead" from him before going into expensive art costs. Also the layout covers the entire ad, indicating main copy and placement of all units to appear. Considerable latitude may be allowed as to poses, clothing, accessories, types, and dramatization. So the work I am laying out here applies from the first rough idea, whether your own or whether turned over to you to be carried forward.

Arrangement as discussed here can take place only after the idea becomes definite, supported by such facts as will lend themselves pictorially. You will begin to see how all the essentials are interdependent with one another and are all directed toward a single purpose. It is important to have the poses fairly well conceived in rough form. The setting, if any, should also be decided upon. At this early stage we begin to think about pattern and tonal arrangement. Some artists start with the figures and action, and develop a setting with them; while some even start with abstract patterns, adjusting the figure to the pattern. It matters little how you arrive at good design. You may go at it differently each time; the important thing is the conception of your picture. The arrangement and design should be considered carefully. There is no law governing arrangement; you must simply do what you think looks best after trying several arrangements and selecting the one you feel is most suitable. Personally, I like to start with a design first and adhere to it as much as possible.

The one advantage in making an abstract pattern arrangement first is that it may suggest so much of the rest of the picture. You get ideas from these abstractions as you try them out. For example, you have a dark pattern here. It may suggest that you use a figure in a dark dress. If the pattern is of a certain shape, it may suggest some accessory, or some unit to go in the subject. The pattern may even suggest the lighting, a mass arrangement of figures, or shadow, a window, a hill, or what not, so long as it is an interesting design. Any subject not limited in the beginning to certain material or copy should always be worked out in miniature roughs for tonal arrangement. May I say that the reason for the lack of this essential arrangement in our everyday art is because it is not sufficiently considered by the artist. He has a thing and copies it and puts something around it and calls it a job. Admitting all subjects are not given latitude in this respect, you can do at least the best you can, if only in the placement of your material.

The most important element in your work, and the thing that moves you ahead fastest, is the conception of your subjects, and it is therefore worth while to give it the time it deserves. You must exercise your inventive faculty if you would ever truly excel. The more jobs you leave it out of, the longer the journey.

Thumb through a magazine. Put a check on the illustrations that seem to appeal to you most, including photos or anything else. Now go back and with a piece of tracing paper rough in the mass arrangement evident in the ones you like. You are really subconsciously partial to good design and arrangement, and so is everybody else. Design is the one way to get away from the ordinary. We all think we can't design, but somehow we do. Often design comes by seizing upon the accidental. We seem to get "hunches," and there are days when we design better. All we can do is to adapt the units which we have to work with, as pleasingly as possible.

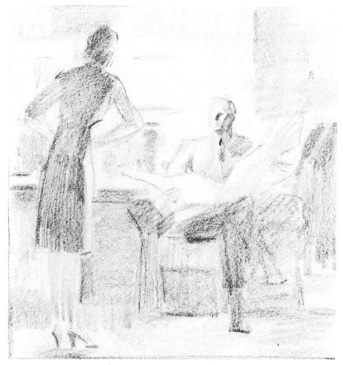

STARTING FROM THE PREVIOUS ROUGH.

TURNING THE FIGURES AROUND AS EXPERIMENT.

TRYING THE FIGURES "CLOSE UP". IMPROVED.

BEST BECAUSE OF DESIGN. STORY CONCENTRATED.

THERE IS NO DOUBT THAT THE CONCEPTION OF A SUBJECT IS OF GREATER IMPORTANCE THAN ANYTHING ELSE. IT PAYS TO SPEND CONSIDERABLE TIME OVER ROUGHS UNTIL YOU FEEL THAT YOU HAVE A GOOD ARRANGEMENT PLUS AN EFFECTIVE DRAMATIZATION OF THE SUBJECT. IF YOU CAN SHOW THE FACE IT IS BETTER TO DO SO. TRY TO WEAVE THE LIGHT,

GREY AND DARK AREAS TOGETHER SO THAT THE PICTURE IS BALANCED AND SPOTTED INTERESTINGLY. THESE ROUGHS ARE FROM THE LAYOUT PAD AND SHOW HOW ONE CAN EXPERIMENT WITH POSES. IT WOULD NOW BE MUCH EASIER TO PROCEED WITH THE MODELS HAVING A CLEAR APPROACH IN MIND. THE FIRST ROUGH IS SELDOM JUST RIGHT.

EMBELLISHMENT

Embellishment as applied here is the carrying forward to completion of the preliminary material you have worked out. You now seek to give your conception actuality. For your figures, you will go to life for character, good drawing, and the things which lend reality. For the tonal qualities of form, go to real form. For the effects of light and shadow you should look first at existing light and shadow. Set up your image in real life as far as possible. The mental image you have been playing with must be made consistent with truth if the thing you do is to have that "quality of existence" without which your work is bound to suffer. It is no easier to fake the truth in art than anywhere else.

Every subject is, of course, an individual problem, and should be approached for its own possibilities. Some subjects seem to call for a specific medium, or even a specific technique. Some should be treated delicately and others with great vitality. Herein lies the charm of embellishment. That artist is so much greater who can change pace, give a mood to his work, treat one thing tenderly and another with power and impact. That is my main reason for devoting so much of this book to a variety of approach. You can keep your work out of a rut, and ever new and inviting. Coupled with the variety of mediums and technique at your disposal, you have different keys of values, different kinds of light, such as soft, diffused, or brilliant and sharp. You have the strong intensities of light to shadow, with little reflected light, or the airy luminosity of the higher relationships, with much lighting of the shadows. You have pure and intense color schemes, tonal color schemes, and soft related schemes. You have the possibilities of line treatment, tone treatment, or a combination of the two. There is really so much to work with in the way of approach if we will but think. If you find yourself working in one medium only, doing the same things with it every day, you badly need to explore the wealth of things at your disposal. There is enough to spend a lifetime of experiment. Do not believe your approach is something narrowly limited. It is only limited by keeping it so.

When you are fairly well decided upon what you would like to do with a subject, and you have spent some good thought over your roughs, then get out your camera and work intelligently with it. You can make it work *for* you in expressing your thoughts, rather than the other way round, of your simply accepting what it tells you.

If you can get your models interested by showing them the preliminary roughs and explaining the story, they will do better work. Let them act out the idea before you click the shutter. You can get enthusiastic support from them by letting them know how important they are to the success of this effort.

I personally prefer the miniature type of camera, using the regular 35 mm. film. I like the panchromatic or color-corrected types of film. I believe it is best for the artist to learn to take his own pictures rather than to depend on the commercial variety, because the right lighting is so important. I do not like to argue with a man who knows his business in his own field but cannot understand that the artist's approach may be something else. I prefer very simple lighting to preserve the form, and it's hard for those fellows not to want to insert half a dozen lights. It's even harder to explain that such copy is not worth a damn to the artist who is form-conscious, and that those lights break up the very beauty that a good drawing or painting depends upon.

Make every effort that is humanly possible to get all the form you are going to paint, registered in the picture you take. Form is registered truly when one light shines upon the same area or surface. Two lights on the same area are bound to destroy the solidity of the planes.

Anyone working with a camera experiences certain disappointment at times when a subject that looked so beautiful while you were taking it appears quite different in the black-and-white photo. Much of the loss is color and value as the eye sees it. Much, too, is lost because the camera does not see in the same proportions and perspective as do the two human eyes. The three-dimensional effect is gone except in the case of a stereopticon camera. Objects diminish in size by reason of distance much more acutely in the lens than to the eye. This will give a feeling of distortion, especially if the subject has been taken at close range. The values you get are the result of the actinic qualities of the light and film and may seem quite different from the way you saw them. Things that appeared so colorful and brilliant have a way of going quite dead. Then there is the overpowering array of sharp detail, which has not the softness as seen by the eye.

For the foregoing reasons it is much better, when making black-and-white copy, to choose things for a variety of value rather than color. That is why your small pattern arrangements should be well worked out beforehand. Get the kind of values in back of and around your model as laid out in your tone plan. Have on hand a very light drape, one of light tone, a middle tone, a dark tone, and a black. Pin up such drapes behind your model so that the right values come to the right edges on the model according to your composition. If the head is to be against dark, put it against dark in your copy. The values in a head appear different according to the value they are seen against. The same values may appear dark against light, or light against dark.

If you intend to show something against a light source, or as looking into the light, about the only way you can get good copy without fogging your negative is to throw a strong light on a white background and then pose the figure against it, being careful to keep that light off the figure. A "fill in" light of lower intensity can then be thrown on the figure, keeping it low enough to hold the mass of the darker values of the figure against the light. Strong lights placed too close to the model "burn" your negative to dead white in the print. Move them back, since you cannot secure such brilliancy anyhow, because nothing can be lighter than the white of your printing paper.

Unless you want very intense contrast of light and shadow, as for instance some copy for a black-and-white line drawing, it is usually necessary in indoor photography to lighten your shadows with a "fill in" light, daylight, or some manner of reflected light. The fluorescent lights are good for this, since they do not make sharp cast shadow within the shadow, which does not happen in nature. If your subject is supposed to be outdoors, by all means go outdoors to take it. Nature sets up perfect values and relationships.

Clippings seldom work out from a lighting and value relationship when you are trying to associate the material from one clipping into another. Lighting must be consistent throughout a good picture, and the chances are slim that two clips will have anything like the same lighting. This is the main reason for securing your own "props" whenever possible. Starting with a clip which has a distinct lighting, you can always adjust the lighting in your photos to correspond when you prepare further material that must appear along with the material in the clip.

Get the right costume if possible. Material is very hard to fake, especially folds, as you probably already know. If it is not possible, get a costume as near to what you need as you can, at least so that you won't have to fake the material, form, or drape. The pattern of the costume can be changed more easily than the forms.

It is wonderful practice to take some interiors, draw them in pencil, and then introduce figures of your own into the subject. Study the interior for its lighting and then try to suggest a consistent lighting on the figures. In this way you get the "feel" of what happens to figures set into a definite environment under prescribed conditions of lighting and space.

THE ILLUSTRATOR'S SCALING SCREEN

Here is a simple prop for the illustrator who draws from photos. It is easy to build and of tremendous help in drawing in good proportion. Build the screen in three wings or four, at a height above the average camera shot. It can be made of beaver board or any light wallboard that can be painted white. Use thin black lines to mark off the square feet as shown in the illustration. Such a screen will also provide a good surface over which drapes can be thrown or onto which they can be thumbtacked. Then the drapes may be taken down and an automatically scaled photograph taken of the subject. This gives you at once complete information for setting a figure into a composition. As we know, every figure should be related to an eye level. You can always determine the eye level in your photo by turning one of the end wings toward the camera. The eye level will be on a line where the lines of the side wing converge to a point. (See Drawing.) It is simpler to find the line on the side screen that appears to be most nearly horizontal.

If your rough or copy determines an eye level, then set your camera up to a similar height. (See Perspective, Part I.) It must be clear that the material from two photographs having different eye levels cannot be set into the same picture without adjustment and appear correct. Many artists continue to disregard the simple rule that the horizon must cut across all similar figures standing on the same ground plane in the same place, or at the same distance up on the figure from the ground level. So if you know the horizon of your copy would cut across the figure at the shoulders, then set the camera at the line at the level of her shoulders, and make sure it cuts all figures of your composition relatively. Should a figure be sitting at a certain distance beneath the horizon, then all sitting figures would bear the same relation to it.

The squared-off screen now gives you the relative size of your subject throughout, making it easy to determine the proportion of one part to another. The squares may be still further subdivided on the photo, and you can lay out a set of squares on your drawing by which you can draw the figure proportionately. Since these are laid out in feet, you can also measure approximately the dimensions of material in your clippings to make the figure the right proportion to be within such an environment.

For your information, the average chair seat is eighteen inches off the floor, or one and one half of our blocks. Table height is about twenty-eight to thirty inches, or about two and a half squares high. A standing girl is about five and one half blocks and a man six. This will be clear to you only if you understand perspective; as I have already warned you, without that knowledge you are only handicapping your future opportunities.

All drawing is proportion and measurement first, and a statement of spaces and contour. The scaling screen will help you in that, though there is nothing so good as training your eyes to distances and relative sizes. With some artists it comes easily, others take considerable time to get it, and some unfortunately never are able to do it. Hence all the artificial means of pantagraphs, projectors, and other devices. But with the scaling screen, you still are doing the drawing and training yourself at the same time. You can use it without undermining your natural ability or creativeness, and therefore it has a place here.

Most artists are fairly good carpenters, but if you cannot build such a screen yourself, it would be wise to have one made, which can be done quite reasonably. The screen serves other useful purposes about a studio, such as shutting off the normal background when you are painting directly from a model. The drawings on the next page should clarify the use of this screen.

The scaling screen amounts to about the same thing as squaring off a study for enlargement, as all artists have been doing since art began. We have substituted the photo, to a large extent, for the preliminary studies of the Old Masters, who perhaps might have used such short cuts also, had they been available. The main thing is not to let the camera habituate us to the least possible effort. We must exercise our drawing sense or eventually lose it.

THE ILLUSTRATOR'S SCALING SCREEN

PHOTOS TAKEN, USING THIS SCREEN AS BACKGROUND, ARE AUTOMATICALLY SCALED OFF. BY INCLUDING SIDES, THE EYE LEVEL IS EASILY ESTABLISHED.

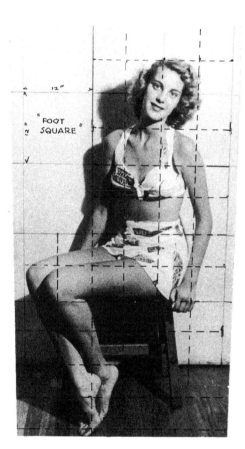

THE EYE LEVEL 5 IS THE LEVEL LINE RUNNING INTO THE SIDE PANEL HORIZON VP

THIS SCREEN WILL ENABLE YOU TO QUICKLY ESTABLISH RELATIVE PROPORTIONS OF FIGURES AND "PROPS", ALSO DISTANCES BETWEEN THINGS, AREAS OF PARTS, HEADS, ARMS ETC.

ANY TWO CONVERGING LINES OF A SIDE PANEL WILL ESTABLISH THE HORIZON OF YOUR PHOTO.

TO BUILD THE SCREEN USE 1 X 2" LIGHT PINE. COVER FRAMES WITH WALLBOARD. USE REVERSIBLE HINGES. PAINT ONE SIDE LIGHT AND THE OTHER DARK. MARK OFF BY SNAPPING A POWDERED STRING. PAINT BLACK LINES ON LIGHT SIDE AND WHITE ON THE DARK, 12" SQUARES. MAKE IT SMALLER IF YOU WISH. USE LIGHTEST MATERIALS.

THE SCALING SCREEN HELPS TO KEEP YOUR WORK IN GOOD PROPORTION WHEN DRAWING FROM LIFE OR PHOTOS. YOU THUS ARE NOT BOUND DOWN TO "PROJECTED" CONTOURS OR DISTORTION OF THE CAMERA. DISTORTION BECOMES OBVIOUS WHEN THE SQUARES IN THE PHOTO ARE TOO UNEQUAL OR ARE DISTORTED BEYOND A NORMAL DEGREE OF PERSPECTIVE. THIS IS NOT A "CRUTCH." YOU MUST STILL DRAW. BUT IT HELPS AMAZINGLY !

SIMPLY POSE YOUR MODEL AGAINST THE FLAT SQUARES.

IT IS SIMPLE THEN TO MAKE COMPARATIVE MEASUREMENTS OF ALL PARTS OF THE SUBJECT BY EVEN USING THE EYE ALONE. FOR EXAMPLE, THE GIRL HERE FROM TOP OF HER HEAD TO BENCH IS 3½ "FOOT" SQUARES. THE HEAD NEARLY FILLS ONE SQUARE. IT IS ANOTHER UNIT TO LINE UNDER BREASTS. IT IS A UNIT AND A HALF TO BENCH, AND SO ON.

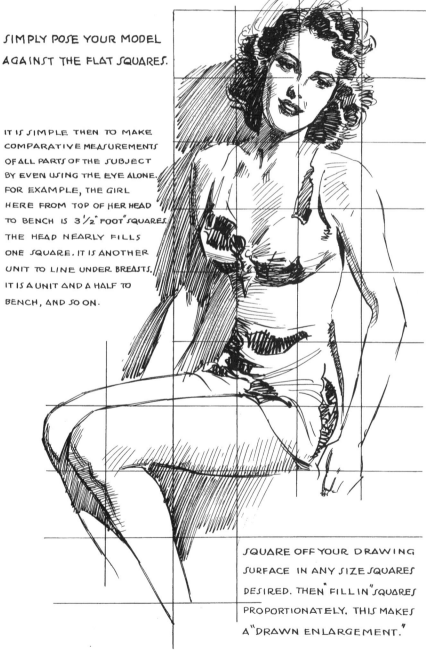

THE LINES OF THE SCREEN MAY BE CARRIED ON THROUGH THE SUBJECT AND BE FURTHER SUBDIVIDED, THUS SCALING THE PHOTO AS YOU WISH. IF THE LINES ARE "OFF SQUARE" A LITTLE THIS DOES NOT MATTER. TOO MUCH DISTORTION SHOULD BE CORRECTED. YOU CAN LAY OUT DRAWING IN SQUARES. SOON YOU WILL NOT EVEN NEED TO DO THAT. YOU WILL ONLY USE THE MAIN LINES APPEARING IN THE PHOTO AND MAIN POINTS OF INTERSECTION.

SQUARE OFF YOUR DRAWING SURFACE IN ANY SIZE SQUARES DESIRED. THEN "FILL IN" SQUARES PROPORTIONATELY. THIS MAKES A "DRAWN ENLARGEMENT."

THIS IS BETTER THAN USING "PROJECTION" FOR YOU ARE CONSTANTLY TRAINING YOUR EYE AND HAND. IT'S WORTH IT.

THE SCALING SCREEN AND CAMERA DISTORTION

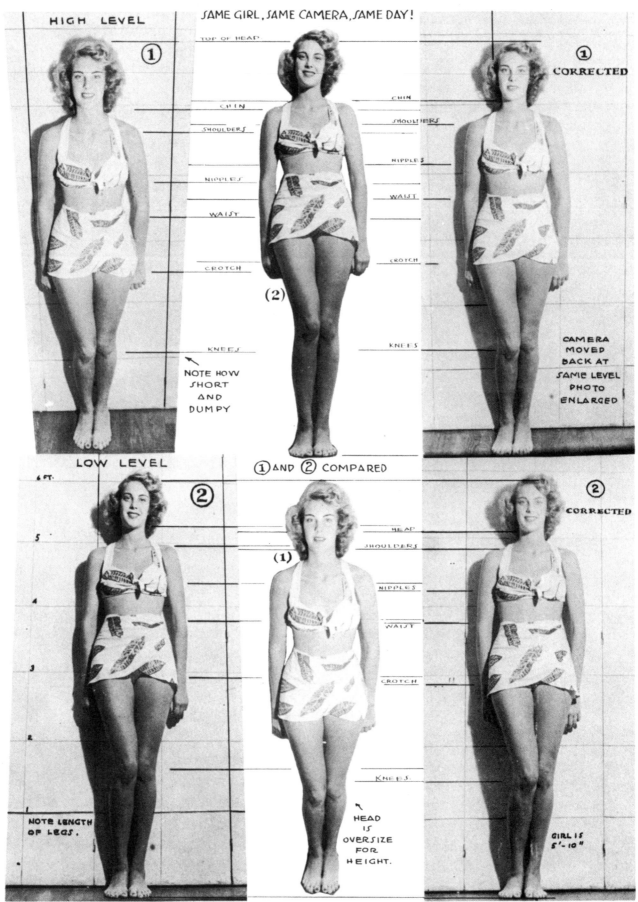

SAME GIRL, SAME CAMERA, SAME DAY!

HIGH LEVEL ① — TOP OF HEAD, CHIN, SHOULDERS, NIPPLES, WAIST, CROTCH, KNEES — NOTE HOW SHORT AND DUMPY

② ① AND ② COMPARED

① CORRECTED — CAMERA MOVED BACK AT SAME LEVEL PHOTO ENLARGED

LOW LEVEL ② — NOTE LENGTH OF LEGS.

① HEAD, SHOULDERS, NIPPLES, WAIST, CROTCH, KNEES — HEAD IS OVERSIZE FOR HEIGHT.

② CORRECTED — GIRL IS 5'-10"

CLOSE CAMERA EXAGGERATES HEIGHT

CAMERA MOVED BACK, PHOTO ENLARGED

THE CONTOURS CANNOT ALWAYS BE TAKEN AS CORRECT JUST BECAUSE THE PHOTO WAS TAKEN FROM LIFE. THE SCALING SCREEN BRINGS OUT AMOUNT OF DISTORTION FOUND IN EVEN THE BEST OF LENSES WHEN PLACED TOO CLOSE. ① AND ② ARE VERY DIFFERENT TAKEN AT HIGH AND LOW LEVELS. YET WHEN THE SAME LEVELS ARE USED FARTHER BACK THE TWO ARE ALMOST ALIKE, GIVING THE TRUE PROPORTIONS OF THIS TALL GIRL.

192

CAMERA DISTORTION

DISTORTION RESULTING FROM CAMERA BEING TOO CLOSE. FOCAL DEPTH MUCH TOO SHORT. NOTE SIZE OF HAND.

CAMERA MOVED WAY BACK AND SUBJECT ENLARGED. HANDS WERE KEPT IN SAME POSITION. BETTER?

THE DISTORTION ABOVE IS OBVIOUS. HOWEVER MOST OF US, FOR THE SAKE OF DETAIL AND SHARPNESS, WORK TOO CLOSE. IN THE END IT IS BETTER TO SACRIFICE DETAIL FOR CORRECTNESS OF PROPORTION. THERE IS EVEN DISTORTION IN FACE TO LEFT, WHICH WOULD NOT BE OBVIOUS WITHOUT OTHER PHOTO. FACE SEEMS NARROWER, CHIN SHARPER, LESS HAIR, AND MODELING OF FORM APPEARS "FLATTER".

WHY THE "CLOSE UP" CAMERA DISTORTS.

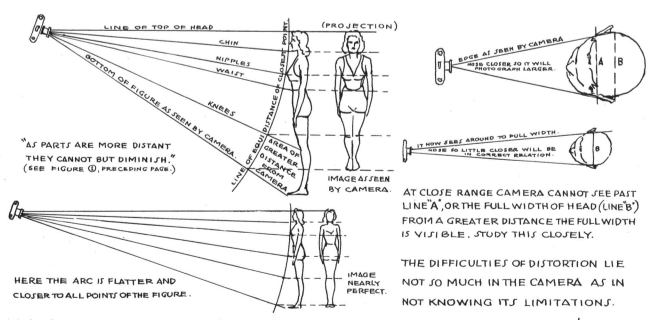

LINE OF TOP OF HEAD

CHIN

NIPPLES

WAIST

KNEES

BOTTOM OF FIGURE AS SEEN BY CAMERA

(PROJECTION)

"AS PARTS ARE MORE DISTANT THEY CANNOT BUT DIMINISH." (SEE FIGURE ①, PRECEDING PAGE.)

IMAGE AS SEEN BY CAMERA.

HERE THE ARC IS FLATTER AND CLOSER TO ALL POINTS OF THE FIGURE.

IMAGE NEARLY PERFECT.

EDGE AS SEEN BY CAMERA

NOSE CLOSER SO IT WILL PHOTOGRAPH LARGER.

IT NOW SEES AROUND TO FULL WIDTH. NOSE SO LITTLE CLOSER WILL BE IN CORRECT RELATION.

AT CLOSE RANGE CAMERA CANNOT SEE PAST LINE "A", OR THE FULL WIDTH OF HEAD (LINE "B") FROM A GREATER DISTANCE THE FULL WIDTH IS VISIBLE. STUDY THIS CLOSELY.

THE DIFFICULTIES OF DISTORTION LIE NOT SO MUCH IN THE CAMERA AS IN NOT KNOWING ITS LIMITATIONS.

I AM SORRY TO UPSET THE THEORY THAT ANY PHOTO IS TRUE AND EXACT BECAUSE IT'S A PHOTO.

DRAWING TO AVOID PHOTOGRAPHIC DISTORTION

Perhaps the examples of photographic distortion I have given you may seem a bit exaggerated and obvious. But I assure you that compared to the way we see things in life, there is much yet to be done in camera lenses. Since the miniature camera has such a proportionately large lens in relation to the pictorial film area, it cuts down distortion greatly. But the examples here were taken with the best of cameras and lenses of that type, proving distortion is still possible when working too close. There is distortion in the average photo which is not obvious, but which, if followed too closely, gives that photographic look to your work. When the squares in your scaling screen do not register as squares in your photo, it proves that distortion exists and that this distortion is affecting the subject as much as the lines on the scaling screen.

Drawing directly from life will always be the soundest approach artistically, for it takes on a quality of proportion you never can get with the single lens of a camera. I do not know enough about optics to explain why things at a short distance from the line diminish faster or get smaller than they do in the same distance from the eye. There are such things as telescopic lenses, wide-angle lenses, and so forth, that are more nearly true in this respect, but when we have such perfect instruments as our own eyes, why should we not train them to do the work in every case where it is possible? I grant that at times we must catch fast movement, expressions, or poses too difficult to hold long enough to draw. Then let us use the camera.

I wish to make clear that because a photo was taken from life, it must not be assumed that it is a perfect interpretation of life. It is not perfect from the standpoint of contour, perspective, or tonal value. If a perfect duplication of what the eye sees were possible, it still would not be art. So perfect duplication of a photo on the part of the artist cannot be construed as art. Individual creativeness must play some part; organization and design, accentuation and subordination, the qualities of tone and individual technique, and the emotional qualities, must be present to make it art. Otherwise we could be content just to go on clicking shutters. Again I want to impress upon the young artist that art is not necessarily a framed picture hanging in a museum or a private collection. Art is all around us, for art is the expression, in one way or another, of individual concept. The smallest and cheapest commercial drawing can be art if it has those qualities. Art is not imitation nor duplication, and that is why the mechanical camera can never become a means of producing art. Art must flow through the camera, not into it; it starts behind it, not out in front.

I have pointed out these faults of the camera here and elsewhere so that you may watch for them and recognize them. I do not quarrel with its limitations, for there is no question that it is a marvelous instrument. But I do insist that since these limitations exist, they should be made known to the student. Photographs cannot be considered an easy way out of good draftsmanship, nor in any sense a substitution for it. The camera should be a part of your equipment. (The projector is another matter, and I hesitate to endorse it in the same degree, although I cannot dispute its value when exact and minute duplication of copy becomes necessary. But when it is merely a crutch, with so much potential loss of individuality at stake, I would prefer to see it thrown out the window.)

You may be sure every figure will photograph somewhat shorter and thicker through the middle than it really is. The proportion of the head and shoulders at one end of the body and the legs and feet at the other will not photograph truly in the case of a standing figure unless at considerably more distance than we usually set the camera. Always remember that the camera is totally impartial to the good and bad in front of it, with no selection or discrimination. The photograph is only a record of an instant. For this it is valuable. Without a well-developed ability to draw, we can copy distortion without realizing it, and unconsciously add a photographic look which breaks down other good qualities.

194

CAMERA DRAMATICS

By the time you are ready for the aid of the camera in dramatic interpretation you have given every other consideration to your subject. You have a fairly clear idea of what you want. You have an action or gesture in mind, or a particular facial expression. Now let us talk about the actual dramatic interpretation.

A model is usually one of two extremes. Either she has difficulty in acting at all, or is inclined to overact, getting a little grotesque with her dramatic sense. We may borrow the first principle of good acting from the dramatic schools. That is the unwritten law of naturalness. Only naturalness can carry conviction, and it marks the best actor. If this principle is true on the stage or screen, it is also true in illustration. The action or emotion should be carried completely through the figure in the whole pose and not expressed just by making faces, or "mugging," as they call it in motion pictures.

There is a good rule in dramatics that the actor should never look at the audience as long as there is any action going on, especially when other actors are on the stage. The invisible "fourth wall" separating players from audience lends reality to the play; you become lost in the story, totally unconscious of yourself. If the actor looks at you, you feel a certain self-consciousness, something like being caught looking into a window of a place where you do not normally belong. Your reaction is that the actor is acting *at* you rather than being a part of a story wholly separate from you. So let us make a rule. *If the reader is not part of the dramatic action, never let a character look directly at him.*

Now we take the other extreme. Suppose we want to make a direct appeal to the observer. In that case the reverse is true. The character looks directly at you, with the intention of making you self-conscious to the appeal in mind. Everybody remembers James Montgomery Flagg's poster "Uncle Sam Wants You," the finger as well as the eyes pointed straight at you. It was tremendously effective. Therefore this principle is used in advertising when character-to-reader attention is

demanded. A pretty girl may be handing you a glass of beer from a poster, a charity appeal might have a head looking at you, saying, "Will you do your part?" This is called "direct" appeal.

Overacting is worse than not enough. Agonizing over a trivial matter, or exploding with joy over a toothpaste, is just not natural or in good taste, and the response could be negative. To get at the most telling dramatic effect, one has simply to think of what he would do himself or what any normal intelligent and well-bred person would do. There is not one set of manners for life and another for the stage, screen, or illustration; they all are based upon a convincing interpretation of life. If bad manners are the basis of the story, then that is something else.

Underacting may be analyzed as "stiffness." This actually means rigidity of body, face, and action. So the next law of good dramatics is utter relaxation. The only tension present must arise from the emotional situation in the story. People are stiff only when dead or frightened. Hence the expression of "being scared stiff," or the slang reference to a corpse as a "stiff." Never let a model pose "straight all over"—that is, with head in a straight line on shoulders that make a T with her line of vision, no bending of spine, or turning of hips, and with the weight resting equally on both feet. If you have not told her the drama you want, that is invariably what she will do. Drop a shoulder, twist her, turn a hip, bend a knee, get her as relaxed as possible. Sitting poses straight in a chair with feet and knees together and arms doing the same thing on each side can be insufferably stiff. It's up to you to get that quality out of the model, and that is the reason for planning poses in advance.

Act it out as you would on the stage or as if you were a director, for that is what you really are. Otherwise you will transmit such stiffness to your work, and no matter how well you draw and paint, nobody will forgive you for it. Believe me, I know. Pay especial attention to the hands: make them express the emotion of the face, make them belong in some way to the story.

195

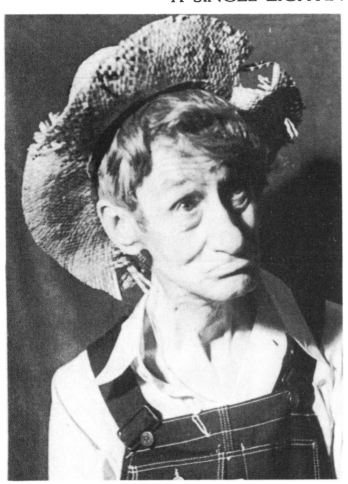
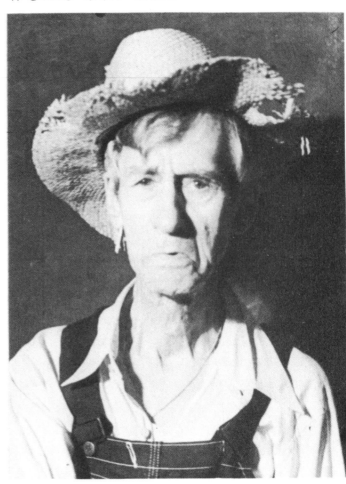
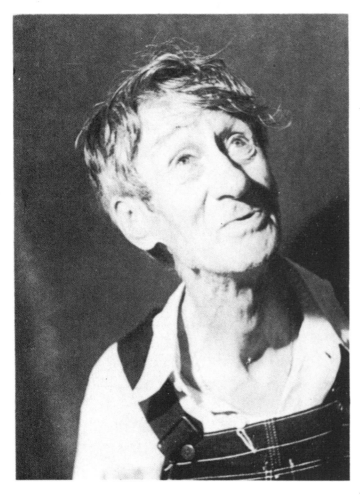
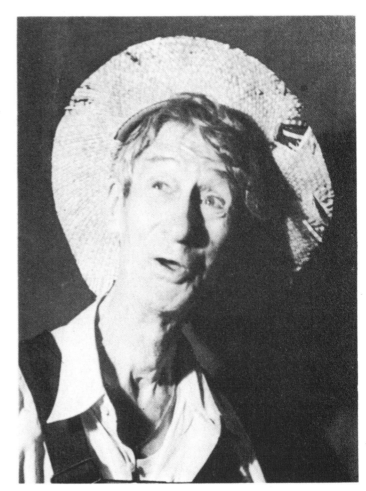

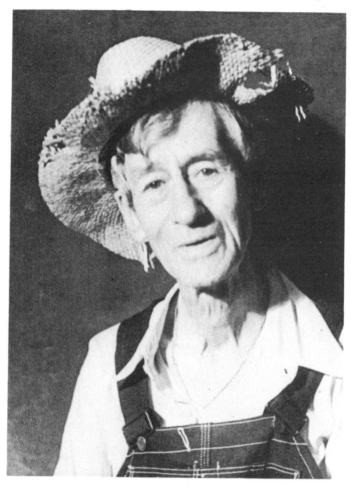 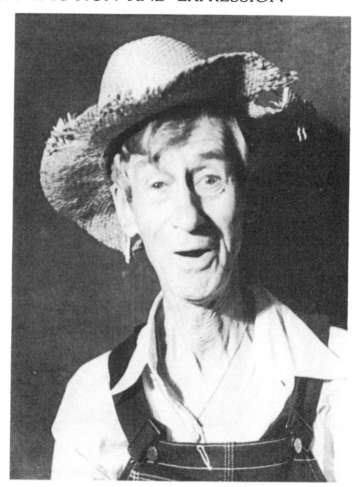

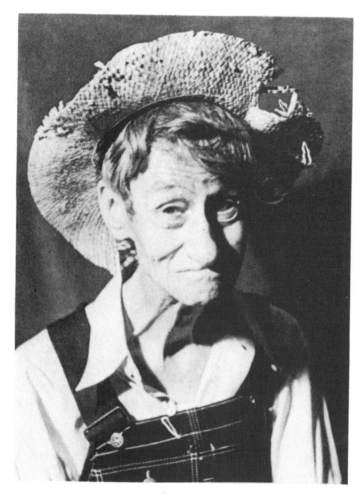 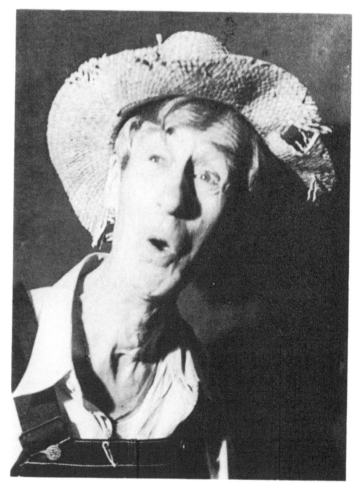

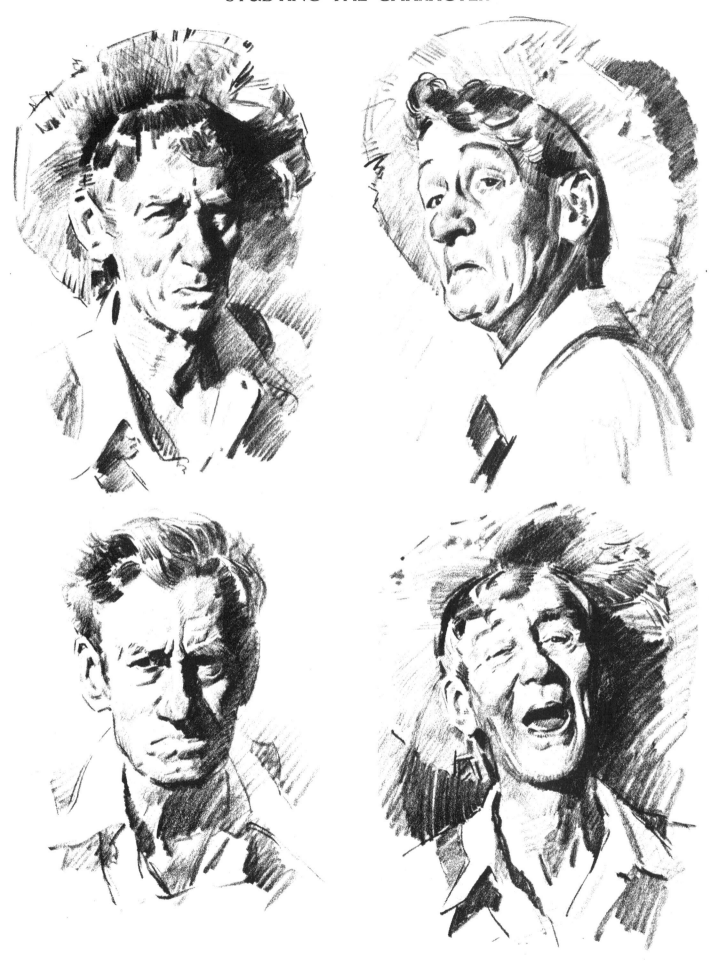

THERE IS NO END TO FACIAL EXPRESSION AND CHARACTER

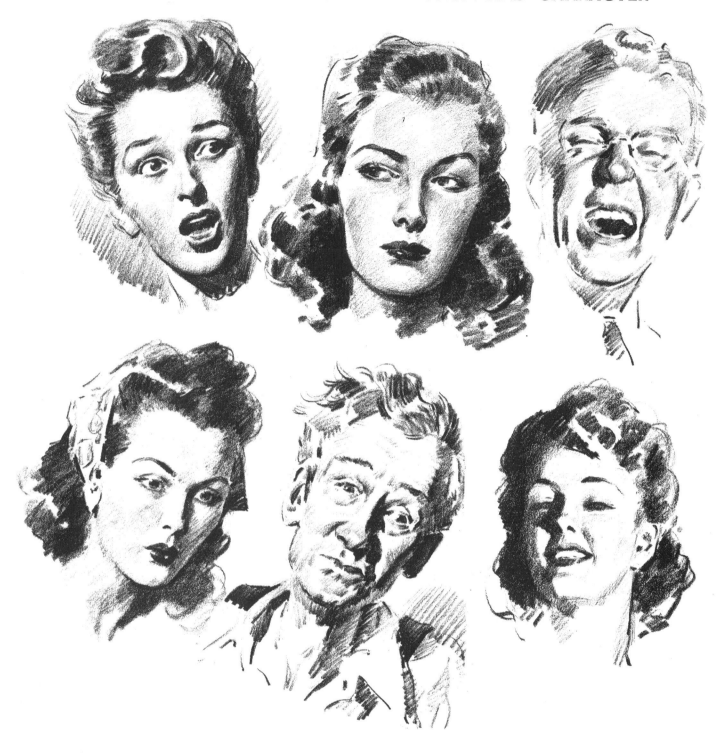

IN ANY EXPRESSION OTHER THAN A NATURAL OR "RELAXED" ONE, IT IS MOST PRACTICAL TO USE A CAMERA TO "NAIL IT DOWN". NO PERSON CAN HOLD AN IDENTICAL EXPRESSION FOR MORE THAN A FEW SECONDS. DRAWING FACIAL EXPRESSION GOES RIGHT BACK TO OUR "FORM PRINCIPLE" SINCE IT IS FORM IN THE "ASPECT OF THE MOMENT." IT AMOUNTS TO CAREFUL DRAWING OF THE HALFTONE AND SHADOW SHAPES. THE SHAPE ITSELF MUST BE RIGHT THOUGH IT MAY BE FILLED IN FREELY. ALL THESE SHAPES SHOULD FALL INTO PLACE AND FIT TOGETHER LIKE THE PIECES OF A JIG-SAW PUZZLE. SKETCH IN YOUR FIRST CONTOURS VERY LIGHTLY, THEN THE SHADOW SHAPES. EVERY AREA BELONGS DEFINITELY TO (1) LIGHT, (2) HALFTONE OR (3) SHADOW. THE VALUE RANGE FROM BLACK TO WHITE IS NOT AS GREAT IN PENCIL AS THE RANGE OF A PHOTO, SO KEEP YOUR HALFTONES LIGHT, THUS ALLOWING PLENTY OF

EMPHASIS IN THE SHADOWS. KEEP THE WHOLE MASS OF THE LIGHT AND HALFTONE WELL SEPARATED FROM THE SHADOW AS A MASS. REMEMBER SHADOWS ARE USUALLY DARKEST AT THE "HUMP" OR TURN OF THE FORM. THE CRISP ACCENTS OF DARK ARE EVIDENT WHEREVER THE FORM IS DEEPLY RECESSED AS AROUND THE EYELIDS AND CORNERS, AROUND THE NOSTRILS, LIPS, AND CREASES. NO TWO FACES ARE ALIKE IN FORMS AND THEREFORE THE TONAL SHAPES OR PLANES OF THE FORM WILL ALWAYS BE A NEW AND DISTINCT PROBLEM. IF YOU DO NOT STICK TO A SIMPLE LIGHTING THE FORM GETS BROKEN UP IN TONE AND WILL BE MORE DIFFICULT. FORM IS ALWAYS BEST IN ITS "PURE", SIMPLE, SOLID, OR "SCULPTURAL" ASPECT. A SINGLE LIGHT IS MOST SOLID. IF SHADOWS ARE TOO BLACK, REFLECT THE SAME LIGHT BACK WITH A WHITE BOARD. TRY DRAWING THE INTERESTING CHARACTER IN THE PRECEDING PHOTOS. DON'T STOP THERE. DRAW MANY FACES ON YOUR OWN.

199

MANUFACTURING CONVINCING EMOTION

Emotional gesture is a very subtle and individual thing. It stands to reason that you are not going to be on hand to catch the genuine unconscious and unaffected emotion very often. It is something that for the most part is going to be manufactured to suit the occasion. You will find that a great deal of it must come from yourself, working through the model and the camera. This is a technique used by many motion picture directors. I find out that if you are not self-conscious in acting things out for the model, she in turn will not be as self-conscious in acting for you. Above all, do not in any way ridicule or belittle your models' efforts. If they do not at first succeed in transmitting the mood and expression, tell them encouragingly that they "almost have it." Repeat the performance again, talking about the feeling you have about the situation, never about what they are doing with their features. If you want the eyebrows lifted do it with your own, saying, "You are more anxious, more alarmed—you are Mrs. Potter of the story, wondering and fearing what has happened to her daughter." It is never a simple "Raise your eyebrows, please."

If you have a radio or phonograph about, try to have some music going akin to the mood you want. You can also set the emotional tempo by reading the copy or story aloud. If possible, let her read it to you. She then instinctively becomes a part of it.

A giggly nervous temperament is characteristic of so many young girls, and this is the hardest mood to combat to catch dramatic expression. Once you let the giggling start, it gets worse. The best way to make them snap out of it is to say: "Now look, Miss So-and-so, this is no funny business. It's a matter of bread and butter, a job for you and one for me. I picked you from a long list of models because I think you have what it takes, and there isn't time to start all over with somebody else. Let's get this thing right. Forget the giggles."

The other type, who cannot smile genuinely when it is needed, is another problem. Nothing falls so flat as an artificial smile. The best thing to do in that case is to walk away from your camera, not letting her know her smile is expressionless. Get a cigarette, offer her one, tell her something funny. The main thing is to transmit a mood, and it can be easily done. You are really the actor and the model is the medium, just as much as your paints and materials, through whom you create drama and characterization. You can't look at her with a "dead pan" face and tell her to smile. It makes the difference between an average job and one with that indefinable spark. Technically, an expression is nothing more than form with light, halftone, and shadow on it. But the man who will look at your picture sees a face, human and expressive.

Imagination is contagious, mood is contagious, and the spirit behind a picture is ninety per cent of the picture. You can be alert for drama all the time. Watch what people do, watch their hands, their eyes and mouths, their unconscious poses. It is amazing, the changes that can come into a single face, and how expressions become associated with thoughts. It is not a bad plan to make a lot of self-posed expressions in a mirror, and shoot them with your camera. Find out what makes one expression dour, another elated, one horrified, and another frightened. All is a subtle movement of the facial forms and lines. Try never to draw a face that does not seem to be thinking something.

Expression is very hard to capture when working from life, but if you can keep the sitter inspired and interested you can get it. I have a large mirror on casters that can be set up behind me so when I am working directly from the model, she can watch the progress of the painting. This eliminates the tediousness of the long hours of sitting still. This seems especially to interest men, and elderly people who like to sit anyway but at the same time like to have something to occupy them.

Perhaps this may help to convince you that you are important to your picture. You are in relation to every part of your work. It is the net result of many things, and most of them are you.

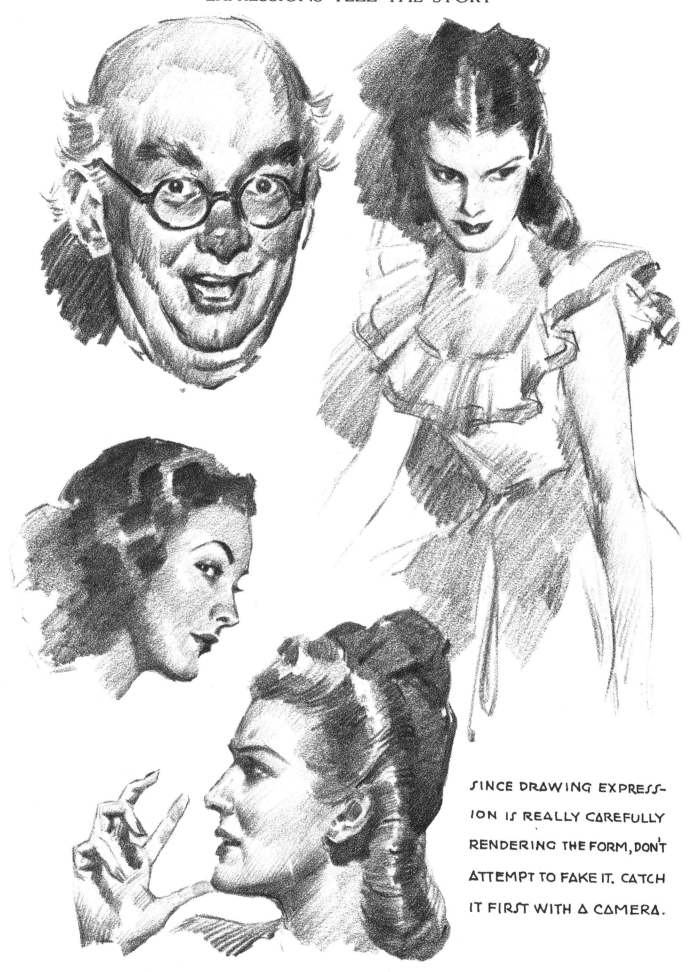

SINCE DRAWING EXPRESS-
ION IS REALLY CAREFULLY
RENDERING THE FORM, DON'T
ATTEMPT TO FAKE IT. CATCH
IT FIRST WITH A CAMERA.

Often the question comes up as to whether or not a background is advisable. Since this concerns both the camera and the painted subject, a few suggestions here might help.

There are good arguments on both sides of the problem, the difficulty being mostly in the decision as to when a background is better and when it is not. For the best answer we must look to the subject itself.

A subject cut out or vignetted against a flat white background, provided that background is kept simple and uncluttered by other units, has a tremendous advantage. White space is often more telling on a page than tone. It makes a design of white area to support other design in the pictorial unit. It isolates the important material so that it can be seen easily. White space is often referred to as "breathing space." It is not often that on a magazine page, either for story illustration or for advertising, the artist may be liberal with white space. In the first place, space is expensive on any page and it is something like asking a merchant to put but a single product in his window, when he has fifty to sell. But a single product well displayed in a window would probably cause more comment and get more attention than the fifty all displayed together.

An argument against cutting away the background is that much of the three-dimensional quality may be lost. The subject gets a "pasted on" look and sticks to the picture plane without any feeling of recession. There is no doubt that a feeling of depth draws the eye into a subject, just as the eye is instinctively drawn to a mirror, a window, an open door, or even a hole in the ground or wall. The subject, if cut out with a sharp hard contour all around, may make the eye conscious of the edge at the expense of the form; a certain cheapness may result when the subject is taken away from its normal relationship with its setting. Such harshness may seem out of place and irritating. A "scissors" type of edge has no place in art.

It follows, then, that if you keep the two extremes in mind, much can be done in either case to seize upon the advantages and to alleviate the disadvantages.

The first thing we should look into is the tone within the subject which is to be cut out or not. A distinct gain or loss of vitality may be the unexpected result if no thought is given these values. If what we are cutting out is already light, with only delicate greys and darks to support the whites, the result will be negative on a white background. Going back to our four basic tonal plans, we recall that the greatest vitality is found in the four basic tones. On the next page the head at the top distinctly loses in punch and vitality by being placed against a white background. Being light in itself, the subject drops the lower half of the much-needed value scale, having no darks or blacks for contrast. I should say that the same head has about four times the punch when it is placed against the dark background, which increases the attention value and gives depth to the subject.

The head at the bottom of the page will prove the reverse. It is soft and grey in its environment of grey background; distinct gain in vitality is evident by placing the same head against white. What we have done here is the same thing we did in the first instance, that of completing the value range to take in the whole scale from black to white. This becomes middle tone and dark against white, whereas the first became middle tone and light against dark. Both, then, accomplish the same purpose.

As far as the cut-out, pasted-on effect is concerned, much can be done by the artist to leave some soft edges, or to carry the white background into the subject in some way. Thus the subject can become "interlaced" with its background as all good vignettes and drawings should.

So the subject does determine what can be done, and knowledge of these facts can give ample basis for a good decision. This little problem will come up to greet you many times over. If you know how to solve it, you will often be enabled to make a striking thing out of something that otherwise would be quite ordinary.

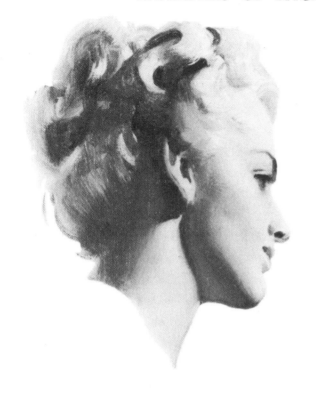
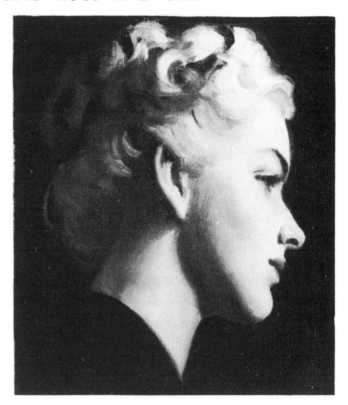
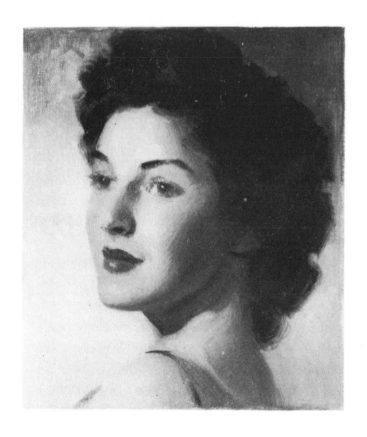
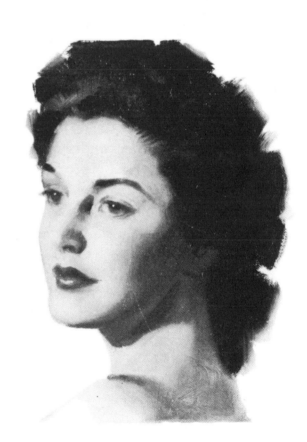

WHAT IS FAKING, AND WHAT IS IMAGINATION

Many students become totally confused by being told at one time never to fake and at another to use their imagination. The subject is worth discussion here. Pictures, to be creative, call for imagination; yet the things that make pictures great are their adherence to the laws of Nature and truth. I think the confusion can be cleared up and a workable basis of approach secured.

Pictures may be conceived from many sources. Sometimes the subject is something that has been laid out before us in life that we recognize as being a subject and one which we would like to do. At another time a picture may be conceived to fill a need, with nothing but the imagination to start with. Sometimes a picture is an occurrence that can be dramatized and set forth. Or a picture may be a record of something that to us is beautiful and worth preserving for all to see. Sometimes a picture is a message to reach others where words fail. Sometimes it might be just a design that has its own intrinsic beauty, as would a fine piece of jewelry or other example of craftsmanship. There is such great latitude in art.

I would say that we "fake" things only when we are starting. It is the beginning of the setting down of the things in our imagination. We are trying to pull something out of a state of nonexistence into actuality. So when we "fake" a figure, it is to a purpose. We are taking the fastest means of capturing the thing in mind. Once the idea is established, we should go to real fact, and bring the original conception to life by working from a live model or other reality.

Whether it is faking or not depends upon what the artist is going after. He should not attempt to fake the effect of light on form. But I would say that if he is trying to work out a pattern and arrangement, he should not always accept things as they are. He must decide whether what he is doing calls for a literal statement of fact or not. He must look for facts and use them at his discretion, not just because they are facts. The artist has the privilege of sifting and sorting the wealth he has to work with. He cannot use it all, nor does he want it all. If we honestly think we can get the effect we want without use of model or nature, then by all means I say to do it. I believe in making most of the preliminary work—composition, sketches and so forth—without material help. I believe the finished thing is more likely to be creative. Then we can go get the facts we need to apply where we feel the need. We also have the means of gathering all the facts first, in studies from life, photos, outdoor color sketches, pencil sketches, etc. From these we may do the final thing without further reference to them, carrying in our minds what we have learned and setting it down from the imagination. You would not be faking a figure after the same thing had been worked out from fact, even if you buried your studies. Either way is perfectly sound.

The point is, if you know a thing well enough, you are not "faking." A man who knows airplanes can paint one in the skies and not be faking. A man who knows horses can paint them in action. And if we know the figure, we are not really faking. We are setting down the culmination of a great deal of study. Faking is truly bad only when we do not know what we are doing. If we do not know what the form is, we cannot hope to draw it correctly.

Color may come purely from the imagination and, so long as the value and relationship is good, may be even more beautiful than in life. I do not consider that faking. That is understanding color.

Not long ago a student brought his drawings to me and exhibited a great deal of pride over the fact that he had "drawn everything out of his head." Considering his work from that standpoint, it would call for considerable praise. But notwithstanding his heroic attempt to be what he thought was purely original, the drawings were not done well enough to stand up against a piece of really good draftsmanship. He could not hope to compete with those who are taking every advantage of model and copy, for he could not *label* his drawings as being done without help or study. He might even have superior knowledge over the man who used a model, but it would be inevitable

that he would lose out against him. Perhaps a self-taught man should be given a great deal more credit than a university graduate. But how we do things is of less importance than the ultimate result of what we do. In the final analysis the credit lies only in the achievement.

The best artist does not fake if there is any possible way to avoid it, because he has learned that the truth itself is better than the semblance of truth. We are limited at best in our ability to comprehend the truth, and why burden our work with unnecessary bungling? Drawing from life does not make our work any the less original. If we have conceived a pose or even photographed it, and made sure that conception is well founded in fact, the result is none the less our own.

Someone had told this particular student that working from a photo was cheating. I feel that it is no more cheating than for a carpenter to work from a blueprint. It could only be cheating if the photo were essentially the property of someone else. Even then it would be more aptly called stealing. Were he to trace or directly project the photo onto his drawing surface, I can see some basis for the charge, but using a photo as a source of information is parallel to a lawyer's building up his case from his law books.

The answer to faking lies clearly in the simple resolve not to guess when you can find out. You cannot argue against the man who has the facts that you have not. If the subject is to be a representation of truth, it cannot succeed except by being true.

It must be remembered that any picture is an illusion to a certain extent, but it is an illusion of form in space, with an imparted sense of reality. Or it may be the opposite, a thing not concerned with reality, a product purely of the imagination. The latter may in a sense have to be faked (if we want to use the word), but I prefer to think of that sort of approach as something else. To set down one's thoughts can scarcely be construed as a subterfuge. We could paint our conception of what it would be like on the planet Mars. We can invent forms without need of censorship. We can invent flora and fauna, textures, or anything else, without being questioned as to our imaginative right. The only things we need be concerned with are the misstatements, things meant to be right that through our ignorance are not. We can idealize, glorify, even distort, in art, completely within our rights as creative people, if our aim is individual expression. Whether such liberty is accepted by others has no bearing on the right or wrong of it, for each has his right to his own taste as much as to his own religion. Every change from the orthodox may bring about dispute, and may lessen the chance of acceptance. But setting aside commercial considerations, the individual's right to creativeness cannot be disputed.

The artist may well think of coupling his imagination with fact, using one or the other to best advantage. It is certain that art lies in the imagination as much as or more than it does in fact. To deal only with fact would be to base our thinking at the camera level.

If imagination can be cloaked with reality, it would seem the logical manner of approaching the realistic-minded, so that through this reality we may carry them into our imagination. If, on the other hand, we give something totally impossible to their own imagination, we can hardly expect acceptance. We then have the choice of working only to please ourselves, or of seeking some new means of understanding on their part. There is nothing to stop us, for example, from such innovations as Gauguin painted on his tropical island, if we are willing to segregate ourselves from society.

Perhaps Newton's laws were a departure, but a departure conceived in truth. A steam engine was unheard of, but based on fundamental fact. Its merit became a thing of purpose and value. That is the way I like to think of the right kind of imagination in art. "Faking" is not the word for it. Perhaps the best guide is to ask yourself whether the truth that you feel inwardly is more than you see visually. When you are convinced that imagination is greater than fact, by all means use it.

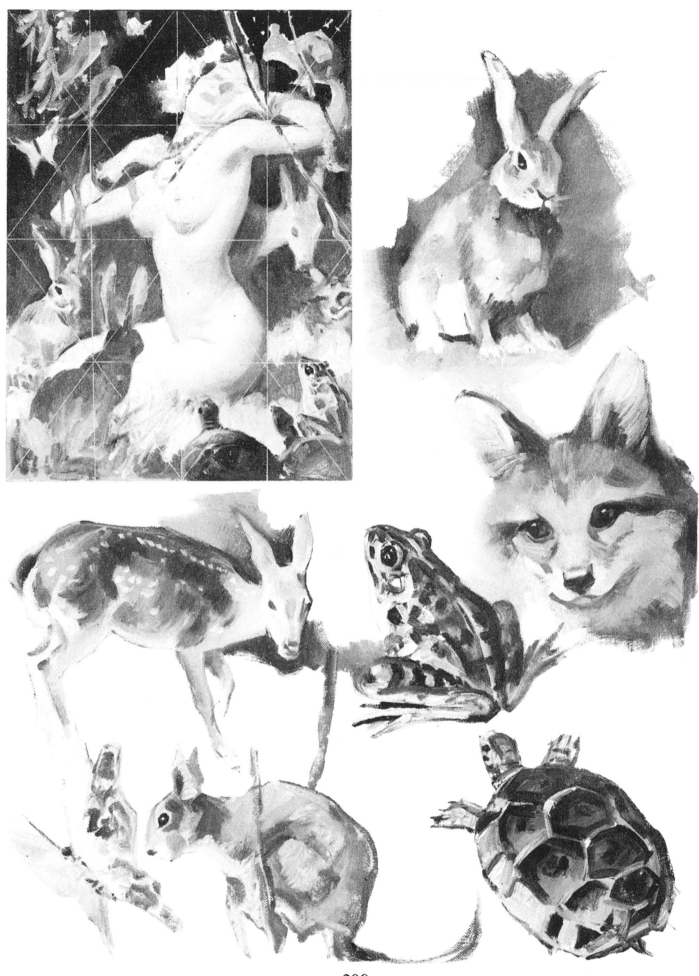

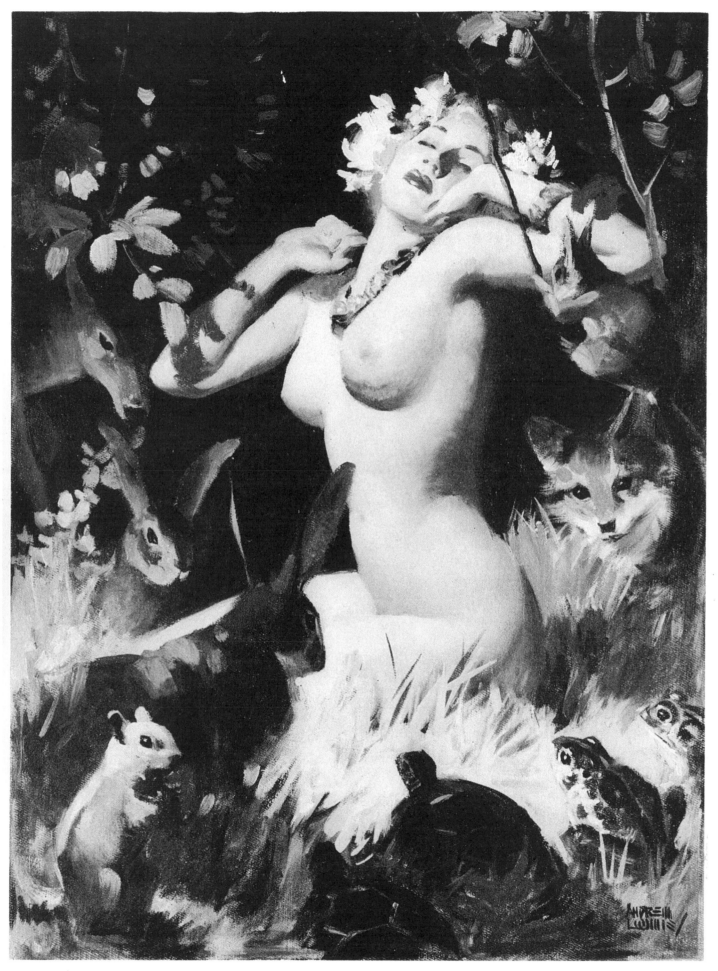

A LOGICAL METHOD

1. Evolve interesting questions

2. Answer them effectively

3. Base on desires and appeals

THE PLAN OF WORKING UP A QUESTIONNAIRE

There is nothing that is quite so difficult for the artist as to sit down before a blank sheet of paper or canvas and produce an idea. Ideas have a way of seemingly coming from nowhere, or as the result of an experience or other suggestion. But there is at least a proved way which can lead one to ideas, by directing the mind into appropriate channels of thought and by first conceiving a purpose, then attempting to meet that purpose. An idea without a purpose would seem more or less inane and ill conceived at best, so let us seek the purpose, and the idea will follow in its wake.

Assuming that intelligent questions will evoke intelligent answers, we can begin with a questionnaire. Take a sheet of paper and down the left margin write every word that you can think of that might be the beginning of a question, or even a group of words that would be the start of a question. Let us assume we are searching for ways and means to advertise a product. Fill in every conceivable question you could ask about the product. When you can think of no more, then proceed to answer your own questions, or at least try to get the information that would answer them. Your subject, the theme and its pictorial presentation, is invariably hidden in the answers. This is a means of developing facts, and when you have the facts they are tangible things to work with. Illustration of tangible facts becomes comparatively easy. It is a means of taking abstract thought into concrete thought.

Facts bring up mental images. If I say the product makes one healthy, you conjure up in your mind a picture of health. If I say the product makes one active, you think of activity in one form or another. So that is the way the questionnaire works. Now your pencil has something to get busy over. Little suggestions begin to evolve out of the answers.

In the fictitious and sample questionnaire I shall give you here, I have purposely taken a product which offhand would seem anything but inspiring or romantic, just a hunk of plain cheese. In my answers I found myself continually but unconsciously stressing energy. So suppose we take energy as our theme. What are its possibilities? New questions come to mind. Who of the family is most in need of energy and vitality? When we come down to hard facts, Dad's energy is most important, since the welfare of the whole family depends upon him. Now, is Dad practical as a theme in a woman's magazine? I believe so, since any wife is instinctively interested in keeping her husband well and healthy. In fact, here lies a rather new and different approach. By actual contrast to the material usually associated with such magazines, our series must attract considerable attention and interest.

Now how can we show "new energy for Dad"? Suppose we show a little insert of Dad as he used to be, and a big picture of how he is now. Let the big picture be full of action. From one answer we find he has "energy to spare." Fine! Now we think of showing energy to spare. How about playing ball with the kids, when he used to mope in a hammock? Maybe he is springing past us on a bike, or out-hiking the kids—even pushing the baby buggy. Now we have something to work with, and ideas begin to take shape. Copy falls into line with the theme and we are all set. So I give you the series of layouts on page 213.

Now suppose we get the reaction from our first attempt that the fact that the product is a *food* is too subordinated, not stressed enough? However, the client likes the theme. Can we hold to the theme, but stress the product more? That is simple. We can show some delicious-looking foods, and subordinate the figures using them to decorate the page. We still have something different. Dad can push the lawn mower, Mother the vacuum cleaner. We get out a recipe book and find out what tastes good if made with cream cheese, and again we are all set.

The food pages would be best if done in color, since black-and-white food has little appetite appeal. Out of the same answers we could have taken other approaches—the fine cattle, the sanitary production, the flavor of the cheese, the many vitamins and other healthful qualities, the variety of uses.

SEARCHING BASIC APPEALS FOR IDEAS

Here is the almost universal procedure adopted by most agencies and creative advertising departments. Advertisements are based primarily upon psychology. Human psychology has been put through such intensive tests that it becomes unnecessary to question the theory of basic appeals. It has been proved beyond a doubt that there are present in all of us basic desires and instincts, and that when we are reached through appeals to these instincts we make certain definite and predictable responses. No proof is needed that a normal woman wants to be as attractive as possible, that a business executive wants efficiency, that most of us want more freedom. Along with the things people like and want, we know the things which normally irritate them, or from which they might like to escape. Such things can also be capitalized upon by suggesting the avenue of escape—for example, even a partial escape from household drudgery for the average housewife.

On page 215 I have prepared some examples of how ideas may be developed from basic appeals. The type of appeal is selected first, and then you begin to think of ways that might express it. This is the most direct and positive way to get reader response, and provides a broad approach to originality and creativeness.

GENERAL APPEALS

Each of these might head a whole column, but they are given here merely as a jumping-off place for others.

1. The maternal instinct
2. The instinct of self-preservation
3. The instinct of protection
4. The desire to flee
5. The instinct of fear
6. The desire to be free from pain
7. The desire to possess
8. The desire to attract
9. Love of praise
10. The desire to excel
11. Pride of ownership
12. The desire for attention
13. The desire to dominate
14. The desire to profit

As long as we stick to known qualities of the human ego, we can't miss by a very great margin.

Perhaps here and there might be a mother who for some reason does not love her children. But since the vast majority do, we cannot go wrong with an appeal which touches upon that love for them. Any way that such a response can be secured is almost "sure fire." This is true of so many basic instincts that no thinking man need ever say there is no basis of approach for creating ideas. The air is full of them when subjects are reduced to plain terms of human behavior.

The variety in humans is largely a variety of experiences and purpose. That we differ in superficial makeup is of no great importance. One wants to sing, another to dance, and another to make the music, but all want attention and praise. That a man does not carry out these desires does not mean that the basic impulse is not there, for one man may only dream of doing while the other does it. We have only to look analytically at our own desires to come fairly close to the other person's. We wish to excel, to shine, and so does he—perhaps in a different manner, but just as much. We do not like ridicule nor chastisement, and neither does he. We resent too much authority; he also. We both have pride. He lives much the same, eating the same things, enjoying the same things, even, in a general way, thinking the same things, so that any basis of approach that would create a response in ourselves would very likely do the same with him.

If we will but study carefully our acquaintances, we will have a fairly good cross section of people at large. A gathering in your home will not differ greatly from one in mine, except in names and personalities. As a group they will act pretty much the same. If an idea appeals to six out of ten, it very likely will appeal to sixty out of a hundred, or you can carry it up to thousands with approximately the same percentage, presuming that all are typical of normal or average people.

In general, human emotion is fairly consistent. All of us register, as does a thermometer, the highs and lows between the extremes of emotion. The important thing is to draw out the desired emotion by means of basic appeals.

A SAMPLE QUESTIONNAIRE

QUESTIONNAIRE FOR DAIRYGOLD
(A fictitious product)

Why *this product*?	Because it is pure and germ-protected.
Who *is most benefited*?	The man who has no energy.
What *does it do*?	Supplies essential vitamins.
When *do you need it*?	All the time, if you want to be active.
How *is it eaten*?	In many delicious ways.
Where *does it come from*?	The greatest dairy state.
Why is *it so good*?	Because of its richness.
At what time *is it best*?	When tired, it brings energy to spare.
How often *can we eat it*?	At meals or between meals.
Does *it taste good*?	Everybody loves it.
Should *I eat it daily*?	If you want to keep up full steam.
Can *anyone eat it*?	Yes, young and old.
Will *it be economical*?	Yes, because it's so nourishing.
Shall *I try it*?	By all means, for new energy.
Is there *any thing like it*?	Not with such flavor and richness.
In what way *does it excel*?	All the good fats are left in.
Which *foods are best with it*?	Fruits, vegetables, and starches.
Are *other foods as nourishing*?	Yes, but in greater quantity.
If *I eat it, how will I benefit*?	You will accomplish more.
Do *lots of people like it*?	More popular every day.
May *children eat it*?	Children need it.
How about *old people*?	Easily digested, gives them energy.
So how *do I get it*?	Just ask for it at your grocer's.
But what *if they don't have it*?	Send us his name, we will send it.
How much *is it*?	No higher in price.
Does it *keep well*?	Its airtight germproof wrapping keeps it fresh until gone.

DAD NEEDS ENERGY, SO A CONTINUITY IS WORKED OUT CENTERED AROUND DAD'S "NEW" VITALITY.

THE PRODUCT IS FICTITIOUS BUT THE APPROACH TO THE IDEAS IS SOUND. DAD'S VITALITY IS
SECURITY TO THE HOME. WHAT HOUSEWIFE WOULD NOT BE INTERESTED? OR WHAT HUSBAND?

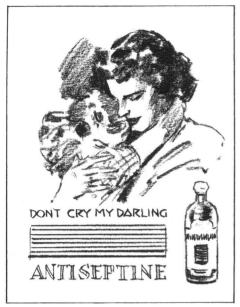

THE MATERNAL INSTINCT

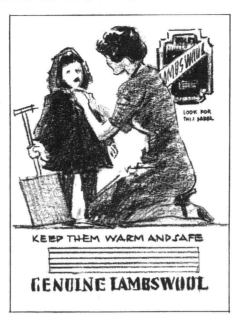

INSTINCT TO PROTECT

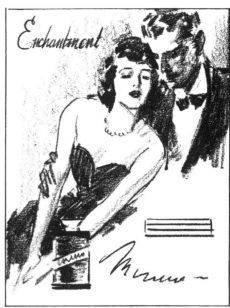

THE DESIRE TO ATTRACT

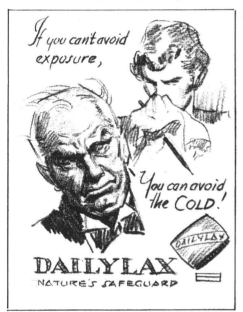

INSTINCT OF SELF-PRESERVATION

THE DESIRE TO EXCEL

THE DESIRE TO PROFIT

THE DESIRE TO FLEE

FREEDOM FROM PAIN

THE DESIRE TO POSSESS

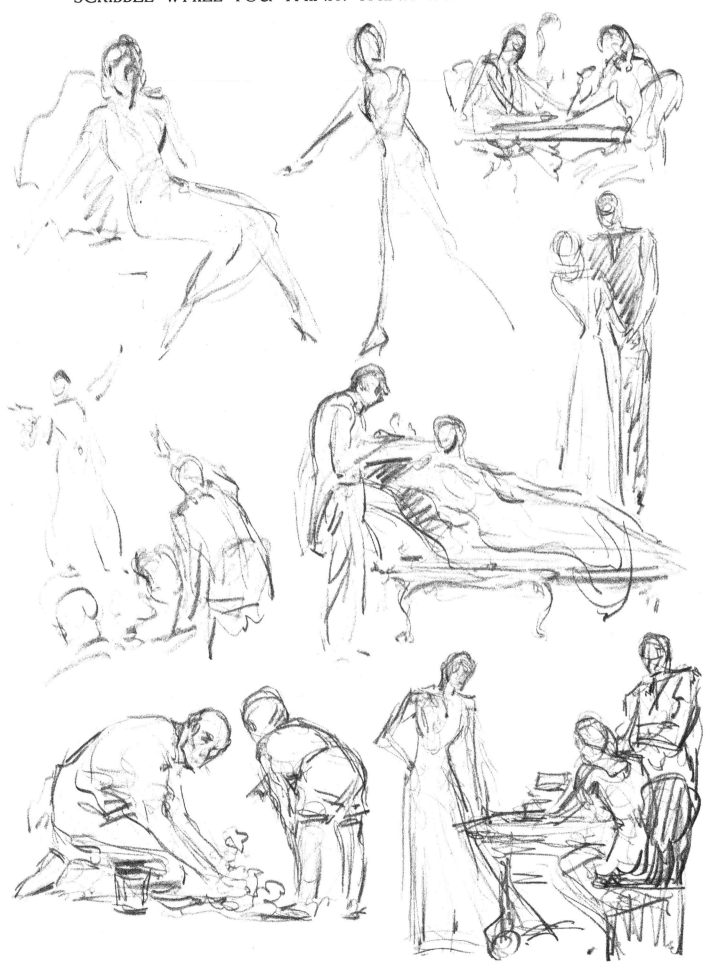

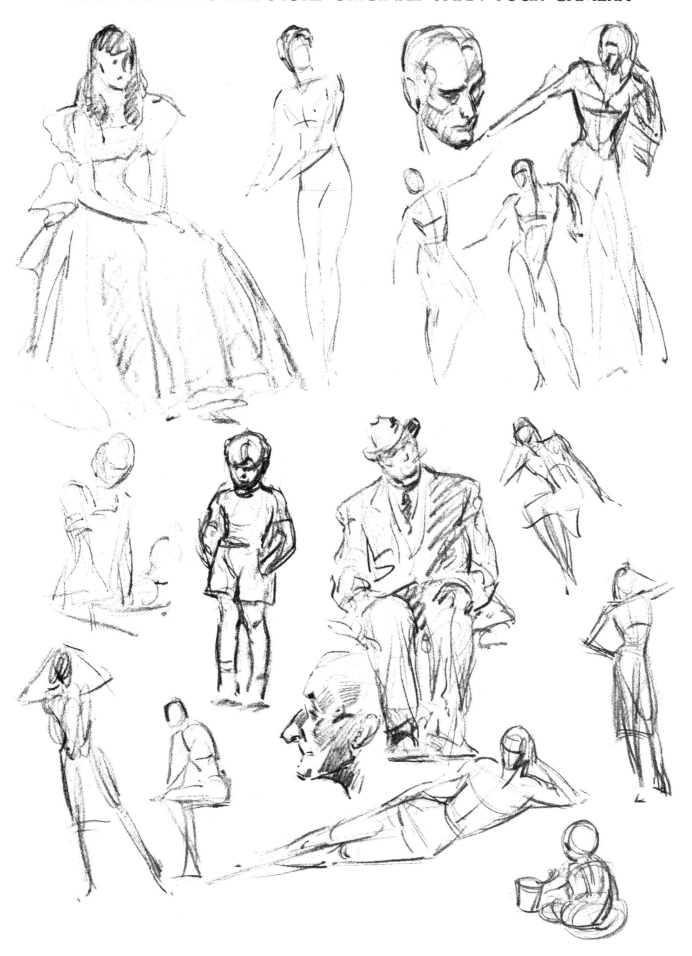

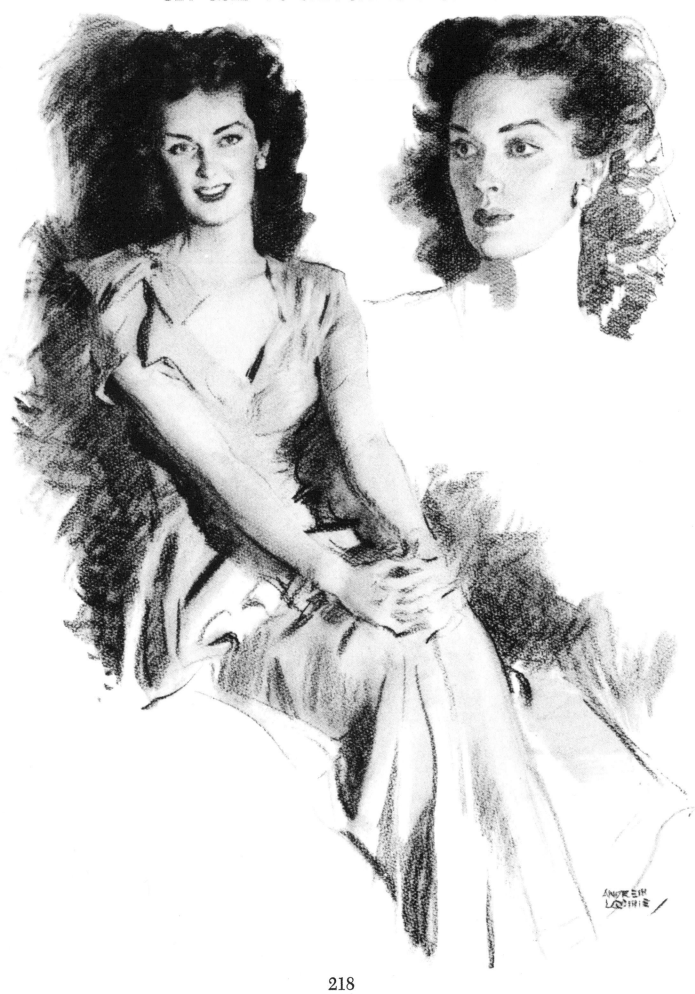

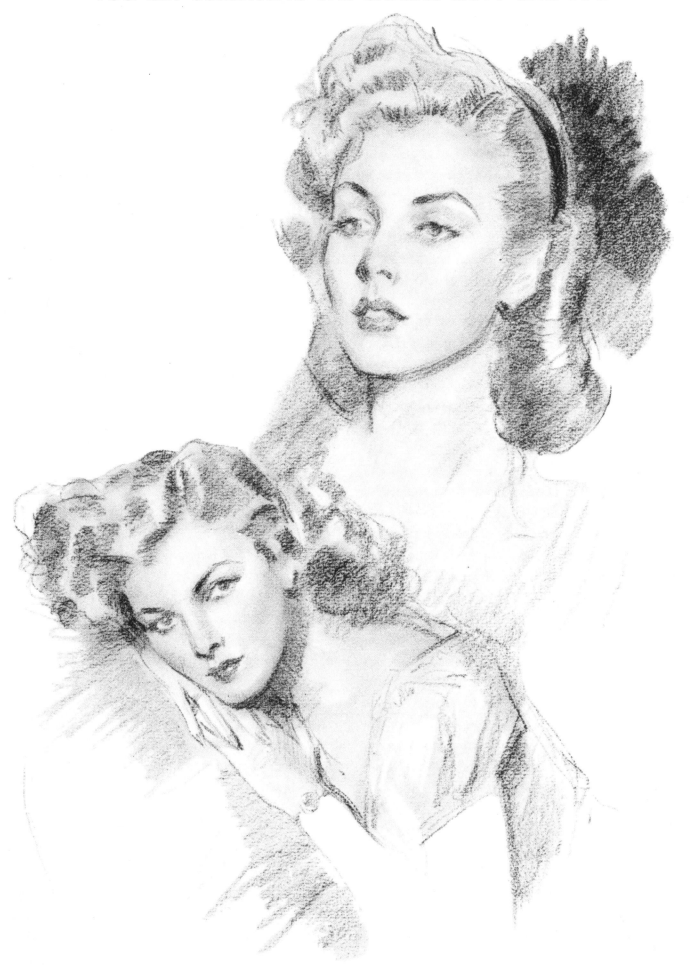

Hardly is there a man or woman without sentiment, even though it be hidden and masked over in defense. Let us assume that no one's life seems just a bed of roses. Sentiment is the bulwark that we lean upon, that makes us able to take the inevitable monotony and commonplace of life in its stride. There is maudlin sentiment, of course, and sentiment dragged in by the heels. Sentiment can be used subtly and with tact and be made a tremendous asset; or it can be like waving the flag after a bad vaudeville act to get applause that is not merited by the performance. Sentiment must ring true to be effective. A search for real sentiment will bring up treasures.

It follows that certain subjects will align themselves with certain psychological appeals, another word for sentiment. For example, a toilet soap associates itself with glamour, freshness — the preservation of, or contribution toward, beauty. Youth, romance, loveliness, then, is the sentimental approach. Switching to a laundry soap, we have the sentiment of the home, the maternal love expressed in clean, fresh and sweet-smelling dresses for the little girl. We have the efficiency of the home, the economy of labor, a thousand and one instances where the use of plain soap expresses sentiment of some kind. Sentiment is attached to the cigarette through the pretty girl and romance. Another approach is the instinct of self-preservation, claiming less irritation to your throat; the appeal of quality, claiming the best tobacco, and so on. Selling flour would naturally be aligned with appetite appeal, tempting food, nourishing qualities, and resultant good health.

After a little experience we find that psychology is definitely the basis of creative ideas. Recognizing the psychological realm to which a product belongs becomes almost automatic. Our real problem lies in the presentation. Here are a few examples of appeals and approaches:

Perfume	Romance, allure, seductiveness, the sensuous, sex
Milk	Health, maternal appeal, appetite, home
Breakfast food	Vigor, health, efficiency for work, appetite
Vacuum cleaners	Efficiency, labor saving, time for other things
Medicines	Freedom from pain, vitality, instinct of survival
Banks	Security, freedom from want, home, preparedness, protection
Motors	Relaxation, efficiency, home, travel, possession, safety
Furniture	Beauty, design, efficiency, home, pride

The list can go on indefinitely. Approaching your subject in this way is simply finding ways and means to interpret the various appeals. Then it becomes a matter of co-ordinating the pictorial fundamentals to fit the purpose. Going back over the above list, many thoughts and pictorial subjects will take shape. It would not be a bad idea to make some little roughs of what comes to mind.

REVAMPING OLD IDEAS

Here is a gold mine if approached intelligently and ethically. There is an old saying that there is nothing new under the sun. There will always be similar situations, similar products, and similar approaches. No one need resort to plain "swipes." Suppose in an old magazine we find what we believe is basically a good idea. With a new headline, a new composition or presentation, such revamping is done every day. Good sportsmanship will stop us from becoming plagiarists. Yet since life continues in much the same way, there is bound to be duplication. Seeing a picture of a mother bathing her baby might give us a similar idea for an illustration. Such a subject could hardly be considered anyone's private property. But for our own pride we would present the subject as originally as possible. Viewed in this way, old magazines are a great storehouse of ideas, and since the subjects have proved themselves worthy in the past, they probably will be good again.

PSYCHOLOGY APPLIED TO COVERS AND CALENDARS

Cover ideas, unless the subject is quite a general one with possibilities for wide variation, should be let alone after having once appeared. If someone has already shown Grandma blowing up Jimmie's football, that is a specific incident, thought up by one particular artist, and any ethical competitor must regard it as his property, not to be repeated. However, a subject such as a girl on skiis is so general that the idea itself may be used time and again.

Cover ideas to be acceptable must be original in conception, be timely, and have general appeal. They should reflect popular interests such as sports, fashion, and other current activities, and should invariably display good humor and good taste. They should be free from prejudice, politics, sectarian religion, racial intolerance, cruelty, or bad example of any sort. If the basis of the idea is a prank, it should be wholesome, without malice or abuse.

Covers may be based on what people like to do, what they would like to be, how they live, and what they love. In some cases covers can be representative of the spirit of the magazine or even of its particular contents. By familiarizing yourself with the cover styles of leading magazines you will note that they lean to different subjects. While one invariably uses a pretty girl head, another may prefer the American scene. And, by the way, pretty girl heads have been done so many times that you will have a better chance if you introduce some new angle or idea into yours.

Covers fall into two broad groups: general appeal and specific incident. All the basic appeals may be applied for sentimental response. A cover based on a broad psychological appeal has much more chance of being accepted than one which is built around a specific incident. A lovely mother and her child, for example, is a subject of broad appeal, while a little girl playing with a lipstick is a specific incident. There is no basis of objection to the first, while there might be to the second.

If, however, you wish to do a "specific incident" cover, you can also develop this through use of basic appeals and the questionnaire plan. For example, we want an idea for a cover of a boy's magazine. The questions might start: What does a boy like to do most? Answer: Build things. Question: What does he build? Answer: Airplanes, dams in brooks, huts in trees, rafts, etc. Suppose we take the hut in the tree. Here is excellent material for experimental work. Or we could show the boys on a raft playing pirate. Soon we have a sound idea.

Covers should usually be submitted in sketch form, since the subject itself may not be acceptable. Covers are not easy to sell, and that is why an idea should be submitted in rough form before any great amount of time and effort has been put into it. If interested, the magazine will encourage you; if not, you will soon know. If you see that the same artist is doing several covers for a magazine, you may be fairly certain he is under special arrangement or contract and that, therefore, there is no opening for you.

Color photography for covers has all but crowded out the artist. However, I believe the chief reason is the dearth of good pictorial offerings. As art really develops in this country, I believe we will see more and more of the artist's work on magazine covers.

CALENDAR IDEAS

Since I intend to take up calendars as a field for discussion later on, I believe it will suffice here to mention the important part psychological appeal plays in calendar art. Calendar subjects are usually of broad appeal and only seldom use specific incident. The main reason is that a specific incident, a prank, a bit of concentrated action or story, is very apt to get tiresome after having been looked at for some months. Suspended action, in my opinion, is not too good for a calendar. I get a little tired of the dog retrieving the quail, of waiting for the bass to be landed, the Indian to fall off the horse, and so on. There is great room for improvement in calendar illustration. I look upon it as one of the great opportunities for the artist of tomorrow.

221

THERE IS EVEN PSYCHOLOGY IN COMIC IDEAS

Sentiment may be applied in comics in forward gear or the reverse. We can appeal to sympathy and human understanding, or we can make light of it, even to the point of ridicule. No one can prescribe an exact formula for comics, since the humor rests in the specific interpretation of an idea, but formula is used, consciously or subconsciously, by the best humorists, and it is all based on human psychology.

Some tried and true formulas may be listed:

1. Outraged dignity
2. Creating the unexpected
3. Making the serious ridiculous
4. Making the ridiculous serious
5. The weak outsmarting the strong
6. The transgressor coming to grief
7. Turning the tables
8. Unexpected opportunity to get even
9. Flouting convention
10. Reversing logical outcome
11. Slapstick
12. Getting out of a predicament
13. The pun (play on words)
14. The gag (funny incident)

The psychology behind getting a laugh is a quick twist of the emotions, a surprise maneuver, a sudden reversal of thought. It has been said by humorists that there are only about a dozen basic jokes, and the joker works with new variants of these. Wisecracks are so familiar that they can almost all be sorted into types, yet they go on making fortunes for the wisecrackers. Much capital is made of the fact that there is something funny in seeing the other fellow suffer—perhaps an outlet for a rather sadistic streak in humans. To see a chair break under a person, even if he gets a splinter in his posterior, can be uproariously funny to everybody but the owner of the posterior. To slip and fall down in a mud puddle is nothing short of a side show for the onlookers, especially if the unlucky victim falls face down. To bend over and have a seam burst is terrific, even though it happens to a good suit. Once I saw a man snipping off Christmas neckties at the knot, with everybody loving it but the gentlemen so snipped. All such things are comic ideas. A laugh comes from a comic idea, or a predicament, or from a twist of the serious to the ridiculous.

My personal experience in comic fields is most limited, but I number several well-known comic artists among my acquaintances. Strangely enough, I find that the producer of comics is rather serious by nature, until called upon to tell a story, when the rare ability comes out. I would say that the comic field, above all others, calls for individuality and originality. Plain exaggeration of drawing is not enough for comedy approach; keen observation of human traits and responses is wrapped up in good comics. The idea is of more importance than the drawing. In fact, some of our best comic artists are not good draftsmen at all, and are funnier because they are not. But there is no doubt that characterization can play a part in pictorial humor, and I do not believe a knowledge of construction, even composition, can hurt a good humorist.

Comics may be sold direct, or, as in the case of newspaper cartoonists, through a syndicate. In order to sell a daily strip, several months of the strips must be prepared in advance. Some cartoonists are kept on salary by the newspapers themselves. Others work as free-lance cartoonists, selling where they wish. Information as to the location and names of syndicates may be had by writing to newspaper offices.

Many artists treat comics as a sort of side issue, because of the highly speculative nature of this field. A comic artist must be unusually good to get into a syndicate, but if he does, it can be highly remunerative—even one of the highest-paying branches of the craft.

Comic drawings should be kept simple, without a great deal of complicated tone or modeling of form. They should be held mostly to line. Elaboration tends to reduce the comic flavor rather than enhance it. The drawings should be kept "open" and capable of considerable reduction. There can be various degrees of exaggeration, though I think it will be conceded that all comic drawing should contain some distortion or exaggeration. Otherwise, it remains a serious drawing which, in spite of a humorous idea, is likely to be accepted without a smile.

IDEAS IN GENERAL

As one becomes experienced in various fields of illustration, it becomes apparent that ideas are often closely related. An idea for a magazine ad may very well be incorporated into a poster or display. The variation is in the presentation. Time is the factor which really determines how an idea is to be rendered—not how long you can work at it, but the time which the observer will likely have at his disposal to take in your idea. Sitting in an easy chair with reading time virtually unlimited, he will respond to a magazine ad with a great deal more in it that would be put into a poster which must be comprehended in a few seconds. Magazine pictures permit more elaboration of environment, background, and extra interest than does the poster. The streetcar card has a little more reading time than the poster, so it can carry a longer text message than a poster, but still not so much as the magazine. The illustration for the streetcar card should be simple and to the point. The drugstore display may be given anything from a passing glance to a few minutes. But there should be simplicity here also.

Any picture idea can be put through the following test to find out if it is practical for its purpose:

1. Can it be seen and read within the allotted time?
2. Is its presentation stripped to maximum simplicity?
3. Can anything more be taken away without hurting its effectiveness?
4. Is the idea consistent with the medium in which it will appear?
 Example—For a woman's magazine, will it appeal especially to women?
 Example—As a poster, is the appeal universal?
5. If the idea must sell something, does it?
6. If it must be seen at a distance, does its detail carry?
7. Would seven people out of ten think it good?
8. Does the picture itself express the idea, or must it carry a supplementary explanation?
9. Has it been noticed and commented upon without your calling attention to it?
10. Can you honestly say it is all your own?

The foregoing test may be considered somewhat severe, but you have the satisfaction of knowing that if your idea can pass it, you are on solid ground. It is much better to put your ideas to the test yourself while there is still time to remedy defects, than to have the defects come back at you. All ideas must go through the mill of criticism and opinion, whether we like it or not. Criticism is hard to take at best, so it is wise to anticipate the unsolicited criticism which seems inevitable and be your own severest critic. You can judge fairly well if criticism from others is unbiased, or prompted by personal motives. Another artist may not be quite as good a critic as a layman, for it is difficult for an artist not to see a subject as he would do it himself. Since you cannot work his way, you should weigh the criticism carefully. He *may* be giving you some good pointers. It is best to seek criticism from people representative of the general public and its taste.

Much early attention which is ordinarily omitted could profitably be given an idea. Many of us could move ahead much faster if we would do more thinking in advance of the job, rather than waiting until it is half finished. We can be our own "I told you so's," and it does not hurt nearly as much from that source. No matter how good we become technically, our conception, ideas, and presentation are all that will carry us forward.

It is only natural that we should be concerned principally with technical execution. But planning things out carefully is the only way we can give that technical ability half a chance. You may think, when a layout is first handed you, that there is no room left in it for personal ideas; but you will invariably find there is some way to do it a little better than expected. If you never get a chance at creating ideas, create some anyway and show them to the boss or the client. Someone will eventually take notice.

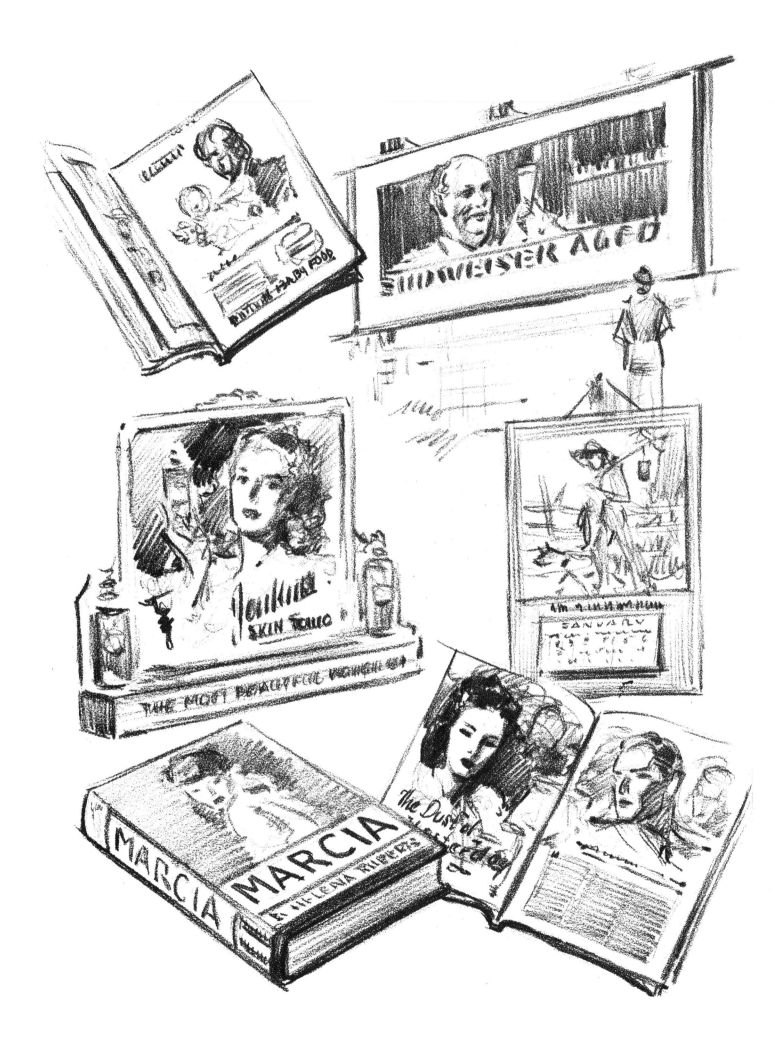

Fields of Illustration

THE MAGAZINE AD

THERE is such an overabundance of material ever present for the study of advertising page arrangement that it seems to me I may safely approach the subject in a more or less general way. Therefore I shall confine myself to types of magazine ads, rather than a host of specific and actual examples. The basic laws of good arrangement should always apply. I believe if an artist can produce good spacing, distribution of mass, balance, and interest pictorially, he will be able also to produce good arrangement for the whole page. Page arrangement really amounts to the setting of given units into a given space as pleasingly and interestingly as possible.

For the most part, arrangement is the province of the advertising agency, and the illustrator has little voice in such planning. Because other elements may be present in a layout, such as conformity to a series, emphasis on given units, selection of type faces, etc., it is often best that these be worked out by the layout men of the agency. But nevertheless the illustrator who is smart will not completely divorce himself from page layout. His illustration must fall into place in the whole design of the page, which design should be understandable to him, and toward which he must be sympathetic and co-operative. He should take advantage of the opportunity for good arrangement which the layout offers him, or, if need be, do what he can to give better arrangement to a poor conception.

The success of the illustration lies greatly in the success of the appearance of the whole ad. If the reader is intrigued by your illustration into reading the copy, the illustration takes on added meaning, and you benefit thereby. If the reader looks at your picture and skips the rest, the whole structure falls apart and the ad fails.

So your first approach to good advertising illustration is: *"How much of the meaning of the text and purpose of the ad can I transpose to my picture?"* More often the picture should amplify and interpret the text than depend upon the text to explain the picture. A good illustration can hold up a poor ad much better than a good ad can hold up a poor picture. You might think of the picture as the show window to the meaning of the ad. If it does not attract, all else fails.

Let us proceed, then, with a clear idea of what your mission is, how you can co-operate to make your advertiser's success your success. Good interpretation is your first law. There are two ways to interpret, the lazy way and the inspired way. The lazy way is always the easy way, the explicit following of instructions with the least possible effort: the attitude of only "This is what he asked for, so this is what he gets." This amounts to a complete subordination of any enthusiasm, individuality, or inventiveness which you may possess—all qualities of paramount importance to your success.

The right way is to search deeply for the psychological appeal, the impelling motive, and the desired response. If you understand these, it will help you tremendously. If you have been asked to portray a mother and child, you are really working toward the deep and vital maternal appeal. Every quality which makes motherhood idealistic and beautiful to you should be incorporated. It might be easier, even more pleasant, to call in that petite little nineteen-year-old blonde who registered the other day and use her for the mother. But can she typify motherhood convincingly? The right way is to hunt up a mother, as "ideal" as possible, and use her with her own child if you can. There will be a spark there that may make your picture. If you cannot do that, don't haul an oversized doll out of the cupboard and make it suffice for the baby. Get a real baby. Such co-operation is not only fair, but wise for your own sake. If you are building a reputation, build it solidly and intelligently.

THE APPROACH TO GOOD ADVERTISING ILLUSTRATION

Of second importance to the interpretation of the text is taking the greatest possible pains to secure the best possible working material. If a price on the final work has been agreed upon, the artist should be willing, if necessary, to pay out at least ten per cent of it in models, props, photos, or other working material. In the long run such an investment will pay large dividends, much better than any other type of investment. If you need to rent a dress, do it, rather than fake it. Get other accessories when possible, for it adds considerably to the ultimate value of your work. I have seen this proved over and over. Two artists may really be of equal ability. However, one fakes, while the other conscientiously supplies himself with the best of everything to work with. The latter will win out, every time. Every bit of working from life is adding to your general knowledge, while every bit of faking keeps you at a standstill, or even drags you backward. You cannot learn except from observation and study. Even a bit of authentic still life in your subject is also authentic study.

Your third and very important approach to good work lies in working out your problem in rough or sketch form, even when such sketches need not be submitted. Find your troubles before they find you. A pencil study from your copy, if you are working from a photo, will be better to work from in your final stage than the photo itself. You will find yourself working more freely and expressively. Much of your pencil study can actually be transposed to the final medium with good effect. As long as the photo hangs next to the final work, the final work will appear unfinished by comparison, unfortunately encouraging you to match the finish and slickness of the photograph. If, instead, your preliminary work is hanging about you, you are improving on what you put into it rather than what the camera saw.

Enlarge by squaring things off. That keeps you drawing, not tracing. Plan your color before touching the final work. Changes are unsatisfactory in any medium. If you have to make a change, get down to as nearly clean a working surface as possible. If working in water color, sponge it down to the paper. If working in oil, take your turpentine and a rag, after scraping with a palette knife, and wipe it down to the canvas. If the under paint is dry, it can be gone over with fresh paint, but it never looks quite as fresh as the first painting on the canvas. Sargent painted every area in a single attempt, or wiped it out and tried it again. Probably much of his directness came from doing the same head over and over until it was so thoroughly fixed in his mind that he could do it in a great economy of strokes. Light paint will never cover dark paint as effectively as dark over light. In time the dark will muddy the lighter paint above it, even if it has not already done so in the first attempt.

When working under pressure it is always a temptation to jump right into the final thing. But my experience has always been that there is no time saved in the process. Getting something out of the mire may take much more time than would have been required to make some sketches and studies. "Worrying through" a picture is bad business. There is enough worry at best, and it should be planned out well enough so that change of pose, different costume, or change of models will never have to be attempted in the middle of the final work. It is better to admit that you made a hasty and bad start, and then start over.

I know one illustrator who made a habit of stretching two canvases for each job. He did all the experimenting, fussing, and fuming on the first canvas. When he thought he had it nailed down, he proceeded to do the thing very directly on the second canvas. It took one-quarter to one-half the time. It was the secret of the ever fresh and spontaneous quality of his work. In reality he was no more direct and certain at the start than the rest of us. Instead of slowing him down, this approach seemed to speed him up, and he thus capitalized on the credit of being a very direct and accurate painter. Had I not been a close friend I might never have known, and since I do not disclose his name, I feel that he is making a contribution to us by his good example.

Unfortunately most artists are really given more freedom than they take. Fear of being wrong can stifle ingenuity and spoil initiative. Try to analyze the intent and purpose of your instructions. If you wish to deviate from them considerably, a telephone call may be all that is necessary. You may be certain that even if your work is well known, no art director can possibly visualize just what you are going to do. He is taking a chance on you, on the basis of your past work. He has to. Nor can you, when you take a job, see the finished thing in your mind exactly as it is going to be. The reason is that the whole thing is a creative process. Little is really going to be said in advance about pose, costume, etc., unless you are handed actual photographic copy to work from. Advertising agencies seldom supply the artist with anything more than the idea and a layout. Your art director is not expected to supply you with copy. If he does, find out then and there how much leeway you have. Copy may be in the nature of suggestion only and not intended to be followed literally. I well remember an art director who had a habit of clipping magazines and pasting the clips into layouts. He would tell the artist to give him something equally good. One earnest young illustrator, doing his first job for him, made a perfect swipe. He brought it back with the time all gone, the deadline at hand, and a frantic art director.

Build up your files of clipped information on as many subjects as you think you will *ever* need, not what you need just now. It takes years to make a good file, and you might as well start early. As you go along in advertising you will begin to recognize certain types of ads. Try as we may to be different and original, most ads will fall into one or more of these types. I have laid out as examples twenty-four fictitious ads which I believe cover most of the types. The variance of course would be in the layout and arrangement. These may serve as general ideas for approach, though the ads must not be actually copied, nor the same slogans, titles, or catchlines used.

TWENTY-FOUR TYPES OF ADS

1. With "Pictorial Interest" Dominating

In this type the picture is almost everything. The illustrator is of primary importance and is picked for his ability. One half, three quarters, and, at times, a full page is allotted to him. It is therefore his whole responsibility to tell the story, to get attention and response. Such an ad is about the greatest opportunity for an illustrator that there is. That is why much of the material of this book is laid out as it is, for here real responsibility is going to rest on your broad shoulders.

2. Interest Centered on a Large Head

Here is where character, expression, and the ability to portray personality come in. A large head, when well done, makes a good ad.

3. The "Eternal Appetite" Appeal

People will always be hungry. It is our job to make them hungry for what we have to sell.

4. Interest Centered on the Product

The purpose of this type of ad is to impress the actual product on the memory of the public. It offers great variety.

5. Romance

Romance is as eternal as the appetite. It will always be the problem of the illustrator.

6. Home and Family

Over and over this type of ad appears, yet there is always some new angle.

7. Historical—Biographical

Always presenting opportunity for interest, and thoroughly enjoyed by the illustrator.

8. "Before and After" Subjects

A well-worn but perfectly sound approach.

9. Prediction of the Future

If it can be made convincing (and sometimes

fantastic) it will almost guarantee attention and interest.

10. The Cartoon Type

The cartoon approach is good because of its contrast to the prevailing seriousness of its neighbors. It acts as a change of pace, and gets attention.

11. The Extreme Close-Up

Very effective for otherwise dull subjects. Fits everything from houseflies to eyelashes.

12. The "Group Picture" Type

Sometimes a group of pictures has an advantage over a single picture in story-telling value. For example, several uses for the same product.

13. The Picture Continuity Type

Borrowed from the comic strip. Tells a story in pictures. Here the artist must be able to repeat his characters under varying conditions. This type seems to be losing punch, since there has been so much of it. But maybe it's still good, who knows?

14. The "Action" Type

Good action is always an eye-catcher.

15. "Sex Appeal" Type

It will always be with us.

16. The Sketchy Type

There is a power in sketches often missed in labored work. It offers real advertising value. Should be used more.

17. "Fear" Subjects

Based on the instinct of self-preservation, and very potent for certain types of advertising. Should not be too obvious or grotesque.

18. Symbolical Subjects

Unlimited in opportunity for originality.

19. "Baby" Subjects

Will always stay.

20. "Character" Subjects

Real opportunity.

21. "Kid Stuff"—One of the Best Sellers

Who can forget childhood? What parent is not interested? There is practically no limit to ideas along this line. Children should be portrayed as realistically and naturally as possible, and not too dressed up. Child appeal lies more in wholesomeness than in being beautiful.

22. "Mother and Child" Subjects

When well done they will always appeal.

23. "Luxury" Appeal

Such an appeal is best in times of plenty, when quality and good taste have a chance. Such appeal might also be listed as desire for prestige or distinction, and pride of ownership.

24. The "Purely Imaginative"

This is your one chance to go a little crazy, and most illustrators welcome it.

My readers' attention is called to the books by Frank Young on advertising layout. Mr. Young's authority on the subject is beyond question. My personal acquaintance with Mr. Young and his work has been of great profit to me in the field, though I confess I cannot hope to compete with his knowledge and experience in the subject of layout. I believe every illustrator should study his works thoroughly, and I take this opportunity to thank him for his inspiration and guidance in the past. I have made no attempt to teach layout in this volume, since it has been so expertly done elsewhere. For this reason I speak of the general types of ads only, realizing that as layouts they may be open to considerable criticism. Frankly, I am not a layout man, and I only wish I were better at it.

May I also call your attention to a recent book on modern layout entitled *Advertising Layout, The Projection of an Idea*, by Richard S. Chenault. This book is expertly done under the capable direction of a well-known and practicing art director, and will clearly demonstrate essentials of real importance.

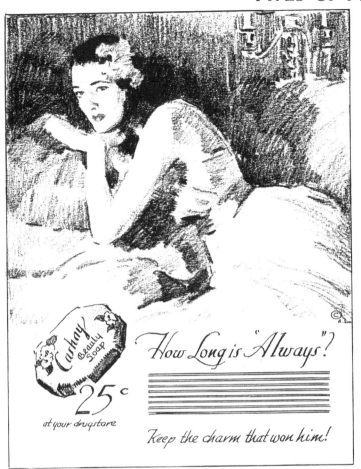

1. WITH "PICTORIAL INTEREST" DOMINATING.

2. INTEREST CENTERED ON A LARGE HEAD.

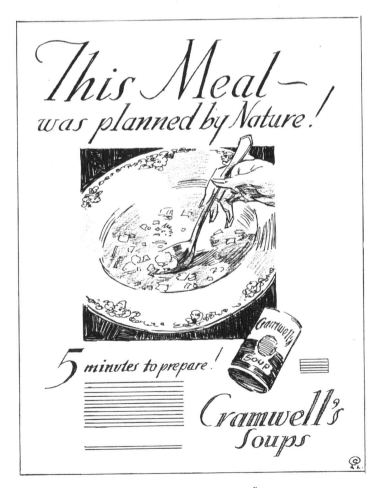

3. THE "ETERNAL APPETITE" APPEAL.

4. INTEREST CENTERED ON THE PRODUCT.

5. ROMANCE

TENSION - the despoiler that works overtime

NEUROLAX

6. HOME AND FAMILY

JUST A BOY WITH FANTASTIC IDEAS.

UNITED RAILROADS

7. HISTORICAL - BIOGRAPHICAL.

" WE KNOW A MAN BEST - NOT BY THE QUANTITY OF HIS POSSESSIONS, BUT BY HOW HE TAKES CARE OF THE LEAST OF THEM " — Benjamin Franklin.

IT'S LONG LIFE MAKES IT COST LESS.

DURAMIX
THE LONG LIFE PAINT

8. "BEFORE AND AFTER" SUBJECTS.

TOMORROW'S TRAFFIC

RADIO POWER

STATION G

NORTH ARTERY

YOU MAY" TUNE IN YOUR AUTO-POWER

COMMANDER SPARK PLUGS

TODAY IT'S ALWAYS COMMANDER

9. PREDICTION OF THE FUTURE.

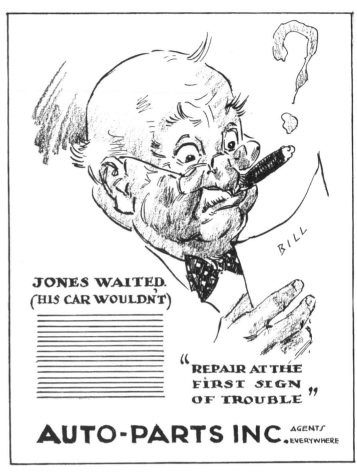

BILL

JONES WAITED.
(HIS CAR WOULDN'T)

"REPAIR AT THE
FIRST SIGN
OF TROUBLE"

AUTO-PARTS INC. AGENTS EVERYWHERE

10. THE CARTOON TYPE.

KEEP YOUR EYE ON
FLEETCARS

10 NEW MODELS
IN OCTOBER

POWER MOTORS CORP.

11. THE EXTREME CLOSE UP.

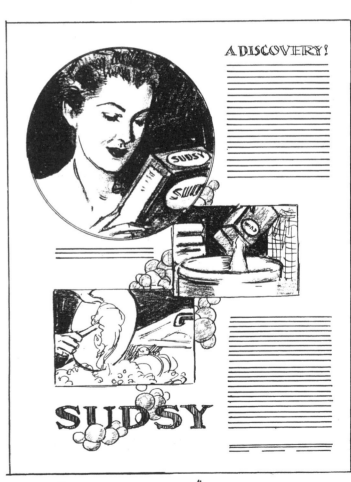

A DISCOVERY!

SUDSY

SUDSY

12. THE "GROUP PICTURE" TYPE

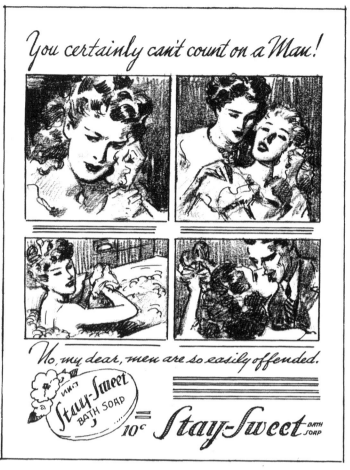

You certainly can't count on a Man!

No, my dear, men are so easily offended.

Stay-Sweet BATH SOAP

10¢ Stay-Sweet BATH SOAP

13. THE PICTURE CONTINUITY TYPE

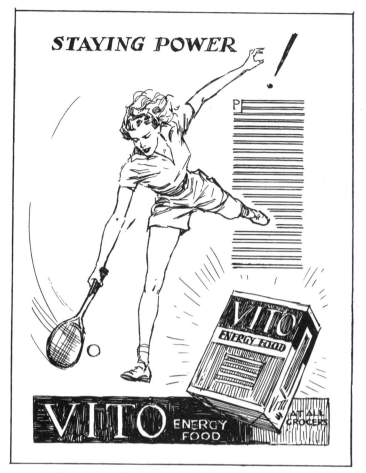

STAYING POWER !

P

VITO ENERGY FOOD

VITO ENERGY FOOD AT ALL GROCERS

14. THE "ACTION" TYPE

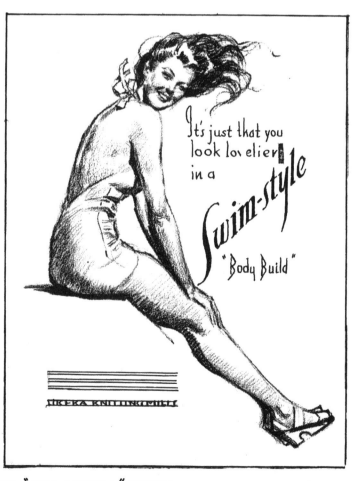

It's just that you look lovelier in a Swim-style "Body Build"

EUREKA KNITTING MILLS

15. "SEX APPEAL" TYPE.

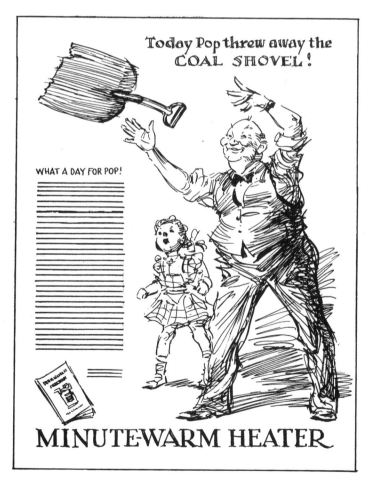

Today Pop threw away the COAL SHOVEL!

WHAT A DAY FOR POP!

MINUTE-WARM HEATER

16. THE SKETCHY TYPE

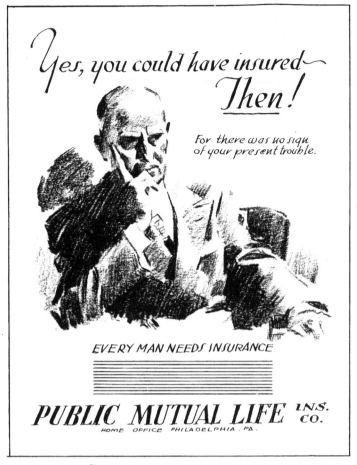

17. "FEAR" SUBJECTS.

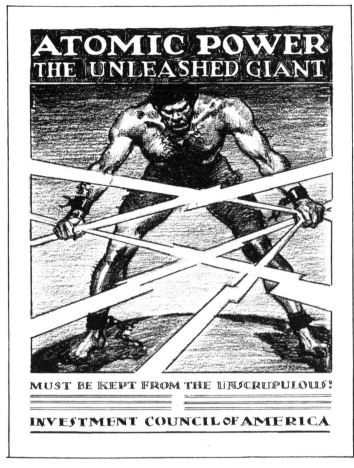

18. SYMBOLICAL SUBJECTS.

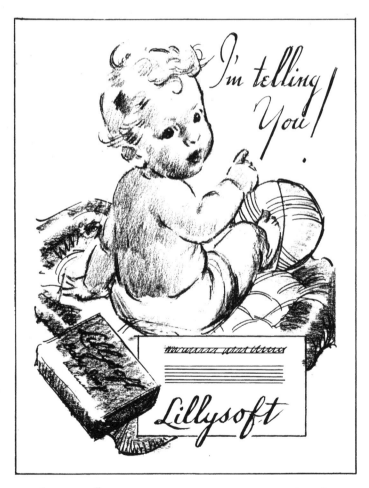

19. "BABY" SUBJECTS WILL ALWAYS STAY.

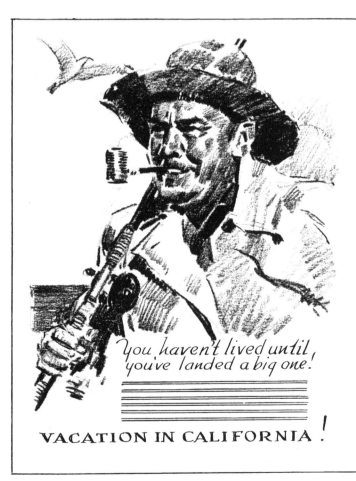

20. "CHARACTER" SUBJECTS.

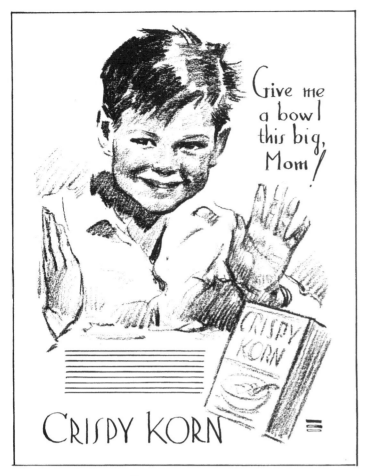

21. "KID STUFF" — ONE OF THE BEST SELLERS.

22. "MOTHER AND CHILD" SUBJECTS. (MATERNAL APPEAL)

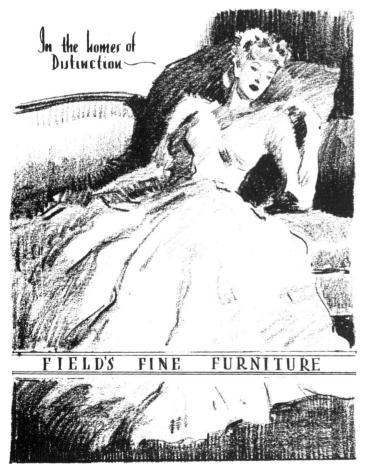

23. "LUXURY APPEAL.

24. THE "PURELY IMAGINATIVE".

235

RELATING YOUR ILLUSTRATION TO THE WHOLE AD

Even though you are not called upon to lay out the whole page arrangement of a magazine ad, it is, as I have indicated, of considerable concern to you. Much depends upon your carrying through the general scheme of layout as well as your execution of the pictorial idea. I will endeavor to give you a few pointers which may help in the ultimate result.

If your layout is already "busy" with complicated and space-filling material elsewhere, try to treat your illustration with as much open space as possible, keeping the masses simple, or not too broken up in light and shadow. In planning the subject, indicate the general masses or patterns of value on tracing paper and lay it over the layout. You will find that much can be eliminated. In a complicated and busy layout the illustration will look better if almost flat and postery, with little or no background, and utilizing the white space to give the illustration "air." A so-called "spotty" picture does not belong in a "spotty" layout. No matter how well done, the effect is unpleasant and the advertising value lost. Every illustration should offer contrast to its surroundings to secure attention.

The same is true of the "grey" layout, or one which contains large areas of small text or type matter. Unless a somber or "moody" effect is desired, the illustration should not also be too grey in appearance. It calls for the largest possible areas of snappy blacks and whites, against which the grey of the text will appear beautiful.

If the layout has good open areas of white space, you are most fortunate. Advertising men have been hounding their clients for years to see the advantage in attention value of white space. But unfortunately space is expensive, and the tendency by the man who is footing the bill is to fill the space to overflowing. In the long run he is paying twice as much, since such an ad is only half as effective, if even that. White space can make or break an ad. In such a layout you can go the pictorial limit, getting at least four good contrasting values in your picture.

You can go back to the original four tonal plans in planning your illustration. If your layout background is white, play some strong greys and darks against it, and also carry some of the whites of the background into the illustration. If by chance your layout is to carry an overall grey or black background, work to the other plans. The point is to put lights against grays and darks, or the reverse. Attention to this factor makes all the difference between an ordinary thing and a truly outstanding ad.

The material in a photograph must ordinarily be accepted and put into a layout as is, although sometimes an enterprising layout man will cut out the figures or material in a photo as you would a paper doll, thereby getting away from the greyness or drabness of a subject. But it looks hard and "pasted on," and has not the value of a good sketch or vignette with planned lost and found edges which would interlace the subject with its background. Such interlacing is necessary to give the unity of effect which is so important.

In delivering your picture, it is well to point out that you have considered the effect of the whole arrangement, perhaps taking along some of the preliminary material by which you arrived at your presentation. Not having the rest of the layout around it, your original may possibly appear a bit overpowering or even a bit weak, and if this is commented upon, you are ready with substantial reasons. This situation seldom occurs, however, for comments usually hinge about the merits of the picture itself.

If the product appears in the layout but outside your illustration, try by all means to carry the eye through your picture toward it, or at least in its general direction, by providing a route for the eye to follow through the design of masses, edges, or lines. This will be greatly appreciated by the art director. Sometimes the product may be superimposed, or so placed that it overlaps into the illustration. In that case, supply suitable contrast in that area to make the product separate in value, so that it stands forward in relief. If the product appears within the illustration, make it the point of interest by leading all possible lines to it.

DEVELOPING THE "CO-ORDINATION SENSE"

It is admittedly difficult for the artist with little experience at once to co-ordinate his efforts into full swing with the advertising or commercial approach. Often the beginner will hear the phrase: "We are not looking for high art here—what we want is good advertising." It is unfortunate that a separation between art and advertising exists in the minds of advertisers, for it can be conclusively pointed out that all the progress in art illustration that has been made in the past twenty years has been in the direction of fine art. A study of the *Art Director's Annual*, covering a period, I believe, of more than twenty-five years, will prove it. Advertising is constantly approaching fine art, and it is my opinion that it has caught up with and in many cases is surpassing much of the so-called "fine art" of the country. In some cases advertisers have singled out the best artists in the country from that standpoint, paying any price to get their work. No advertiser will ever object to fine drawing, good values, arrangement, color, and conception. There can be no line of distinction drawn between advertising art and "high art." Either is only good or bad. The basic difference between the two has nothing to do with paint, medium, or technique. The advertising approach leans more to the telling of the story, the psychology of appeal, attention value, and response. High art may be anything that has its own intrinsic beauty and is created for no other purpose.

Where advertising art may suffer by comparison is in the inconsistencies permitted. "Blurbs" or "balloons" may be borrowed from the comic strip and inserted into a finely executed painting, with no better result than to become incongruous and show extremely bad taste. When taste is sacrificed for attention, what good is the attention, if drawn only to bad taste? Who can display bad manners anywhere and benefit by the attention so obtained? Advertising falls short of the mark continually by the erroneous idea that tight and overinsistent detail makes the best picture. The chances are that such detail will draw attention away from the idea and product more than it will enhance it. Advertising fails with respect to color when it insists that color lies only in primary or spectrum color, with one fighting another. In the end, such an attempt only publishes, on a grand scale, the advertiser's inherently bad taste. If the advertiser does not believe color lies in tones and beautiful relationships, let him attend any technicolor movie. It is more brilliant than his primaries.

Advertising fails sometimes because the people who are given authority to plan and order pictures may lack the fundamentals of pictorial knowledge, and hence may give out directions that are totally inconsistent with good advertising art. Oddly enough, the less a man knows, the more orders he is apt to give. The ablest art directors, recognizing ability, give it every freedom possible. They get consistently better results.

The best way to get the "feel" of advertising presentation is to thumb through a magazine. Take an ad, and on your pencil pad start moving the units about in a new arrangement. Eliminate some of the "deadwood" for white space. You simply make blocks, lines, and white spaces in miniature pattern in a design of whites, greys, and blacks. Out of ordinary layouts can come gems if thought is given to balance and design. Before long such experiment will begin to express itself in a flair for good spotting and arrangement.

Co-ordination between artist and advertiser lies in mutual understanding of intent and purpose. He contributes the merchandising theory and the space as well as a reputable product. You contribute your understanding of light, form, design, and dramatic interpretation. It cannot all come from either side, and your contribution is even greater than his, for your particular knowledge is even more difficult to acquire.

The best commercial artist is by no means the complete "yes" man. But he is willing to listen and co-operate in every way short of producing illustrations or art that he feels would actually do his reputation more harm than good. Rather than deliberately make a very bad thing, let him have the courage to refuse the job. When the job means only the fee, forget it.

237

A TYPICAL MAGAZINE AD ASSIGNMENT

Let us assume that a call has come from the art director of an advertising agency. We find that he wants an illustration in black and white for general use in the magazines. On the next page I give you a layout in approximation of a typical agency layout. We assume the layout is to be followed for space allotted to each unit. The account is a company that manufactures heat control units. The headline is to be "Perfect Weather Inside." We agree that the idea is rather novel and interesting. The psychological appeal is "freedom from cold." Coupled with this would be love of home and family, and desire for security and comfort. We note that the contrast, or "before and after," is to be supplied by the small line drawing of a man in an overcoat subjected to a blast of cold wind. (The art director tells us that this line drawing will be handled inside their own art department.) Thinking further about the psychological angles, we find that "freedom from care," "desire for relaxation," and many others, are implicit in this subject. All of this points to what we can do with the illustration.

Let us show the father free to give his time to his little daughter, the mother affectionately hovering over them and interested. It is logical to entertain the child with a story book in the evening, when man is most apt to be home, and when the outdoors is coldest. The busy art director may not go into any more detail than to say: "We want a sweet little family group, all happy and warm. We want it well done, and we need it in a hurry." (Everything having to do with advertising is always in a hurry.) He says he will not need a comprehensive sketch, but would like to see some roughs for general composition.

Following you will find the roughs as they might be submitted, or which a conscientious artist would make anyway before hiring models. One of these is selected as coming closest to the purpose, and the models are called in and photographed in the poses wanted. Several lightings are tried out, and many attempts are made to get as closely as possible the expressions that will tell the story.

You will note in the final illustration an attempt to get away from hard photographic detail. Edges are considered carefully. A back lighting was chosen, since it would be logical to light the book over one's shoulder, but also it gives us good opportunity for reflection and luminosity within the shadow. When there is no color to support a subject, it depends entirely on values for pictorial effect. Every subject should be studied carefully for a good balance of darks, greys, and whites, for black-and-white interpretation. The one thing to avoid in black and white is a feeling of heaviness and darkness, especially in a cheerful subject. Values are so related to mood that sometimes, when not considered in that light, a picture may unfortunately present a mood wholly in opposition to the idea expressed.

I believe it will become more clear, the farther you get in the craft, that the individual feeling and personality of the artist is most important. Pictures are so much more than filled-in outlines of something, and the only place to find expression is in the interpretation of the source—which means nature, light and form, plus your individual feeling about it.

So much of advertising has so little personality, so much formula. There is such a tendency to imitate, so little invention on the part of art director and artist. It is not surprising that often, with the extreme tension and pressure all have to work under, little thought is turned toward these things. The answer is not in your competitor's approach. But so few of us exhibit any courage in striving for individual expression. And yet if it never has a chance, it never can really come out into the light!

Let us start believing that our eyes, not our ears, are as good as the other fellow's. Let us believe we have as much right to expression as he. If we do not know what to put down, it is because we have not dug deep enough into the subject or into ourselves. If nothing in the world interested us, we would have no ideas. As long as there *is* something that does, we have a basis for expression of our feelings about it.

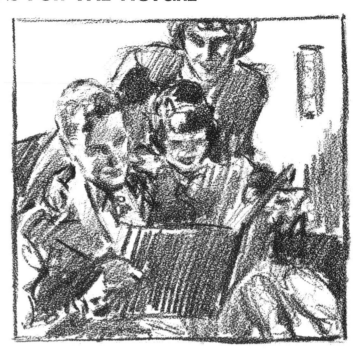

AFTER CAREFUL CONSIDERATION OF THE AGENCY LAYOUT WE BELIEVE WE CAN MAKE THE SUBJECT BETTER BY CROPPING, GIVING LARGER HEADS. AS GIVEN TO US THE FIGURES FACE OUT OF THE AD. IT SEEMS TO DRAW THE ATTENTION AWAY FROM THE PRODUCT, RATHER THAN TOWARD IT. SO WE TRY TURNING THE FIGURES AROUND. WE CHECK THIS WITH THE ART DIRECTOR BY PHONE OR BY SHOWING THE ROUGHS. WE ARE NOW READY TO CALL IN MODELS FOR PHOTOS OR STUDIES. HAVING THESE ROUGHS WILL MAKE THE CAMERA WORK THINGS OUT OUR WAY INSTEAD OF OUR WORKING FOR THE CAMERA. TRY IT OUT.

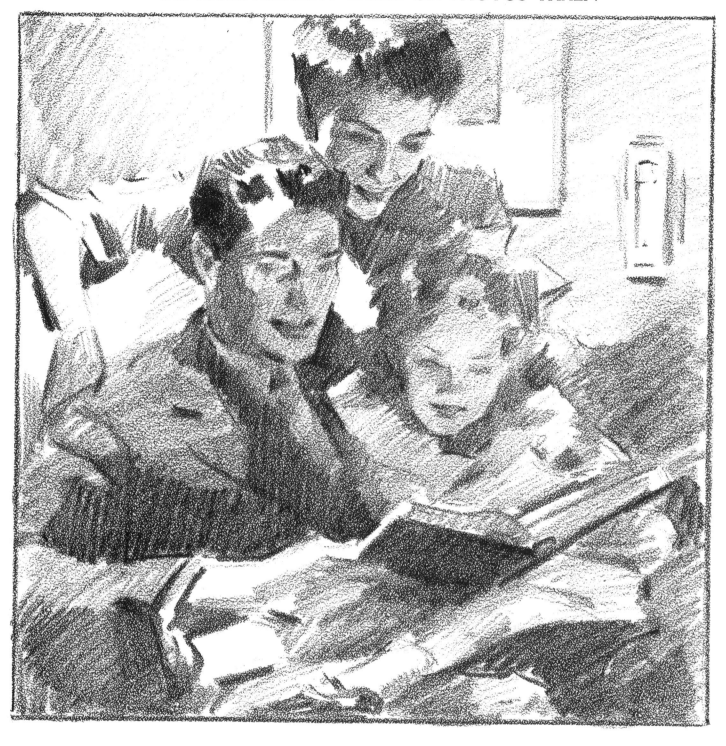

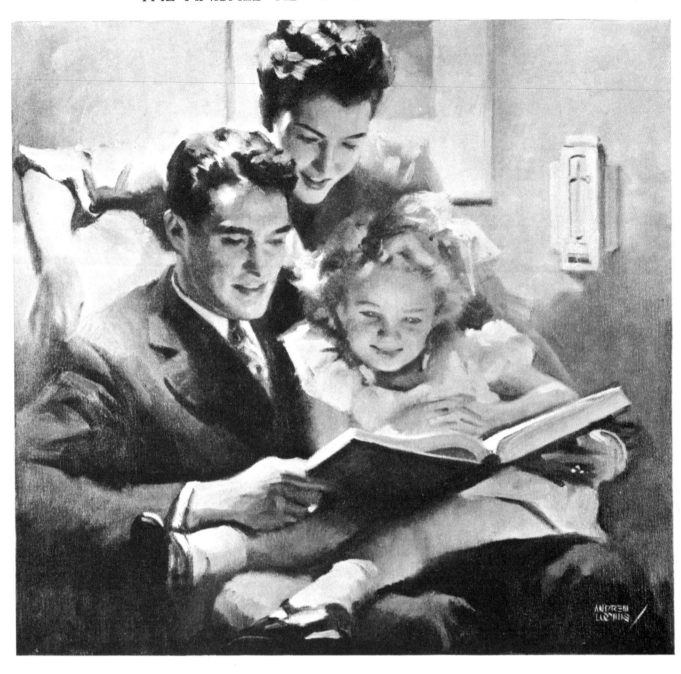

WHAT IS THE FUTURE IN MAGAZINE ADVERTISING?

It would seem that magazine advertising has done almost everything possible, that we have reached the place where duplication is inevitable in any approach. But magazine advertising must go on, and unless we artists can contribute something more it would seem that it is destined to go on in much the same way.

One of the greatest drawbacks to good taste in advertising is the clamor for attention. Types get heavier and bolder. Color gets louder. Space gets jammed. Space gets more expensive, and as it does, more has to go into it. Every artifice to force attention is naturally seized upon. It is much like a group of people in a room. One talks louder than another, forcing the next man to raise his voice also. Perhaps someone booms on the radio, and soon everyone is shouting. The quiet dignified person is hopelessly lost. A magazine ad would be a wonderful thing if it could be handled on the basis of "Let's everybody be quiet but me," as a little boy once said. It reverts to the philosophy that "If everybody insists upon being loud, what can I do but shout?"

But fortunately the printed word cannot shout. There is a misguided conception of what boldface type, gaudy color, blurbs, and script can do. The very element of contrast which makes these things gain attention, can make them inaudible by lack of contrast when everything else on the page "shouts." Just as quiet in a room lends distinction to a single modulated voice, so can simplicity and space lend attention to a charming presentation. Boldface type eats up the very space an ad must have to be fully effective. Clashing color destroys both itself and that very quiet and contrast which brilliant color demands.

Suppose we have a floor strewn and cluttered with everything under the sun. We sweep a square of open space and set an orange or an apple in the middle of it. That, to me, is the principle of focusing attention. If we had dumped a crate of oranges among the rest of the confusion, it would not have gained us one-tenth as much attention.

This is the most difficult fact in the world to get over to the advertiser, but the effectiveness of it, once tried, is proved over and over again. I think of a Coca-Cola poster with the single word "Yes" on it, as a single girl figure in it proffers a bottle of the product. I think of a Campbell Soup ad showing the head and shoulders of a boy who holds out a bowl, with the title "More." White space enveloping a bit of bright color—in the first example, a flat green enveloping a large head. I think of a jewelry firm showing a single piece of jewelry in the middle of a black page. I think of the simple effectiveness of the McClelland Barclay Fisher Body ads, which are still advertising history. I could go on with many more instances, proving that all the boldface and blaring types of approach never equaled these in selling the product and the advertiser's name.

Since we cannot put neon lights on a magazine page (even this has been tried, as far as the pictorial effect could reach!), it would seem obvious that shouting and screaming is not the answer. Granted that contrast is valuable and necessary when possible, may it not be that the best possibility left for contrast is good manners against bad? Can we not lend distinction through simplicity, sweeping up the clutter of bad advertising with good white space?

If advertising is to progress, is there much more that can be done with copy and text? Are there any superlatives left? Not so many years ago the magazines produced the bleed page. This allowed an inch or so more of space on each side. Everybody seized upon it who could afford it, for was it not more space that could be filled up? It made one ad a little larger than another, but to what purpose? The beauty of the white margin which gave effectiveness was finally pushed off the page, so that the ad merged with the carpet. Size, when crowded, has so little to do with effectiveness. I call the reader's attention to the fact that no matter how big or small a face may be on the movie screen, we are never conscious of its being anything more than the face of a human being. Size only permits us to see the same thing, in close-up appearance, from a greater distance. When such

243

an effect is an asset, it is valuable in advertising. But size is always obtained at the expense of marginal isolation or "breathing space." When size laps over the edges it ceases to function, just as a man can get too fat for comfort and appearance. An ad can spill over its space as easily as a fat man over a chair. Little has been gained by the bleed page, except to the very smart advertiser who takes it as breathing space, the extra room being worth the extra cost. The bleed page is like an unframed picture.

If advertising cannot get louder and bigger, what is left? There is but one answer: better taste. Better taste in art, copy, and presentation. Advertising has grown out of its old clothes. They will not do forever. Instead of shunning good art, it must finally seek it. The things that have made the greatest art will make the greatest ads — the straightforward presentation of truth, embellished with imagination and taste, simplicity of approach, subordination of the trite and irrelevant, and the inexhaustible reaching for the ideal.

There are possibilities for art in advertising that have not yet been explored. But such developments must come from the realm of art itself, not from the ad man's desk. The advertiser cannot, nor ever could, tell us how to do it. He tries to tell us what he wants, but he has to take what we can give him. He is more limited than we. That is why we must not limit our individuality or ability to the things requested of us. We must give him more than he asks for.

There is no other course open than to produce better layout men, better artists, and better copywriters, for magazine advertising can never be anything more than the co-operation of the three. If possible, we must strive to eliminate the distinction between art for advertising and fine art. It does not seem quite logical to starve in order to produce fine art, at the same time keeping aloof from advertising. Instead of the "fine" artist's "lowering himself" to advertising, why should he not lift it up to the highest possible level? Cannot the observer enjoy a good thing as much from a printed page as from an exhibition wall?

Can one doubt the effectiveness if one of our magazines were to reproduce a Sargent water color, or one of his amazing charcoal heads? What, after all, holds advertising on a lower pictorial level, but the art we produce for it?

No, my dear reader, magazine advertising is far from having done everything possible. It will align itself with the best ability we can produce. When we get good enough, it will stop telling us what to do. It has its own department of good taste to clean up, in layout and presentation, but that is far less to acomplish than the task which lies before *us*. We must put the fundamentals to work as has never been done before. We must not regard a year or two in art school as all the study we need. Such study is only the apprenticeship to the individual study we will have to do for ourselves.

There is no doubt that new forms of advertising may spring up with new inventions. Publicity is publicity, whether we sing it, say it, picture it, or act it. Advertising is any way in the world to get people to look or listen.

When we think of an increase in taste as the only answer to the future of advertising, let us consider the average motion picture of twenty years ago as compared with the present. Compare the acting, the presentation, the creativeness all the way through. The hero and heroine of yesterday could not possibly "get by" today, nor could the producer.

We can look at architecture, industrial design, engineering—every one has progressed along the lines of greater simplicity and good taste. Advertising cannot be the unique profession which does not need to change its course.

To prepare for the advertising of tomorrow, do not look too much at today's ads, but look rather at life, nature, form, color, and design. Go to the only source that can give your work the fine qualities that are so needed. Paint heads as if you were painting a fine portrait, paint form as carefully as you would sculpt it. Look for the beauty of tone and color that would go into an exhibition painting. There is no better way.

THE OUTDOOR POSTER

THE RELATION of reading time to advertising has already been pointed out. Nowhere is this consideration more important than in planning the outdoor poster. It is agreed among poster authorities that ten seconds is the maximum reading time. Therefore, the poster must be planned on that basis. Now, ten seconds is very little, and even that would be quite too long to take one's eyes off the road when driving a car. In order to give maximum reading time and at the same time cut down danger to the motorist, two plans for poster display are followed when possible. One is to place the board at an angle so that it can be seen for some distance ahead. This accounts for the zigzag arrangement often seen in billboards. The other is wherever possible to place the billboard in front of the driver and in such a position that the line of vision is in line with the traffic. The number of words is cut to the minimum and the poster's arrangement is the simplest possible, designed to carry the maximum distance. Take it as an axiom, then, that a poster must be simple, direct in appeal, and capable of being quickly read.

A large head probably holds first place in poster planning—or if not a head, then a large single unit of some kind. A single figure, especially if it can be inserted lengthwise, is good. If half figures are used perpendicularly, more figures can be used. The poster seldom attempts the solid picture running to four corners, unless the subject is extremely simple.

Eight words on a whole poster is about all that should be used, including the name of the product, and every word that can be further eliminated will be so much to the good. A poster with but one word is the dream of every poster man. Advertising agencies accustomed to preparing copy for magazine advertising often miss badly in planning posters.

Flat or very simple backgrounds are almost a necessity. Some sort of a diagonal arrangement is good, since it contrasts with the usual horizontal and vertical arrangement of competing posters. Dropping the top line of the poster background a little and then letting the pictorial unit reach above it is also good. This makes a dip in the line of other posters and is a device for getting attention. A line of lettering is often used above a poster background for this reason. The four basic tonal arrangements given earlier in the book are almost indispensable to a good poster. Posters must be clean-cut, sharp, and in good contrast.

The layout of poster sheets on the following page should be carefully studied, so that you will not plan posters with the edges of the sheets cutting through eyes, fingers, or even through a head, if these can be placed on a single sheet. Do not let a sheet cut lengthwise through a line of small lettering. If the bill poster is pasting on a windy day it is almost impossible to match or fit the sheets together exactly. Every bit you can help the lithographer in reproducing your design results in a better job for both of you.

Note that the half sheets may be placed either at the top or bottom, or above or below the two larger sheets. This permits a good deal of latitude in your design, and you should be able to place your material so that unfortunate cutting through important elements can be avoided.

Posters are sometimes syndicated, with space left for imprint of the dealer's name. In that case, such space must be planned into the original poster. Posters, even more than other illustration material, need to be planned carefully. You are usually asked to make a comprehensive sketch before making the final, and that is a good thing, for a good poster is seldom guess work.

There are several more or less "stock" arrangements of posters which should be familiar to you. It is really hard to get very far away from them and still produce a good one. The horizontal shape of the poster is not easy to fill with good design, and is different from the usual shape of any other type of illustration. Experiment with it.

245

HOW A POSTER IS DIVIDED INTO SHEETS

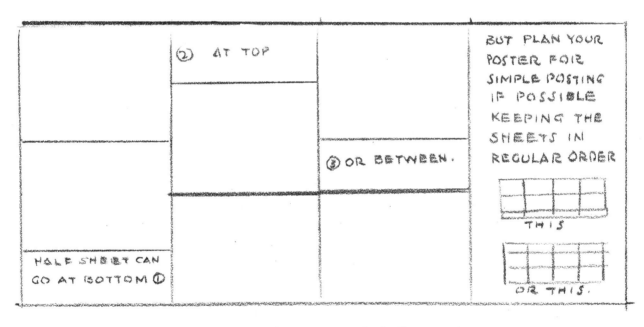

LENGTH IS 2¼ TIMES THE HEIGHT.

DIVIDE BY FIVE

2/5THS 1

2/5THS 5

⅕

2¼ SHEETS

1 2 3 4

FOUR SHEETS ACROSS

5 6 7 8

FULL SHEETS

HALF SHEETS.

LAYOUT OF OUTDOOR POSTER SHEETS.

② AT TOP

③ OR BETWEEN.

HALF SHEET CAN GO AT BOTTOM ①

BUT PLAN YOUR POSTER FOR SIMPLE POSTING IF POSSIBLE KEEPING THE SHEETS IN REGULAR ORDER

THIS

OR THIS.

PLAN YOUR POSTER

A POSTER CAN JUST AS EASILY BE PLANNED RIGHT FOR THE LITHOGRAPHER AND PASTER. AVOID HAVING SHEETS CUT THROUGH EYES, MOUTHS, FINGERS ETC. WHICH WOULD LOOK BAD IF SHEETS WERE PASTED SLIGHTLY OUT OF ALIGNMENT. SUCH CUTS ARE BAD FOR THE LITHOGRAPHER. IF YOU CAN, GET THE FEATURES WITHIN THE SHEET. WATCH THAT THE LATERAL CUTS DO NOT SEPARATE OR CUT THROUGH A LINE OF SMALL LETTERING. "THE BETTER FOR THE PLATEMAKER, THE BETTER THE PLATES." DO IT RIGHT.

246

ILLUSTRATIVE INTEREST ON ONE SIDE, AND MESSAGE, PRODUCT AND NAME ON THE OTHER. NOTE LAYOUT OF SHEETS.

DIAGONAL ARRANGEMENT BETWEEN NAME AND CAPTION. CAN BE DIAGONAL EITHER WAY. CATCHES EYE.

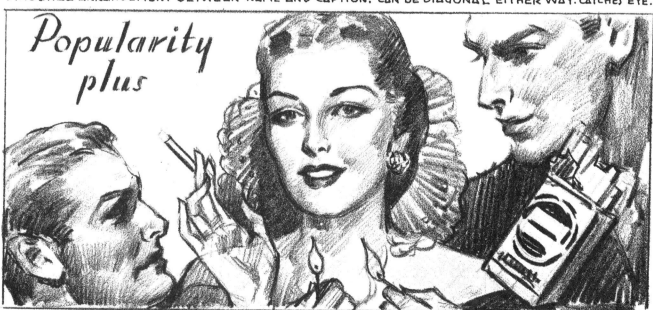

ILLUSTRATION ON BOTH SIDES. AREAS LEFT FOR CAPTION, NAME OR PRODUCT. CAN BE A SOLID PICTURE.

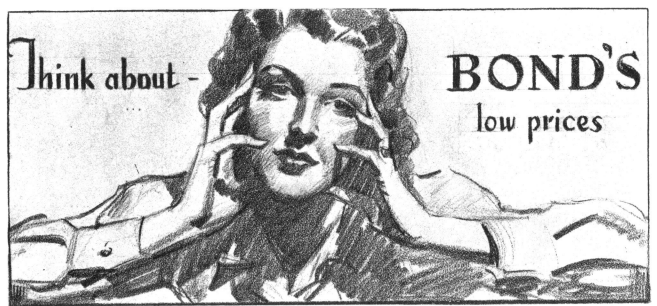

CENTERED INTEREST, LETTERING AT SIDES.

SUDWEISER-AGED!

SUBJECT OVER NAME

FIVE MINUTES TO PREPARE!

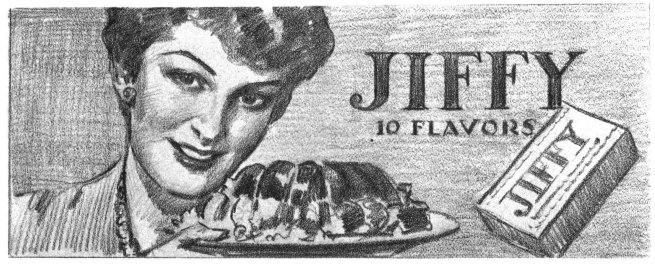

CAPTION OVER TOP.

A TYPICAL POSTER ASSIGNMENT

Let us suppose we have been commissioned to do an outdoor poster. We will take a fictitious product and I shall try to carry it through to completion exactly as I would were it an actual problem. Suppose we take a soft drink, a lime drink. We will call it "Zip," since I know of no actual product by that name. Now, if it is a lime drink, there may be some people who do not like a drink too sour; so the problem might easily be to produce an attractive poster emphasizing the point that "it is as sweet as you like it." This calls to mind several captions:

Sweet as you like it *Couldn't be sweeter*
Just sweet enough *Sweet as can be*

The last one is probably the best. It calls to mind a sweet young girl, but since the drink is named "Zip," she should have a peppy breezy quality about her too. We must show the bottle and perhaps a glass. If we show her in action, the bottle and glass would have to be separate. So in order to tie the figure directly to the product, let us show her holding the bottle and perhaps a nearly filled glass. Since this is not very active, we will go to the other extreme. She is dressed in play clothes, has been active by suggestion, and is now relaxing after exercise on some sort of an outdoor lounge.

I should say that she should be looking out and smiling at you (it will ever be thus). The poster, being long in shape compared to height, is ideal, then, for the subject.

The product name or trade-mark would have to be incorporated into such a poster. So we will design one here, though in a real order it would already be worked out. I have never been an expert letterer, and that part has always been taken care of either by a lettering man under my hire or by someone who is buying the poster. So, even though some may find my lettering at fault, I will do the best I can, and ask your indulgence on that part of it.

I have just drawn a few pencil roughs for general arrangement, very small. For lack of space, and since all but two were discarded, I will not reproduce them. However, from the two most promising I have worked out two a little more complete in the size of four by nine inches. These must be reduced a little to fit our book page size. From these I have worked out two color roughs. Since these are for general effect and color choice, I have made them as simple in treatment as possible. Were I to submit an actual color sketch, I would carry it farther and make the sketch ten by twenty-two and a half inches in size.

Choosing one of the sketches, I now call in a model and set up the pose the best I can. I would either work from life or take photos. I want an animated smile, and want to nail it down, and since I have worked out a fairly good color scheme, I take a photo based on the roughs.

Selecting the best print, I proceed with the final work. The painting will be in the proportion of twenty by forty-five inches. The reproduction will be made from this large painting. I now lay out the poster in charcoal. First I lay out the sheets. I find that, by using the half sheet at the top on the left side of the poster, I can bring the girl's face completely within the second sheet down. Also it brings the caption onto the half sheets at top. Satisfied that everything is going to work out for the lithographer, I start the final painting. The background is painted in first, then the red lounge. The background is a color made up of the color in blouse, lounge, and the white shorts. The white shorts have been related with a little of the other colors.

The picture has been completed and the paint allowed to dry. I now add the lettering and some final touches to the whole thing to bring it all to completion at the same time. A white margin was left around the painting to simulate the blanking space of white which is around every lithograph outdoor poster.

There has been a hue and cry against outdoor posters as defacing the beauty of our cities and countryside. In the open country they may be an eyesore, it is true; but just as often they may screen dilapidated buildings or empty lots heaped with rubbish. With better art they need not be ugly. It's up to you.

A GOOD ARRANGEMENT. HOWEVER THE GIRL'S LEG IS APT TO PULL ATTENTION AWAY FROM NAMEPLATE, OR OUT OF THE POSTER. SO WE WILL TRY AGAIN.

GOOD, BUT NOW THE LEGS ARE TOO SUBORDINATED. THE ANSWER LIES BETWEEN THE TWO SKETCHES, PROBABLY IN DROPPING THE KNEE OF THE GIRL IN TOP ROUGH.

AFTER SEVERAL SMALLER ROUGHS THESE SEEMED MOST PROMISING AND WERE DRAWN UP MORE CAREFULLY, REVEALING A TECHNICAL DIFFICULTY. IT WOULD HAVE BEEN BAD NOT TO HAVE DISCOVERED SUCH ERROR EARLY IN THE WHOLE PROCEDURE, PROVING THE VALUE OF CAREFUL PLANNING. FROM THIS POINT ON, THE ARTIST WOULD BEGIN TO THINK OF COLOR, STARTING WITH SOME TINY ROUGHS. WHEN HE GETS A GOOD ONE HE CAN LAY COLOR RIGHT OVER THE SELECTED PENCIL ROUGH, OR MAKE SEVERAL QUICK ROUGHS OF DIFFERENT SCHEME LARGE ENOUGH TO CARRY ACROSS THE ROOM.

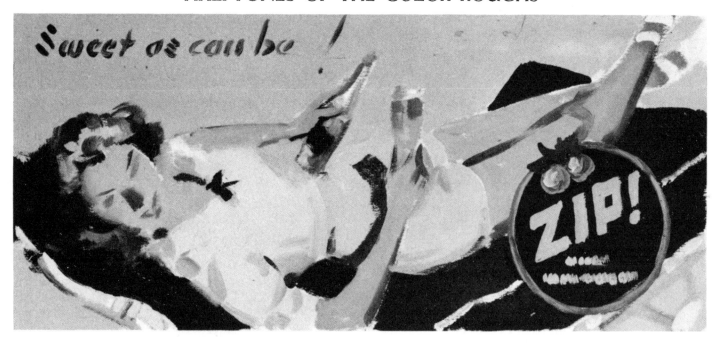

THE COLOR ROUGHS CAN BE DONE FROM MODEL OR PHOTO, OR THEY
MAY BE DONE WITHOUT DATA, IF NOT TO BE SUBMITTED. SUCH ROUGHS AS
THESE ARE FOR THE ARTISTS OWN EXPERIMENT AND SATISFACTION. IT AMOUNTS
TO THE ASSURANCE THAT ALL IS WELL (OR OTHERWISE). SATISFIED, HE MAY GO
AHEAD WITH THE FINAL WORK. SUCH ROUGHS SHOULD BE LOOKED UPON AS
EQUALLY IMPORTANT AS THE FINAL WORK AND A PART OF IT, FOR IT WILL
INCORPORATE THE BIG THINGS THAT ULTIMATELY MAKE A GOOD POSTER.

251

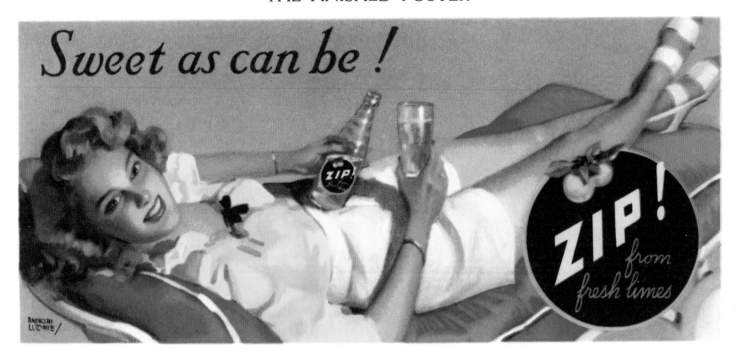

Here we have the finished poster, and it could have been any one of a half-dozen ideas or schemes.

DISPLAY ADVERTISING

LITHOGRAPH cut-outs and displays may be considered as having somewhat more reading time than outdoor posters. However, such reading time is not always leisure as in the case of magazine reading. In fact, most displays must be seen when people are in a hurry, passing windows, shopping or lunching or going to and from work. Therefore, the display should be planned for brevity of text, simplicity of pictorial elements, and directness of appeal.

First let us consider the various types of displays. The most consistently used type is the single panel, with lettering or message on the picture, above or below it. This may be supported by an "easel" in back, or be made to hang on the wall. Sometimes some sort of a base is used to stand it on, and sometimes the actual product or package is displayed upon this base or step. There are single-sheet displays and posters made to be pasted, tacked, or hung up. Such single-sheet posters are not mounted on stiff board as are all others. (In most cases the mounting is done after the printing.)

With other types of displays, all sorts of ingenuity is used in die-cutting, and in experimenting with various folding and interlocking devices for stability. Almost anything can be built of cardboard in this manner, often producing a three-dimensional effect and giving great latitude for creativeness not present in other forms of advertising. A figure or group may be cut out and placed in front of a background. Displays can be most intriguing and tricky. Intricate die-cutting is expensive, however, and therefore such die-cutting is held to a minimum. Cutting is usually planned for the outer contour, without inside cuts, such as a space between the elbow and the body. Such holes require separate dies. The dies cannot cut extremely sharp points and angles, so tiny serrations and intricate outline should be avoided. The die is a steel band which must be set or bent around the outline.

Another type of display is the three-wing variety, set up as you would a three-wing screen, or having the wings locked into place by locking devices. It therefore stands without back support, and its advantage is that it may be set at the back of the window or against the wall on a shelf, with products displayed in front of it. It is usually planned with the middle panel largest and carrying the main pictorial interest. The side panels may be used for the products, or for the advertising message.

The "two-plane" type of display is usually die-cut on the front plane with some sort of opening to the back plane, providing a permanent background for the pictorial matter, since a single-plane cut-out might appear against any background, often losing thereby in effectiveness. The back plane may be pasted onto the front in a box-like arrangement so that it will fold flat for shipment. The effect is that of making the cut-out material seem to stand out in space, and with the added roundedness of modeling by values, a very lifelike appearance may be achieved. This illusion of reality adds so much in attention value that it merits additional expense in producing such an effect. A display like this should be made in miniature and discussed carefully with the client, who when he sees the enhanced effect is more apt to feel that the extra expense is justified.

A very popular type of display is the large cut-out figure which stands around the store in conspicuous places. Artists have nicknamed these the "Oh, pardon me" type, for people are always bumping into them and taking them for real people. In such a display the legs and feet are a problem, for a fairly wide and quite solid base must be provided. Small feet would break off, and the thing would always be falling over. Long dresses of course are the best answer, and when you are not able to use one, the only thing left is to put something in the way of a background behind the legs, or just some dark color.

DISPLAYS ARE "POINT OF SALE" MERCHANDISING

The greatest value in display advertising is that it is displayed where the product is sold, and, seen by the customer, becomes a direct salesman. It does not need so much "memory value"; rather it is "on-the-spot" selling. Therefore a good display should not be general selling, but a positive person-to-person type of selling. The word "you" is excellent in displays. Let us say that the objective can be summed up in these phrases: "Here it is, buy it"; "Try it now"; "Take it with you"; "It's good, buy it."

Often a good display may be built around its use or application. A huge toothbrush may be brushing huge teeth, a large lipstick might be touching full large lips. Large hands may be applying nail polish on large fingernails. Or we may show the inevitable pretty girl using or applying the product. As in outdoor posters, the large head seems to be most effective. In fact, anything may be enlarged to gain attention.

Basic appeals apply to displays as much as to any other advertising. Sometimes displays are a final co-ordination of other advertising into a direct consumer appeal.

Let me say that in displays the advertising possibilities and opportunities for the artist are hardly touched. We have had, of course, millions of displays. Unfortunately the full value artistically is seldom reached. In recent years the lithographer's customer has been encouraged to buy some of the best art talent in the country, and for this reason some displays are beautiful. There is still much of the garish and gaudy, the cheap and tawdry. But the field is steadily improving, with better conception and better execution. There is no reason why a display cannot be as fine a work of art as any museum painting. I am sure the crudity lies in the conception rather than in the demand or interest of the public. Why must the belief persist that people cannot appreciate good art?

I am sure that misconception has been a part of the lithographic field too long. The better lithographers are proving every day that the bet-ter art pays, and attracts, and sells. We do not need the gaudy stuff to sell.

It cannot be denied that brilliancy of color is good in a display, but lithographers apparently do not yet know of "relative brilliancy," and that it is really more brilliant and beautiful than the everlasting combination of raw primaries. Lithographers have shied from tonal or greyed colors as a horse shies from a snake, not realizing that the support of such color makes the brilliant color sing. They do not know that pure yellow robs red, pure red robs blue, and by their very fighting they give most of us a negative response amounting to an acute pain in the stomach. The public is not sold when nauseated, and some day there will be a law against concocting poisonous color for public consumption just as there is against concocting poisonous food. Both can make one sick. The burden of responsibility falls on you, young artists, to begin the crusade of good color. I think you will do it. I wish I could paste up a huge sign in every lithograph plant: *"If you use one full-strength primary, for Pete's sake tone the other two."* That is all it needs. And you can tone them with a bit of the full-strength one. It is as simple as that.

There is so much opportunity still left for originality in displays. Instead of the hard-edged, pasted-on type of illustration, so much can be done with quality painting wherein values, softnesses, and beautiful tone all play a part. Why cannot a display be done in the manner of a lovely portrait instead of a pasted-up photographic thing on which all modeling has been bleached out for the sake of so-called "clean color"? Clean color is a delusion—for instance, the idea that flesh can contain nothing but red and yellow. Clean color lies in the true value and nothing else. There is no real reason for lithography's lagging behind the other fields in art production. With better art understanding, lithography could well lead the pack. But many ills must first be cured.

Let us suppose we are searching for an idea for a display. As pointed out, ideas spring from facts about the product which can be related to psychological appeal. To make the appeal, we either make a promise that will bring satisfaction, we satisfy a desire, or we seek to alleviate a situation that is unpleasant. Naturally our basic intent is to interest the customer in, and to sell, the product. Fitting the basic appeals to the product, it then becomes a matter of evolving material that will carry through the complete purpose and intent. To assure us that our idea and approach is sound we can list the elements that should be incorporated into a good display, and make an analysis of the material to see if it comes reasonably within these requirements. It must be realized that no matter how beautiful the art work, if the function of the display fails, all is lost, including our effort and our client's investment. Therefore it is well to check with the following requirements when preparing a display.

ESSENTIALS AND FUNCTIONS OF A GOOD DISPLAY

1. It must establish contact with the purchaser at the point of sale.
 a. It must be seen clearly from the sidewalk or at considerable distance in a large store.
 b. To be seen and to carry well, it must be of simple design and good color.
 c. It must call the customer's attention to the product.
2. It must conclude a sale, if possible, on the spot. Therefore:
 a. It should contain a convincing sales argument of some kind.
 b. The pictorial content should amplify such argument.
 c. For required visibility, such pictorialization should be composed of large units, stated simply and with good contrast to background.
3. It should identify the name, package or wrapping, and use. Therefore:
 a. It should picture the package somewhere on the display, or be designed to exhibit the actual product.
 b. If the package is small, it should be shown enlarged enough to secure attention and identification.
4. Any sales argument should be based upon a sound appeal, and the merit of the product should be made as evident as possible.
 a. It is most effective with person-to-person copy so that customer is personally addressed.
 b. If general appeal is used, make sure that it is directed to the average person.
 c. If the appeal is specifically to one sex, make sure the appeal is a logical one for that sex.
5. It must be brief and to the point. Therefore it should:
 a. Assume that the customer is in a hurry.
 b. Incite curiosity and interest.
 c. Create a desire for the product.

From the above you will note that display advertising follows in a general way the typical routine of all good advertising. The main difference is that instead of striving for an impression upon the memory, it calls for immediate response. In the selection of material we should weigh this carefully. Does it concern the reader specifically or generally? Let me illustrate the difference in the two following catch lines: "How is your breath this moment?" This for immediate reaction as opposed to "Takes away unpleasant breath," which does not lead the customer to question his own breath or assume that he needs the product.

It is good to make the preliminary roughs for displays on a two- or three-ply bristol so they can be cut out and set up in miniature. You may not have much to do with the idea and text at first, but by proving to the client that you understand the whole set-up you will become more and more valuable to him and will be granted the opportunity to exercise more of your own taste and judgment with each commission.

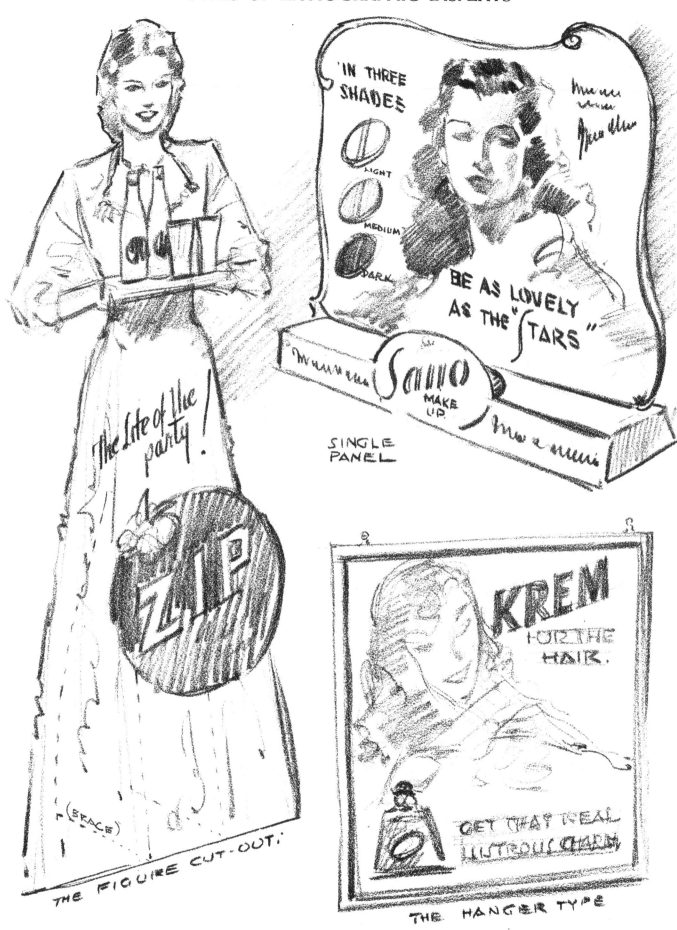

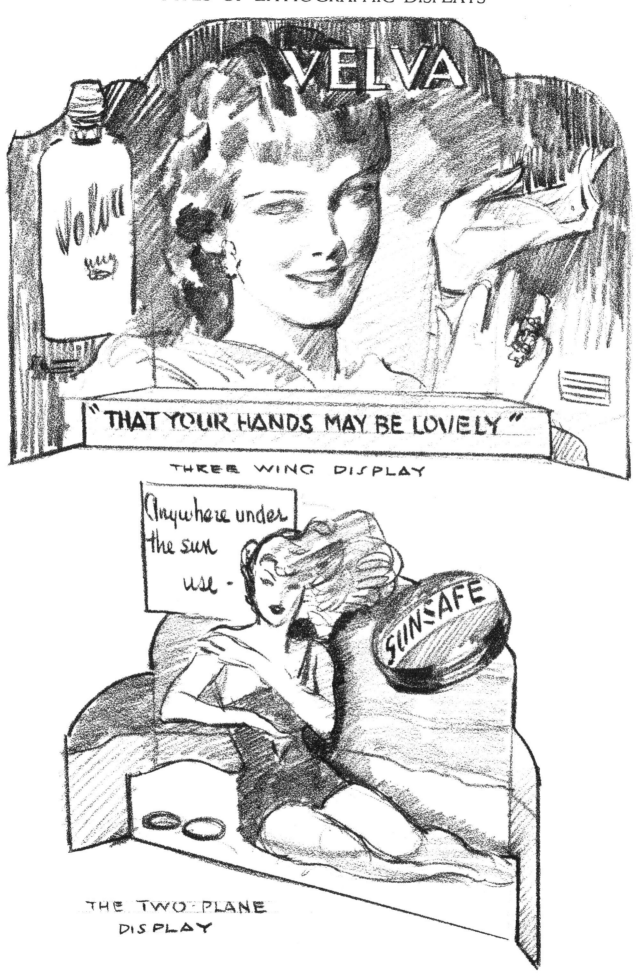

VELVA

"THAT YOUR HANDS MAY BE LOVELY"

THREE WING DISPLAY

Anywhere under the sun use -

SUNSAFE

THE TWO-PLANE DISPLAY

In fairness it must be pointed out that for the artist the display field is highly speculative. Unlike the other fields, the lithograph salesman will rarely come to you at the outset with the order for the final picture. He is ordinarily competing with several others, and while he is willing to spend money to get the final order, he cannot guarantee you that there ever will *be* an order for the final work, since the display may go to some other lithographer. All competing salesmen are going to make the best preliminary showing possible. To outdo one another some will submit finished paintings, which makes it difficult for the others. Since the lithographer may have only one chance in five or ten, he may hesitate to order and pay full price for a finished painting. Each would be content to submit roughs if sure that all the others would follow suit, but until lithographers get together and agree upon ethical tactics with one another, this situation will continue. Thus the salesman is rather up against it. If the salesman can land one order out of four, he is indeed a good one.

On the other hand, there is no reason why the artist should bear the burden of this speculation by producing a finished picture that has such odds against it without any guarantee of a selling price. Every lithography house accumulates a "morgue" of unsold paintings, and the paid-out value runs high. If a salesman can "resurrect" or revamp an old picture, either yours or his, this is one way of cutting down sales cost. If a new picture is needed, he may come to you with any kind of a proposition to hold his costs down, since he does not want to hurt his prestige by adding to the morgue.

I contend that the fairest arrangement is fifty-fifty. The artist may gamble half the sale price with the lithographer. If the job sells, he gets the other half and sometimes a bonus. If it does not land the order, he is entitled to half the original price for his time and labor. Under no circumstances should the artist take the whole gamble, and reputable houses seldom ask him to do so.

If the artist is striving to make a reputation, such a gamble may be sound from a business standpoint. Getting a good display reproduced has a compensating value in publicity for him. However, if the artist's time can be otherwise so filled that he is not called upon to speculate, then it is fair that one client should pay as much for his time as another, with no special privileges to the lithographer.

If he works for an agreed price, to be paid in full only if a final painting is made, the artist can speculate with a preliminary sketch at a reasonable cost, and this can be submitted with full-size tinted photostastic copies. In the case of better artists, even the sketch and the "blow-up" accompanying it stand a good chance against other finished work. Then if the sketch does not get the order, it does not represent heavy loss on the part of either artist or lithographer.

You can hardly blame the lithographer for wanting finished work if he can get it, without going the full limit of cost. Nor can you blame the artist for not wanting to shoulder the whole gamble by doing a finished painting for nothing if the order goes elsewhere. You can make your own deal, but remember that if your work is considered good enough to submit, then it is too good to do for nothing. Do not accept a "double or nothing" proposition, for it does not stack up with the odds of less than a one-to-four chance of selling. If the art were the only thing that sells a display, the odds might be better. But poorer art than yours might still get the order if it were coupled up with a better idea, and the idea may not be the artist's at all.

I have had instances where the lithographer has voluntarily added money to my bill when the order has been secured, or when some lithographic work purchased in the past turned out to be a "bell-ringer." It proves that, while struggling hard to make a profit, they will share it when they do.

CALENDAR ADVERTISING

THE THEORY of calendar illustration is just the reverse of displays. The appeal is general rather than specific. A calendar must fit almost any product. Therefore there is seldom any direct connection between the picture and product, and unless specially prepared the picture would not contain a specific product. The product of course could be generalized, such as beer, bread, or something sold under many names, or it could be planned for an industry, such as automobiles, hardware, dairies, and bakeries. However, the purpose of the calendar is directed toward good will and continued patronage, stressing service, quality, and economy. The object of the calendar is to promote friendliness and good feeling.

It is important that the illustrator sense the difference of psychological appeal in the calendar as compared with other types of advertising. Calendars are coupled with indirect selling, selling the firm or business rather than a specific product. This is known as "institutional advertising." Since the same product might be bought at a hundred places, the calendar assumes importance in the relationship of dealer to consumer. Or, in the case of a calendar advertising a specific product, it becomes an appeal of the dealer to buy that product from him. A dealer imprint space is therefore left on nearly every calendar, whether the advertising is specific or general.

As a result of this difference in approach, calendar illustration leans to general human interest subjects, ideas that appeal to the emotions, creating sentimental response. The calendar does not incite to action, curiosity, or the urge to buy. Rather, it creates satisfaction, lends tranquillity, brings contentment. I do not mean that a calendar cannot portray action. Sometimes action is very good, as in calendars depicting sports, or in subjects that are action within themselves. But it must be remembered that a calendar must be lived with a long time compared with other types of illustrations. Suspended action can get mighty boring when you wait three hundred and sixty-four days for some trivial thing to happen. It is something like the effect of a motion picture getting stuck in the projector, with the resultant booing and catcalls from the audience.

Much of the appeal in calendars is by association with present and past life, recalling pleasant memories, or making a picture "strike home" to one who has gone through much the same experience. Calendar pictures may be those which provide an escape from the monotonous routine of life into fanciful dreaming. Psychologists point out that we all have two little worlds to live in, the world as it is and the world as we would like it to be. The latter is the one of dreams, ambitions, and the escape from reality. The calendar illustrator has much to learn from psychology. Relief from tedium is sure-fire appeal. Make a picture a man or woman can dream in, or escape into, and you can hardly miss.

I believe this factor accounts for the tremendous popularity of the Maxfield Parrish calendars of the past. He provided the dream castles, blue skies with billowy clouds, children and lovely ladies out of another world. But there was another thing—he gave it all a sense of reality. So we can make fancy real. We can provide trips to mountain streams that people love but cannot reach. We can glory in the outdoors, and the activities most of us would dream about. We can sail blue waters with billowy sails, provide adventure, love, romance, appeal to patriotism, glorify the home and simple life. We can seek out the things that would give pleasure, relief, and relaxation. The pretty girl of the calendar may give a man an imaginary romance, his "dream girl," so to speak. We can give youth to the old, romance to the forgotten, vitality to the weak, broad worlds to the narrow. No wonder calendars go on year after year as a permanent institution.

BASIC APPEALS APPLIED TO CALENDARS

My feeling, just as with displays, is that the calendar opportunity has hardly been touched. Calendars offer to an even greater degree a channel for really fine art. Unfortunately, much of it has been cheap, tawdry, and with maudlin sentiment. The chief worry of the calendar house will always be subjects. The next worry is finding artists with enough ability to do them. When the artist can do more thinking, better calendars will be with us. The day of the inane pretty girl holding a pet is almost over.

Let us look at the green pastures open to us. Again, the basic appeals hold good. The home, the soil, children, animals, serenity, security, patriotism, religion, are just a few. In addition to that approach, there is everything of general and popular interest, as the Boy and Girl Scouts, community activities, youth movements, military interest, school, sports, charities, recreation, church, vocational enterprises, and many others. Almost any example of valor, generosity, kindliness, thoughtfulness, faith, confidence, patriotism, courtesy, neighborliness, courage—in short, all the finer qualities of humans—is good calendar appeal. Simple, homely ideas take on just as much greatness as more grandiose ones.

I have noted that many individuals tear off the calendar pad and use that alone. Inquiring why, I found the answers interesting and revealing. Here are some of the reasons. One man remarked that the picture was so sexy that it reflected back on his business and personal character. Being a respected person himself, he wanted nothing to injure that reputation. Another said, "It's so gaudy you can't see anything else in the room, and I believe my other things reflect good taste." Another said, "Why should I use my home as an ad for some garage? If the lettering were not so big, I'd have kept it." Another said, "I'm sick of bird dogs." Still another, "That isn't the way the outdoors looks to me, there is something wrong with the colors." Whatever the reason, if they keep the pad and throw away the picture, the artist, calendar house, and advertiser have all failed. It shows

that there is somewhere a lack of ability, a lack of good taste, and a lack of understanding. There is no reason why we should consider the public as lacking in appreciation and good taste. There is no proof whatever that there is not appreciation, but, on the contrary, plenty of proof that there is. There is proof that the public taste leans toward sentimentality, but that is nothing against it. By vote, during the Century of Progress Exposition at Chicago, Breton's "Song of the Lark," a peasant girl with a sickle at twilight, Whistler's "Mother," that grand old lady, and similar subjects led all others in popularity. That means they would still sell as calendars. It also means that sentiment need not be dragged in by the heels.

Summing things up, calendar appeal should be colorful but with some dignity, alive but not jumping off the walls. There is room for good taste in subject, sentiment, design, color, and execution. That is not an easy order, but it is what is really needed. You may be certain that truly good calendar subjects and ideas will find a market. Much of the bad stuff you see is used because there really is not enough of the good to fill the demand. Calendar houses are combing every place, all the time, for good material, and only a small portion of what they find is really good. It is a mistake to think that pictures turned down for every other purpose will finally sell as calendars. While it is true that pictures which would be good elsewhere might also make good calendars, the converse is far from true. Calendars offer opportunities for fine work not always present in other fields, and for the very finest kind of reproduction and printing. Good calendar paintings are by no means cheap in price. Some of the highest-paid artists are commissioned yearly at top prices to do the best calendars. Keep your eye on the calendar market.

Calendar houses, if a man is good, may offer exclusive contracts or arrangements. The artist must decide whether he wants to work that way. I myself have never liked exclusive arrangements. I prefer to keep the door open.

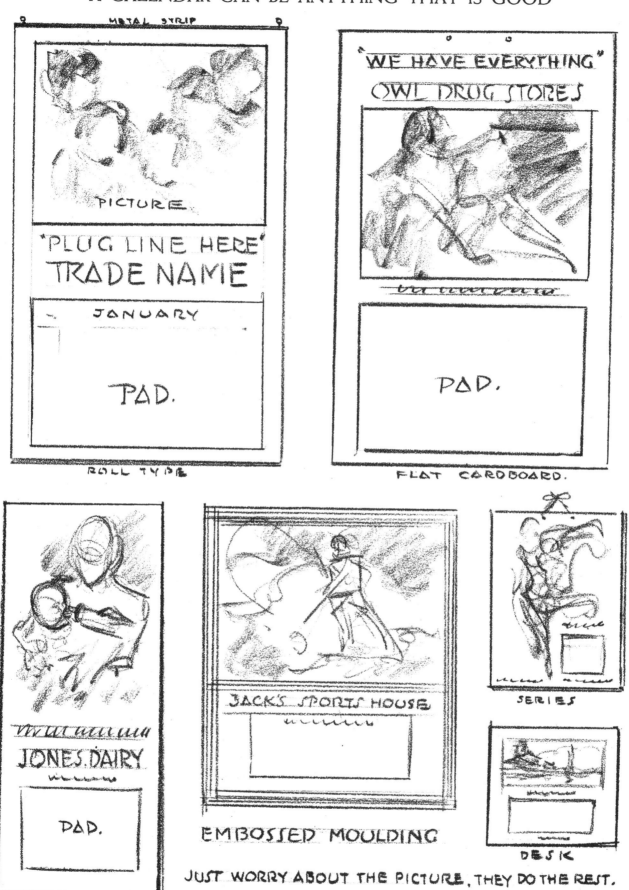

METAL STRIP

PICTURE

"PLUG LINE HERE"
TRADE NAME

JANUARY

PAD.

ROLL TYPE

"WE HAVE EVERYTHING"
OWL DRUG STORES

PAD.

FLAT CARDBOARD.

JONES DAIRY

PAD.

JACK'S SPORTS HOUSE

EMBOSSED MOULDING

SERIES

DESK

JUST WORRY ABOUT THE PICTURE, THEY DO THE REST.

ESSENTIALS OF GOOD CALENDAR ILLUSTRATION

1. It must create enough of a response that one will want to look at, hang it, and keep it for its own sake, as well as for the convenience of the calendar pad.

2. Its subject and meaning should be clear to anyone.

3. By preference it should be soothing, relaxing, restful, since it must be looked at for a long time.

4. If it can provide an "escape from boredom," so much the better.

5. If it contains action, let it be of the lively, healthy sort intended to release pent-up energy, nothing to induce emotional unrest.

6. The color should by all means be harmonious if it is to keep its place on the wall. Raw colors eventually irritate.

7. The sales or merchandising approach should be indirect.

8. Sentiment should be genuine and convincing and not overdone.

9. It should not be too seasonal if this can be avoided.

10. It should show the better human characteristics.

11. It should not show cruelty, racial prejudice, malice, or other negative traits.

12. Mode or style should be generalized enough to be good for some time.

13. It should have full meaning with or without a title.

14. It should be entirely original, containing nothing that could be considered as copied from other work or copyrighted material.

15. Its design should give it carrying power or attention value across a normal-sized room or store. This means simplicity.

Calendar subjects may be sold for "calendar rights" only, retaining the original. Or the sale may be outright, the picture becoming the undisputed property of the calendar house. Some firms require a release from the artist of any further claim. If a calendar has been sold once, it cannot be sold again for the same purpose.

It is useless to try to "fake" calendar pictures. You will only get them back. Calendar houses are too aware of good art and good craftsmanship. Do not copy any picture of a motion picture star and expect to sell it as a calendar. Such a project would require a special release from the subject. In fact, you cannot use any printed copy as calendar copy. Subject and material must be all your own, so you can release it with a guarantee that there can be no claims against the calendar house.

Any material submitted should be securely wrapped and postage paid both ways.

Any color medium may be used for calendar reproduction. Here is a good market for pastel. I believe oil is preferred rather than water color, though I see no reason why a water color would not be used, if good enough.

The full composition, or picture carried out to the four corners or at least with color background, seems to fare better in selling calendar people. But this is just an opinion, and I think it really depends on subject and execution, no matter what the subject or medium. Wit and good humor play a strong part in calendars, though I know of no calendar house that actually buys comic drawings.

The calendar, like the poster or display, can very well adhere to the four basic tonal plans. All must be seen, and must carry, as far as possible, and there is no better way to get this quality. You may find calendars with delicate subjects, but I believe I am safe in saying that those with good contrasting values and arrangement stand the best chance. Related color will always apply because it is good color. The calendar people certainly want vitality, or brilliance, in their subjects, and at times overstep the limit into bizarre and gaudy color. One thing is certain: they are not interested in drab and muddy pictures. These will inevitably come back unsold. Figure subjects must have some story or meaning, and not be simply portraits of people. Even finely painted heads will be returned if they have no sentimental appeal to the public. Some calendar houses have "line committees" which pass on all subjects.

PAINTING FOR CALENDAR REPRODUCTION

Calendar reproduction should be considered in a different light from reproduction for magazine pages. The latter must be printed at terrific speed and dry very fast. The ink cannot contain the amount of pigment used by the calendar printer; in fact, it must be diluted to a large extent with certain fillers to make it flow easily and dry fast. Calendar printing is largely by lithography. Instead of the three-color plates and black, there may be six or more colors used. It amounts to a light and dark of the basic colors, including a light grey, light brown, and others. Thus a richer effect of color is possible. The calendar is printed on fine stock, where the magazine must often use the run-of-the-mill and cheapest papers.

This concerns the artist and his work considerably. Much more delicacy of color and value is possible in calendar illustration. More suble graduations and softness of edges may be used. Tonal qualities of color, or color varied to the warm and cool, are not the problem to the calendar printer that they are to the magazine engraver and printer. Ordinarily much more time is spent over calendar color plates, since it is not a matter of meeting weekly or monthly closing dates.

In painting for calendars a full palette may be set, using two yellows, two reds, and two blues, meaning a warm and cool of each. In fact, there is hardly any limit in the way of color to the artist; he is free to do almost anything he wishes, with the single exception of too much widely contrasting "broken color." "Broken color" means small patches of varying or contrasting patches of color laid side by side as did the French Impressionists. That is every plate-maker's problem, and it is very hard to reproduce. The difficulty is in arriving at the identical values.

The artist rarely plans the complete calendar, including mats, frames or borders. Your picture may be put to a variety of purposes, and be cropped to fit various sizes. For this reason, calendar people like plenty of extra cropping space around a subject.

The principle of glazing in painting is not too good for lithographic reproduction. This means transparent glazes of one color over another. Such an effect is almost impossible, since the color must be one thing or another in any given spot to make good plates. That is why many of the Old Masters are very difficult to reproduce. The many coats of varnish give them a very yellow hue, which must be counteracted somehow by the engraver.

Give your engraver a clean, simple color scheme, starting with a few colors, and you will get good reproduction. Your paint may be applied thickly or thinly and they will get that effect. Some lithographers go so far as actually to emboss the paper to give the effect of thick paint, making it difficult to tell the reproduction from an original oil painting.

The one greatest opportunity I see in calendar illustration is to take the many neglected phases of American life and develop them. There is so much that is untouched. Many calendars develop into a series which have year-after-year possibilities. I have two such series which have been going right along for several years and which get more interesting all the time. Educational subjects must find a market with schools, banks, and all sorts of typically American institutions.

The so-called popular, or pretty, subjects could very easily give over to things of greater character and deeper meaning. There are many more subjects to be had, but it is up to the artists to put on their thinking caps and take the new and fresh viewpoint to the calendar house, rather than wait for them to come to you.

Check among people all you can as to the kinds of things that interest them. In this way new ideas and approaches will become possible. What do people love to do with their spare time? What are their hobbies? What do they day-dream about? Deep down are many psychological answers to the things they really want.

COVERS AND JACKETS

THE MAGAZINE cover field at the present time appears to me as most wide open for improvement of any of the art fields. For a good many years photography has practically usurped this field, with the result that we have been surfeited with covers very ordinary in conception and monotonous in execution. Through this period there have been a few stalwart magazines that have stuck to the belief that art is better as a magazine cover than photography. Some have straddled the fence, some have gone over completely to the idea that photography, all in all, does a better job. However, this is not surprising in view of the development of color photography and the erroneous belief that photographic detail is superior to art and its appeal. The fly in the ointment has been that there is so little to distinguish one color photograph from another, so little individuality and personality. One cover could be switched to another magazine by simply changing the name, without noticeable difference.

The truth is that all idealism has been sacrificed to fact. Instead of the ideal girl, we have one who looks like an individual belonging to somebody else, with a definite address, and working for a definite model agency. She may be on this magazine this month, and on another next month. The faces become as well known as movie stars'. She ceases to be your dream or mine, and becomes as unattainable as any famous movie star. The famous Gibson girl of the past was a conception, not a fact. She belonged to all. The Christy girl, the Flagg girl, the Harrison Fisher girl, were all dream girls of their era, and the public went mad over them. We cannot go mad over the cover girls of today—there are too many, and they are too obviously picked for their photogenic quality out of our own ranks, not out of the imagination of an artist.

Because of the very deluge of photogenicity, covers are passively accepted, although some magazines make a heroic effort to get away from the pretty girl entirely. Most, not knowing what to do, stick to the photogenic, relying on hats and whatnots to put them over. The idea of a cover subject is still present on only a very few magazines. By "subject" I mean an appealing and storytelling idea. We may all be grateful to Norman Rockwell for holding the line, and every indication points to the fact that what he stands for in the way of covers is most loved by the public. It is granted that all magazines are not interested in telling stories on their covers, but it is also true that modern dress and charm could be more beautifully presented in fine art than by photography. What we need most is the artist who can deliver. I thoroughly believe that with the advent of better artists, the magazines will be quick to seize upon such ability. I also believe that the very reason so much photography has been used is the dearth of comparable production in the way of art. When as a group we outshine the camera, we won't have to worry about being used. But if we make photography our goal and limit, we are going to lag hopelessly behind it. It would be the best thing that could happen to artists and art generally if every camera were taken away for a few years and we were forced to create with our eyes, hands, and brains. We will never arrive at art through photography.

As the field stands today, our opportunity is limited. The chances of selling a cover are indeed slim. The reasons as they stand are:

1. Few magazines can depend upon the unsolicited submission of material.
2. The artists used are generally working close to the magazine, some by contract.
3. With the necessity of complete speculation, the use of photography, and the continued use of a few artists, the average artist is discouraged.

4. The desire to couple the cover with the contents of the issue.
5. The relative disinterest of the magazines in the production of good American art.

About all you can do to sell a cover is to send in an idea in sketch form, or take a chance with a finished painting. You will probably get it back. But I am thoroughly convinced that more and more art will be purchased for covers, as fast as the good becomes available, and that some day photography will be frowned upon as the cheapest of art. At present it would be a bit foolhardy to specialize in covers alone. If you are a good artist in other fields, there is nothing to stop you, when you get a good idea, from working it out as a side issue and taking a chance on it. But if you are new to the field, depending upon an income from covers might result in very slim pickings. If you can get a steady arrangement with the smaller magazines, it might be quite worth while.

THE BOOK JACKET

Here is a field wide open. The book jacket is a challenge to the ingenuity and cleverness of the artist and therefore is interesting and exciting to do. To keep it simple and effective is not so easy. Publishers like rather short titles. They do not always get them. Title and title space on the jacket is of first importance, more important than the illustrative space (if any is left). But illustration has a place on the jacket, and can contribute largely to the attention and interest in the jacket and the ultimate sale of the book. As a general rule, jackets must be printed fairly cheaply so that flat color in postery effects is desirable. If the jacket can be done in two or three printings, that is in its favor, for a few pennies saved in publishing a single unit may run into sizable amounts in the run of thousands of copies.

In function the book jacket is much like the display. In fact, it *does* display the product at the point of sale. As usual, simplicity is the keynote. Punch—crisp sharp treatment, with few values and colors—is the soundest approach. To get a clear idea of the function of the book jacket will help immensely in the conception of your jacket design. It is questionable whether even the best jacket can sell a poor book, or whether a good book might not sell in spite of the jacket. However, it is somewhat like putting a good product in a good package. There will be many instances where it attracts one to the product and therefore makes a sale. Let us set down the essentials and functions of the book jacket:

1. It must be quickly seen, and the title read.
2. Title is more important than anything else.
3. Expensive color plates should be avoided if possible.
4. Flat postery treatment is most desirable.
5. It must carry for some distance.
 a. Since yellow carries farther than any other color, it is good for jackets.
 b. Red is powerful, especially with black and white.
 c. Almost any jacket needs at least one primary color.
6. The jacket should be as exciting as possible.
 a. It should awaken curiosity.
 b. It should stimulate interest.
 c. It should promise entertainment or information.
7. All possible contrast of color and value should be utilized to gain attention.
8. Sometimes a printing can be saved by using a colored stock.
9. Here is good opportunity for the attention devices spoken of in Part I.
10. Small figures are not effective on book jackets. Half figures and large heads are good.
11. Expressed action is good. Anything for attention.
12. Make a rough of your idea. Wrap it around a book and set the book among others with the brightest possible competition. This is the best way to judge.
13. Submit sample jackets to publishers. If interested, they will contact you. Getting in with several publishers will bring you considerable income.

TITLE GOES IN THIS SPACE

AUTHOR'S NAME

A PLUG LINE FOR BOOK

TITLE SPACE

AUTHOR'S SPACE

ILLUSTRATION

PUBLISHER'S SPACE

A TALE OF THE SOUTH SEAS

ROMANCE ADRIFT

BY VIRGINIA HORTON

Author of "How Deep the Pearls"

BLANK PUBLISHER

TITLE ON FLAT COLOR

AUTHOR'S NAME

PUBLISHER

THE DUST OF YESTERDAY

BY MARION WHITE

THE BLANK PRESS

MARCIA

BY HELENA ROBERTS

THE CASE OF MARY JANES

BY GEORGE ACE

THE QUESTION BOX

BY

MAX FIELD

FUN FOR THE WHOLE FAMILY

STORY ILLUSTRATION

ILLUSTRATORS whose work appears in the leading magazines are a rather small group. It is only fair to the reader to advise him that he must develop considerable ability to get into that group. I do not wish to imply that story illustration is the top of the ladder, though it must be admitted it is near it. Nor is it the highest-paid of the illustrative fields. Since there are but a few magazines of national circulation, and since each can use but a comparatively few artists, the group represented must necessarily be small. I should say that your chances of becoming a well-known story illustrator are about equal to your chances of becoming a well-known author or actor. But the chance is always there, and somebody does it all the time. New names are constantly appearing, and old names drop out. At any rate the magazines are constantly searching for new ability, and if you have what they want you will get in.

Most illustrators come up the hard way. For the most part they have proved their ability in other fields before they get their first story. Many have come from the fields of advertising illustration, since the two are so closely related. Many work in both fields. It is more often that illustrators come up from lesser importance than down from the fields of fine art to illustrate. Yet some illustrators are taking their places in the fields of fine art, and are capable of producing pictures worthy of fine art exhibitions. So there are no rules except that your work must be practical for what is needed.

The chances are that you will not make the big magazines in one quick stride. But even if you never make them, it does not necessarily discount your ability. Every field demands the best of ability, and if your chance is not here, it can very well be there. Few of us know at the start where our particular talents may lie. The main thing is to try to be good, and never stop trying.

You may question why the magazines do not pay as much as advertisers. The answer is that to the magazine illustration is more in the nature of production cost, while to the advertiser it is investment. Frankly, the magazine's real income is from the sale of advertising space. The magazine in the largest sense becomes a medium for advertisers. What is done in the magazine itself is to create the largest possible circulation, thereby giving value to the space sold. If the magazine fails as a magazine it also fails as an advertising medium.

The advertiser, on the other hand, is promoting sales of a product, and the best art work he can buy is to his advantage. Therefore, since there are more advertisers than magazines, he must compete with others for the artist's time, which naturally sends the prices up. In this sense the artists compete with one another to get into the magazine section, while the advertisers compete with one another to get the artist. If and when the magazines must compete for the artist also, then his price will move up. It is the old law of supply and demand.

Now, you may question why the artist, if paid less for magazine illustration, sometimes chooses to work for the magazine in preference to advertising. The answer is twofold. First, he will be smart not to have all his eggs in one basket. The magazine illustration adds prestige in other fields, and also there is that little matter of pride of accomplishment entering in. The good artist cannot measure either his ability or interest in terms of dollars. All jobs will be his best at any price.

Illustration is a challenge that the artist who is not afraid of work likes. So much more is left to him, and he accepts the responsibility with a certain pride. Perhaps, since his name is allowed to appear (though pitiably small), he feels that the public may be a whit more conscious of his efforts to please them. Perhaps he senses a bit of glory in his efforts.

WHAT DO THE MAGAZINES WANT?

Illustration unquestionably takes more of your time, even at a lesser fee. Unlike the advertising commission, you must, for the most part, do your own planning, thinking, and execution. About all you get from the magazine is the manuscript, or in some cases a rather fantastic rough, or a very simple layout showing little more than the space allotted. At best you cannot count upon the assistance that you get from the average advertising agency in the way of conception. Many magazines request the layout or rough from you, which shows the importance of being able to create for yourself; and they request not one situation but several, to choose from. Some allow you to pick situations for illustrations, some ask you to take a given situation. But they usually want some idea in advance as to what you intend to do. All this involves time and effort, and much of it is destined for the wastebasket.

But since so much is left to you, I suppose that is why you work so hard at it. The opportunity for self-expression is infinitely greater. You make your composition, you select your characters, and you tell the story. You make your own research for data and material, you assemble it, and make the most of it. If, when it is all done, it is good, you may take full credit.

It may be interesting to know that many art directors of magazines have served their apprenticeship in other fields. The magazines in competition have given more and more attention to layout and physical appearance. One of the great aims is variety, or "change of pace," evident as one thumbs through, to alleviate monotony and to keep the material ever fresh and inviting. The general layout of each issue is handled within the magazine, and you do not see it until published. Your picture may be cropped, cut out, or changed as the art director sees fit. It may be enlarged, with just the main interest of your picture used; it may be changed from full color to something else. In fact, you will never know what may happen. Sometimes you are delighted. Sometimes you are greatly disappointed. But you eventually learn to take it in your stride—or else blow up and quit.

To try to tell you exactly what the magazines want would be little short of mind reading. But there are general specifications which apply most of the time, and these can be listed.

1. A beautiful heroine, plus a manly hero.
2. Good characterization all the way through.
3. Strong dramatic interest.
4. Exciting and unusual arrangement (impact).
5. Strong accent on mode or fashion, good taste in accessories.
6. Interesting technique but thoroughly understandable.
7. Variety in medium and individuality of style.
8. Illustrations that sell the story.
9. Inventiveness of conception.
10. Striking color but in good taste.

Let us approach each of these separately and discuss them.

THE BEAUTIFUL GIRL OF THE MAGAZINES

Make no mistake about it, she is of first importance. This means a careful study of head construction. It means learning the planes and values in the head under different lighting. It means to place the features in the head correctly, as well as drawing them attractively. The treatment of the hair is very important, both as to mode of hair dress and technically. Hair should be painted not as so many thousand hairs, but as to the forms into which the hair falls, with just as much thought as to plane and value as you would put into the forms of the face.

You will hardly ever find the perfect model for any heroine. Much idealization will be yours. You will be called upon to do heads close up, and also half and full-length figures. You will have to study the current fashion magazines to keep her dressed properly to suit any occasion. She should be more than pretty—she should be both well-bred and striking. So you will experiment with expression and gesture. You will probably develop a type very much your own, try as you may to make your heroines individual and different. If you came up

269

through the advertising school, you will have been developing pretty-girl types along the way. When you are successful with the beautiful girl in advertising, you have gone a long way toward success in story illustration.

THE HERO

First of all, he must never be effeminate. That again means head study, especially the anatomy of the male head. Regular fellows, lean and muscular, win out. Clean-cut square jaws, full lips, heavy eyebrows, prominence of bone at the brows, well-defined cheekbones, leanness between cheekbone and nostril, rather deep-set eyes, make up the ideal type. Yours will vary from mine, but neither of us will ever make him fat or round-faced or characterless. When he makes love, never let his pose be of the flowery matinee-idol kind. He may even be a bit awkward, but he crushes her with a good deal of determination. Dress him stylishly and neatly, but no patent-leather hair oil. The smooth-shaven face goes best, but give his jaws enough tone so that he appears to have a beard, even if smoothly shaven. His expression is important. If he sits down, don't put his knees together, and if he stands, don't put his hand on his hip unless with closed fist. One bit of effeminacy and the cause is lost. Study the heroes of other illustrators, but best look around until you find that rugged but cultured type and use him.

GOOD CHARACTERIZATION

Once in a while you will find a character nearly perfect, but most of the time you will have to add your bit. Apply your conception of the proper type to the best model you can find. At least have the values and planes of a head to work from, and build the character into the model.

STRONG DRAMATIC INTEREST

Study your story. Act it out yourself. Plan it in little manikin roughs. Even if you cannot act, you can express yourself through the model. In order to practice dramatic interpretation, get out your camera and your favorite model and make some

camera tests as they do in the movies. Try to interpret the following moods:

Fear	Hate	Suspicion
Anxiety	Anger	Selfishness
Surprise	Coyness	Defiance
Adoration	Doubt	Self-pity
Hope	Interrogation	Envy
Joy	Impending	Love
Bewilderment	disaster	Greed
Frustration	Hilarity	Conceit
Jealousy	Intoxication	

Figure out some situations. Decide on the mood called for. Try to get the model to live the part. If the model is totally unresponsive and cannot act, get another. It's too important to do without. The last thing you want to do is to create "dead-pan" characters.

Just now the magazines are leaning very much to "close-ups," with the pose and facial expressions telling most of the story. The dramatic interest should be as concentrated as possible. If a part of a figure will tell the story just as well, cut it down to that. But continue to practice with the larger scene, setting figures convincingly into environments of all kinds, for fashions in illustration are constantly changing.

Much can be done with lighting to enhance the dramatic. If you have a strong emotional situation, find ways and means to concentrate the reader's attention on the important character. Much can also be done by layout or arrangement. By using a vignette, conflicting interest can be eliminated and dramatic force given the pose. The main character or head can be given the greatest contrast of background, can even be cut out against white paper. Study the dramatic whenever you find it. Study real joy, real sorrow, and various moods as they happen in real life.

The best way to practice is to make small pencil visualizations of stories you read that have not been illustrated. If you get something that looks promising it might be worth while to work it up into a sample illustration. But make sure it is an illustration and not just a single figure doing nothing.

EXCITING AND UNUSUAL ARRANGEMENT

It is really more important that the story illustrator consider the whole page arrangement than that the advertising illustrator do so. In fact, the story illustrator will have considerably more to do with it. In planning your miniature roughs, always deal with the whole page or the spread of two pages, as the case may be. Blocks of grey text should be indicated. Some illustrators paste actual text into a rough to get the effect of type set around the proposed illustration. I know a prominent illustrator who paints his rough in opaque oil right over a page of text matter torn out of a magazine, to get the desired effect. The placement of title, blurb, catchline, text, and white space should all be laid out. That the art director may not follow it does not matter. It is your business to design a good-looking page.

To make a page different, exciting, and unusual is by no means easy. But the man who can achieve this, plus good drawing and color, is the man most sought after. This is one of the qualities that makes Al Parker outstanding as an illustrator. Very often the whites of the paper can be pulled into the subject. An unusual viewpoint may help. The selection of accessories is vital. The spotting of unusual color, the unexpected in pose and gesture, the originality in telling the story, all play a part. Make every possible experiment you can think of. "Impact" is vitality, and vitality is simplicity with force. The character expressed is important. You may be sure that if your subject is complicated, indirect, cluttered, and ambiguous, it cannot be very exciting. If the characters are ordinary, without anything unusual in looks, pose, or costume, no one will be terribly excited. It may seem that everything has been done, but such invention comes from the subject plus the ingenuity in telling the story. No two stories are exactly alike, nor two situations or characters. For an Al Parker, there is always a way that is different.

You have linear arrangement, tonal arrangement, color, and the story. They can be juggled about forever. Anything that is to be new, different, and exciting must grow out of these; that is why they have been made the basis of this book.

Out of tonal arrangement can come many surprises. Suppose we do a whole page all very light, then (wham!) a little saucy dark hat in the middle of it. Maybe the whole thing is grey in feeling, then out pops a concentrated spot of black and white placed together. Wonderful things can evolve out of a black gown or coat, thrown against brilliant color. Values can be full of impact and surprises; in fact, that is where impact for the most part comes from, especially when tied up with color. Your inventiveness nearly always comes out of the subject and its interpretation, rather than from stock layout tricks. The stock tricks usually are the props of the imitators.

ACCENT ON FASHION

In selecting styles for illustrative purposes, an important consideration is their relation to value and mass. That a dress is stylish is hardly enough. It may be a good style, but not a good value or color for your subject. Your preliminary composition and pattern arrangement is more important than the dress. Do you want a simple tone, or a busy tone? Do you want it light, middle tone, or dark? Will you break it up in light and shadow or keep it almost flat, with a front or back lighting? Would stripes or a figured pattern go well, or not? That is the way to pick a costume. If you want a figure soft in its environment, then you would pick a value for the dress close to what is planned for the background. If the figure is to stand out forcibly, then a good contrast would be your selection. The dress will appear twenty times as attractive if planned to fit the whole scheme. Just because it came out of a late fashion magazine, or just because it looks good on the model, is not enough. But keep the fashion magazines on your subscription list. Few of us are good enough to invent styles.

Practice drawing costumes from fashion magazines, just in soft pencil on layout paper, trying especially to catch the drape and smartness. This will be easier for women than for men.

Since the magazines are thoroughly conscious of fashion, it is an important basis for criticism of your work. Use the simplest terms of the prevailing modes, however, rather than the extremes. Trimness and neatness will outweigh the highly ornate. Avoid if possible the "too fussy" in style which is present in some form every season. It is usually found in the overornamental, extreme tightness in conspicuous places, too many ruffs and ruffles, flounces, loud pattern, and so forth. Many models lean to extremes. If three-inch heels are worn, they wear four-inch. If skirts are short, theirs are shorter. If hair-do's are high, they go higher; if hats are wide, they can hardly get in the door. The artist can easily be taken in if he does not know. The only way he can know is to find out by the magazines and style exhibitions. In good magazines and shops you will also find information about accessories. Everything available to one illustrator is available to another. The difference lies in the greater pains one will go to in the way of research and information.

Hats will always be a problem. The illustrator will do best by getting advice, for who can possibly keep up with them? I avoid the use of a hat at all, wherever possible, since they are subject to such a great variety of taste.

I believe hair styles should be determined not entirely by the mode of the moment, but also by the personality of the character. A young sweet thing looks younger and sweeter in a loose soft hairdress. A sophisticated person looks more sophisticated in a severe and upswept hairdress. It is therefore a matter of judgment, and the model should be willing to adjust her hair dress to requirements at all times.

TECHNIQUE

Technique is yours. In general, the only time technique will be complained about will be when it is too "fussy," or when a muddiness of value is produced. Bad technique is ordinarily the result of poor grounding in fundamentals, for almost any application of medium will look good when the fundamentals are right. Simplicity of technique is always in a man's favor, yet it can be so flat and smooth as to be oppressive, lacking character and the feeling of medium manipulation which should always be present. If you cannot tell what it was done with, you can be fairly certain that it is not very good. Tricks of technique should never become more important to you than good honest craftsmanship. I remember a student who came to me glowing with enthusiasm. He thought he had found the key to originality. When I asked him what the great discovery was, he confided that he had invented a "basket weave" technique. Leaving him to his own resources was the kindest thing to do. Unfortunately his drawing, values, and color were all bad, and without these his "basket weave" had no chance. The best way to get technique is to worry about everything else.

VARIETY IN MEDIUM AND INDIVIDUALITY IN STYLE

Your medium will have much to do with effects. Each medium has its own peculiarities under your individual manipulation. Every medium holds possibilities for your own original application of it. Try never to work in one medium all the time. Use pencil and crayon for studies if not for finals. When practicing, try the same subject in different mediums. In this way you find the one most expressive.

Magazines are always interested in new treatments of medium so long as they are practical for reproduction and effective on the page. There are untried possibilities of medium combinations, so the artist should be continually experimenting with new effects. It is very easy to get into a rut with too much similarity of treatment. We are not going to change around much unless we do something about it, and we can't experiment too much with bona fide jobs. The experiment can be done separately, then shown as a possibility. You may get a chance to use it.

If you can't afford models for such experimentation, work from some of the excellent material in the fashion magazine. Work for effects rather than faithfulness to copy.

ILLUSTRATIONS THAT SELL THE STORY

How often the illustrator hears people say, "If I like the pictures, I read the story!" That is the keynote of the illustrator's job, to sell the story just as he would any product. You can do it first by gaining attention, secondly by awakening curiosity, thirdly by the promise of entertainment or interest in the material you are illustrating. Thus part of it is visual and part emotional or mental. That is why illustration must be approached from more than the technical angle. All factors must work together to function properly. It is this fact that thins down the ranks of good illustrators. Many can draw and paint well, but since the emotional qualities must be so thoroughly a part of practical application, and the imagination must be set free, the demand upon the artist is great. I do not think it would be unusual for the good illustrator to be a fairly good actor, to be able to write a good yarn, or to express himself in other creative ways. Because, after all, story illustration is more completely the individual interpretation and expression of the man than is the case in any other illustrative field.

The magazine cannot tell you how to make an illustration that will sell the story. They can only sense your ability to do it. No one can tell you. But if the story is interesting (and sometimes even when not), there is bound to be an approach of some kind that has never been used in exactly the same manner. Even if a few hundred "clinches" have been used as illustrations, the two clinching are never exactly alike, nor do they clinch in exactly the same way, under the same circumstances. Nor do they have to be put on the page in the same manner. Something can always be added.

If the subject is trite or a bit hackneyed, there is always design, spotting and color, types and accessories. Movies have been ending with clinches since the day they began, yet these are never completely tiresome if approached with finesse and intuition. Any subject under the sun can be approached interestingly; it all depends on how much interest the artist himself has in it. A picture can always be made that will sell the story.

Inventiveness and conception will always come ahead of execution. It will forever be impossible to tell an inventor how to invent. But if he senses a need and purpose first, this will help carry him to an idea. I think a lack of inventiveness may come more from a lack of the ability to analyze than from a dearth of ideas. Sometimes inventiveness in illustration does not come from detailed description within the story at all. The illustrator analyzes what might have taken place in the situation in real life that was not made apparent by the author. The author probably tells us "he kissed her full on the lips," and lets it go at that. The illustrator decides whether he lifts her face up to him, whether her head is tipped back or laid on his shoulder, whether she wears a smart little hat or a beret, and whose face is to be partly hidden.

If they "clinch" at a railroad station, perhaps the author did not mention their baggage, nor the fact that a bag is toppling over or falling in mid-air. The author may not have described the grinning gateman. That is invention—plausible analysis of the situation to make your conception interesting and original. Originality is not dealing with facts alone, but building things reasonable out of the facts. Every story can have a story within a story. Your illustration is the story you tell about the story.

STRIKING COLOR AND GOOD TASTE

All the things discussed in our Part Three dealing with color may find expression in story illustration. Tonal color schemes have a great place. Related color can be snappy and do wonders for a page. But the magazines do not want color for the sake of gaudiness. Remember, the magazine is sold closed up. The color does not have to reach across a ten- or fifty-foot space—only from the lap to the eyes. Screaming color is woefully out of place. You would therefore approach a magazine illustration differently from a bill poster, calendar, or display. Brilliancy is all right, but brilliancy supported by charming companions of tone and color.

QUESTIONNAIRE FOR STARTING AN ILLUSTRATION

Since good illustration is good analysis, the following questions may develop an approach, and help you toward something effective:

What is the nature of my subject?

Has it a mood? Is it powerful, average, or weak?

Should it be color? If so, should it be bright, or somber and grey?

Is it indoors, outdoors, day or night? What kind of light?

Can anything be done with the lighting? Bright, diffused, dark, shadowy?

For action, what would *you* do under the same circumstances?

Can the story be told in more than one way? What are the choices?

Can *you* tell anything that the manuscript omits?

What can you do to enhance each character?

Has the setting character? Can you add some?

What have been the action and circumstances leading up to the moment illustrated?

What possibilities of emotional contrasts are there?

Is the situation dependent upon facial expressions?

Which figure is most important? Can this importance be concentrated?

Which of the accessories are most important?

Can you eliminate things of unimportance?

Is it possible to express a feeling of linear or mass movement in your composition, even though these in themselves are static?

Does your subject lend itself to pattern? How can you arrange it?

What is the dominant thought of your picture? Can you give it one?

Can the thought be dramatized?

Can you employ geometrical shapes, line, or informal subdivision here?

Can you create a focal point with line, with contrast, with direction of gaze, color, or in any other way?

What about the poses and gestures? Can you add anything of your own?

What pose would the character be likely to take, considering his character, mode of life, culture, background, habits, emotions?

What about costume? Is there a chance for anything that would help you to a striking effect? Can the costumes be made a part of an interesting composition?

Can you embellish the characters by the environment, or do they stand up without placing them against a background?

Can you add to the drama by the background—using accessories, neatness, clutter, richness, bareness, or anything else?

Into what category would you put this situation?

Old, new, cheap, smart, tawdry, unwholesome, clean, orderly, unusual, average, costly, healthy, dirty, vile, wholesome, modern, Victorian, antiquated, good taste, bad taste, rural, urban, clear, foggy, dank, musty, fresh, bright.

If it falls into one or more of the foregoing, how can you incorporate those qualities into it?

Now can you make some small roughs of what has come to mind?

After laying out your rough, would it be better if reversed on the page?

Have you reread the manuscript and noted all the facts?

Will your composition have to be cropped to fit the page, leaving room for title, text, and blurb?

Will the gutter cut through things of importance, such as faces?

Have you tried out more than one tonal plan?

Can it be in more than one color scheme?

Can the subjects be stripped of anything without hurting the drama, the composition?

If someone else had had this assignment, do you think he would have done it just as you have planned it? Is there no other way?

Have you really planned this independently? How many examples of others are you following? Could you just as well put them away and start over?

Is the artist you are imitating really capable of better thinking than you are?

WORKING OUT A TYPICAL STORY ILLUSTRATION

At this point it may prove of value to you if we take an actual situation and illustrate it. For the sake of simplicity, although there are several characters in our story, we will build a picture about the heroine only, assuming that a large close-up of the girl will have greater impact than would a whole setting with several figures. You will recall I have said that in modern illustration, simplicity is the keynote; our first problem of this kind will be handled with more regard for the page effect than for the complete illustrating of the incident. We shall assume that the following paragraph is the one chosen to be illustrated.

She had the allure of ancient Egypt, all the mystery of the Pyramids, the sensuousness of a sultry summer night on the Nile. She belonged to no era; she was ageless as the Sphinx. Her full lips were as scarlet as the gown that bordered her white bosom. Dark eyes like hers had looked upon the Pharaohs. The black lines of her brows seemed to reach out nearly to touch, at her temples, the wealth of ebony-black hair that crowned her head. She sat, one shoulder drooping, a cigarette poised in her slender fingers. She spoke slowly, evenly, deliberately. "Is there no love beyond marriage?"

Now, if the above paragraph does not stir something in your imagination, stick to advertising. I see a very sensuous, provocative creature, not necessarily Egyptian but of a type that bespeaks the spirit of Egypt. We need not put her in a boat on the Nile, nor even ring in the Pyramids or the stars. We should not make her just a bobby-socks modern high school girl with black hair, but a type, an unusual one if possible, that will catch the reader with a sort of Oriental beauty. A scarlet low-cut dress is going to look good on a page. Her ebony-black hair and white skin add two important values to the four-value scheme. We can add a light tone, and more darks and lights to go with the others. The four-simple-value plan is most important to us even before we start out, because it will be the basis of our pattern, and of the miniature roughs in which we attempt to arrange the masses.

Our paragraph is quite specific about details, even to the pose. There are perhaps a thousand interpretations possible. I hope that yours will be quite different from mine.

I see the girl, before I begin, with her head slightly drooped but looking straight at the reader (one of the rare occasions), because we want that allure to reach the reader, almost as if he were the character talking to her. Should we show a man, she would be unconscious of the presence of anyone else. Sensuous eyes, however, are twice as sensuous turned upon you as upon someone else. Let us capitalize upon that fact.

Now, the dress was only specifically red, not any specific material. That helps, for it leaves us to our own taste so long as our illustration shows a low-cut dress. If the writer had said velvet, for example, we might have had to go to no end of trouble securing a dress of that material. For rest assured, if we are concentrating on a single close-up figure, whatever she wears must not be faked, since the writer has given her dress considerable importance.

As to her hair style, when we read of a "wealth of hair," we do not think of it as close to the head. Rather it would be full, loose, and soft about the face.

On the next page I will proceed to rough out in miniature some poses and patterns. I would like to have you do the same, diverging as much as you possibly can from the way I have worked it out. Juggle the four values about. But remember, the red dress is equal to a dark grey in the black-and-white scale. Her hair must be very black; the skin, white. Take a soft pencil and a tissue layout pad. Keep the first sketches small. Think, think, think at the very start, and once you get going, the rest will fall in line.

If you prefer a new subject, select a paragraph from some story and rough out your version of it. The only way to learn to illustrate is to start *now* to call upon your own imagination and inventiveness. Story illustration was never learned overnight.

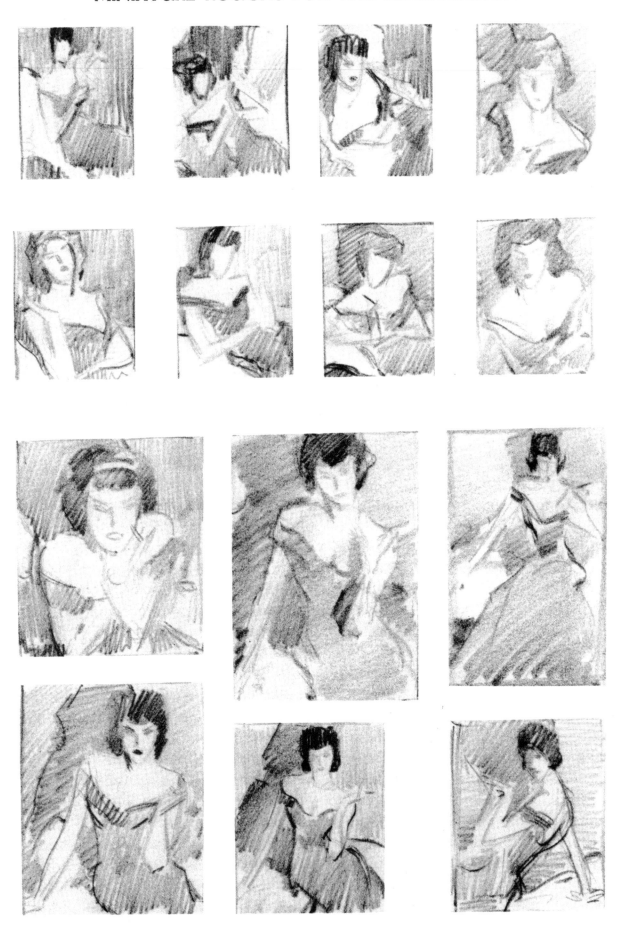

DEVELOPING THE ACTUAL-SIZE ROUGH

The preceding page of miniature roughs has been done mainly to get at a satisfactory placement of the figure and a spotting of the general masses. I have made the choice indicated mainly because of the movement in the design, with all lines carrying the eye to the head. The white bosom and shoulders are supported by a dark shadow, and the bright red dress will come next to white. Back of the head will come a low tone and dark shadow, both of which should enhance the very light and very dark value which will be in the head itself.

The problem now is to make up an actual-size rough which would be submitted to the magazine editor. This could be done in pencil, charcoal, or colored crayons. When the magazine is thoroughly familiar with your work, elaborate roughs are not as necessary as during your first assignments. Sometimes two or three roughs are asked for, often of different situations. Normally, these roughs should be done in color, but for purposes of this book, this rough can be illustrated just as well in black and white.

If the situation, as in this case, has already been chosen, then it is advisable to call in your model even for the rough, for you will then be able to follow up in the final with much the same character, dress, and so forth. It is also advantageous to thus familiarize yourself with the type you are going to paint; the rough acts as a preliminary study for yourself as well as for the magazine editor. You can either make the rough direct from the model or get your camera out and take some poses. You may find new suggestions when setting up the subject before you that will be better than any of your first vizualizations. It matters little how you arrive at what you are going to do, so long as you eventually make up your mind that it is the best approach you can think of. But once you start the final picture, everything should be well decided, so that there will be no changing of horses in midstream. A color sketch for your own satisfaction is well worth the time it takes, and for this I shall make one, even though we do not reproduce it.

A word should be added here stressing the importance of a model file as well as a file of general data that is likely to be needed. As an illustrator you never know what is likely to come up, or the type of story that will be given you to illustrate. I have found it worth while to take "tests" of models as would be done in motion pictures. Try them out for dramatic ability and expression. Have some typical heads, full-length, and costumed poses on file. Your file should be as complete as possible, with men, young men, women, young women, and children. It is expensive to call in a model and find out after she gets there that her shoulders are too bony for the evening dress, that she is knock-kneed in a bathing suit, or that she is short and thick-thighed, which the head photo on file would not indicate. The photographs models leave on file have usually been retouched, sometimes almost beyond recognition. You should know what she looks like in front of your camera, when you are working with your individual apparatus.

For the most part, models are disappointing in one way or another. It seems that no model was ever meant to be perfect, with both a fine figure and a fine head. If they are beautiful they may be unable to act. You may be almost certain that you yourself will have to contribute much in the way of imagination to any photographic pose. Where the model is most necessary is for the contribution of character, "something for the light to fall upon," as one artist put it. Models give you an indication of form in light, and color, telling you where the planes are, and the relationship of values. I do not believe any artist is so good that he can dispense with models.

Your data file should contain, mainly, the material to be used in backgrounds and settings, since you cannot copy actual poses of people. Try to keep up on interior decoration, modern furniture, current fashions and accessories. But there is also the life of the past, the small town and farm life, outdoor material, horses and other animals, costumes of various periods, stores and shops, night clubs, sports, and almost every phase of life.

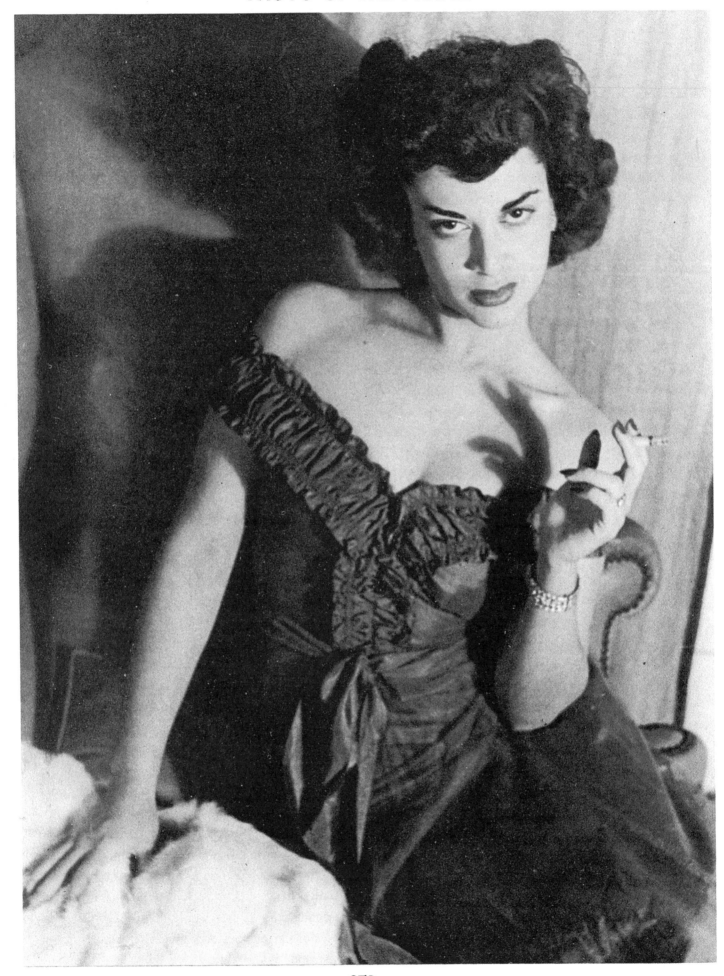

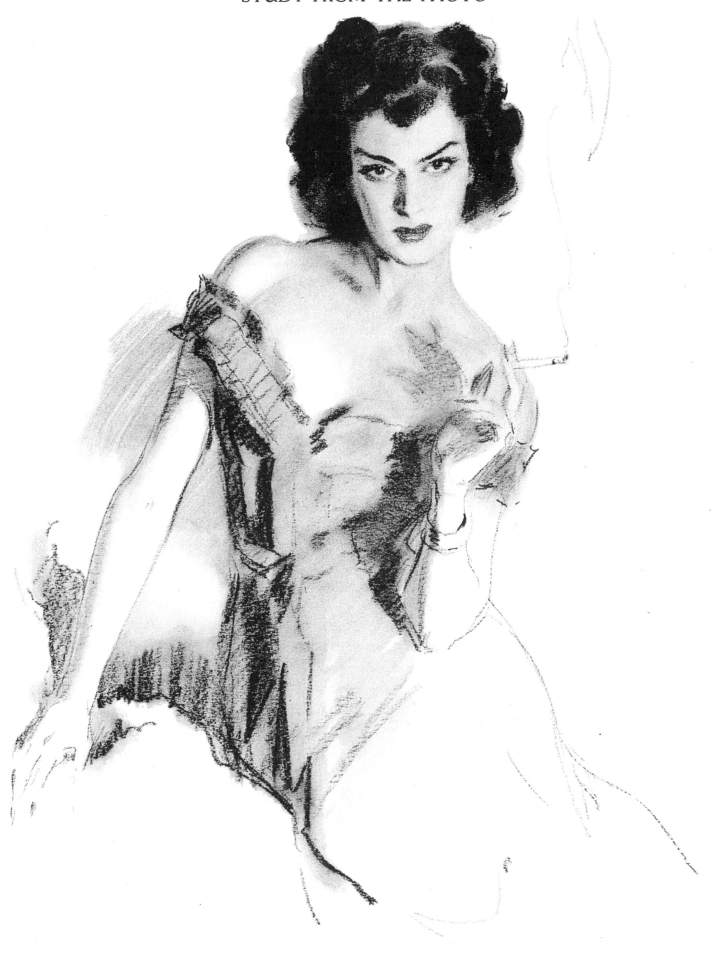

THE FINAL INTERPRETATION

I have reproduced the photograph posed according to my selection in miniature rough. This young lady was selected mainly because she appealed to me as being an unusual type. I am deliberately seeking to get away from the standardized cover girl type, or the so-called photogenic model. Her slanted eyes and brows, the fullness of her mouth, together with the smooth neck and shoulders, seemed to coincide with the author's description. The charcoal study of the photograph was done mainly to see if I could bring out these qualities without literally copying the photograph. Were this a definite commission, I would send the charcoal drawing to the editor, accompanied by comments about what I had in mind as to the illustration, the color, and anything else that might make my intentions perfectly clear.

The art director would in turn submit this to the other officials of the magazine and return it to me with their comments as to the possibilities. This might save a great deal of lost motion. If the magazine were not in sympathy with my approach, or had any objections, this would be made clear before the start of the final work. If the charcoal study is approved, the illustrator can proceed with confidence that all is well. This procedure is most practical for all concerned. Each issue of the magazine has a definite closing date by which time all work must be satisfactorily completed. The average monthly magazine's closing date is three months in advance of publication. The illustrator should try to have his work completed ten days before the deadline. It is very bad to force the magazine to use your work, because of the shortage of time, when it is unsatisfactory. For the most part, criticisms from the magazine are warranted and would not be forthcoming unless deemed absolutely necessary. The last thing an art director wants to do is to delay publication. He will therefore appreciate early delivery upon your part, which will give him an opportunity of making changes without causing delays.

You will find that each magazine has an individuality. The physical appearance of the content will be closely allied with the personal likes and dislikes of the art director. There are art director who seem to have very decided preferences as to both artists and types of illustration. One may like the "close-up" type of picture showing large head and expression. Another may prefer the "full picture type," showing the characters in a setting Any art director strives to produce a variety of approach throughout the magazine. This is often the reason for the cropping of a full-size painting for he may not wish to have two similarly treated subjects close together. There are those art directors who lean toward certain mediums, perhaps preferring water color to oil; or crayon, charcoal dry brush, and similar mediums to the so-called heavy mediums. It is a good plan at the start to familiarize yourself as much as possible with the types of illustrations most generally used by each magazine. If you have any new or inventive approach in mind, it is better to submit something along this line at an early stage rather than attempt to surprise the magazine with an unexpected technique on a final assignment.

All in all, the whole procedure should be one of closest co-operation. The art director is just as eager as you are to give his magazine distinction by any means possible, but he must know his ground from start to finish as far as your ability is concerned. This is why a certain amount of your time should be set aside for experiment and study, so that you can keep your ability and approach flexible and dynamic. You can keep him informed of any new ideas you have, and this may often pave the way to new opportunities if the magazine is willing to experiment with you.

Since the final interpretation of our subject is in color, it is necessary to place the picture among other color plates in this book. The reproduction of the painting will be found on page 291, entitled *A Sample Illustration*. I suggest that the reader review the paragraph which we have taken as our problem, and then decide whether, in his judgment, I have caught the dramatic and emotional qualities suggested.

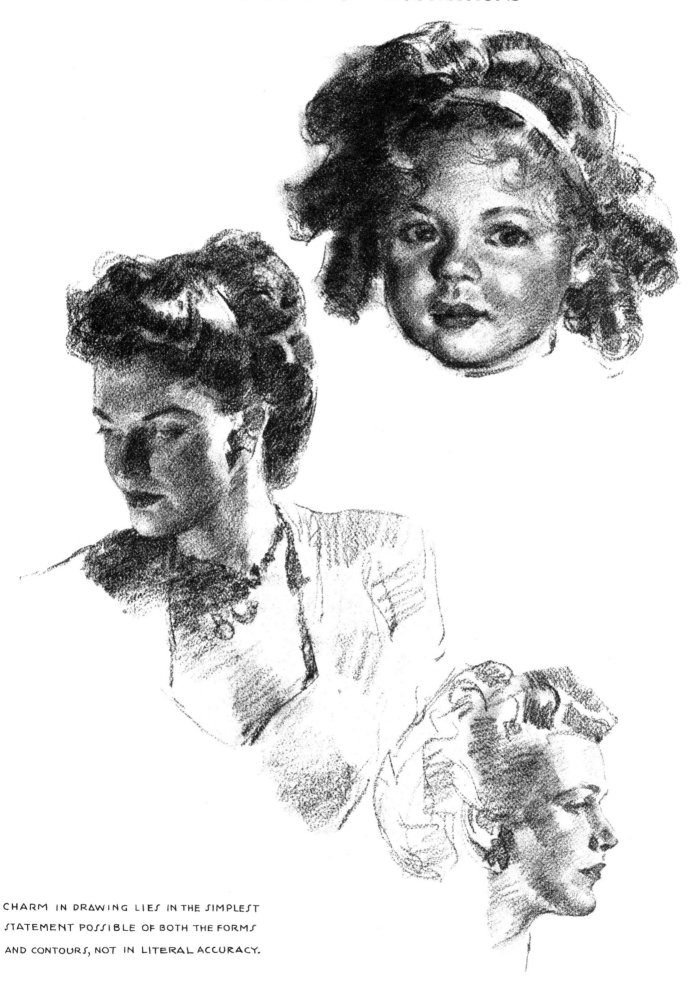

CHARM IN DRAWING LIES IN THE SIMPLEST
STATEMENT POSSIBLE OF BOTH THE FORMS
AND CONTOURS, NOT IN LITERAL ACCURACY.

GETTING INTO STORY ILLUSTRATION

This volume would hardly be complete without a discussion of how you can get into story illustration and what preparation you must have. To discuss it frankly is not meant to be discouraging nor disillusioning, but to lay before you some of the undisputed requirements. Seldom does an illustrator of magazines get there without art training. Whether the training is in schools or by dint of his own hard effort, the training is a necessary adjunct to his native talent.

It is likely that most of you, as young artists, even as skilled and trained artists, cherish this ambition. I wish to go on record as stating that the opportunity is always there. Whether you can make it a reality depends on many "if's."

First of all, you will need to be skilled in life drawing and anatomy, perspective, composition, and color. But you will also need that rare sense of the appropriate, and the ability to tell a story pictorially. Illustration may be thought of as belonging to two classes: the idealistic, for one, and the interpretation and characterization of life as it is, for the other. Illustration in the highest sense is not a matter of drawing pretty girls and pink hair ribbons. The Second World War has brought forth much that is new and forceful in the way of illustration. Illustration is holding the mirror up to life, and the best of it carries the strongest message of life itself. Much of our present-day illustration cannot but appear insipid as compared with the work of Howard Pyle. He has left a record of early Americana that excels all others. That spirit should go on. It will go on in some of you, who perhaps are still in your teens, but who have overpowering ambition and strength of purpose. But it will not come by dreaming. Every day will have to contribute a small part to your ultimate goal.

Art is an exacting mistress. Her rewards are great, but they are for a chosen few. Yet art is one of the few vocations where success lies wholly in the effort and character of the individual— granted first of all, of course, that he has talent. There are no strings to pull, no favors to be granted. Art is thoroughly subject to public opin-ion, other people's opinion, and one must labor almost in spite of it. Opinions are something that we get more of with less effort than anything in the world. If anything else is given as freely as opinions, especially negative ones, I cannot imag-ine what it can be. Yet we must to a large extent abide by what others think of our work. They can make or break us.

Illustration will always be subject to public opinion. But opinions need not cause us to break faith with truth as we see it. And opinion on the whole is not only apt to be fair, thank Heaven, but most of the time it proves itself right. Public opin-ion is far more in accord with present-day illus-tration than with modern art. I have every reason to believe it will stay that way, for both illustra-tion and public opinion spring from the same source, the reaction to life itself.

Therefore it is my plea that illustration be kept rational, in keeping with good taste and the better things of life. In helping you to chose a path to illustration, I would beg of you to keep your two feet firmly grounded in reason and truth as it appears to you. There are so many blind alleys, whetting our curiosity and glowing with specula-tions that prove to lead to nowhere, that I feel you should give much consideration before tossing out the dictates of your own personality and ability. I contend that art is not imitation nor duplica-tion of realism, but an expression of the individual, based on truth. Such a definition is neither narrow nor confining. It is as wide open as the blue skies.

I have stated that you cannot be a finished illus-trator in one jump. The main reason is that you cannot take in life in one glance, one day, or one year. It is far better to seek your development through the channels that point to your goal than to try to make one leap to the goal. All commercial art is illustration, and all of it gives you equal opportunity to progress. Be content for awhile with the little jobs, knowing that it is all training for the big job later on. When you have a chance to draw a face, a character, a figure, try to think of it as illustrating one of the best stories in the best magazines; do it that well. Do it as though

your whole future depended upon it. Actually, your whole future *could* easily depend upon it, for this very sample might interest another person with a bigger opportunity to offer, and that might bring another, and so on. You never know what a good job may do for you; but a slighted one, a lazy one, a disinterested one, leaves an impression hard to shake off.

When your work in other fields becomes noticeable, the chances are that somebody will find you. There are artists' agents constantly on the lookout for talent, just as there are movie scouts. If your daily work is not providing you with avenues pointing toward your goal, there is nothing to do but make your own opportunity. Take a story and illustrate it. Show your work to others. If they respond favorably, maybe Mary Jones the magazine subscriber might like it. I would not submit illustrations to the top magazines until you have developed a background of experience and are making a success in other fields. Send your work to reputable agents first; they can advise you intelligently, and even submit your work to the magazines if it seems promising. Such work may be sent periodically. You will probably get in faster through a good agent than by trying to go directly to the magazine. However, if something unusually good is sent to a magazine, they will contact you quickly enough if they like it.

But you may be sure they are all getting a deluge of mediocre work submitted by every unqualified Tom, Dick, and Harry, and only once in a very great while does an unheard-of novice break directly into the magazines. There is no ritual to be performed; anything can happen. But a logical step-by-step procedure to your goal is the best bet in the long run.

I have tried my utmost in this volume to give you a working basis and suggest the things you will need. But you will naturally make your own interpretation of the fundamentals here. The main object has been to make you think and to do for yourself, to believe in yourself. There is only one other course open and that is to go out and imitate the other fellow. It is granted that such a course might bring in some return, but it seems to me that if you are good enough to get there by imitation, you are certainly good enough to get there on your own. The imitator is not going to outlast by very long the imitated. Suppose there are also five thousand others imitating the same man you are. Suppose by the time you are ready your idol has already been imitated to death, the whole vogue has passed, and someone new is there in your idol's place. After your idol is out, what chance have you?

Young people imitate thoughtlessly. They like to be led, rather than take responsibility based on their own perceptions, beliefs, and decisions. But the young people who forge ahead are those who take the reins and do their own driving. They must realize this is their world, not ours in which they are always to be told what to do. We would much rather have them do it, giving what assistance we can, than to do it for them. It is not imitating when you work with line, tone, and color, and produce form. It is not imitating to work from a photo you have conceived and posed. Nor is it imitating when you are practicing. It is imitating when you tack a successful job by another artist on your drawing board and copy it for professional use. It is imitating when you try to sell something you have not in any way created. There is a vast difference.

If you are really ready for the magazines, you will not have to worry. You will get in. Worry just about getting ready, so you can then worry about staying in when you get there. But worry can be lots of fun, when it's over something we love to do anyway!

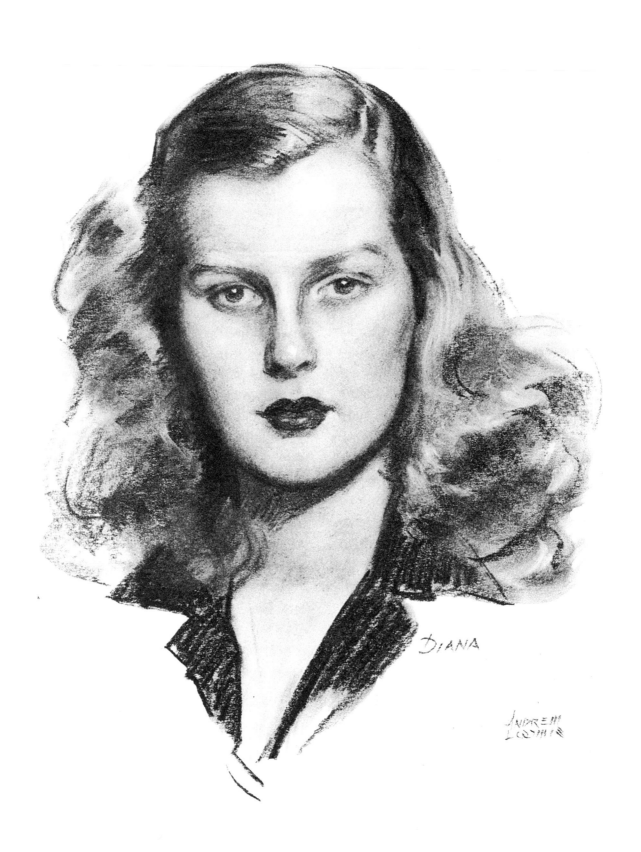

DIANA

Experiment and Study

EXPERIMENT AND STUDY

THERE is no greater impetus to a successful career in creative illustration than experiment and study. In the earlier years of actual professional practice, I would recommend a continuance of school study in the night classes. You will find that after having some practical experience in the field you will learn twice as fast. You are more enlightened as to what you want, and perhaps your weak points have begun to show up. But whether an art school is available or not, you can set up an organized routine of further study for yourself. A good way is for a group of commercial artists to set up a class by themselves, calling in models and drawing and painting them. If such a class cannot be organized, then set up a space at home where you can work evenings, Saturday afternoons, or Sundays. I do not mean that you should not take time out for relaxation, but the faster you get over the ground in developing yourself, the sooner you are going to get there. There is a course of study for each individual, and sometimes he can lay out such a course for himself better than someone else can prescribe it for him.

There is one thing not to do, and that is simply to drift along with the daily routine, making no extra effort. You will soon find yourself middle-aged, having done nothing more than routine jobs, and being little farther along than you were years ago. The extra effort is the difference between the great mass of mediocre artists and the comparatively small group of very good ones.

It will take a great deal of concentration and determination to get over the first hump. If you do not really know anatomy, that is a good place to start. It can be done at home in a few evenings a week. Perspective is another thing that you might as well get at and learn. It will not take long. Practicing composition is something you need not go to school for. Practicing pen and ink, crayon, and charcoal can all be done in leisure time. Color should be practiced in the daytime, in good light. No light is nicer than Sunday morning, both indoors and out. It's a shame to shut it out to sleep. If Sunday is your golf day, then play only eighteen holes and work Sunday afternoon or every other Sunday. If Sunday is your church day, then no artist will suffer by developing his soul. Work Saturday afternoon. It's up to you and the Missus when you will study, and if she is not enthusiastic, try painting her and the kids. It does not matter how you work it out, but it is important that you do work it out.

Set up subjects for still life. They are not boring at all when you really begin to see tone and color design. Make outdoor sketches while the youngsters wade and Mother reads a magazine. Put your sketch box in the car and go out and try it. Painting from life is refreshing after a harrowing week on the job. It stimulates you to good color and freshness in your work. You will find that shadows are light and airy, that the blue of the sky really gets into them. You get away from the reds, browns, and oranges that we all seem to use when faking. Seldom do we find an artist who fakes in delicate greys and cool colors. In fact, these soft tones and colors rarely enter the mind of the artist until he has come to know the beauty of them. In the studio, color is thought of in terms of tubes and pots; when you look for the same colors in nature they do not seem to be there. Nature looks quite dull at first, but when you set down her tonal and greyed colors you are surprised to find that they are much more beautiful than the contents of the pots and tubes.

So many of us never take the trouble to really get acquainted with old Mother Nature, and then we wonder why our progress is so slow. She is the one real source, and the more you neglect her, the farther you stray from home. Most of us do not take the trouble to go sketching, feeling that where we live there is nothing in the way of a subject. That can hardly be true. Even a back alley of a slum can be wonderful material if seen with an artist's eyes.

286

FINDING SUBJECTS FOR EXPERIMENT AND STUDY

River towns, mill towns, old towns, even prairie towns, always present material. There is bleak drama as well as exciting drama, and it is all part of the American scene. Those funny rococo houses are great subjects. Art does not have to be "pretty." Pretty art has troubled this country too long already. Artists are seeing for the first time America as it is, and some wonderful things are being done.

I do not mean that we deliberately set out to paint the grotesque and ugly. The point is that all things have form, tone, and color and it is quite amazing what that form and color might look like in paint. I think that having the ultra and super of everything thrown at us so long has rather blinded us to the beauty of the commonplace. It makes us think that everything must be polished and shiny and new. Beauty is more apt to lie in character. Just the old barns on a farm have character.

Values, tone color, design! All have charm, whether they occur in Peoria or on Fifth Avenue. That little patch of garden back of Joe Melch's old house takes on tremendous meaning in New York. Americans are becoming more and more aware of the significance of our national background—that we are all a single people with different addresses.

There is no valid reason why you cannot study on your own, benefit by it, and enjoy it. Set up that bunch of cut flowers. See if you can paint it loosely and artistically. Sketch funny Mrs. Higgins, who you always thought was quite a sketch anyway. Make a pencil study of that gnarled old tree you have admired down on Sawyer Avenue where the cars turn. Take a look at the children next door in terms of planes, color, and personality. They are probably as real kids as any ever painted. Horses, dogs, cats, old folks, snow, barns, interiors, buildings, mines, lumber yards, canals, docks, bridges, boats, vegetables, fruits, bric-a-brac, country roads, wooded hills, skies, the old swimming hole. There are subjects galore if you will recognize them and try them out. This is all material for learning and material for the future.

This is something no art school can give you, and it's closer to real art than anything you can get. If that front lawn needs mowing, get up early and do it, but don't let it rob you of your chance to study. Anyway, it is not enough reason for not studying. Keep a sketch pad and a sharpened soft pencil in your pocket. Get used to noting things quickly and setting them down. That is where pictorial ideas come from. The merest notation may later become the basis of a great picture—you never know.

It seems strange that most of us need to be sold on the world we live in. We do not know how good it is until we are in danger of losing it. The average artist is living in such a wealth of material that he cannot see it. He is too close. Main Street may not mean much to you, but it does to the *Saturday Evening Post* if it is seen with sympathetic and understanding eyes. The world wants vision and interpretation of the life it lives, and our life is just as vital to us as the life of the French court and nobility, or the life depicted by Gainsborough, was to painters of those eras. Poor Velasquez, living in sunny Spain with all its color, its winding streets, its blue Mediterranean, had to stay in the house and paint noblemen. He died young, probably needing fresh air. He must have squirmed at times and been ghastly sick of it. But he left us masterpieces.

Subjects are in the mind of the artist, the quick eye, and the interested hand. Were there a great canvas called "Sunday Afternoon in the Park," painted in any small town in the 'eighties, people would swarm to see it today. It would make any magazine if well done. Think of the quaint costumes, the life of our grandfathers made vivid today! The same thing will be true in the year 2000 A.D., which is really not very far off. People will be just as interested then. The American life of today and what is left of yesterday will soon disappear. Catch it while you can. We are coming very definitely into a new era. So work hard, young artist, with your eyes open.

If you have no subjects to paint, you are going about blindfolded or totally unconscious.

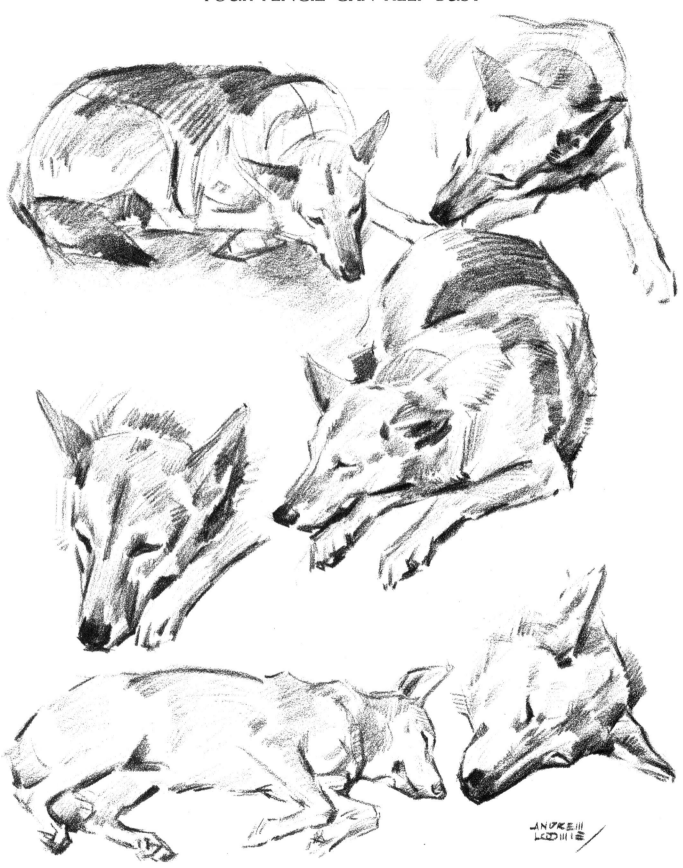

NOTHING IS QUITE SO PLEASANT AS TO SPEND AN EVENING WITH A PENCIL
AND A DOG. IF BRUNO IS SLEEPY HE IS A GOOD MODEL, BLOCK IN BIG FORMS
FIRST AND THEN WITH THE SIDE OF THE LEAD LAY IN THE HALFTONES AND DARKS.

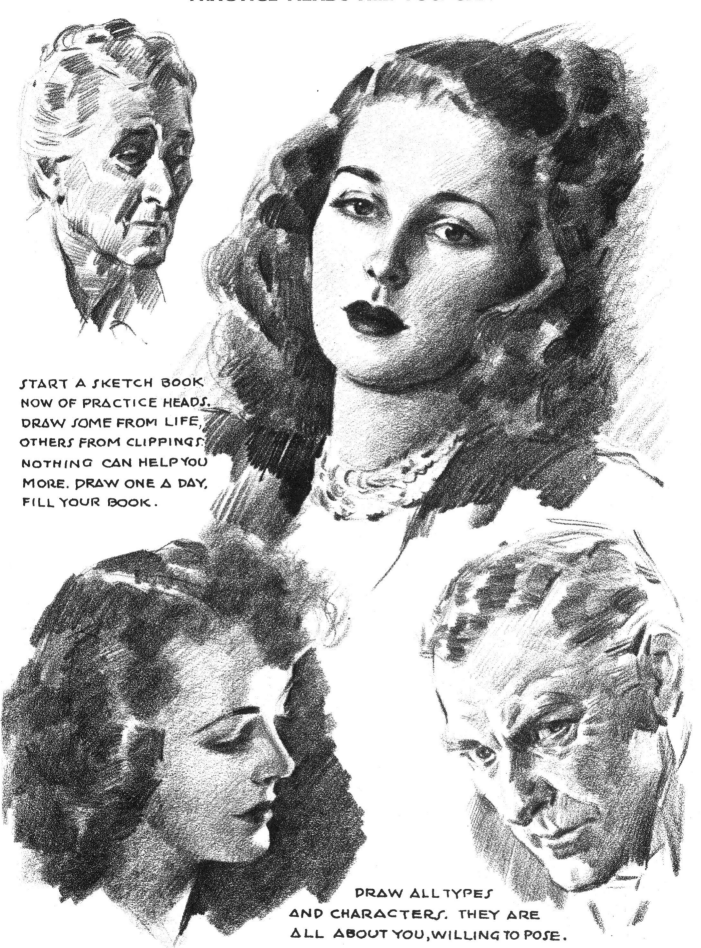

START A SKETCH BOOK
NOW OF PRACTICE HEADS.
DRAW SOME FROM LIFE,
OTHERS FROM CLIPPINGS.
NOTHING CAN HELP YOU
MORE. DRAW ONE A DAY,
FILL YOUR BOOK.

DRAW ALL TYPES
AND CHARACTERS. THEY ARE
ALL ABOUT YOU, WILLING TO POSE.

STUDY OF AN OLD MAN

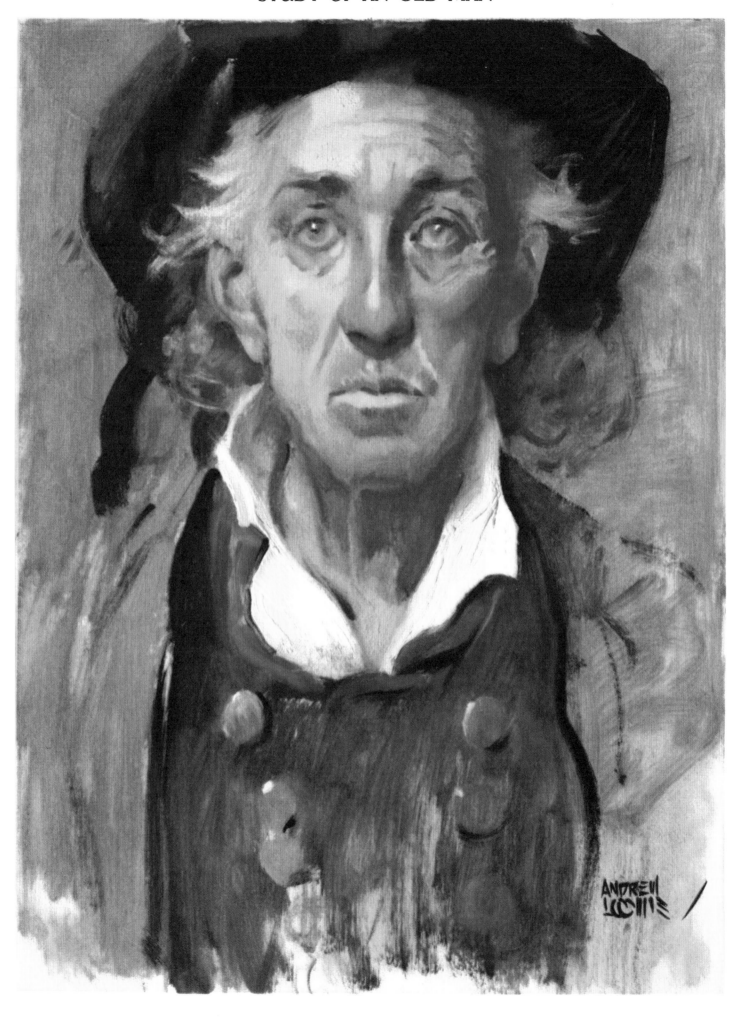

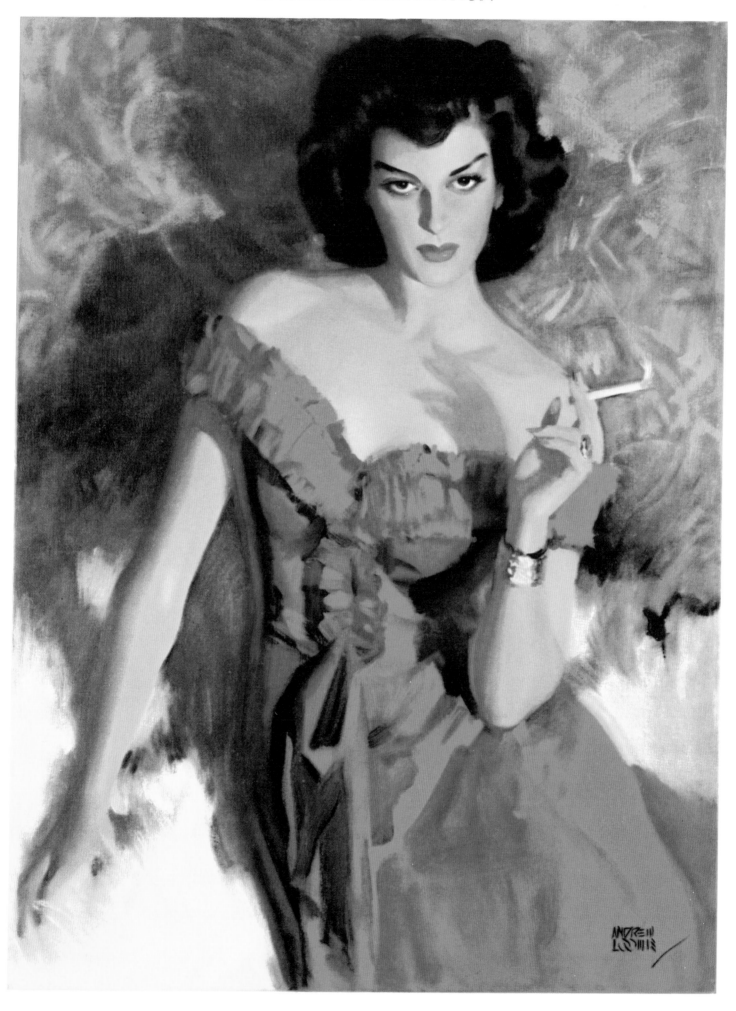

SKETCHING

It is important that the artist fix firmly in his mind the basic difference of attitude in a sketch as compared with final work. Logically considered, a sketch is a search for information that will be transposed later on to the final thing. It is the "nailing down" of essentials that you deem important. Every sketch should have a definite something that you are going after. A sketch presupposes action, mass arrangement, light, shadow, and color, without intricate detail. If you are searching for potent detail, you would think of such preliminary work as a study.

A sketch may be for design or arrangement alone, and the decison as to a color approach. Such a sketch is a "color composition."

In commercial work there is what is known as a "comprehensive sketch." Such a sketch might be quite finished. Usually it is the actual size of the intended reproduction (except in the case of displays and posters). The purpose here, of course, is to give the client a fairly accurate idea of what you intend to do with the subject, its color arrangement and general effect. Such a sketch is usually done from the material that would be used in the final work, and its purpose is to clear up any difficulties or objections that otherwise might carry over into the final work.

Make up your mind as to the intent and purpose of the sketch. Here is the real joy of sketching. In a sense you cast off the meticulous labor for an uninhibited expression of the thing in mind. We know more about an artist from his sketches than from his finished work. That is the reason sketches are often more interesting and beautiful, being of simpler statement and far more expressive. After having made such an analysis and statement, the final work is much more apt to carry the emotions of the artist into it.

In the biggest sense, sketching is an experiment with the pictorial material, searching out the usable facts and assembling them for effect. You are meeting and getting acquainted with your subject. The mental conception of a subject is always abstract. We cannot know what the visual effect will be until we set it down. "Seeing a picture in the mind's eye" is a bit more picturesque as a phrase than it is in actuality. We do not truly see the thing until we have mastered the problems attached to it.

So many effects of life and nature are fleeting. So we make "notes." The camera has helped to catch many of the changeable aspects of life. But the camera cannot supplant the vivid mental impression one needs to produce a good picture. By actually coming to grips with the subject, you are drawing upon your taste and selection, and you are filled with an inward excitement over what the subject contains. The whole conception is more apt to be creative and original by starting with your own first interpretation rather than with a photo.

The time element in sketching is important. Nature changes so fast we have not time to become absorbed in little things. That is why so many fail completely in the ability to make a sketch from life. But suppose the drawing is a bit out? A sketch is not a demonstration of the things you can do with time. Big shapes, big tones, big relationships are what you are after. If you want to carry away the detail, take along your camera; that is what it is for. But the detail will not make the final work any better as a picture. The tonal color and mass will be better than anything your camera can capture.

The ability to make a good and even fast sketch will make a better artist of you in the end. Sketching should not be neglected nor underestimated. The main value lies in the freshness and spontaneity it will eventually give you.

Sketching should be done in almost every medium, under every kind of circumstances, and of all kinds of subjects. If you would illustrate, you will prepare yourself to draw anything and everything. That is not so difficult as it sounds, for everything is simply line, tone, and color. Form is always expressed in plain light, halftone, and shadow.

Your sketching outfit can bring you more real pleasure than any other part of your equipment, especially if you sketch with a purpose.

FIGURE PAINTING

I would like to discuss frankly the importance of figure painting to the average craftsman in illustration. All too often a student leaves the art school having had but a meager start at it, and, anxious to get into remunerative fields, discounts the real value of it as applied to everyday work. True enough, the paid-for picture is seldom a nude, and it may be hard to understand what real connection it could have with other work. Since in most instances it would be actually unlawful to paint a nude figure into an advertisement, why bother with figure study? It is with difficulty that the average young wife can appreciate its real importance to her artist husband's career. I hope she will take my word for it here that it is very important. But far more important is her husband's genuine and honest attitude toward it. It is, frankly, a delicate situation which should be met frankly and openly.

Figure painting in the beginning should be done in class in association with other painters. This, mainly for the reason that one learns faster in co-operation with others. If possible the study should be under a good instructor. I really feel that the night class is best at the start, since the artificial light more clearly defines the form, producing definite light and shadow. Daylight is most subtle and quite difficult. However, it is most beautiful.

There is a difference between life drawing and painting. In drawing we are dealing with line and tone in a black medium. In painting there is seldom a real black on all of the flesh. It means that the artist must raise his values tremendously. Because he has been used to setting down black and white tones in drawing, the student's first paintings are usually overly dark, heavy, with opaqueness in the shadows. The planes in the light are mostly overmodeled, often too brown. Here is one of the most important qualities he can add to his daily or routine work from the experience of figure painting. Flesh tones and modeling are the most subtle and delicate of all form. They are much like the modeling of clouds in light. It forces one to get up into a fresh high key in color

and value. After painting flesh, he finds that he approaches all things in a new light, or with new vision.

The next great value of it is the correlation of drawing, tone, value, and color, all of which are present in the figure. We can paint one apple too red, and it does not matter. But a forehead or cheek too red—and only slightly too red—can be very bad. Almost any other thing can be too much, a sky too blue, grass too green, a dress too yellow, a shadow too warm or too cool. But not flesh. Good flesh tones must be true in tone value and color, or they do not have the quality of flesh. Commercial artists who have spent little time at serious figure painting have a common habit of painting flesh on the "hot" side, with red, yellow, and white, in light or shadow. It makes much of the cheap-looking art work we see.

If you can truly develop your sense of value and color, coupled with the subtlety of plane and construction that is evident in the nude, you can tackle almost anything else with considerable assurance of getting these qualities. A combination of figure and still life painting, first one and then the other, over and over again, offers you the best possible chance to develop the best qualities of painting. Because you draw well is no real assurance that you can also paint, for the simple reason of values and relationships. The only way you can get them is to paint, and paint with a great deal of conscientious study. The reason for working in a group is that values, good or bad, are more apparent in the other fellow's work than on the model. You learn from his errors as well as from his advancement over you.

Go also to the art galleries and museums and study the way flesh tones are handled. It will help you see them for yourself.

Learning to paint flesh well is not easy, and it does not happen overnight. It is not surprising that, of all things, flesh is the most difficult to paint, for, of all things, flesh is perhaps the most beautiful. May we not be thankful that it, rather than the hides and furs of the lower animals, was given to us! Let us appreciate it and respect it.

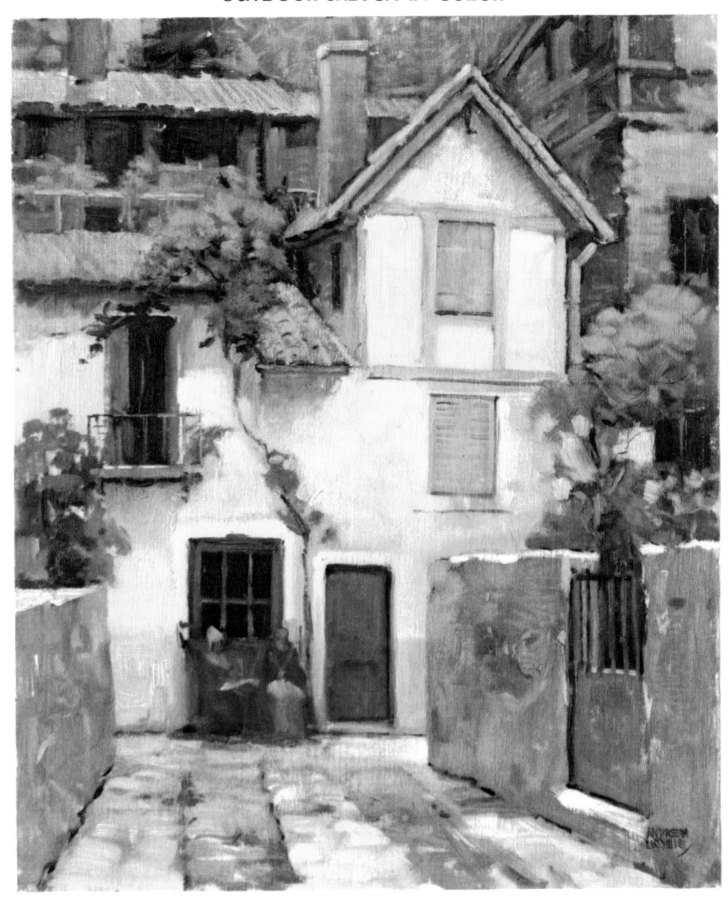

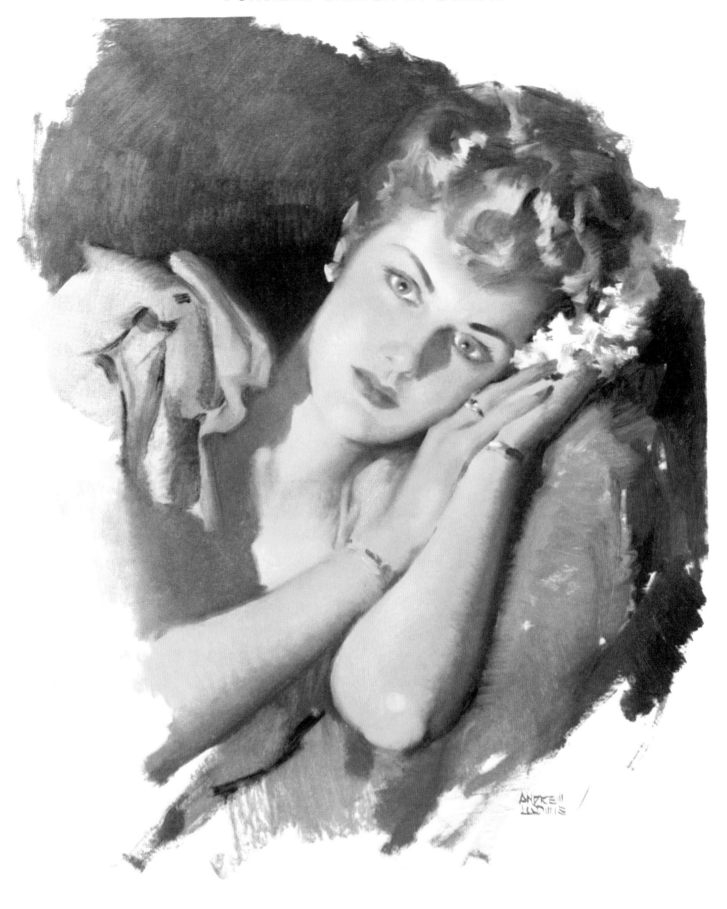

CLOSING CHAT

IT IS with a feeling of regret that I come to the closing pages of this effort. It is something like the parting of father and son. We have been close companions, this book and I, over a period of many months. I can scarcely leave it—and you—without touching upon a few of the more personal things that are bound to make up your life as an artist and illustrator.

First of all, may I impress upon you the importance of developing the ability to make decisions. Hardly a day goes by that you do not have to decide something. Making decisions is the high-road to creativeness. Every bit of art that you do is a collection of little decisions. From the single plan of approach to a single subject, to the whole plan of approach to your ultimate goal, and the carrying through of that plan, all is decision. It is obvious that the artist must be agreeable and co-operative in order to succeed, but there is such a thing as being a little too much of a "yes" man. You can easily get so used to following directions and instructions that you cease to exercise your best faculties. There are many proper and legitimate ways of projecting your personality into the things you do, while still continuing to meet the demands of your assignment. By real analysis, you will find the average assignment wide open to creativeness. I should say that if you have a job that never allows a decision or opinion on your part, get out of it, for you can only move upward by adding something of your individuality to any job.

Perhaps it is just as bad to want to do everything in your way and yours alone. There may be very sound and practical reasons for certain instructions which happen to "go against the grain" with you artistically. Often it is the other way round, since the instructions may have been prepared by those who really have no sense of the artistic, and who would be agreeable to change if the practical reasons from the artist's viewpoint were tactfully pointed out. Art buyers as a rule are not artists, and it is up to the artist to sell his knowledge and good taste wherever possible. You can give the buyer what he wants, and still be giving him what he should have. You would not sell a man a bad anything just because he did not know it was bad.

If you find that you seem to antagonize your clients repeatedly, it is better to get a representative, or work through an agent who knows how to deal with art buyers. Artists are not always good salesmen. Bad salesmanship can stand in the way of your progress. If you fail, it should be because of your work, not because of lack of salesmanship. If art work is good, somebody can always sell it.

The essence of good salesmanship on the part of the artist is the evidence of real enthusiasm over the job. If you like to work for a man, tell him so. But never criticize the ideas of a buyer. That buyer may end up as the art director of the agency or magazine that later on you might want most to sell. Again, every man is entitled to his ideas; the fact that you do not always agree, does not necessarily make the idea unsound.

It is so easy, after a prolonged struggle, for the first successes of a young artist to "go to his head." Often this can be a great and unsuspected detriment to success. I have yet to see the artist who is infallible. The way up is long and slow, but the trip down can be like greased lightning. I have always contended that the man who is big on the outside must be equally big inside. People are sensitive the world over. No one is big enough to belittle the other fellow. It cuts deep, and the wound is lasting. In my day I have seen many of the little fellows overtake and pass the big ones, making the "big shots" eat their words. There is an old saying in Hollywood, "Be nice to people on the way up, for you may meet the same people on the way down."

CLOSING CHAT

I spoke of making decisions. There are many kinds. On the negative side there are lazy ones, intolerant ones, procrastinating ones, impatient ones, indifferent ones, inadequate ones, and impulsive ones. Then there are those that contribute so much. There are those blessed with humility, determination, thoughtfulness, intelligence, and perseverance. There can be the decision each day to make that day count in some way toward your big goal. Art takes so much time that waste of precious time is costly. You must not just *try* to find time for study, you must somehow make it. And, in art, study can never stop. You will find sketches galore in the studio of the good man, with the paint quite fresh. The mediocre artist's sketches are old and dusty. I have seen so many middle-aged artists still hoping, whose samples are frayed at the edges, and thumb-marked with time. Sometimes it has been a matter of years since they sat down and actually did something to give their hopes any promise. They are plodding their lives away at something they hate, and doing nothing about it. These are the men who never seem to have had a chance. The truth is, they never seized a chance.

There is a difference in working "at" a thing, or working "for" it. We can really study, or we can putter. The "for" should be definite before you sit down. You are working for a better knowledge of anatomy, perspective, values, or some definite objective. You are training your eye for proportion, or to see the lost and found of edges, you are developing your vision and technique for more looseness and expression. If you do not seek, how can you possibly find? If you feel that you are making many errors, that is good. That you can sense them is so much better than if you could not.

It is most natural to seek advice on important questions. But do not get the habit of going to others for your decisions. So many artists have written to me for decisions that neither I nor anyone else could possibly make for them. "Shall I take up art?" "Would I be a better illustrator or poster artist?" "Should I work in oil or water color?" "Should I quit a steady job to draw and paint?" One chap actually wrote, "Shall I get a divorce and have the freedom to follow up my art?" Many ask if they are too old to begin, what cities to work in, where do you get work, and how much do you get?

May I say that most advice is conservative. Most people do not want to shoulder the responsibility of another's choice, success, or failure. Asking for advice seldom brings the advice you want. Too often advice is negative. Nobody wants to make your decision, and nobody ever will.

I cannot recommend one art school over another, for several reasons. One is that it is impossible to be familiar with the courses and instructors of every school. It is many years since I attended any art school, and since then each may have changed and probably has a completely new personnel. To recommend a school I would have to be familiar with your work, sympathetic with your particular ambitions, and probably knowing something of your personality, character, perseverance, and adaptability. It is too much to ask, and I do not feel qualified to answer.

Seek the school which shows evidence of the things you would like to do. A school cannot make you a good student, but you can be a good student in any school. School is mainly the opportunity for you to work things out for yourself under the best of conditions, with space, models, and instruction supplied. But you will still have to do your job. It may be a bit harsh, but true, that the average school is much better than the average student, and it would be better if the school could pick the student, rather than the student the school. Some schools require entrance examinations, and if so, you need not worry about the school.

I wish it were possible to list places to sell your work. But your experience will probably be something like mine. After winning an art school scholarship with a figure painting, my first job was to paint a ketchup bottle. I found there was a lot more to painting a ketchup bottle for advertising than I ever dreamed. Then one day I painted

297

a Santa Claus. An art director saw it, told someone who was looking for talent about it. It got me a tryout in a studio. That led to other work, which opened up further opportunities. That is about the way it works out. You cannot be good in art in this country very long before someone begins to take notice. And you can see to it that your work is noticed, by sending it about.

If you intend writing me, as so many have done, I must apologize here for not being able to answer more than a fraction of your letters. My routine work demands most of my time, and I do not believe in form letters or secretarial answers. I have tried to steer you to the best of my ability in this book, and, though I tremendously appreciate personal contact with my readers, I find it impossible to make personal answers to their queries. For this reason I have set up *Answers to Queries* in the back of this book. Perhaps you can find your answer there, or at least it may indicate where the decision must be your own. I shall, however, appreciate letters, especially those that do not request advice in personal matters, which in the long run will be better if worked out by yourself.

The most important thought I wish to leave with you, aside from making big and little everyday decisions, is the great worthiness of our craft. If you succeed in it, the world holds high respect for your accomplishment. There seems to be a certain reverence for good art in all walks of life. Just because art is made for industrial or commercial use, there need be no stigma attached to it. The fine artist works for a living also, and his pictures may be reproduced and sold for profit. I can see little difference between painting a portrait for a fee and painting anything else for a fee. Such difference lies only in the skill of the artist, and there is nothing to limit skill in commercial art. For this reason commercial art has by far the greatest future, since it is open to greater and greater ability; whereas in the fields of fine art there has been such perfection as to leave a very narrow margin to be surpassed. I believe this is the real reason for the trend of fine art today to diverge from the idealistic toward the spectacular, from the tangible to the abstract. This is the only door that seems to be open.

Let us remember the influence exerted upon the average individual by pictures. From the cradle he learns to love them. Pictures of one kind or another do much to shape the pattern of everyday life. Pictures suggest the clothes people wear, the interiors they live in, the things they buy. Pictures visualize the present, the past, and the future. Still more, art brings to life the nonexistent, enables the eye to see the product of the imagination. Art can be fact or fiction, personal or impersonal, truth or distortion, dynamic or static, concrete or abstract, fundamental or flamboyant . . . it's what you make it. Where else in the world is there less limitation?

Let us as artists, then, feel that we have a trust. Let us be sincere, if for no other reason than to give our craft character. Let us choose to reproduce beauty rather than the sordid, if only to elevate the standards of beauty. If we seek an audience to our way of expression, let us make the things we have to say worth while. When we have a choice, let us build, not tear down. If we are endowed with the vision to encompass beauty, let us be grateful, but not selfish about it. To live and work only to please one's self, using art as a means of display for uncontrolled temperament and undisciplined license, for divorcing oneself from the normal and ethical standards of life, to my mind is wrong. Art belongs to life, and essentially to the common, everyday man.

Art is essentially giving. Ability of high order is rare. The successful may well rejoice that they few, among the many, have been given the eyes that see, the hand to set down, the perception to grasp, and the heart to understand, the big truth. What we take in, we can strive to give back in greater perfection. It seems to me that this would not be possible without patience, humility, and respect for life and mankind.

ANSWERS TO QUERIES

1. I would not advise the student just out of art school to set up an immediate free-lance studio. Get a steady job, if possible, in an art department or organization. You will need a period of practical application of your work. Work among other artists. One learns from another.

2. Begin to work to a specified delivery date as soon as possible. Do not let work dally along. Finish one thing before you start another.

3. Please do not ask me to hunt up books for you. Most art books can be purchased by proper inquiry from a book dealer, who carries lists of publications and publishers. You can go to the library and have books looked up for you. Art magazines also usually have a book service.

4. Do not ask me what books to read. Read all you can afford to buy. Start now to build a library of your own. Do not be satisfied with any one book to cover a subject.

5. Do not send me checks or money orders, since the author has nothing to do with the sale of his books. Write direct to the publisher.

6. Please do not ask me to supply you with information concerning art materials. Art supply dealers are listed in most art magazines. Every city has them. Specific materials can be located by inquiry of a good dealer.

7. What school? You must decide. Art schools are advertised in art magazines and listed under vocational training elsewhere. Send for the prospectus.

8. What course? You must decide.

9. What mediums? You must decide. Try them all. All are practical except pastel. Even this can be used if fixed and shipped carefully. Use a pastel (not charcoal) fixative.

10. What city to work in? You must decide. New York and Chicago are the largest art centers. Every city has possibilities.

11. You cannot copy pictures from the magazines and sell them. All printed pictures carry a copyright. Especially do not copy pictures of movie stars or other individuals. You must have a release or written permission.

12. Names of models appearing in my books cannot be given out.

13. There is no specific price for model time. She may work at any price agreeable to both parties, unless otherwise specified by her agent or agency. Model fees should be paid at once, without waiting for publication.

14. An art diploma is not needed in commercial and illustrative fields.

15. Either you or a purchaser may set the price. Sketches should be paid for if they have been ordered and submitted, whether accepted for final work or not. Sketches may be included in the final price. Price for final work should be agreed upon before work is started.

16. If your sketch is given to another artist for completion of the final work, you should be paid for the sketch. This should be deducted from the final price paid to the second artist and paid to you.

17. Request written orders for your work, duly authorized by a responsible signature. It is within your right.

18. Changes or corrections of a nature not in the original request or understanding, and changed through no fault of yours, should be paid for. Corrections made to bring the work up to a required or worthy standard should be at the artist's expense. If changes or corrections are simply a matter of opinion, such expense, if any extra, should be agreed upon before changes are made. Do not bill a client for extra fees unless so agreed. Stick to your original price if you possibly can, for this may have been quoted elsewhere.

19. If you have made a finished picture on order and it is rejected, it is fair to ask for an adjustment, if not the full price, according to your time and expense. If you are a well-known and established artist, your client is expected to be familiar enough with your work to give you a bona fide guarantee of payment, whether accepted in turn by his client or not. Ordinarily the artist should make any reasonable concessions. He should consider carefully whether the work truly represents his best. If not, he should do it over at the original price without extra fee. All artists have a few do-overs. If the client is reputable and fair, his future business is worth the extra effort, and he will not be without appreciation of your fairness. He cannot pay you twice for the same job. If he will not give you the second chance to redeem yourself, then he should pay a fair price for the expense and effort you have gone to. If he wants you to do it over without changing original instructions, you should do so at no extra fee. But doing it over to fit new circumstances, through no fault of your own, should be paid for at a price agreeable and understood previous to the final execution.

20. Never sue a client without having a previous bona fide order and an agreement as to price, also evidence that you have satisfactorily delivered equally important work to other clients. Your work is likely to be passed on by a competent jury, usually artists of note. It is better to forget it if you are certain the work has not been, and will not be, used. Maybe it really is too bad to accept. At any rate, if you sue and win, you may be sure you are through, at least with that client. Few good artists have law suits over their work. In the case of long or extended work, that is different. If part of the work was acceptable and used, that should be paid for. If a contract was made, your client should be held liable.

ANSWERS TO QUERIES:

21. Advertising illustration normally pays a higher price than story illustration.

22. Do not sign an indefinite or lifelong agreement with any representative or agent or broker of any kind. You may be paying for the rest of your life on everything you do, whether it is secured by that agent or not. It must be specified that you pay a commission only on such work as that agent has sold for you, and for a limited period. If all is satisfactory you can renew the agent, while if it is not you can go elsewhere.

23. The agent's commission should not exceed 25%. A lesser rate may be expected as you become well known, since it will be less difficult to sell you.

24. A fine art dealer's commission is anything you mutually agree upon. Some go as high as 50%.

25. You cannot, without postal authority, send nude photos through the mail. Any published nudes must pass censorship, unless unquestionably considered as art subjects, or used in conjunction with art text.

26. All work submitted on speculation should be accompanied by return postage or fees. No magazine will be liable for return or loss.

27. The author does not select the illustrator.

28. You cannot force anyone to publish your work, even if paid for.

29. Please do not ask me for addresses of any kind.

30. Please do not ask for original sketches and paintings, since I cannot possibly meet the number of requests.

31. Please do not ask for autographs. While I am pleased, I honestly have not time to repack and mail your books. For this accept my apologies and sincere regrets.

32. I cannot possibly sell your work for you on commission, nor buy pictures, nor can I hire artists or represent them.

33. Please do not send me your work for personal criticism and appraisal. I have given you everything I can in the book, and cannot extend such service to my readers, though it is much to my regret.

34. Please do not ask for letters of introduction or recommendation. If your work is good you won't need them. I hesitate to deprive an artist friend of time, for that is what he values most. If I would not do it, I cannot ask him to give you time. Some day you will understand.

35. I wish it were possible to give you personal interviews, but I am in the same boat as my artist friend. When working to a filled schedule, there just is not time. The artist has sold his time and it belongs to his clients. It is not his to give.

36. The time given to this book has been given at considerable expense and loss of other work. I can think of nothing more that I could tell you personally. I urge you to get in that boat of yours and row it with all your might. Don't ask for personal decisions. You will find it is better to make them yourself and see them through.

37. Whatever your problem, there has been the same problem over and over for everybody else. Some have licked it, so can you.

38. I do not conduct any classes nor try to give individual instruction, because I want to remain active in the field as long as I can. I could start a school, I suppose, but I'd rather paint. When I'm ready to quit the field, then I hope to feel that I have earned my right to what time is left to work for the sheer pleasure of it. The fun will always be in the doing, and I'd much rather be a student always.

39. I do appreciate letters, especially those that do not ask me to make decisions.

40. In closing, I wish to assure you that in art there is truly a reward waiting for all who have the courage it demands.

Farewell
and
Good Luck

Andrew Loomis